J

Bachelors of Art

Bachelors of Art

EDWARD PERRY WARREN &
THE LEWES HOUSE BROTHERHOOD

David Sox

FOURTH ESTATE · *London*

First published in Great Britain in 1991 by
Fourth Estate Limited
289 Westbourne Grove
London W11 2QA

A catalogue record for this book is available from the British Library

ISBN 1-872180-11-6

Typeset by York House Typographic Ltd, London
Printed in Great Britain by Hartnolls, Bodmin

Contents

Introduction

John Fothergill at Lewes House, c.1905 to Edward Perry Warren:
'The whole tale is a sad one; you should have your little case
written up, the story of your curious life and all the curious tales
of relations with you.'[1]

At Golders Green Cemetery, near London, on 1 January 1929, Frank
Gearing carried out the last request of his former employer, Edward
Perry Warren, master of Lewes House in Lewes, East Sussex. War-
ren's body was cremated at 1 p.m. A brief printed note issued by
Gearing stated that 'the ashes will be conveyed later to Bagni di Lucca
in Italy, where they will be placed next to those of his friend, the late
John Marshall'.

Another friend, John Fothergill, later could not remember 'how
many, if any others, were in the Golders Green chapel, save Harry
Thomas and myself'. But outside he recalled 'the most touching scene
of my life . . . a little row of [Warren's] old servants, pensioners and
carpenters . . . looking sad, silent, quite old and altered.'[2]

There was not one member of the Warren family present, and,
despite his extraordinary career as a collector of classical antiquities
and his significant benefactions to the Boston Museum of Fine Arts,
Bowdoin College, Leipzig University, the Ashmolean Museum and
Corpus Christi College, Oxford, no one from that world turned up
either. Warren was to be remembered that day only as the former
master of Lewes House, and soon to be forgotten altogether once
interred at the English Cemetery in Bagni di Lucca.

The baths of Lucca to the north-west of Florence, made fashionable
in times past by Montaigne, Shelley, Byron and the Brownings, are a
little seedy today and, according to one commentator, 'certainly not
fashionable . . . Nevertheless, Bagni di Lucca is an inexpensive place
to take the waters or merely to savour the somewhat claustrophobic
atmosphere created by the mild, humid climate, the mature plane
trees and the weight of nostalgia for the vanished Victorian
presence.'[3]

The English Cemetery was begun in 1842 to take care of the increasing population of expatriates (including President Cleveland's sister, Rose) who desired eternal rest in Tuscany rather than Ohio or Sussex. Frank Gearing arrived with Warren's ashes on 5 April 1929, and they were placed in a simple tomb already containing the remains of John Marshall and his wife, Mary Bliss (Warren's cousin). The Marshalls spent many of their last days at Villa Buonvisi in Bagni di Lucca. She died there in 1925, and Marshall in Rome in February, 1928.

Now the cemetery is submerged in weeds. Not far from the bizarre sarcophagus of the prolific Victorian writer, Ouida – crowned with a full-length effigy – and next to three crosses, one of which marks Rose Cleveland's grave, is all that can be seen of the Warren-Marshall monument: a plain Grecian urn. The large base with the names of the deceased around it has sunk into the ground.

None of the Warren family ever visited the site. Bagni di Lucca is a long way from their Beacon Hill mansion in Boston and the paper-making empire in Maine which created their wealth. For Edward Warren, it is also far from his Georgian house in the High Street at Lewes, where he collected art and young men. Warren tried to forge them into a brotherhood of aesthetes, but in the end they all abandoned him. Even in death Warren had to share his place next to his beloved 'Puppy' (as he called John Marshall) with Marshall's wife.

Seven years later, Matthew Stewart Prichard, once considered the most able of Warren's aesthetes, was quietly buried in Parslows Hillock, Buckinghamshire. He had once been a confidant of Henri Matisse and the Stein clan in Paris, but only his brother, retired Brigadier General Charles Stewart Prichard, and a few townspeople witnessed the scattering of his ashes in the back garden of the house the brothers had shared for several years.

On 26 April 1957, John Rowland Fothergill, the one member of the Lewes House brotherhood to become well known in Britain, died in a modest terraced house in Rugby at the age of 81. During his long life Fothergill had dabbled in classical archaeology, put in brief stints studying at the London School of Architecture and the Slade School of Art, and managed the Carfax Gallery. Posterity, however, will remember his latter day career as an eccentric innkeeper and author. His grave is marked by one of those hideous mass-produced white concrete crosses which a friend said he 'would have loathed'.

By the end of the 1950s, only one of the Lewes House brotherhood was still alive, Harold Woodbury Parsons. After the death of Warren and Marshall, Parsons carried on the Lewes House tradition of purchasing classical antiquities and fine paintings, and he greatly enriched the collections of three American art museums: Cleveland, Kansas City and Omaha. Like Fothergill, Parsons had a long life, despite several attempts at suicide. In his last days he was obsessed with forgery in the art world. When Parsons died in 1968, in Rome, few mourned his passing, and most of the art establishment remembered him only as 'a pompous operator in the fashionable upper crust of the art world of the 40s and 50s'.[4]

Parsons, Fothergill, Prichard, Marshall and Warren – each in his own way eccentric and extraordinary. Their friends and acquaintances make a veritable who's who from the art and literary world: Oscar Wilde, Robbie Ross, Lord Alfred Douglas, Isabella Stewart Gardner, Henri Matisse, Jacob Epstein, Augustus John, William Rothenstein, Romaine Brooks, Harold Acton, Bernard Berenson, Evelyn Waugh, J.P. Morgan, George Santayana, Clare Booth Luce, Joseph Duveen, Gertrude and Leo Stein.

I first came across Warren and Marshall and their friends several years ago when I was writing about the art forger Alceo Dossena. After Thomas Hoving, editor of *Connoisseur* magazine, read my book on Dossena he said he knew what my next book should be: the Lewes House connection. Hoving was right, but neither of us had any idea where the project would lead or what material had survived.

Five years before his death, Warren started writing his autobiography but he never completed it. A fragment does remain and covers his childhood in Boston up to his years at Oxford. In his will, Warren made provision for his literary editor, Osbert Burdett, to continue the story but Warren also set certain conditions: 'any Memoir should so far as possible be limited to statements of fact and that gossip and expressions of authors' opinions should be excluded'.[5] Burdett died in 1936, and, reluctantly completed by his associate E.H. Goddard, *Edward Perry Warren: The Biography of a Connoisseur* appeared in London in 1941 but attracted a very limited readership.

An author who has recently written about the Warren family, Martin Green, described the Burdett and Goddard book (as it will henceforth be called) as 'one of the worst biographies known to man' and 'an act of betrayal of their friend and patron'.[6] That judgement is

excessive, but Burdett and Goddard is not an easy read. Sometimes it is impossible even to say who is speaking and often no chronology is given. The authors followed Warren's dictum to the letter – we are forced to read between the lines.

Unfortunately, the sources used by Burdett and Goddard have largely disappeared, and for that reason both Green and I have often had to rely on their version of events. It was, however, fortunate that Burdett and Goddard presented Warren's autobiographical fragment in its entirety and included a large amount of correspondence between Warren and Marshall. Some of these letters (and others) remain at the Ashmolean Library in Oxford as well as a number of notebooks and diaries. I refer to the originals wherever possible. Sadly, the materials at the Ashmolean are in a remarkably poor state: disorganized, unpaginated, undated and haphazardly stored in old cardboard boxes.

Several discoveries especially encouraged me, the previously unpublished memoirs of John Fothergill and the remarkable Mrs Kathleen Warner, whom I met. Mrs Warner was a kitchen maid at Lewes House during Warren's time and is now 91. She has a vivid recollection of the house and its occupants. Also helpful were the daughter and granddaughter of Harry Thomas, Warren's last private secretary. They made available to me many valuable letters and notebooks, also providing interesting insights of their own. In addition to their father's memoirs, Fothergill's sons, Anthony and John, allowed me access to extremely useful letters and papers which were not published in Fothergill's innkeeping diaries.

Particularly significant for the section on Matthew Stewart Prichard was the unpublished draft biography of him by Harry Rowans Walker. I am indebted to Andrew Gray and Sir John Pope-Hennessy for bringing it to my attention. Charles Calhoun supplied me with an important letter from Harold Woodbury Parsons and I also greatly admire his article on Warren in the *Bowdoin* magazine. Thanks are also in order to Sir Harold Acton, Thomas Hoving, Joan Mertens, William Royall Tyler, Milton Girod, Sherman Lee, Charles Stewart, Sir Steven Runciman, Brian Cook, Pico Cellini, Brian Macgregor, Caroline Dalton, Penelope Smith, and Jennifer Brooke. I was fortunate to have known Bernard Ashmole before his death, and am grateful to him for the material he gave me. I also welcomed the comments and aid of Margaret Warren who is related to the Warrens by marriage. Thanks are also owed to Travis Warren's son, Fiske. I interviewed a number

of art dealers and experts who expressed a desire for anonymity. Often they confirmed many of my suspicions.

This book is dedicated to Tony and John Fothergill, Penelope Braithwaite, Pamela Tremlett and Kathleen Warner without whose help *Bachelors of Art* would not have happened.

PART I

Edward Perry Warren – a Dream of Youth

With faces bright, as ruddy corn,
Touched by the sunlight of the morn;
With rippling hair; and gleaming eyes,
Wherein a sea of passion lies;
Hair waving back, and eyes that gleam
With deep delight of dream on dream;
With full lips, curving into song;
With shapely limbs, upright and strong:
The youths on holy service throng.

the first stanza of *A Dream of Youth*
by Lionel Johnson, much loved
by Edward Perry Warren[1]

1

New World Beginning

'My grandfather, an old-fashioned Calvinistic Congregationalist, used to pray on Sundays at Mount Vernon Street for out-pourings of the Holy Spirit, for awakening which should bring all to enquire: "Men and brethren, what shall we do to be saved?"'[2] Thus begins the autobiographical fragment of Edward Perry Warren who spent most of his life avoiding Calvinistic salvation ('My grandfather was not a man to influence me personally')[3] and just about everything else Puritan New England had to offer.

Born at Waltham, Massachusetts near Boston in the year Lincoln was elected President (1860), Ned Warren soon revealed traits of the future. When Ned – as he was invariably addressed throughout his life – was 37, his mother, Susan Clarke Warren, the daughter of a Congregational minister, the Reverend Dr Dorus Clarke, sent her son a 'strictly private and personal' letter (21 January 1897). In it, she wrote that in her opinion he was 'more nervous' than the other children, and times had been difficult for her when he was born. Father had not been well, the family doctor had died, and she had been left too much to herself. 'Now does not this account for your nervous troubles?'[4]

Mrs Warren's prayer that Ned 'might be made in his father's very image'[5] was not answered. Samuel Dennis Warren was a descendant of John Warren who arrived in Boston on the *Arabella*, in 1630, from England. For two centuries the Warren family were modest farmers in Massachusetts. Samuel Warren, however, was determined to make his mark and saw his chance in paper manufacturing. Warren worked his way up from office boy at the age of 15 to partner, aged 21, in a Boston paper company. In 1894, he borrowed enough money to buy a paper mill in Westbrook, Maine, the predecessor of his enormously successful Cumberland Mills. By the time Ned was born, his father was well on the way to becoming a millionaire.

Up to the middle of the nineteenth century, paper was made from rags and cloth, and in the years before the Civil War supply could not keep up with demand. Sam Warren moved fast, travelling abroad to look for good supplies of rags. He found them. For a while Italy

remained his best source, but soon hardly anywhere was left unexplored. Even wrappings of Egyptian mummies were made available to the US market. Southern cotton had been the most important material used in paper manufacturing, but the blockade of southern ports in 1861 made the cost of paper rise steeply. A substitute for southern cotton and foreign rags had to be found. The answer was, of course, wood pulp. In the 1870s, the 'soda pulp' method of papermaking came to Maine and quickly established itself as the preferred method. As early as 14 January 1863, *The Boston Weekly Journal* proudly boasted it was printed on 'paper made from wood'. With this vast, seemingly endless supply of raw material and demand for paper, rapid expansion of the paper industry was guaranteed.

Warren made a fortune. S.D. Warren & Company became one of the largest paper manufacturers – and remains so today as a division of the massive Scott Paper Company. The tributes paid to Warren when he died in 1888 suggest that he was a benevolent tycoon. He established the Warren church and parsonage at the Cumberland Mills site, together with a hundred tenements for the employees; even a library – later equipped by Ned with books on archaeology and art.

In 1863, when Ned was 3 years old, the Warrens moved from Waltham to 67 Mount Vernon Street in Boston's Beacon Hill. He described the house as 'long, running from a narrow front on Mount Vernon Street back toward Pinckney Street and eventually after my father built an addition, to a broader front on Pinckney Street itself'.[6] Henry James thought Mount Vernon Street was one of the best streets in America. The Warren establishment was far from being among the most impressive, but it had some distinctive features: a conglomeration of parlours (one filled to the brim with Venetian furniture), a great hall, two libraries, and a drawing room with panelling of Louis XV court ladies. Ned thought the latter did not suit the portraits of his father and mother, but he loved a little Venetian cabinet which was filled with china. The china 'offered some relief to my aesthetic instinct'. He enjoyed taking favourite pieces to his room at night and often they would be discovered under his bed by the maid in the morning. Soon he put together a little collection of china in a corner cabinet of his bedroom. He remembered being late to bed on occasion due to rearranging the pieces: 'I was learning . . .'[7]

Ned developed into a most unusual boy. While the other Warren children and their friends played Cowboys and Indians he would wander about the countryside alone in a Roman toga of his own making. The seeds of the later pagan aesthete were sown. His early

obsession, however, was with religious denominations and his mother was alarmed as she saw him wandering about to various churches: 'principally Unitarian, Episcopal and Roman'.[8]

Unitarianism was rather sterile, Catholicism was too foreign, but the Episcopalians with their Elizabethan language, candles and flowing surplices attracted Ned. Early on in his enthusiasm for Episcopalianism, he persuaded his mother to hear him read Morning Prayer and Litany in the parlour with the Venetian furniture: 'She was busy; yet she took time and came, constituting . . . the whole congregation. I wore a night-gown, and for stole, a broad pale-blue Japanese scarf embroidered with fans.'[9]

His mother indulged Ned's little passion; his father thought that his son would grow out of playing with religion. Though described at his funeral as 'an honourable outgrowth of Puritan soil',[10] Samuel Warren thought religion important largely for social and business contacts. It was not Ned's obsession with religion as such which bothered him but the fact that his son was so different from other boys. Ned gloried in his distinctiveness: 'I could not be inconsistent enough to be like other boys.'[11] He joined in no games and had few friends, except for a girl he called Lucy in his memoirs. Lucy and Ned had two interests in common: confirmation and candlesticks. The two went to various shops looking for just the right ones to use in their make-believe church services at home: 'We would examine them with the greatest attention, decide whether they were pretty in every detail . . . and then whether we had enough money to buy them.'[12] These were Ned's first art acquisitions.

Ned became Lucy's religious instructor and drew up forms of prayer for their services. For this he acquired books of devotions, missals, liturgical calendars and lots of ribbons in different colours. The changes in liturgical colours throughout the church year fascinated the two of them. Ned also insisted upon a rigorous attention to intercessions and confession. The intercessions 'grew very long in time and included an endless litany of friends'.[13] Confession also became very complicated. The two 'discovered faults of omission and commission pretty well' whenever they discussed them at break times at school. In time, Ned's rule was revised. Prayer services were 'supplemented, rectified, or remodelled, till the marginal notes, after filling all the available space, lost themselves in fine writing at the corners. Then a fair copy had to be made, and the copy likely suggested alterations, till Lucy, though provided with a simpler service than my own, grew quite bewildered.'[14]

Back at Ned's school, Phillips Grammar School in Anderson Street, his reputation among the boys had been 'marred on arrival'. He had appeared wearing his sister's boots with two tassels fastened on the front: 'Everybody looked at my feet. I couldn't think what was the matter with them. Then it came out. A popular song – "Tassels on the boots. A style I'm sure that suits. You Yankee girls with hair in curls wear tassels on your boots".' Ned became 'Tassels' and forever remembered the name called out by the boys as he walked home. He also remembered that the boys were rough: 'Once I was knocked down and bruised on the back of my head. I was convinced that the hair would never grow there again, and lamented the loss very much.'[15]

Despite these traumas, Ned enjoyed all the advantages of having a wealthy father. He was taken to Europe when he was only 8 years old, and again when he was 13. During the first visit he was blessed by Pope Pius IX, and in the Tuileries in Paris when playing with a hoop he 'ran into the Emperor Napoleon III, who took my impact very politely'. Ned said these trips gave him his 'only sense of real life'. Later on he recalled how impatiently he waited for the departures to Europe in front of 67 Mount Vernon Street. He reflected that he was 'a boy cloistered from the American world in a domestic museum on top of Beacon Hill yearning for those things of which I had inadequate evidence at home'.[16]

Ned had other problems as well. He fell in love with several boys at Phillips. He wrote a poem about one – the first of hundreds in his lifetime – and he compared the boy to Hadrian's favourite youth, Antinous. He said he 'worshipped' another boy at a distance: 'I knew where he lived, and as the window shade was often not quite drawn I could stand in the street at night, and see the curly head bent over his books. Sometimes the shade was drawn down and I had come in vain.'[17] The boy never knew of these visits, but one night as Ned was looking at him he heard a laugh behind him. His French maid had tracked him down.

Ned took the maid into his confidence. She knew the boy whom Ned admired and was able to borrow a picture of him from which a tintype was taken before it was returned. Ned said the tintype was one of his treasures, and another was the autograph which the boy gave him: 'This I put into an envelope, cut a hole that I might see it, glazed the opening with transparent paper to keep it clean.' Ned also 'surreptiously acquired' the boy's Greek exercises from a waste-paper box and pieced them together 'as well as might be'. To the boy he

wrote an ode which Ned considered his 'first transition from an ideal to a real love'. After watching the boy play football on ground near the Old South Church, Ned described him as:

Clothed in the sweat of action, powerful, great
With health and sinews mighty, born to live,
To live and not to die, to seize the world
Not vanish from it . . . [18]

Ned also developed a boyhood adulation for the pianist, Ernst Perabo. Perabo was born in Wiesbaden where he was soon recognised as a child prodigy. In 1852, his parents emigrated to the United States but Perabo stayed to study at the Leipzig Conservatory. Later he joined his parents in Boston and became both a successful concert pianist and music teacher. He was said to have had 1,000 pupils, among whom was Ned, who said that Perabo taught him 'far more than music'. Perabo also had a keen interest in art. With Ned, Perabo shared stories of his unhappy boyhood being driven by his father to excel. Ned recalled that Perabo displayed 'an extreme and almost morbid tenderness'. He also instilled in Ned a great love for music: 'He used to play to me when I hadn't learnt my lesson. Then he would ask how I liked what he had played. I was always slow to judge, and had to hear the new thing many times over before I would say.'[19] This was Ned's first exposure to the culture of the Old World. He kept in touch with Perabo throughout his life and acknowledged the musician's influence on the direction his life was to take.

Samuel and Susan Warren had six children, of whom five grew to maturity. The first-born, Josiah Fiske, died at the age of 3 in 1853. Oddly, before Josiah was a year old, his parents went to Europe and left the child in the care of another couple. Sam Warren (the II) was born the year Josiah died. He was to leave his chosen profession of law and a highly successful partnership with Louis Brandeis (later Justice of the Supreme Court) to run the family business. Henry Warren was born in 1854 and, in his own words, when he was 3 years old he 'tumbled out of the carriage . . . which my mother was driving. I struck on my head and soon after grew hump-backed and ever since I have been excessively delicate and always ailing.'[20] Henry grew to only five feet tall.

Ned was always protective of his brother. Henry found that he was 'rather sympathetic with me and a firm critic of others'. Henry's room

was kept so overheated 'as to melt the snow on the roof of our neighbour's home'. Because he found it difficult to eat at the table with the others, cold chops were left on a table outside his door 'that he might eat in the night'. Henry's sleeping arrangements were also bizarre: he used to get inside a bag which was placed on top of a desk which had a blanket hanging down in front. Sometimes he decided that this was not for him and climbed into Ned's bed.[21] Despite his condition, Henry went to Harvard and became an orientalist and the author of *Buddhism in Transition*. He was also a respected Sanskrit and Pali scholar. Throughout his life, in order to work, Henry had to stand supported by crutches or to lie on his chest or side. He died at the age of 45 in 1899.

The only daughter, Cornelia, was born in 1857, and by all accounts was a good daughter and sister. Despite the fact that she wrote *A Memorial of My Mother* in 1908, we know little of substance about the environment in which she was raised. She was in the best tradition of emotionless Bostonians and in his memoirs John Fothergill wrote: 'She politely loathed me; controlled the household and was a blue stocking.'[22] Evidently, the only time Cornelia expressed much emotion was against Ned's peculiarities. He said little about his sister in his memoirs except that she 'has never been interested in pretty things'.[23] Even so, Fothergill maintained that later in life Ned had 'terrible dreams about her'.[24]

Fiske Warren was two years younger than Ned and was in some respects decidedly the more eccentric. He became a political radical, devised elaborate social theories based on a 'Single-Tax idea', and backed the Phillippines against 'American imperialism'. His personal habits were also unusual: he wore reformed clothing and digitated socks, fitted to each toe like a glove. Fiske also had a liking for nudity, and on one occasion at least was asked by the police to 'dress and cease to cause scandal'.[25] Fiske had married well. His wife, Gretchen Osgood, came from a family which claimed descent from John Quincy Adams and ancestors who had played a role in the American Revolution. The historian H.A.L. Fisher who knew both Ned and Gretchen, described her as 'gay, lovely, affectionate and gifted'. He also hinted that the couple did not get on: 'Her multifarious tastes left Fiske entirely cold.'[26] John Singer Sargent's portrait *Mrs Fiske Warren and Her Daughter Rachel* hangs in the Boston Museum and was painted in the Gothic Room at Fenway Court in Boston. It appeared to be the ultimate social acceptance of the Warren family, but according to one critic Sargent was not terribly impressed and showed them 'as if they

were incapable of rising to the distinction they knew only Sargent had a right to claim'.[27]

The sibling rivalry was strongest between Ned and Sam. The two were decidedly different and their relationship was always potentially explosive. Martin Green, in *The Mount Vernon Street Warrens*, maintains 'Each *despised* the other',[28] but there is nothing in Sam's own words to indicate how he felt about his brother. We do know, however, of Ned's bitter feelings about the turn of events which led to Sam controlling the family business. Ned suspected that he was being cheated over his inheritance. Sam also became President of the Boston Museum of Fine Arts for which Ned amassed many antiquities, though Ned was of the opinion that his brother never took collecting seriously enough. Unfortunately, the two never really got to know one another very well, and as Cornelia observed: 'Sam was away so much that he scarcely counted as one of the children.'[29]

There is another element to all this. Ned recorded some odd remarks his mother made concerning Sam. She said that because Sam was 'a known doubter or disbeliever', she 'had always felt that the hearts of her other children were right, but that Sam's heart was against God'. Ned added that 'this was not the first time a difference had arisen between her and me . . . Now on hearing that Sam's heart was against God I broke out in the most inconsiderate way . . . There was no evidence of an evil heart in Sam.' Ned went on to remark that after he had confronted his mother his 'Papa alone judged rightly. He did not make the dogmas a test of character.' Mrs Warren did not like hearing this and broke into tears telling him to go to his father since Ned seemed to have 'confidence in him'.[30]

There were strong, conflicting emotions at work in the household with Mrs Warren at the centre of it all. Unfortunately, we never get a clear picture of her in any of the writings of Ned and Cornelia. John Fothergill said: 'She went mad in the end'[31] but there is no corroboration of this. We do know that she became jealous when her husband was away from the house, as he often was because of his business. In 1860, when he left for Rome for health reasons, it seems Mrs Warren did not know she was already carrying Ned. When he returned many months later, she greeted him and 'dissolved in tears with a fancy that he might possibly think it was not his child'.[32] Ned never commented on these remarks but they were recorded in his memoirs in the context that he felt he was 'her favourite child'. Psychologists may make of this what they will.

On several occasions, Ned let his reader know that he was his

mother's 'pet'. When she and Cornelia visited England in 1894 he declared this was the time he 'admired Mama most. I was her pet son. She had come from America to see me.'[33] Despite these assertions Fothergill noted in his memoirs that Ned was 'passionately devoted to his father and his memory, whilst he hated his mother'.[34] Again, these are Fothergill's words and as with the earlier comments concerning Cornelia and Ned's mother, they may well be the biased assertions of a man who never felt comfortable with any of Ned's relations.

On the other hand, Ned Warren confided many of his strongest sentiments to Fothergill, and it is possible that his feelings towards his mother in later life became quite ambivalent. Aside from his declarations that he was mother's 'favourite', there are few other signs of deep affection towards her in his memoirs or surviving letters. His brother Henry appeared to share some of this ambivalence. Ned recorded that once after a bitter quarrel he had had with his mother, Henry told him: 'It's no use to protest against Mama's doings: they are a storm; we must allow it to pass over.'[35]

Strong egos often collided among the Warrens but, as becomes increasingly evident, the family was adept at keeping the Mount Vernon Street curtains tightly closed. In some respects, the household mirrored the convulsive Boston society of the 1870s, outwardly tranquil but shaking underneath. For the upper-crust sons of Puritan fathers nothing seemed to have changed over the last few decades. Most would have agreed with Sam Warren when he wrote in a letter to his former classmate, Louis Brandeis: 'Boston is the only locality in which a civilized man can exist.'[36] The blue bloods acted as if Boston was still theirs alone. That was basically true up to the middle of the nineteenth century, but by 1880 so many Irish immigrants had arrived that they comprised more than half the population. Boston was no longer the WASP bastion with the 'Lowells speaking only to the Cabots, and the Cabots speaking only to God'.

Even Harvard was beginning to open its doors to non-Yankee stock, though it continued to be the number one choice for the children of the old Boston families. Naturally, Samuel D. Warren sent his sons there. He himself had been denied a college education and apparently 'esteemed that advantage to the point of exaggeration'.[37] Young Sam did well at Harvard and reached the highest social level by being elected to the Porcellian and Hasty Pudding Clubs. He went on to graduate *cum laude* from Harvard Law School where there was only one student smarter than he – his best friend, Louis Brandeis.

Ned Warren entered Harvard in 1879 when Louis Brandeis and Sam were together at law school. Ned said he was ready for Harvard a year earlier, but unlike Sam he was 'proficient in Mathematics not at all'.[38] When Ned described his 200 classmates there is a snobbishness which elsewhere in his memoirs he decried. The Warrens were significant socially – but they were not up there with the Saltonstalls and the Lowells. Ned said of the 200, 'only seventy or eighty counted socially, and of the seventy or eighty only forty-five were in the first circle . . . '[39]

The social pecking order was important. The forty-five were separated from all the others by the tables where they ate. There were three important tables. One consisted mainly of Philadelphians and another of Bostonians. Ned's table had three Bostonians (including himself) and the rest were New Yorkers or 'Westerners'. He observed that the Bostonian table were 'very Bostonian, the men belonged to well-known families. I and my two Bostonian companions were not thus illustrious.'[40]

Generally, Ned did not particularly enjoy Harvard and described his freshman year as one 'passed in stupidity'. His social position 'was utterly unhappy and unsettled . . . ' and he said that his social advances were largely rejected. Most of these observations were written just five years before he died and throughout he constantly compared his latter-day experiences to his situation at that time: 'To this day I am said not to see what others think. Then, when I was far more afloat and less self-respecting, my course must have been quite wrong . . . I must have seemed a strange mixture of snobbishness, bad form and refinement.' His interests in music and 'beautiful things' kept him going but he described himself as having an 'absent-minded air and slouching gait'. His clothing was 'either neglected or else intended to be extremely smart. My fashionable boots with olive uppers pinched me to distraction. I had the lowest and broadest billy-cock going.'[41]

Poor eyesight plagued Ned throughout his life and he said that he avoided studying in the evening and often went for walks. These were usually through the sections of Cambridge and Boston where he noted the goings on of the highest echelon of society: 'I caught glimpses under half-drawn shades of the parlours which the elect of the earth inhabited.' He complained to his mother that they 'were not born in the purple',[42] but she did not like these reminders that a higher order existed.

While at Harvard his fascination with churches and denominations

continued. He attended three churches in particular: Trinity, where the famous Episcopal cleric, Phillips Brooks, attracted large crowds for his brilliant sermons, the Church of the Advent (which was the fashionable Anglo-Catholic parish), and Old North Congregational Church. He found, however, that none of them satisfied a deeper need. He was looking for something – someone to be exact: 'I had always condemned my companions because their friendship was superficial, i.e. not really love . . . My friends were affectionate, but their affection did not pass beyond a certain point, or had not as yet. They seemed to me not to differentiate between a casual friendship and that final recognition of their friendship which involved their holding together.'[43]

Ned mentioned only a few by name. One was Charles Perrin who had been brought up in Fort Leavenworth, Kansas where he had 'guarded the [family] house at night for fear unruly soldiers might want to get at the woman-folk of his family'. His mother was a member of the Page family of the 'First Families of Virginia'. Ned described Perrin as 'passionate, unreasonable, uncultivated and very fond of music'. He was also very attractive and to be 'worshipped at a distance'.[44] On at least one occasion Perrin visited Ned at Waltham, but their friendship appeared to run hot and cold.

During Ned's second year, his rooms were opposite those of Joseph Peabody Gardner, whom he said was 'the most thorough gentleman and the most tender and conscientious in heart and life whom I have ever known'.[45] Joe Gardner was the eldest of the three orphaned sons of Jack Gardner's brother, Jack being the husband of Isabella Stewart Gardner, the art collector who became closely associated with Ned's companion Matthew Stewart Prichard and with Bernard Berenson. The Jack Gardners took the boys into their household and Aunt Belle, as the boys called her, raised them as 'proper little Englishmen'. Joe Gardner was attracted to Ned and thought he was an upstanding youth with strong religious connections. He was protective and tried to steer Ned away from bad influences. Later Ned told him: 'I've often thought to tell you that I was not as good as you thought me.'[46]

By all accounts Joe Gardner was a charming youth and said by a classmate to have been of 'supernormal sensitiveness'.[47] Once he had reached the age of 21, in 1855, he bought a homestead estate of 235 acres at Hamilton, to the north of Boston. His foster-parents assumed it was for some girl he was planning to marry. But there was no girl, and according to some accounts the object of Joe's attention was Berenson's homosexual brother-in-law of Logan Pearsall Smith, sup-

posedly, Pearsall Smith had broken Joe's heart. Jack Gardner half suspected the truth, and so he and Isabella decided to include Joe on their 1886 European tour. This ended in disaster when, on 16 October, Joe committed suicide in a hotel in Dieppe. The Gardners learned of his death in a telegram from Boulogne which was signed with Pearsall Smith's initials, L.P.S.[48]

The last portion of Ned's recollections of his time at Harvard indicates that he had reached a critical state. He spoke of a revolt which was connected with his long-time dabblings with religion, but there was far more to it. Ned was not able to deal with his homosexual feelings, much less reconcile them to his religious convictions. He said that he had 'passed from the highest worship to the most intense passion of which I was capable, and the passion itself was now burnt out'. On the eve of his birthday in 1882 he said that he could not sleep:

> I went to the wooden bridge nearest Harvard and sat on a pier from three to six in the morning watching the slow dawn. Then my past died. I could no longer play music with expression; I had no overmastering sentiments; I felt commonplace; the world appeared to me as others saw it, if I might judge by their words; I could now understand them. I rejected their conventions, but what was 'superficial' seemed natural. I did not want to continue at Harvard.[49]

Ned told his father so, saying that he felt he was not accomplishing anything. He got his bachelor's degree but let it be known that he wanted to study at Oxford. His memoirs jump to the days at Oxford with only a pause to mention his growing interest in poetry and a particular love for the verse of Swinburne, whom he described as 'the master of my soul'. Ned also recorded Oscar Wilde's visit to Boston in 1882. This was during Wilde's lecture tour of America and Canada. Wilde said to his Boston audience that theirs was 'the only city in America which influenced thought in Europe'. This praise was marred by the mocking behaviour of some Harvard students in the audience. After reading Wilde's lecture on 'The English Renaissance', Ned remarked, 'I lost my head at once'.[50] Brother Sam was said to have had 'a less than favourable opinion' of Wilde which Ned interpreted as 'practically condemnation' and was peeved at Sam's insistence that he should not try to see Wilde. He did not see him in Boston but did meet him later in New York. It is regrettable that Ned wrote so little about this meeting, considering how strong an

influence Wilde had upon many of the people whom Ned was to get to know in the next few years.

Another curious omission from Ned's memoirs and surviving letters is the role he played in Bernard Berenson's early career. But this influence can be pieced together from a scattering of references. The relationship was more significant for Berenson's early financial stability than some writers have indicated. It was Warren who sponsored Berenson's admission to Harvard, and the time of Ned's last year there the two had become friends sharing similar tastes in classical languages and art. Later, together with Isabella Stewart Gardner and a professor at Harvard, Ned contributed to a purse of $700 to make it possible for Berenson to travel in Europe. He supplemented this initial grant on several occasions when Berenson thought he would have to return to America. Berenson, on the other hand, was responsible for some of Warren's earliest art purchases and for a time acted as his scout. H.A.L. Fisher, who met Berenson at New College, Oxford, said at the time he was 'practically ignorant of art. He had never been to Italy. He had seen few Italian pictures, and it was . . . to Ned's intelligent munificence that B.B. owed the opportunities . . . which have made him one of the most accomplished art critics of his generation.'[51] Fisher was unique in recognising this.

Far more than anyone else, Ned Warren was responsible for Berenson's first steps towards success, and it is highly doubtful whether Isabella Stewart Gardner would have come to his rescue financially at this early stage. It was only natural that Berenson should dedicate his 1895 essay on Lorenzo Lotto to Ned. The two shared a budding aestheticism and an attraction to the Old World. There, both would become great connoisseurs, but Ned's future course would go in directions quite different from that of the celebrated Berenson.

2

Old World Choice

Clearly a man with such ideas and with such a soul would be a misfit in every way imaginable in New England society.

Osbert Burdett and E.H. Goddard in
Edward Perry Warren: The Biography of a Connoisseur

Ned's move from Harvard to Oxford turned out to be his hegira and it is odd that he wrote nothing about the intermediate circumstances. Obviously he was not about to enter his father's business, and the memories of family trips to Europe – his 'only sense of real life' – had stayed with him. All Burdett and Goddard have to say is that although the father disagreed with his son's decision to go to Oxford, he had 'the generosity of heart and spirit to let his unorthodox son go his own way'.[52]

Ned had an introduction from someone he identifies as 'Brearly, a graduate of Balliol' who led him through the intricacies of applying to a particular college at Oxford. He first considered Balliol but was 'afraid of Balliol ideas as being too modern, and of its system as having too many men who lived out of college'. Ned also disliked 'the architecture of the hall'. It was to be New College: 'the tremulous intonation of the service at New College delighted me'.[53] New College was founded as St Mary College of Winchester in Oxford in 1379 by William of Wykeham who was a royal surveyor of castles as well as being Bishop of Winchester. Since Wykeham helped with the design of Windsor Castle, his college looks like a fortified monastery.

The setting appealed greatly to Ned, but he said his first dinner at college was a disappointment: 'None of the men seemed to me well dressed; and though I had come to Oxford for culture I nevertheless felt an undercurrent of snobbishness'.[54] But he came to love his new environment. He had come home: 'I found people who did not damn my ideas as incorrect but, on the contrary, found them interesting. I was at one with others, and seemed to be patted on the back.' Ned also noted more democracy at Oxford than he had known at Harvard:

'At Harvard exclusive societies and clubs were necessary to the fellowship of those of a kind, and the kinds were very different. At Oxford we were more of the same social level.'[55] In chapel, however, Ned was wretched. Religious ambivalence continued to haunt him and he excused himself from attendance on the strength of a parental letter, saying that he had been brought up a Congregationalist. Despite this, Ned admitted the beauty of the New College singing and was tempted back on occasion to hear it – 'my emotions pulled me back for the hour'.[56] However, his religious feelings were still riddled with guilt concerning his sexual proclivities. He was pulled back for the hour, but no more.

Ned was looking for more – specifically for 'affections between my own sex, real affections'. He found that the beauty and charm of youth were more appreciated at Oxford than at Harvard. He noted other differences as well. Americans coming to Oxford thought it odd that undergraduates invited one another to tea. He relished these differences and absorbed so many English characteristics that some of his countrymen at Oxford were unaware that he was one of them. Fothergill said that he spoke 'perfect, too perfect English, and sometimes affected the Oxford don's Mandarin style'.[57]

The Oxford of Ned's time was almost a totally male environment. Up to the 1880s dons were not even allowed to marry. As Jan Morris observed: 'Old Oxford neither understood nor much admired women.'[58] Archbishop Whately (an Oriel don in the 1820s) proclaimed: 'A woman is a creature that cannot reason and pokes the fire from the top.'[59] In a sermon at New College chapel the year after Ned arrived, Burgon, the Dean said of females: 'Inferior to us God made you, and inferior to the end you will remain.'[60]

Obviously such attitudes fostered a dislike of women and encouraged a certain amount of homosexuality. Undergraduates had come from public schools where, for four or five years, many of their sexual exploits had been turned in among themselves. Evelyn Waugh said that though most young men had indulged in 'light flirtations' with the opposite sex during their vacation, 'they plunged themselves more wholeheartedly into deep friendships with other men in term time'.[61] Jan Morris suggests that, generally, 'In the old days a man's memories of his Oxford years had a sensual tilt to them: the emotional impact of the city was itself warm, and vivid, and often the friendships formed within his college were highly charged – if not overtly homosexual, certainly shot through with rapturous undertones . . .

College loyalties and personal friendships were all diffused in a cloud of golden recollection, illuminated at its edges by poetry.'[62]

This was the Oxford experienced by Warren – down to the illuminated poetry, as we shall soon see. Martin Green tastelessly remarks, 'Ned was not ever a screaming queer' but 'involuntarily drew attention to himself as queer'.[63] We know nothing of Warren's actual sexual exploits. Obviously he was a homosexual, but from all accounts there is no indication he was a practising one. A more tactful observer of Ned's homosexuality is Charles Calhoun who maintains that the most conclusive piece of evidence that Warren was not overtly homosexual is the 'innocent blatancy with which he espouses "Greek love"'. Calhoun adds that in the aesthetic circles of the 1880s, 'one might have gotten away with a good deal, as long as one cited Theocritus or some other classical poet'.[64]

'Greek love' seems quaint today, but the idea of essayist Walter Pater that the love of beautiful young men was connected with the spirit of Greek sculpture is at the heart of Ned Warren's homo-eroticism. Most of Ned's associates at Oxford viewed him as intimately connected with Pater's approach. Though Pater's writing was attacked by some academics as unscholarly, he had a profound influence on undergraduates of the 1880s and 1890s. After Wilde's imprisonment, and once the love that dared not speak its name had been named, it was even more important that high-minded feelings went no further than the mind. As Calhoun justly says: 'it would have been folly, especially for a resident alien, no matter how rich, to practice openly in Britain what some Hellenists still preached'.[65] Ned preferred another whimsical term, 'Uranian Love', as in his magnum opus *A Defence of Uranian Love*. The word was first used in a homosexual context by the Austrian writer Karl Heinrich Ulrichs (1825-95). Uranian, of course, came from the Greek god, Uranus, who was the father of the Titans and personified heaven. Those who came to employ 'Uranian Love' were saying that such love was of the highest order, the platonic ideal of love.

John Fothergill wrote that often Ned was 'more a misogynist than a homosexual', and went on to imply that he was almost asexual – certainly in his relationship with his disciples at Lewes.[66] The point about Ned was that he was an unresolved mixture of emotions and desires. Ned's misogynism, however, was undiluted and greatly enhanced by friends like Oscar Burdett who disdained women in general, and women's rise to power in particular.

We see this unresolved mixture in a melodramatic story Ned wrote

while on holiday in Naples, in 1887, three years after he met John Marshall. *A Tale of Pausanian Love* was not published until 1927, a year before Ned died. It is in this tale rather than in anything Ned said in his memoirs that, as Burdett and Goddard observed, we come 'nearer to the person of its author' than ever attained elsewhere. Here is Ned at his most revealing – and his most vulnerable. He recounted, through the narrator, that he had always found women 'outside the circle of my thoughts'. He could not defend himself against the feeling that 'intellectually they were my inferiors'. And the love of the inferior was to him 'a contradiction in terms. One could only worship that which was above one's self.'[67]

The book is only 136 pages long, and as with several other works of a homosexual nature written by Ned, was issued under his pseudonym, Arthur Lyon Raile. When the book appeared in 1927, privately published and read by Ned's friends, there was little doubt as to whom the two main characters were meant to be. Ned was Claud Sinclair, an Oxford student of partial foreign birth. His German mother died when he was 15 and his father lived in Germany. The tale is told in the first person by Claud who is like Ned even down to his physical appearance. Claud is rather a fuss-pot with expensive china and a willingness to play nurse-maid when his friend is ill. His description of Oxford life is far more lively than the Oxford of Ned's autobiography. Like Ned, Claud loves college life: 'When the college gates were behind us, life seemed to begin again, sacred, austere and secluded . . . It is only at Oxford, and only alas! for four years, that the flower of youth can be observed in all its graceful lightness.'[68] There is an overabundance of description in the story, flowery and insufferably sentimental. The characters are emotionally charged but generally perform in a wooden manner.

Claud's friend, Alfred Byngham, evokes John Marshall. There are identical physical characteristics: Alfred's ability to use his arms like a monkey; biceps very flat at the side, and very long when seen from the front. The third character, Ralph Belthorpe, was incorrectly identified as Harry Thomas (Ned's last private secretary) by Harold Parsons, who was obviously unaware that Ned had written the story almost twenty years before he met Thomas. However, Ralph, described as 'athletic, sunny and possessing the peculiar charm of Eton men', is a Harry Thomas type and it is Ralph who makes the story so revelatory. Only gradually – and in a muddled fashion – do we learn that Alfred and Ralph have had an affair.

At first the set-up is quite straightforward: Claud is enchanted with

Alfred, who, like John Marshall, only 'shines' when 'you get to know him';[69] the two like Greek poetry, and in time Alfred introduces Claud to *The Symposium* which he coyly refers to as his 'charter'.[70] It takes an inordinately long time before Claud realizes that Alfred has fallen for Ralph. He is so obtuse that even when he bursts into Alfred's room to announce a college victory and discovers 'an affectionate good-bye between Alfred and Belthorpe – certainly unusually demonstrative', he still 'thought nothing of it'.[71] By page 27, however, Claud has a flash of intuition: 'All the world knew they were intimate friends . . . I began to suspect more.'[72]

Claud begins to take note of Ralph, who is described as 'well developed and light in build, every muscle showing without exaggeration . . . like a moving bronze'.[73] Such admiration causes Claud to be ashamed of his own body, which like Ned's was heavy: 'It might enable me to carry a bench or pull a boat but never to look more than hulking beside his grace.'[74]

As was to be true in later years concerning Warren's experience with Harry Thomas, so Alfred came to realize that Ralph's 'proper future might be made for marriage'. After confessing to Claud that he had actively pursued Ralph for some time, Alfred decides to give Ralph up. Their parting is melodramatic: 'He left me with a kiss, the most sacred I have ever had. I told him all was over . . . Marry; it is the best thing you can do, for yourself and for me.'[75]

It takes many pages for Ralph to accept this advice and the agony surrounding his marrying is strangely prophetic of Ned's future anxiety regarding the collapse of his brotherhood at Lewes when Marshall, Thomas and several others left to take a wife. The last two chapters move at a quicker pace. Claud is invited to Alfred's home sans Alfred. Claud suspects something is up, as indeed it is. Alfred's mother, Mrs Byngham, his sister, and even his Nanny appear to have recognised his proclivities. Nanny is exceptionally perceptive as she has taken note of what she considers to be 'questionable reading matter': books by Pater and Symonds. Nanny, who never liked Ralph, assumes it was he who gave them to Alfred and has been leading her Alfred into 'bad ways'. 'If only Nanny knew,' muses Claud. Then he wonders if Ralph's future depends on his lying or on his speaking out'.[76]

Claud decides to speak out. Mrs Byngham remarks that she only knows what her son has told her, but 'men's lives are so different from ours . . . and sometimes they won't tell all'.[77] Claud throws caution to the wind and declares that men 'won't tell what women

might not understand'. Nothing but the truth would now set matters right. He goes on to say:

> My decision was taken . . . The most dangerous was the only way. I began very distantly to speak of warm relationships that might not be understood by women, of affections that sprang up unconsciously even against the will. This was not quite true to what Alfred had told me. I was drawing on my own experience. But I did it to try the ground, and, finding that she followed not without sympathy, and even growing eloquent under the encouragement of her gentle eyes, I told her that Belthorpe had had a passion of which none need be ashamed, whatever people might say – of which, on the contrary, he ought to be proud. I entreated her to think of it as something, which, being a woman, she could not understand, but in spite of this, something pre-eminently noble, more especially with such a man; a man, I said in my heat, whose love neither man or woman would have the right to refuse. I did not name him, but when I had ended, Mrs. Byngham picked up with 'My son . . . I can understand any love for him.'[78]

How Ned would have loved to have had that recognition from his own mother. Alfred's mother is now able to put it all together: 'I see it all now. I understand his moods, his gloom . . . Nanny suspected it.'[79] First, Alfred goes abroad and then enters a publishing firm in London. Claud sees little of him. Ralph moves towards marriage. One evening, Claud receives a mysterious note from Alfred: 'The parting of the ways is at hand. I shall write to you to-morrow.' Claud nervously watches every post: 'When I saw Alfred's hand, I tore open the letter knowing it was my doom or my salvation.'[80]

Alfred's letter says that he had to wait until Ralph's marriage before he spoke his mind: 'You will never know what it cost me to keep silence till now. But I had one selfish consolation which you had not. I understand you. You do not know me. Will you come to me, Jiffy. Will you come?'[81] And so the tale ends. 'Jiffy' is the nickname Claud and Alfred used for each other; much like 'Puppy' used between Marshall and Warren.

That last touch is just one of several parallels between the tale and Marshall and Warren's own life. Apart from the physical similarities and personal quirks, Warren also has Claud planning to found a 'Greek-style' graduate school of athlete-scholars. This dream was to

be an obsession for Ned throughout his life. Both Claud and Alfred
are keen on Greek archaeology and artefacts. Claud's father is extre-
mely wealthy and his mother leaves him a sizeable legacy. All this
was to be true of Ned's life. The love triangle – Alfred, Ralph and
Claude – uncannily foretells future difficulties among Warren, Mar-
shall and Thomas. As we shall see, such jealousies and potential
rivalries were to be a feature of many of Ned's relationships: Mar-
shall's betrayal of Ned to marry Ned's cousin; Matt Prichard's alliance
with Richard Fisher; Fothergill's homosexual and bisexual romances
and eventual marriage; Ned's infatuation with Thomas and Thomas's
marriage.

It is more than fascinating that Warren could foresee how certain
matters would go three years before he leased Lewes House, but as
the story was published in 1927, it is possible he added to it or
changed some of the original. This possibility, however, seems less
likely when we read in the instructions he left his literary executors
not only that he thought the tale was 'not good', but referred to it as
'The Tale of Rathbone, or whatever he is called . . . '[82]

The differences between the story and reality are also pronounced.
There is no indication that either Warren or Marshall had a 'Ralph' at
Oxford. Green suggests that Ned was romantically inclined towards
Berenson but that is impossible to substantiate. Before they met,
Warren and Marshall were equally inexperienced, and both were very
confused regarding their sexuality. There was also an important
difference which Fothergill noted. Like Harry Thomas, Marshall was
not adverse to the idea of marriage. For Ned, that course was utterly
unthinkable and a betrayal of homosexual idealism. As in Ned's tale
of Claud and Alfred, neither Ned nor Marshall were always entirely
honest with each other. Claud's desperate remark as he waits for
Alfred's letter, 'I should have confessed my love',[83] are words Ned
would wish the two had uttered by the time Marshall considered
marrying Ned's cousin.

3

Oxford Days

Bernard Berenson described visiting Ned Warren just a few months after Ned had completed *A Tale of Pausanian Love*. Ned lived at 31 Holywell Street which was just across from New College. They had been together in Paris in the autumn of 1887 and had roamed the galleries together. Berenson was introduced to the literary lights among the students and commented that nothing equalled Oxford and the men he looked upon: 'Take your best and imagine it more refined, more intellectual, saner and you have the English youth I meet.'[84] Berenson's interest in the male charms of Oxford was, however, quite different from that of his friend Ned, and, in time, he objected to what he and his wife referred to as 'the Brotherhood of Sodomites'. B.B. boasted that at the time he made 'homosexuals' mouths water'.[85] He also appeared to be pleased that while at Oxford he went out with a new acquaintance every afternoon. A dozen years later, Berenson reflected on his brushes with sexual deviation, and though he admitted 'a delight in the beauty of the male that can seldom have been surpassed, and with an almost unfortunate attractiveness for other men', he was categorical in that 'I have not only never yielded to any temptations but have deliberately not allowed temptations to come near me'.[86] According to his biographer, Meryle Secrest, Berenson had a 'squeamish dislike of what he would have considered a sexual abnormality, as well as his fear of guilt by association'. Secrest says that homosexuality never attracted Berenson, and his infatuations with attractive young women later in his life were well known. However, Kenneth Clark maintained that he was always terrified that people would accuse him of sodomy. Nothing could be more damaging to his career.[87]

There was no doubt about the proclivities of Lionel Johnson who was a friend of Warren and Berenson's. Johnson was seven years younger than Warren and the son of Captain William Victor Johnson of Broadstairs in Kent. He said of himself that he was the only male member of his family who had not had military training, and his brief life was both brilliant and tragic. Lionel Johnson entered Winchester

College when he was 13 and like Ned was attracted to a variety of religious expression: Anglicanism, Buddhism and finally Catholicism. Santayana knew him well when he had rooms at New College, overlooking Holywell Street where Warren lived, and described him as 'a little fellow, pale, with small sunken blinking eyes, a sensitive mouth, and lank pale brown hair. His childlike figure was crowned by a smooth head, like a large egg standing on its small end.'[88]

Others were less generous. There are descriptions of Johnson with permed hair and wearing face powder as well as girlish shoes and blue silk stockings.[89] He devoured books and while contemptuous of his fellows at college was at the same time enamoured by the beauty of some of them. Santayana said that Johnson lived on eggs in the morning and nothing but tea and cigarettes during the rest of the day.[90] The tea was soon replaced by alcohol – a liking for which he apparently first acquired at Winchester where he drank eau de cologne to the amusement of his classmates. Johnson blamed his alcoholism on a doctor who once prescribed a glass of whisky before retiring to steady his nervous disposition. Towards the end of his life in order to 'ensure the Bacchic haze that engulfed him from the world,'[91] he was drinking two pints of whisky every twenty-four hours. According to one account, Johnson's death at 35 was brought on from a fractured skull he suffered from falling off a bar stool while eating a sandwich at the Green Dragon in London.[92]

Berenson and Warren shared with Johnson a passion for the writings of Walter Pater, the high priest of the Aesthetic Movement. Johnson became quite close to Pater and he was one of many young Oxford men who wished to model their lives on *Marius the Epicurean*, the last of Pater's works. Warren never directly acknowledged a debt to it, but Berenson's other biographer, Ernest Samuels, says: 'It was probably Bernard's reading of *Marius* as much as any more prudential motive that led him . . . to take the first of his dramatic steps toward his ambition of perfect culture.'[93] Today, the book appears indigestible with an impossible plot. It is the spiritual odyssey of a Roman youth who seeks 'to meditate much on visible objects . . . on children at play in the morning, the trees in early spring, on young animals, on the fashions and amusements of young men; to keep ever by him if it were but a single choice flower, a graceful animal, or a seashell as a token of the whole kingdom of such things'.[94]

Unfortunately for Berenson, Pater made himself unavailable for any tête-à-tête, and Ned, not wishing to appear to be a devotee, made no effort to be admitted to Pater's lectures. That not withstanding,

both Berenson and Warren were charged by his thinking and Pater's *Marius* was passed among most of their closest associates. It was a bond which also united them to Oscar Wilde. Johnson was a more direct link to Wilde for Berenson. At Winchester College, Lionel Johnson had come to know his cousin Lord Alfred Douglas better and it was Johnson who introduced Douglas to Wilde, a momentous act to say the least. The introduction was later to have a great effect upon Johnson who came to dislike Wilde. Secretly he dedicated his poem, *The Destroyer of a Soul*, to Wilde. It is strong venom. The opening line says: 'I hate you with a necessary hate', and goes on further to proclaim: 'You, whom I cannot cease/With pure and perfect hate to hate . . .'[95] Nothing else is known of the circumstances of the poem.

Berenson met Wilde at his house in Tite Street and enjoyed 'immortal Oscar's outrageous wit' but, according to Ernest Samuels, he also 'prudently resisted Wilde's advances', an attitude which led Wilde to exclaim that Berenson was 'completely without feeling' and 'made of stone'.[96] Berenson remained in touch with Wilde throughout the sensational trial of 1895 and afterwards during Wilde's imprisonment in Reading gaol. Despite John Fothergill's close relationship with Wilde, and the fact that Fothergill often referred to Warren's acquaintance with Wilde, Warren only mentioned Wilde once in his memoirs: when he saw Wilde in New York during a lecture tour.

Similarly, Warren only wrote about Johnson in a detached manner. When he was writing *The Beardsley Period*, Osbert Burdett asked Warren to supply a sketch of Johnson. Warren concentrated on Johnson's love of controversy: 'His points of opposition were well taken, but they were taken for the sake of opposition . . . When he had made, or was about to make, his submission to the Latin Church, he informed me that this action was "wholly for purposes of controversy" . . . I liked Johnson. I thought him a good critic and a discriminating controversalist. I could not find that he revered truth.'[97]

Johnson was not easy to know, as one of his few close friends, Frank Russell, related: 'Friendship with Lionel Johnson in any ordinary personal sense was not an easy thing: he was aloof and detached and apt to suggest an Epicurean god rather than a human being. He didn't want to be like this; he passionately loved his fellow creatures in theory, but he found it difficult in the flesh.'[98]

There was more than a bit of Johnson in Warren, but Warren was too restrained to be in danger of going down the path of inner destruction. By the end of his brief life, Johnson had left an extraordinary body of literature: hundreds of poems evoking a remarkable

transcendentalism. But as Santayana said: 'Lionel Johnson lived only in his upper storey, in a loggia open to the sky; and he forgot that he had climbed there up a long flight of flinty steps, and that his *campanile* rested on the vulgar earth.'[99]

When only 20, Johnson wrote a poem for Warren, *Counsel*. On one level he had certainly entered Warren's psyche: 'Bring not to her Golden lore of poetry: Not on those dark eyes confer Glories of antiquity. What wouldest thou? She loves too much, To feel the solemn touch of Plato's thought, that masters thee.'[100]

In his memoirs, Maurice Bowra, the classical scholar who later became Warden of Wadham College, described the Classics course at Oxford which Warren would have experienced. Bowra said that it was 'a survival from the past when the study of Latin and Greek were regarded as the base of all human education'. That is why its title was *Literae Humaniores*: Humane Letters. Bowra explained what was expected of young men at New College:

> For his first five terms a student works for Classical Moderations, or Mods, and this means that he studies Greek and Latin literature in breadth and depth. For the next seven terms he studies Greats, which is a combination of ancient history, both Greek and Latin, with philosophy, both ancient, that is Plato and Aristotle, and modern. It is thus an education in the study of classical antiquity in a full sense . . . [The student] must have enough command of the ancient languages to be able to read them in bulk and to know what the texts mean.[101]

Ned was well prepared for this kind of study and his results in Greek and Latin Literature in the Trinity Term of 1885 were excellent. However, he only took a pass degree in 1888 and, according to the official Oxford record, that was 'because his sight failed him after Moderations, the first set of University exams he took'.[102] Other records refer to Ned's having a 'physical breakdown' at this time. H.A.L. Fisher spoke of it in those terms and exclaimed that with the breakdown 'all chance of a First in Greats and a Fellowship vanished'.[103] Writing in the *Bowdoin* magazine, Charles Calhoun suggested a psychosomatic origin for this and Ned's other ailments.[104] This view is supported by Sam and Cornelia's scepticism about Ned's claims of ill health. Whatever the situation, by 1887 Ned's daily reading was reduced to four and a half hours.

In his memoirs, it is Ned's contention that there had been no reprieve from poor health between 1885 and 1894. At Lewes House, Ned's health was continuously discussed. Mrs Kathleen Warner (still alive in Lewes and once a kitchen maid at Lewes House) says Warren suffered from pernicious anaemia and used to eat raw liver as a cure. On several occasions she remembers a local doctor aggravating his condition by applying leeches to Warren's neck. Warren wasn't the only one inclined towards hypochondria at Lewes House. So also was John Marshall – and his future wife, Mary Bliss. All three tried a variety of cures at continental spas.

John Davidson Beazley, who catalogued the superlative Lewes House collection of ancient gems, was close to two other New College men who knew Warren: Maurice Bowra and Harold Acton. Beazley was devoted to Warren and tried hard to present his friend as much as possible as a serious scholar: 'Warren loved ancient Greece; and especially its earlier phase; that athletic, aristocractic, and heroic age which became fully articulate, just at its close, in Pindar and Aeschylus, in Critius and Myron. He was an admirer of exact scholarship, and made light of his own attainments in that respect.'[105]

Beazley was too much of a gentleman to reveal that Warren's endless translations of Greek and Latin verse and texts were consigned to oblivion, ending up in his dust-filled cupboard at Oxford, when he was Lincoln Professor of Classical Archaeology from 1925 to 1956. Subsequent holders of the chair (including Bernard Ashmole who was close to both Marshall and Warren), left them undisturbed in the same cupboard until, in the 1970s, Warren and Marshall's personal papers were moved to the librarian's office at the Ashmolean Museum. This is where I found them several years ago: uncatalogued, unpaginated and unread.

Ned found it hard to compete with the likes of John Marshall (who gained First Class Honours in his final examination) and his complaints about poor eyesight appear to sound like an excuse for top achievement. Later, referring to not having taken Honours, Ned admitted, 'I should never have understood philosophy.'[106] He admired precise scholarship and was never happier than when poring over an obscure translation or creating verse in isolated splendour at 'Thebes', the name he gave to his study above the stables at Lewes House. Warren never made it as a scholar, and certainly not as an author. Apart from a pamphlet on Classical and American Education, and translations of Greek legends which were published · by Blackwell in 1919, all his other works like *A Tale of Pausanian Love*

and *The Wild Rose* were privately printed. Stacks of those two titles can still be found in the attic of Harry Thomas's cottage at North Chailey.

During Ned's long summer vacations from Oxford, his mother tried to get him to return to Boston. He would not go the first summer, so she came over to Heidelberg where Ned joined her. The next summer (1885) both parents came to Oxford and stayed at Oriel House. Brother Sam and his wife of two years, Mabel Bayard Warren (daughter of US Senator Thomas Bayard; later Secretary of State and the first Ambassador to London), stayed at Canterbury House. Sam admitted feeling melancholy 'to be in a place where there had been such good times in which I had no share'.[107]

Ned's father was not well and was told to rest: 'He sat helplessly in his chair while Mamma and I shopped. She asked my advice frequently, most often on china. There was a tea-set at Walpole's which she rejected as too flamboyant. It was of that flaming apricot colour which I have chosen for mine. I bought it myself. It was sent to the lodgings, and when Papa saw it he said: "Well, I'm glad you have got that."' Ned's father was glad his son's taste had overridden that of Mrs Warren. Ned felt, however, that his father's own taste was sometimes questionable as on the occasion long before when he bought a massive tea-and-coffee set, highly embossed: 'Mamma had dutifully used it for the rest of her life but had not, I think, after that purchase, allowed him to buy anything. She had an eye not so much for household furnishing as for pictures and ornaments, and she was too willing to buy things at small prices instead of reserving herself for important pieces.'[108] In a few years' time, Ned was able to change her attitude in that respect on several occasions.

While the three of them were staying at Folkestone (as a change from Oxford), both Ned and his father went to visit a doctor. Ned was given a tonic which did him a world of good and his father was told that he had been suffering from a serious retention of urine. This was the first indication of the gravity of Samuel Warren's illness. Mrs Warren was unaware of the potential physical danger to her husband, and to Ned she complained of his father's 'inability to make a decision: he used to find it so easy.'[109] She continued to press Ned to return home, but although he was 'her favourite' he was reluctant to yield to her. However, when his father told him he needed him 'for his help', Ned agreed at once to return the following winter. He never said much about his relationship with his father, but as earlier noted,

Fothergill had the impression that Ned was 'utterly devoted to him', and this incident seems to confirm that impression. Despite his willingness to please his father, Ned wrote that he was not looking forward to Boston: 'For me home was no excellent prescription, nor was I very comfortable at 67 Mount Vernon Street.'[110]

Ned did not like the changes to his boyhood home very much: the house had been extended backwards to Pinckney Street, taking the place of an old house which had never been connected to Mount Vernon Street. The ceiling of the dining room had been decorated in the likeness of lacquer with inlays of mother-of-pearl. Ned said that he regretted the expense which these changes entailed, and wondered whether the new parts, 'all sunless save two rooms in the suite, would ever be wanted by Papa's successors'.[111] He also complained that he had been given the cold northern ground-floor room as a sitting room, and a cold northern bedroom in the main house. Ned's younger brother, Fiske, occupied the new suite at this time. Nevertheless, Ned's sitting room had one advantage: there was an entrance from Pinckney Street which served the whole of the new wing, so that when Fiske was away Ned's visitors could be received unnoticed. Otherwise, he was so uncomfortable that he begged for the reception room, then only used for casual callers. This was refused and Ned began to feel that 'tradition and my mother's grandeur overweighed human need'.[112]

As it turned out, there were not many gentlemen callers. Ned admitted: 'Invitations to tea or for the evening only brought old friend, John Moore.' All his old Harvard friends were too busy in their offices in town to come and see him. Ned sulked: 'My unhappiness came partly from the loss of my English companions who had refreshed me with their health . . . I looked at a group of Oxford men in a photo and asked: "What would you do?"' His mother was oblivious of Ned's discomfort: 'She was delighted to have me, and I remember how, flushed with the furnace-heat and nervous of my aimless existence, I noticed her contentment and ignorance of my trouble.'[113]

Both parents seemed totally unaware of Ned's new longings. If after their visit to Oxford they had picked up any clues, they kept them to themselves. Unlike the Claud of *A Tale of Pausanian Love*, Ned was not prepared to open up in any respect. He said that every morning he 'came to Papa and asked whether there was anything I could do for him. Only once or twice did he answer "Yes". I began to suspect that my mother had occasioned his request for my return.'[114]

Towards the end of the summer Ned insisted on leaving; it was to be his last visit to Boston while his father was alive. Ned returned to Oxford and found that all his friends had gone down; but there had been an influx of younger Eton men: 'I found myself at home with the younger set and received invitations, till at last I refused a Freshman saying, "You really can't want me."'[115] On this maudlin note, Ned's autobiographical fragment ended.

Samuel Dennis Warren died on 11 May 1888 and, supposedly for health reasons, Ned did not go back for the funeral. Not returning to Boston at this time – or for the next few years – was a great mistake. Samuel Warren's funeral was a fairly low-key affair, though the mill town of Westbrook, where the family fortune was made, organised a memorial service befitting the man who had made Westbrook significant. The flag was flown at half-mast; the Warren church was draped in black and its bell tolled seventy times. A three-hour service was held. The memorial book, later published by 'the people of Cumberland Mills', provides vivid details of their mourning: 'The organ was covered with black, relieved by white hangings. In a frame over the key-board was a large photograph of Mr. Warren. Above this was suspended a white dove, with wings extended heavenward.'[116] Westbrook invited all the local dignitaries and encouraged them to speak. Which they did; so much so that their remarks fill fifty pages of the memorial book, excluding the memorial sermon which itself runs to twenty pages. F.M. Ray, a former judge of the Municipal Court, said boldly: 'He was rich. For years the fact that he was a rich man has been uppermost in our minds when we mentioned him.'[117]

Warren was indeed rich, leaving an estate worth $1.9 million. At his death, S.D. Warren and Company was making between $300,000 and $400,000 a year. In his will, the vast residue of the estate (after small bequests to brothers and sisters) was divided so that one-third went to his wife and two-thirds was equally divided among his five children. The will was a straightforward affair, but perhaps foreseeing future difficulties, Warren had suggested in it that the family might consider the option of selling the business. However, they did not take up this option, falling in instead with the suggestion made by the young Sam Warren's partner, Louis Brandeis, of setting up the Mills Trust, which was largely Brandeis's creation.

Sam, who administered the Trust in an autocratic manner, told Ned that as he had failed to come to Boston, and because there was 'so much explaining to do to the other children', he did not need to see a detailed amount of the Trust.[118] By children, Sam meant his siblings.

Blindly, Ned signed the agreement which sealed his financial future, being unaware of how much capital his father had left or what his own income would be.

Over the years, the inequities would become painfully apparent. Fiske Warren, who was supposed to occupy an important role in the Trust, was gradually squeezed out of his partnership. Originally, he was given 16⅔ per cent of the firm's profits to Sam's 33⅓ per cent. By 1903, Fiske's share was down to 2½ per cent and Sam's was up to 47½ per cent. The other siblings were similarly downgraded. By the time Ned decided to hire lawyers to look into the matter, it was discovered that the Trust owed Sam's brothers and sisters something in the region of one and a half million dollars plus interest.[119] Ned did not know the full story until 1910, and his investigation would tear the family apart.

PART II

Edward Perry Warren –
the Collector

1

Why Do Men Collect?

Why do men and women collect? As well ask why they fall in
love: the reasons are as irrational, the motives as mixed, the
original impulse as often discoloured or betrayed.

Kenneth Clark in *Great Private Collections*[1]

Despite the discrepancies which would be unravelled later after his
father died, Ned Warren was a very rich young man. His companions
at Oxford did not know this. Though he served good wine and food at
Holywell Street, Ned dressed so shabbily that undergraduates
assumed he was as poor as they, for he forced himself to live off a
smallish fixed income. The full extent of his wealth would only
become apparent when he took to collecting. Ned's *Tale of Pausanian
Love* had Alfred saying to Claud: 'You should go in for Greek vases
and archaeology.' Ned certainly did go in for Greek vases – and quite
a bit more. With his new income, he and John Marshall would so
corner the antiquities market that Alexander Murray of the British
Museum would exclaim there was nothing to be had as the two were
'always on the spot first'.[2]

Ernest Samuels makes the comment that though Ned made 'a
distinguished beginning' at New College 'his heart was in collecting
rather than scholarship'.[3] The second part of the remark is closer to
the truth. It was to be in collecting that Ned most realized his dreams
and ambition, and it was only his collections which earned him any
real sort of recognition.

The collecting of art today has reached such a pitch that it is difficult
to realize how it stood towards the end of the nineteenth century. In
the course of the 1980s and early 1990s, the world record for a painting
rose from £2.7 million to almost £50 million, the latter sum being
reached at Christie's in New York, on 15 May 1990, when Hideto
Kobayaski held up a pad indicating the final bid for Van Gogh's
Portrait du Dr Gachet. Not so many years ago, auction houses sold
mainly to dealers who added on their mark-up and then sold to their

33

own clients. By the early 1980s, dealers were being cut out of the game by collectors or their agents buying directly at auction. Private collecting became a legitimate end in itself at the beginning of the nineteenth century, and by the 1850s millionaires rather than noblemen had assembled many of the great collections. The 1880s and 1890s witnessed an expanding economy in the United States, thereby creating an aristocracy of wealth which began to see the acquisition of fine art and antiquities as advancing its social status.

During the nineteenth and early twentieth centuries the collecting of classical art and antiquities went hand in hand with archaeological excavations. Lord Elgin's exploits are well known. The hunt for antiquities in Greece soon became a fully fledged competition among English, French and German archaeologists and treasure hunters who were assisted by agents and collaborators sometimes from bizarre backgrounds. Luigi Palma di Cesnola, for example, was an Italian immigrant to the United States who, as a reward for his services in the Civil War, was appointed American consul to Cyprus. In this capacity he was able to unearth some 35,000 Cypriot antiquities of gold, bronze, marble and terracotta which were purchased by the newly founded Metropolitan Museum in New York. In recognition of his treasure troving, Cesnola was appointed Director of the Met. Soon Warren and Marshall would be submerged in and consumed by the unreal world of archaeological digs, unscrupulous dealing, political intrigue and attempts at high-minded classical scholarship.

Warren inherited a liking for collecting from his mother who used to be amused by his love of porcelain. Later, as we have seen, she occasionally relied on his judgement in her purchasing, although her taste in art was quite different from Ned's. After her husband's death, her collecting gathered momentum and she came to own over a hundred paintings, amongst which were numbered six Corots, four Daubignys, three Rousseaus and five Millets. She also had a particular liking for American paintings done in the Barbizon style of French landscape painting of the nineteenth century. Before her death, in 1901, Ned took an interest in his mother's collecting. In 1898, Mrs Warren had travelled in Europe with Cornelia, buying pictures which attracted her attention. Ned was called in to advise and to establish certain spending limits. According to Cornelia, Mrs Warren developed an extraordinary enthusiasm for mixing purchasing with travel: 'when the two of them alighted from their carriage at some Flemish

inn, her mother said, "You get rooms and unpack – I saw an antique shop a few streets back."'[4]

Unintentionally, Mrs Warren came into competition with the prima donna of all Boston connoisseurs, Isabella Gardner. Early in 1896, Berenson learned that Gainsborough's *Blue Boy* might possibly be coming on to the market. He urged Mrs Gardner to purchase it, but that was not really necessary since for many years she had longed to own this youthful image of the British aristocracy. At the same time, she was also eager for a major Titian for her growing collection, and Berenson learned that the Earl of Darnley was willing to sell just such a one, a painting any collector with the right money would go for – *The Rape of Europa*, dramatic and perfectly preserved. The asking price for the Gainsborough and the Titian was likely to be $100,000 each. Berenson was in a quandary: he did not think Isabella Gardner could afford them both but eagerly desired to handle the two works. He felt that she was more anxious to have *The Blue Boy* and offered *The Rape of Europa* to Ned's mother. All seemed well, and then *The Blue Boy* was withdrawn from sale. After hearing that *The Rape of Europa* was considered by experts to be among Titian's very best paintings, Mrs Gardner decided to buy it. Berenson was playing for high stakes at that moment; potentially alienating not only his major patron but also Ned who had been his benefactor. Luckily for Berenson, Mrs Warren decided against the Titian. If she had purchased it, the Warren family would have come to possess what is considered to be the first major Old Master acquisition to go to America.

In February 1899, Ned summoned Berenson to Rome to assist in his mother's hunt for pictures. According to Ernest Samuels, it was 'a delicate business as neither wanted Mrs Warren to appear to be a rival of Mrs Gardner'.[5] Eight months later, Ned was able to report to Berenson that 'the last of Mama's pictures had left Italy'.[6] Ironically, among the half dozen was a Titian.

While he was still financially dependent upon Ned, Berenson scouted for potential purchases for him, and in Naples, in 1898, he reported that among the best buys from the ancient Saint 'Angelo collection was an extraordinary painting by Filippino Lippi. We will hear about this tondo later in other connections, but its purchase would be the most important item in Mrs Warren's collection and another source of family contention. Berenson's purchasing relationship with Ned is clouded in mystery because the records only give hints as to the full extent of operations. In a letter to Mrs Gardner, on 1 April 1900, Berenson wrote: 'Ned Warren altho' he lives in the midst

of the market never buys a Renaissance object without consulting me, and it is only in cases where I have to travel and give time that I let him pay [me] 2½% or more.' Three years earlier Berenson had related to Mrs Gardner an odd occurrence regarding Ned:

> in a book shop I stumbled upon Ned Warren, looking quite gray. [This was three years after Ned said there had been a 'let-up' in his poor health.] The odd thing is that yesterday on my table I found the name *Waren* on an envelope. Supposing that Ned had come to see me, and having no card had given his name to my servant. He assured me nobody had been, and that the name was of a friend of his once to whom *he* had begun to write on *my* paper, and my desk. Ned assured me he had only arrived today. He would not tell me where he was staying. He remembers you with terror as a person who had tried to get some secret out of him.[7]

Whatever the relationship, both Berenson and Warren desired to create in Boston outstanding collections of art. Mrs Gardner fared quite well under Berenson's tutelage, and Ned once said to him: 'I don't like to see pictures wasted, and I do like them in the United States.'[8] For Ned the United States always meant Boston and until his death he had a love-hate relationship with his home town. His letters bristled with loathing for Boston and its provincialism, but like all expatriates he was never freed from its hold. Once asked whether he gave Greek antiquities to Boston for the sake of the hundredth person who might appreciate them, or whether the ideas for which these antiquities stood were a fundamental challenge to American conceptions, Ned replied: 'For both reasons, but especially the latter.'[9]

Calhoun suggests that sending to Boston the vestiges of an earlier and by his estimation a more superior civilisation, Ned could both 'express his contempt and try to improve the place'.[10] Also he needed to demonstrate to his native city his worth as a Warren. Berenson did not have this problem but he did have an imperious patron to please. In 1900, Ned assured him that if Mrs Gardner failed to bring more masterpieces to Boston: 'I would certainly do my utmost to fill the gap.'[11] According to Samuels, Ned proposed that if that occurred they should consult on a strategy. He even said that he was willing to set up a fund by selling some of the antiquities he had stored at Lewes House. It never came to that, but it is both frustrating and significant

that we do not have more records as to Berenson's later relationship in Warren's collecting enterprise.

In response to the question as to why people collect, Kenneth Clark said that 'the reasons are as irrational, the motives as mixed, the original impulse as often discoloured or betrayed' as to why they fall in love.[12] With Ned Warren love and collecting were inexorably entwined and the extent and direction of that collecting took shape in the context of the love of his life, John Marshall, his 'Puppy'.

2

The Wooing of Marshall

... I have just got Richard Le Gallienne's 'The Romantic '90s.' I, who lived in them, wonder if they were so splendid and romantic. I don't quite know where they have got such a reputation. The stone age was really the romantic age.

Reginald Turner to Edward Hutton,
6 June 1928[13]

In his *A Tale of Pausian Love*, the narrator, Claud Sinclair, is a man longing for another man with whom to share his life and interests. This, of course, was the situation with Ned Warren once he decided to live in England. On a practical level, Ned also needed some sort of secretary to help with the collecting enterprise. He made several attempts to find the right man before he finally convinced John Marshall to join forces with him.

Ned's first choice was Arthur George Bainbridge West. He was born in 1864 at Dunholm, near Lincoln, and received his BA at New College, Oxford in 1888 and his MA in 1892. West was, therefore, four years younger than Ned and had been at New College much of the time Ned was there. Before West studied for his master's degree Ned persuaded him, in 1889, to travel to Wiesbaden and Rome. During that trip Ned confided in West his desire to share his life with 'an alter ego'. They would read Greek authors together and also search for classical antiquities to purchase. Ned admitted some reservations: would his companion be comfortable 'seeming to be a rich man travelling with a friend when he was in reality accepting both salary and hospitality'.[14] Ned was worried what the people they met might be thinking.

When stated that way, West was not happy with the possible implications of such a relationship. He was not well off, and if Ned was worried about what people would say, he was even more so. West also raised some practical concerns: he did not think he could adequately care for Ned who appeared to have a number of ailments. After all, their first stop in Europe had been at a spa in Germany. West was devoted

to Ned, but he also wondered how involved he might become in Ned's complicated life. There was an even more important consideration: for a long while it had been his desire to enter Holy Orders.

The year before this trip West had gone to Sicily with Berenson. They had met at Oxford and Ned suggested they would be good travelling companions. In a letter to Mrs Gardner, Berenson was ecstatic over the glories of Syracuse the two had seen. But as both were running low on money they parted in Rome. Five years later Berenson visited West in Wales. He had been ordained and was a curate in a mining town, where, Berenson was shocked to discover, West had to 'philanthropize 7,000 people on a salary of £20 a quarter'.[15] Apparently such poverty both amazed Berenson and made him nervous. However, West's lifestyle improved with marriage and the rectorship of Saint-Dunstan's-in-the-East in London. Despite the rebuff, Ned remained devoted to West and went on to become a godfather to his two sons. One, Charles Murray West, became Ned's secretary at Fewacres, his house in Maine. With a handsome salary from Ned, he ran the estate as if it were an English country house, complete with a butler who regularly served afternoon tea. Murray West was viewed with amusement by the Warren family and the locals who thought he was an effete English addition to Ned's American residence. At Ned's death, Murray West inherited Fewacres with its extraordinary collection of seventeenth-and eighteenth-century furniture and Graeco-Roman marble sculptures.

Ned did not record his other attempts at finding the right man, but we do have a full account of his protracted wooing of John Marshall. Just before Marshall gave in (1889), Ned told him that after his attempt with West he should have contented himself with 'a common or garden' variety of secretary. Of course that was a joke. Ned would never have settled for a common place alter ego – he was far too arrogant for that. John Marshall was made to order to a degree that in time friends said the two came to resemble one another. Photographs clearly show this, and Oscar Burdett said that the two men became replicas of each other: 'When seen at a distance . . . so alike in girth [they] made a pair of Punchinellos, and when they were pacing arm-in-arm on the lawn at Lewes House they presented a pair of indistinguishable backs, so that one could hardly tell one from the other.'[16]

Marshall never wrote much about his background or his family in Liverpool. There are, however, the accounts he gave in various forms to Ned and Burdett. His father was a wine merchant and a staunch Anglican and a Tory. John's mother was also deeply attached to

religion and both parents fully expected that he would enter the Anglican priesthood. From Liverpool College (where he spent four and a half years) he won a Classics scholarship to New College. He had done very well at Liverpool and his records also indicate that he was planning to take Holy Orders. It was in his third year at New College (1884) that he met Ned. Oddly, Ned never mentioned Marshall in his autobiographical sketch, though he may have planned an extensive section later.

As noted earlier, Marshall was a better student than Ned and all his marks were first class. With this success he was virtually assured of a Fellowship. After meeting Ned, however, he did not pursue this possibility – at Merton College, and basically turned his back on further academic achievement, as he had done on becoming a priest. In a letter written at Ned's behest, in 1889 or in 1890, he explained:

I went up to Oxford to enter the Church: at the time I was thoroughly religious, that is to say I was a regular Churchman, took the creeds and Articles (of Religion) for Gospel, attended Church conscientiously and read, horror of horrors, a great deal about the Romish controversy. Once at Oxford, when I was pressed for money and did not wish to apply for it from home, this stood me in good stead and paid my bills. That was at the beginning of my third year, I think. Both my father and my mother were very anxious on the point, she especially was eager for it. They thought it would break their hearts if I failed to take orders; they never contemplated the possibility of what really did happen. They took it for granted that if I got through the schools I would enter the Church; it was getting through them which they thought most important.[17]

Marshall had few friends at New College but three of his Liverpool College classmates were at Pembroke College. One was especially close – Richard Fisher, who was to become a friend and sometime secretary of Ned. Burdett and Goddard said of Fisher that he was 'the most shadowy' of Ned's group: 'gentle, not very effective . . . whose main preoccupation was running the household and stable and practising photography'. He and Ned's most brilliant associate, Matthew Stewart Prichard, both left Lewes in 1901 to work at the Boston Museum of Fine Arts. Fothergill's memoirs and other writings make Fisher (nicknamed 'Fishlet' at Lewes House) out to be a rather boring

individual, so it is interesting that in his 1889-90 letter to Ned, Marshall said:

> like others, you will be amazed that he [Fisher] more than another should have made me what I am. I often wonder why he liked me or I him: we have not a taste in common. He sits and smokes and talks small talk, – so do I – but he talks nothing else; or else he sits and plays Italian operatic music of which he knows no end, but which is to me equally uninteresting. He never read for reading's sake. I very foolishly once lent him Voltaire and that he does read now: but the Dictionary is rather an odd literature. Perhaps it was his face which attracted me, but it is thirteen years since I first saw him and I cannot say. We grew up the firmest friends.'[18]

Later Marshall said of Fisher: 'there is in him what is in no one else, a sympathy of ideas, more like a woman's.'[19] That last admission was one of the significant differences between Warren and Marshall. Ned would never have said that, and what at the time appeared no more than a variance of personality was, in ten years' time, to become a breaking point.

In his letter to Ned, Marshall credited Fisher for helping him through his doubts concerning the priesthood. When Fisher was not with him, Marshall said he 'went to the dogs'. This was particularly acute during one vacation when he was at home in Liverpool. There had been 'much melancholy in parting from old Oxford friends and acquaintances'. All he could could bring himself to do was read. Marshall had made up his mind not to pursue Holy Orders and it had been a difficult decision. But even harder was facing his parents with it.

In a letter to Ludwig Curtius, an archaeological colleague, many years later, Ned wrote about this period in Marshall's life and said his friend was 'rather pasty-faced and 'by no means well'. During that vacation at Liverpool Marshall 'seemed to be much like a light burning out'.[20] He told his parents of his decision not to enter the priesthood but not about Ned Warren's offer to live with him. He wrote to Ned: 'Your kindness struck me dumb: but you see the danger. It is only by a great effort and in a perhaps visionary hope that I have been able to do anything lately to escape from the idle life of constant reading and sleeping. I feel happier in having something to

do and my very poverty may encourage me. I hope it may be; it seems to me my last chance; you would not, I know, weaken it.'[21]

It was only later that Marshall discovered that at the time when he told his parents about his decision concerning the Church, his father had been sustaining great financial losses. His father never spoke of them, and for weeks would come home angry and go to bed. Unaware of the truth Marshall supposed that his father's anger was directed towards him. Later it hurt him greatly that he had misunderstood his father at such a critical moment. The two never had an open quarrel and Marshall lamented: 'It would have been infinitely better if it had been so'.[22] Servants told Marshall that when he was out his father would go and look at what he had been reading. Marshall misinterpreted this as spying: 'I was mad enough to think of my father as a spy.'[23]

In the letter to Curtius, Ned had also commented on how he viewed his future lover: 'I used to think that he took his tragedy in daily life, and his comedy in literature . . . He was a man very much preoccupied with his own subjects, and with his own ideas. Sometimes inappreciative of others who did not strike his own fancy, a better judge of art than of people, but unpretentious and very touching in his affections.'[24]

It was these two last traits which so appealed to Ned. In his sustained effort to win Marshall to his side, he used every tactic possible. The letters from this period are numerous and intense. On 27 February 1887, Ned asked: 'What will become of our project for travel? . . . I am exceedingly desirous to spend the summer in Cumberland or Westmorland. I wonder whether it would amuse you to take lodgings with me?'[25] On 5 July of the same year: 'I do wish you were here (Oxford).'[26] In August 1888, Ned was in Germany and he commissioned Marshall to purchase the ancient benches from Ormskirk church in Lancashire. This was their first great purchase together, and the benches remained as the dining room seating at Lewes House for many years.[27] From Bad-Ems, Ned commented: 'It is strange that you can be so good about old oak, and so villainous a correspondent about other matters . . . Unless I hear from you at once . . . I shall cast out my lines for other fish whom I see drifting down stream. You understand, if you came, you would not have anything to pay, nor anything to do save grumble if I did not provide properly for you.'[28] Marshall remained unmoved.

Then Ned tried a new tactic. The next year he wrote from Rome of his loneliness:

Plato has given me help and confirmed some of my ideas, but I must use his evidence indirectly and not pose as a Greek astray, although I feel my separation from modern life often . . . I take refuge in my Breviary, interpreting it in my own sense, and in the Roman services, Mass at times, but mostly Vespers. This is half bracing and half exhausting because I have the effort all to myself. The statues of the Vatican, histories of Greek art, shops containing Greek and Roman antiquities and bits of similar reading are my resources for rest and forgetfulness.[29]

It was in this same letter that Ned first mentioned his desire to find a house in England – 'in Surrey or in Sussex near the Downs, where I can ride and establish myself more or less'. Marshall carefully avoided the subject of the house and concentrated on the Roman sculpture of which Ned wrote. In his letters Marshall gave valuable comparisons of similar pieces to be noted in museums and his own judgements concerning possible purchases. In this low-key manner, the collecting enterprise began.

Ned stepped up his pressure. In June 1889, he asked: 'Why is it so hard to stir you?' and a month later: 'I think, my boy, that when you have spent some months at the house I am hunting for you, you will feel happier and stronger and be less inclined to take into account differences of property, etc. which are external, as you well know.'[30]

It was those 'differences' which worried Marshall. Like West, he did not like the implications of living off someone else's bounty. But by September, Marshall weakened and presented his conditions for becoming Ned's secretary. Ned responded: 'Dear Maréchal, your plan of the secretaryship comes near to what I have been wanting for a long time.' However, he did not agree with one of the conditions. Marshall said he planned to dine with the servants. Ned's response was: 'I shall be most charmed, of course, to let you do so if I may be of the party, but I had hoped that usually you would consent to dine alone with me.'[31]

The remaining letters from this period hammered out the details of their living together. Marshall's salary was to be £200 a year and all his expenses were to be paid. From what Marshall had first told them, his parents assumed their son was entering some sort of service. They were more at ease when he insisted it was similar to an academic position. Marshall was at last hooked and wrote to Ned: 'You were to me at first a quality, then a collection of qualities, and at last . . . well! you were Warren: and now everything you say and do seems insepar-

able from you and my love to you. That makes my judgement in the matter infallible.'[32] John Marshall admitted he was in love.

In the midst of the high emotions, Ned sensed the future might not be totally bright. In words reminiscent of his *Tale of Pausanian Love*, he said that his chief fear was that he might 'hurt' Marshall: 'You are bound to exaggerate everything – your own faults, my likings or dislikes . . . After we have lived together sometime, you may get tired of my cloddishness and reach a true and distinct view. I hope that then you will not confirm by judgment the [initial] instinct you had to avoid me.'[33] These were strong and telling remarks passed in the heat of establishing a relationship. It was not until much later that Marshall would fully comprehend this augury.

By November 1889, 'the man of his choice' was at Ned's side. They left England and spent most of the winter in Wiesbaden. Matters moved fast the next year. In April, Ned received the assignment of the lease of Lewes House. He had first seen it in October 1889, and from the White Hart Hotel just up the street he decided it would do. He described the house as 'huge, old, and not cheap. It has only three or four sunny rooms . . . It is in the centre of Lewes and yet has a quiet garden, a paddock, greenhouse and stables *ad lib*. Downs accessible and green woody country as well. I am much inclined to it.'[34]

Today, Lewes seems an odd choice for a man of Ned's tastes. Recently, one observer said it was 'soft . . . a place of stripped pine and florid knitwear, opulent but hippyish . . . Exactly the place, in fact, to have given the world Clothkits'.[35] There is not much to distinguish Lewes. Visitors are shown the Castle ruins which dominate the skyline but not much remains inside it. Anne of Cleves' House also looks impressive from the outside, but she never lived there and it is a rather odd little folk museum these days. Americans are told that the radical philosopher Thomas Paine lived at Bull House in the High Street for six years before accepting Benjamin Franklin's invitation to settle in Philadelphia, in 1774. Little survives, however, of his stay.

The early Georgian features of Lewes House date from 1733 and previous owners included Henry Shewell, a Major-General in the British army. In 1910, Ned's initial lease was extended at an annual rental of £150; outright purchase of the property was effected in 1913 for the sum of £3,750. In time, Ned came to own two other fine houses in Lewes: next-door School Hill House which was another elegant Georgian town house with a brick façade, and further up the High Street, the spacious mansion, The Shelleys.

The gardens and grounds of Lewes House were two and a half acres. Harold Parsons described the most attractive aspect of the property:

> the back of the house is a perfect Queen Anne structure with large rooms, flagstone entrance hall, a noble staircase, the windows giving onto an immensely long garden with tapis-vert rolled lawn like a billiard table and walls down the sides with shallow garden beds; the walls vine-covered and with the best figs I have ever eaten . . . The great South Downs rolled away to Brighton, and when we rode our horses up there, on a fine day you could see the Channel glistening in the distance like a great silver shield.[36]

Inside Ned furnished the house with a remarkable display: rare examples of furniture from the fifteenth to eighteenth centuries; Old English, continental and oriental china and porcelain; over 900 ounces of very fine old silver; beautiful old embroideries and brocades; antique bronzes; Grecian columns and ivories. There were fourteen different china dinner services, including Capo di Monte, Minton, Crown Derby, Wedgwood, Worcester, Hizen, and Lowestoft. The house was lit by candles (except on the stairs and passageways) and only quill pens were allowed. Despite the sheer glut of silver, china, glass, antiques and paintings which came to be assembled, Lewes House was often described by visitors like William Rothenstein 'as a monkish establishment'. Rothenstein went on to remark that 'women were not welcomed. But Warren, who believed that scholars should live nobly, kept an ample table and a well-stocked wine-cellar; in the stables were mettlesome horses . . . Meals were served at a great oaken table dark and polished, on which stood splendid old silver'.[37]

Though it was well provided with substantial, good things, Oscar Burdett said there was nothing in Lewes House that could be called comfortable: 'It was cold, and bleak and full of artistic treasures, but there were no soft armchairs . . . few curtains, and the furniture was mainly of old oak, with monastic-looking beds . . . the oak benches from Ormskirk church were the only chairs on the bare polished floor of the dining-room.'[38] There were compensations, however, for discomfort: the colours of the Filippino tondo of the Holy Family glowed brilliantly opposite a drawing in sepia by Titian, and a Della Robbia plaque of the Virgin and Child complemented a honey-toned Grecian marble relief.

Few townspeople, except the tight-lipped staff, ever saw the inside of the house; they were only aware of 'the mad American millionaire', as some called him, when he and his friends rode off on their Arab horses followed by a pack of St Bernards, or when they swam naked in the community pool or the River Ouse which borders Lewes. One of the staff is still alive – the former kitchen maid, Kathleen Arnold Warner. At 91, Mrs Warner still lives in Lewes at Talbort Street in a little terrace house which was a legacy from 'Mr Warren'. Her memory has not dimmed and her eyes twinkle as she recalls 'those mellow days at Lewes House'. She was 14 when she entered service under the head cook, Martha Shepherd, who was the wife of the butler, James. Martha was Mrs Warner's aunt who warned her that 'anything heard within the walls of Lewes House must remain within the walls of Lewes House'. She was so devoted to Ned ('a gentleman to his finger tips') that ten years ago when she returned to Lewes House (which had become the offices of the Lewes District Council), she admitted a nervousness at opening the front door to enquire about the rates: 'We *never* entered that way . . . I fully expected to encounter Mr Warren behind that door with a gentle reprimand.'

Life for a young kitchen maid was not easy. Kathleen cleaned the huge flagstone kitchen floor every day and polished the oak floors upstairs once a week. With other staff she had a small third-floor bedroom which was approached only by a back staircase. James Shepherd was also young when he arrived at Lewes House after a stint as pageboy to the Duke of Devonshire. Formally dressed with patent leather shoes, James served Ned and 'the gents' as the staff called Mr Warren's assorted secretaries and friends. They got used to the absence of women at the table, and when, on the very rare occasion a female – such as Ned's doctor's wife – appeared even the servants viewed it as an intrusion. After their marriage, Martha and James basically ruled the staff in much the same manner as Hudson and Mrs Bridges in *Upstairs Downstairs*. Martha instructed Kathleen: 'You must never engage in conversation with your betters.' Once when Kathleen and another young maid were invited to hear music in the parlour given by musicians from London, Mrs Shepherd said: 'Of course, you must go but please don't do anything silly and embarrass us all. Remember it is a privilege to be among Mr Warren's guests.' Once, Kathleen had to stand in for an ailing upstairs maid and prepare Ned's bed for the night. As it was a particularly cold night, she wrapped his pyjamas around a hot water bottle and placed them in the bed. Ned was unaccustomed to this arrangement and

46

rang for Mrs Shepherd, who later castigated Kathleen: 'How's the governor supposed to know that ridiculous lump in his bed is his pyjamas?'

The staff were never allowed to use the front door. On one occasion when deep snow surrounded the staff entrance, Kathleen and another young maid tiptoed to the main entrance. They were spotted by Mrs Shepherd who shouted: 'The least you could do is walk on all fours in case Mr Warren spied you.' Several times James and Martha' travelled first class to America with Ned to act as his staff at Fewacres. Despite this, wages were not very high. The most they could anticipate was around £50 annually. There were few holidays, and Kathleen Warner remembers being with her mother at Christmas only once. Ned made a point of having the entire staff present at Christmas. Weeks of preparation were necessary for the many cakes and fruits. The Christmas fruit was placed in Kathleen's bath tub with Mrs Shepherd telling her: 'You'll have to go without a bath for a while.' Nevertheless, Kathleen enjoyed her time at Lewes House: 'It was wonderful spending someone else's money at the markets.' Chests of tea and coffee regularly arrived from Fortnum and Mason; soaps and linens were sent down from a speciality shop in Mayfair. Dorothy Powell of Lewes recalls how her mother often played the Bechstein at Christmas for Ned and one or two others. Ned insisted she perform in an unused room which had no carpets on the floor and no curtains at the windows so 'Mozart would not be muffled.'

All in all, Ned was an unusual addition to Lewes, but the staff was so devoted to him that his eccentricities were never mentioned. As for his apparent sexual proclivities, Mrs Warner says that it was only later in life that she heard anyone say he was a homosexual: 'I do not recall any of the staff *ever* saying anything derogatory about his lifestyle.' She added: 'In those days, if you had certain thoughts – you kept them to yourself.' In town there were rumours that Mr Warren collected young men as well as art, but Ned was so rich and engaged so many local townsfolk that no one ever said very much.

Ned's running of Lewes House was described as like 'a tiny German court'.[39] He liked dealing with the problems of his staff as well as his companions, and was a *paterfamilias* and priest rolled into one. Matt Prichard used to speak of Ned as 'a sort of Buddha to consult upon everything'.[40] There was little interest in the outside world: newspapers were rarely read; neighbours never called – not even the vicar. Ned's great map of Sussex symbolized the attitude. So large was it that when folded it required a leather case. When Ned

had the case embossed it was with the words, 'The Country round Lewes House'.

Aside from those who receive special attention in this book – Prichard, Fothergill, Thomas and Parsons – Ned also had several other assistants who were attached to Lewes House for brief periods. Among them were Harold Spencer Scott and George Valentine Harding. Ned knew Scott and Harding at New College; both received their B.A. in 1887. Scott was from Lancashire and his father was a solicitor, while Harding whose father was a clergyman came from near Monmouth. Originally, Scott was a friend of Marshall and was never formally employed by Ned, but appeared to have had a brief stint at Lewes House to see if he might take to the collecting enterprise. He did not, and was later employed by the Clarendon Press at a salary of £10 a year. Of Scott, Ned said: 'I like the glorious name, because he is a humble person, who does good work for little pay.'[41]

Like Prichard, Harding was trained in the law. However, he did not stay with it for very long. He arrived at Lewes at the same time as Prichard, but it appears that Ned never intended to employ them both. After Warren and Marshall's first major sale (the Van Branteghem in Paris, in 1892), Lewes House desperately needed secretarial assistance. Later that year, Sam Warren visited his brother in Lewes. Of all of Ned's acquaintances, Sam was most impressed with Matthew Prichard. As mentioned previously, Prichard had been trained in the law but he also had a remarkable eye for art; to Sam he was the obvious choice for a new secretary. But Ned had already made up his mind to hire Harding and had told him so. In the end, Ned decided against 'crossing swords with Sam' and decided to take them both on as secretaries.

Matt Prichard's relationship with Ned is fully explored later in a separate section. George Harding, however, gave a very sympathetic ear to Ned's complaints about his health, but he left to get married; the first of Ned's circle so to do. Marshall did not like Harding whom he nicknamed 'Harder' and said he was 'neither a great success nor an interesting person'.[42] Ned's other friends viewed him as 'thick' and 'overly fond of drink', and when it came to dealing with art collectors, Marshall said Harding was 'a disaster'.[43]

Usually, there were four or five of them at Lewes House at a time. The place sometimes resembled a college dormitory with coats, hats and trunks used indiscriminately. In the bathroom, towels, sponges and soap were also shared by all. The upstairs bath was large enough to accommodate two or three at a time which usually was the case

after games or riding on the Downs. Life at Lewes House was often difficult for the staff. Breakfast was at eight though Ned was usually the only person on time. Afterwards he would retire to bed until eleven o'clock since he often woke at five and read Greek until breakfast was served. At eleven he would go over the correspondence and accounts with a secretary or two. Following lunch Ned would ride and take tea afterwards. Everyone was expected at tea and dinner which followed at seven. As soon as dinner was finished, they would gather in the Red Room and talk until ten o'clock. Ned was quite regularly ready for bed by then but the others would stay up for an hour or so afterwards.

Most days Marshall spent much of his time at his books in his room, while Prichard and Fisher were often mending vases in the North Room and Ned was down at 'Thebes' writing poetry. 'Thebes' was built over the coach house, and was Ned's secret place in his fiefdom. It remains the only part of Lewes House which still bears a strong resemblance to the past. The study was reached by an oak staircase with a door which could be locked. There were two rooms next to the study which were occasionally used as bedrooms, but more often filled with Ned's most private papers and purchasing accounts. Ned wore the key to 'Thebes' on a gold chain around his neck.

Close to 'Thebes' were the stables where three or four horses were kept at a time with two grooms on duty. One of them, Thomas, was described as containing within himself elements of all the invaders from the Phoenicians onwards. Ned loved riding but was not terribly good at it, and in spite of his not gripping the horse with his short legs which swung to and fro, he managed never to fall. Marshall fell quite often and loved to ride on the Downs alone. Once Ned became quite anxious when Marshall, who had been out alone, did not return at sunset, so he sent for a furniture van and packed it with ham and drink. Harding was put in charge of the search. In an hour's time, Marshall returned alone. Much later Harding drove up. Half the ham had been eaten and all the drink was gone.[44]

3

The Great Collecting Time

When all is said, the world owes private collectors an enormous debt. Without them many of the greatest works of art would have been lost or destroyed. Our public collections are, to a far larger extent than anyone realises, private collections which have been accumulated and combined.

Kenneth Clark in *Great Private Collections*[45]

When the supply of an article cannot keep pace with the demand for it, the item will become expensive and imitated, for honest or deceptive purposes. This is particularly true of fine works of ancient art and craft, the supply of which ultimately depends on chance.

Arvid Andrén in *Deeds and Misdeeds in Classical Art and Antiquities*[46]

In 1912, Thomas Case, the President of Corpus Christi College, asked Ned Warren how his collecting enterprise began. Case was curious about the numerous benefactions to the Ashmolean Museum and elsewhere. Ned dictated a response to Harry Thomas, who was his private secretary at the time. Thomas replied that the collecting began in 1892 at the Van Branteghem sale in Paris where Ned purchased a kylix decorated and signed by Euphronios, the Michelangelo of vase painting. The collecting continued until 1902 and Thomas attributed the end of it to the 'domineering policy' of the Italian Director of Fine Arts and Antiquities. He did not add that Ned and two others had exposed the Director's dabbling in counterfeiting and stolen art objects.[47] But by the time this letter was written, there were other matters of concern which had also spelled an end to one of the most significant private collecting enterprises of the turn of the century.

Mette Moltesen, Keeper of Ancient Art at the Ny Carlsberg Glyptotek in Copenhagen, ends her 1987 scholarly analysis of the dispersion of the Borghese family collections by saying: 'The transactions here treated are characteristic of the changes taking place in the late 19th

50

century and continuing to this very day where power, wealth and patronage of the arts have moved from the landowning aristocracy of Old Europe to the industrial "princes" of Europe and the USA, such as Carl Jacobsen, E.P. Warren, J. Paul Getty and Peter Ludwig.'[48] Ned would have been quite surprised to find himself coupled with such high-powered souls.

The period from 1875 to 1900 has been termed 'the marvellous quarter' by American historians: during those twenty-five years the United States doubled its population and trebled its wealth, and the national debt was halved. This was an ideal time to buy art in Europe. The year 1870 had been a landmark for American museums. Two great institutions were incorporated – the Metropolitan Museum of Art in New York and the Boston Museum of Fine Arts. They were the first of the 'encyclopaedic' galleries in America, and began to fill their halls with all the Old Masters, Greek statues, Chinese vases and Egyptian mummies they could lay their hands on.

Removed from the restrictions of state control which prevailed in Europe meant that the American museums could develop with freewheeling enterprise, which those with far-sighted directors certainly did. The museums were greatly handicapped, however, by their distance from the active centres of the art market, but these difficulties were overcome by means of having purchasing agents resident in Europe. Warren and Marshall were among the first to operate in this manner. Not long after establishing himself at Lewes, Marshall substituted his obsession for Greek texts for Greek art. With the Van Branteghem sale, the two became well known to dealers and their serious collecting began. At last John Marshall had something which would consume his energy – and something which would further link him to Warren. In the *Tale of Pausanian Love*, Claud reflected that Alfred's desire for him to 'go in for Greek vases' was an interest which soon became 'a passion'. Another element of Ned's tale was about to become a reality.

A year before the Van Branteghem sale, Marshall met Edward Robinson, curator of antiquities at the Boston Museum, in Munich. That meeting would have far-reaching consequences. Robinson's initial reaction to Warren and Marshall's collecting was somewhat cold, but in 1894 he was a guest at Lewes House and much time was spent in drawing up lists and prices. Since it was normally a museum director's business to do the buying, Robinson felt somewhat piqued at Warren and Marshall's methods of outright purchase which he viewed as 'more than unusual'. Eventually, however, Marshall won

him over, and the curator remarked: 'I wasn't aware Ned had any-
thing like this.' The more he saw of recent acquisitions 'the more he
was delighted'.[49]

Back in Boston, museum trustees were not enthusiastic about
Greek pots. During the autumn following the Van Branteghem sale,
Ned elicited the support of his mother and spelled out the virtues of
his pots to her: they throw light on the best periods of Greek art; many
are high art in themselves; and others answer questions for which we
have but scantily written records or none. Ned's final plea was: 'A
museum, more especially an American museum, should possess
large collections of carefully picked specimens.'[50]

Today, Warren and Marshall's vases are well loved in Boston and
constitute one of its strongest collections. It is used in a fashion which
would delight him – as an introduction to Greek art and culture for
young people. The year 1894 was a watershed, and the next couple of
years were hectic with Marshall setting up an apartment in Rome in
order to be at the centre of purchasing. The next great sale for the two
was that of Count Tyszkiewicz's extraordinary collection of vases,
glass, gems and small bronzes. Ned considered Tyszkiewicz the
collector *par excellence*. Michel Tyszkiewicz was huge and affable, but
sometimes used by Roman dealers to their own advantage. This was
especially true of the Jandolo family whose gallery on the Via Mar-
gutta we will hear much of later. Ned's purchase of the Count's gems
became, in the words of Harry Thomas, 'the speciality of Lewes
House', and Prichard and Ned spent countless hours studying them
and making impressions of intaglios. Numerous notebooks at the
Ashmolean Museum contain this work. Marshall was on the scene in
Rome for the purchase. Frantically, he wrote Ned: 'Now the gems.
There are only twenty-five . . . the price is one hundred thousand lire
. . . I take all dark-red translucent stones, rather darker than your
Hermes [intaglio], to be sards. By amethyst I mean a lucent coloured
stone, coloured like the colour amethyst. If I can tell a paste, there are
no pastes. But then I can't tell a paste!' As with Greek pots, ancient
gems did not arouse much interest in American museums at this time,
and Marshall also recognized that 'they are about the most difficult
point in archaeology, I suppose'. He further acknowledged that he
had much to learn about gems: 'I know nothing about the matter, and
I can't very well point out in the British Museum collection gems
exactly similar or similar enough for your judgment. The whole made
an impression on me of being more like jewels – so much light came
through them and from them. I can see you can't judge them as you

judge sculpture.' Marshall was, however, learning fast: 'Count T. said that he had bought very many gems in his time, and nearly all he got at first were bad . . . I like the Count, he is so very simple. Probably I must be all the more on my guard.'[51]

Despite their value being unrecognized in America, Ned developed a passion for gems. He had a number which he prized most set into rings which he wore and which are now set in an elaborate necklace and owned by Harry Thomas's daughter. She remembers how 'Uncle Ned' used to instruct her and her brother in the fine art of making wax impressions from intaglios: 'We thought it a rather complicated game.' The ancient Greeks employed materials now considered to be semi-precious, namely, carnelian, sard, chalcedony, sardonx and porphyry among others. They were cut with intaglios for use as seals. Often impressions indicated master craftsmen at work. Ned tried to instil his passion for these tiny masterpieces into the Lewes household. It was an extension of a boyhood obsession – in Boston he had collected tiny rocks and stones which he carried around in his pockets.

In the end, Ned had to outbid the Czar's agent to get the Tyszkiew-icz collection. The Hermitage learned of the impending sale and sent agents to Rome to have a look. They had been authorized to go as high as 100,000 francs. Ned was unimpressed, 'took the plunge' and got the collection for 106,000 francs.[52] These heady successes were not without problems, however. The Boston Museum had not yet worked out a regular scheme for dealing with Warren and Marshall's purchases. The two went to Boston; it was Marshall's first visit ever, and Ned's first trip back since 1890. The museum trustees thought their collecting was unbusinesslike. Ned's system of financing, however, was extremely generous as he charged cost price plus 20 per cent for expenses, although this never managed to cover ordinary expenses. Brother Sam had become a trustee in 1892 – in 1902, he would go on to become President of the trustees and Chairman of the Building Committee. The two brothers rarely saw eye to eye as to what was most important for the museum's future. For Ned, a museum was its collections; for Sam facilities and prudent management were uppermost. By 1894, Ned was $77,000 overdrawn and he had used $40,000 of his capital. Robinson had become convinced that Warren and Marshall's efforts would greatly benefit the museum, and intimated that the trustees were not being realistic. Sam felt pestered by Ned's endless letters and cables; and was beginning to think the overdraft was a symptom of Ned's general lack of good judgement. These

feelings infuriated Ned because they came just at the time when he had found something to which he could give his all. On 9 January 1896, Ned wrote to his brother Henry how difficult it had become. Whereas the splendid Boston Public Library had become great with the benefit of taxation; the Boston Museum struggled on its own. Ned said the museum was at present something like 'a Sunday school compared to a real school'.[53]

Back in Europe the main problem was dealing with the dealers. In the early stages of their collecting, it was Ned who appeared better equipped to manage the odd assortment of Roman dealers with the utmost diplomacy, as well as an occasional touch of chicanery. In a letter to Marshall, he indicated how much he had learned:

> If you go to Capua, first meet Innocente [one of Ned's first contacts who was later discovered to be dealing with vases touched up by Raimondi, later identified by Marshall as 'the most able forger living'] and be trotted about by him. He will probably put you up for the night with a friend. I advise you to accept, but to offer payment to Innocente in the morning to give to the host . . . Be patient with long confabulations, and offer a little less than your final price at first. The price asked is 5,000 francs for the two vases. They are what the Italians call 'urn-shape'. Assume that they are genuine and unbroken, unless they look suspicious. If you think that the Museum would want them, make up your mind how much they would be worth to the Museum, and if you think there is any chance that that sum would be accepted, offer it. If there is no chance, say we do not want it . . . It is to his interest to buy at a fair price, but he would not want to pay very high prices, because he would have to continue paying high prices later on . . . Do not pay for them until you have examined them at your hotel with methylated spirits or benzine. If they are wrong, or broken in any serious way, return them without paying the money to Innocente . . . Remember that Italians expect you to spend a long time over a purchase . . . You will not have to play a part, but you will seem dull and uninterested . . . Try and spot whether Innocente pays less than you offer, or gets part of it back again afterwards.[54]

Soon it was Marshall doing most of the negotiating without many instructions from Ned. More and more, Ned left his friend to follow his own instincts. Previous successes made the two well known to a

number of foreign archaeological scholars residing in Rome. Their papers are filled with references and dealings with three Germans in particular: Ludwig Pollak, Paul Hartwig and Wolfgang Helbig. Today, revelations that academics have been involved in wheeling and dealing in the art market or creating false authentications and inscriptions for antiquities are not terribly startling. Warren and Marshall, however, had very little inkling just how far such practices went with two with whom their collecting enterprise was intricately connected – Helbig and Hartwig.

The full extent of Helbig's activity has surfaced only in the last five years. Heretofore, the only major involvement of either Warren or Marshall in art forgery was the latter's spectacular misjudgement in purchasing the Metropolitan Museum's Etruscan warriors. (We will learn the full story later.) Interestingly, those who have brought Wolfgang Helbig out of the closet are three highly respected archaeological scholars: Professor Margherita Guarducci of the University of Rome, Arvid Andrén, Director of the Swedish Institute of Classical Studies in Rome, and Mette Moltesen, Keeper of Ancient Art at the very depository of most of Helbig's recommended purchasing, the Ny Carlsberg Glyptotek (the creation of Danish beer magnate, Carl Jacobsen).

It was not long after Warren and Marshall had centred their activities in Rome that they became involved with Helbig. It seems that Warren first met him when he was giving advice on the Tyszkiewicz collection. Andrén describes Helbig as 'a complex personality, gifted, inventive, ambitious and unscrupulous'.[55] He was also very handsome and a bit of a dandy. In 1889, Ned said Helbig was his 'Italiker-in-der-Po-Ebene and Campanische-Wandmalerei man . . . overseeing my purchases'. While the negotiations for the Tyszkiewicz sale were progressing, Marshall told how Helbig went off to have breakfast at the Russian Embassy in great feather: silk hat, new gloves 'and God knows what else'.[56]

Helbig was 23 years old when he arrived in Rome with a doctorate from the University of Bonn and a scholarship at the German Archaeological Institute. Within just three years he was made Second Secretary of the Institute which basically meant he was Director. The next year he married a Russian princess, Nadejda Schakowskoy. One look at their wedding pictures makes it clear that this was a marriage of convenience: the princess was large and coarse looking, while Wolfgang looked like a gigolo. It was a good match for Helbig, however, and provided a ready entré to the houses of the best families where he

soon found an abundance of archaeological treasures on their estates. It was not long before he was having a glass of champagne regularly on Sundays with Rome's most distinguished collectors of art and antiquities: Count Michel Tyszkiewicz, Baron Giovanni Barracco, and Count Gregoire Stroganoff (about whom we shall hear later). The Sunday gatherings were a weekly review of their latest acquisitions – and Helbig had an inside track.

Helbig's major conquest was Carl Jacobsen. In 1887, he procured for Jacobsen's Glyptotek a large number of copies of Etruscan tomb paintings. The same year, Helbig and his princess went to live in high style at the spectacular Villa Lante on the Janiculum Hill overlooking the Vatican. He also left the institute in anger at not being promoted to the position of First Secretary. The apparent reason was because the Central Directorate in Berlin was alarmed at his behaviour and activity as a middle man between Roman dealers and foreign collectors like Ned Warren and John Marshall. That did not worry Helbig. As Andrén puts it: 'he was able to continue his lucrative trade and his fashionable life as a venerated scholar in the Villa Lante, thinking perhaps at times with secret pleasure of how capitally he had deceived those supercilious colleagues of his who had dared to criticize him'.[57] Helbig became a principal supplier for Jacobsen's ever-increasing collection. He had powerful and dubious help from one of Rome's most successful art dealers, Francesco Martinetti (1833-95), who was 'morbidly suspicious, wealthy through dealings in genuine and less than genuine antiquities'.[58] In the latter, Martinetti was helped by being a skilful restorer and gem engraver which should have raised alarms among Warren and Marshall. He also employed a number of expert goldsmiths and sculptors for necessary 'restorations'.

Andrén's assessment of the two is pointed: 'The illustrious Helbig and the shady Martinetti were the most successful of the foreign archaeologists and native antique dealers who operated together in Rome during the latter half of the nineteenth century, unscrupulously and for mutual profit, in order to provide transalpine and transatlantic museums with antiquities from Italy, genuine or forged, and exported by fair means or foul.'[59] Many of the items they supplied were outstanding and genuine. Until Jacobsen died in 1914, Helbig was his major purchasing agent, the latter acquiring an astounding 955 items by this means. Among them were some astounding fakes, such as the 'Diadumenos Carlsberg' acquired in 1896 as a fine Roman copy of the famed statue created by Polyclitus in the fifth century BC.

The same year, a beautiful statue of an athlete also came from Helbig via Martinetti. Both had been created by the 'master forger' Pacifico Piroli who lived in the Via Sistina (not far from Marshall's flat) and who worked for Martinetti. Piroli had good credentials – he carved many of the figures for Rome's 'wedding cake', the Victor Emmanuel monument.

Apparently, Jacobsen never twigged that Helbig was directly involved in any of the fakes which appeared at the Glyptotek, and his 'Diadumenos' was quietly relegated to the garden of his Villa Gammel Bakkegärd, where it can still be seen. And Helbig was remarkably thick skinned. Once, when he was told that the Glyptotek might be investigated because pieces were arriving there with no indication of their provenance, he recommended: '*Pazienza* – Italy without art commerce would be like Prussia without military drill!'[60] After getting his hands on a number of magnificent statues from the Villa Borghese in a rather circumvented fashion, Helbig boasted: 'All the [Borghese] brothers are very civil towards me. Apparently I have grown in their esteem for having conned them.'[61]

The question that needs to be asked is did Wolfgang Helbig con Warren and Marshall? There is no direct answer to this, but going back to the earliest references we have of Helbig's relationship with the two collectors does shed some light. Writing in 1929 in the bulletin of Helbig's former employer, the German Archaeological Institute, a long-time admirer of the two, Ludwig Curtius, described how as a student he was taken by Helbig to meet Warren. Auspiciously, they met in front of the Ludovisi Throne which was then kept at the Palazzo Piombino. The rest of the great Ludovisi collection was also spread out before them. Curtius said of the meeting: 'I had no idea who he was, but found myself instinctively drawn toward this well-groomed young man of medium build and athletic appearance, who had a keen look in his dark brown eyes.'[62] The Ludovisi collection came to consume more time and energy than any other pursuit in the careers of Warren and Marshall.

Much has been written about what was the centrepiece of an assortment of articles from the now-vanished Villa Ludovisi which succumbed to urban development at the end of the last century. The Ludovisi Throne, now the major attraction in Rome's National Museum almost came into Warren's hands; he had to settle for what the Boston Museum still thinks is its 'counterpart', the so-called Boston Throne. The Ludovisi Throne is dominated by the birth of Aphrodite on the front slab, an image reproduced countlessly in art books as one of the

great productions of the fifth century BC. 'The very light garments [of Aphrodite] are used with great skill . . . the artist has endowed Aphrodite's face with a beautiful expression of joy,' is how the Michelin Guide describes it.[63]

There are three slabs to the 'throne' and according to the tale circulated to attract potential buyers, once it was 'unearthed' in 1887, the whole piece was thought to be a throne for a big statue of a god or a goddess. Two years ago, the respected Italian art critic, Federico Zeri (recently called 'the greatest art historian of the century' – *Art News*, November 1990), asserted the throne came from a well-known fakes workshop operating at the turn of the century. Zeri also maintained that Martinetti was involved in its creation, as well as with the Boston Throne.[64] Over the years, Warren's acquisition has had fewer admirers than the Ludovisi Throne and a number of Italian scholars have said it is *falsissimo*. Its central figure is a plumpish Eros judging a contest between the two seated figures of Persephone and Aphrodite, and Eros has elicited less praise than the voluptuous Aphrodite of the Ludovisi Throne. One critic (who becomes a central figure in Parsons's story in Part VII), Giuseppe 'Pico' Cellini, asserts that after Warren's unsuccessful attempt to acquire the Ludovisi Throne, 'a group of local forgers, keen to offer the disappointed client a counterpart to the Ludovisi sculpture, sawed one end off an old sarcophagus to imitate a chair and carved the Eros sculpture'.[65]

Margherita Guarducci has taken an interest in Helbig after researching the unpublished memoirs of the German archaeologist, Ludwig Pollak, who was close to Warren and Marshall. Her case goes much further than Cellini's suggestion. Like Cellini, Guarducci thinks that the Boston Throne is a fake recut from a sarcophagus, probably by Pacifico Piroli. The throne was made with the advice of Helbig and Paul Hartwig, who were involved in its sale to Warren. Hartwig was less tainted with forgery scandal than Helbig with whom he was close, but he did certify the authenticity of the so-called Nephele dish once owned by Count Tyszkiewicz, which was a clever fake. Hartwig also had commercial interests with Martinetti. Guarducci claims that the idea for the Boston Throne was dreamed up by the dealers Alfredo and Alessandro Jandolo.[66]

Andrén does not accept that the Boston Throne is a fake, but notes that it passed from the Jandolo brothers into the possession of Martinetti and Paul Hartwig who negotiated for its going either to the Boston Museum or the Staatliche Museum in Berlin. Helbig acted in the background to facilitate its export. When the sellers accepted

Warren's higher bid in 1896, they brought down upon themselves the wrath of the German archaeologists who thought a great find had been delivered to hated American competition.[67] The money received for the sale was divided among Hartwig, a brother of Martinetti (Martinetti had died in 1895) and 'a person unknown' whose share was handed over to Helbig. The throne went to Lewes House where it remained in the garden until 1908 when it was finally shipped to Boston. Bostonians did not view it until 1909. William Rothenstein remembers it at Lewes House: 'In the garden was the famous throne . . . which by hook or crook, rather, I think, by crook . . . had been smuggled out of Italy.'[68]

Part of the problem in settling the case of the Boston Throne has been that the scholars who have taken an interest in the piece have known very little about the purchasers, Warren and Marshall. Unaware of Warren and Marshall's purchasing practices, Guarducci, Zeri and Andrén speak only of the Boston Museum as the client in the purchase. There are several final touches to the case. The major reason that scholars such as Andrén and Mette Moltesen at the Ny Carlsberg Glyptotek have continued to defend the authenticity of the Boston Throne is the investigation the Boston Museum carried out in the 1960s. The 1965 report of the findings said that the lower bed of the throne had been 'studied for some hours inch by inch. The whole surface is covered with a hard deposit, including "root-marks": there is not the slightest doubt of its being both natural and ancient.' The deposit could not possibly have been applied artificially. Furthermore, the relief was extensively compared with the Ludovisi Relief and small samples from both monuments were made for photographic study. The two were compared and found to be only slightly dissimilar in structure. The root-marks on both pieces indicated that they 'both were long buried under similar conditions'. In conclusion, the Boston Museum proclaimed: 'In any case the claim that the Boston Relief is a forgery can, except as a psychological curiosity, now be forgotten, together with the misleading scholarship, the innuendo, and even, lately, the arrogance with which it has been supported.'[69]

The investigation by Boston sounds very convincing indeed – until a few facts are faced. First, when the piece came to Lewes House the surface was covered with a hard incrustation which took Frank Gearing, Ned's household secretary, weeks to remove with the help of a razor. That sounds good, and further proof of authenticity. Gearing was aided in his restoration by a very youthful William J. Young, who in 1929 went to the Boston Museum to establish a

research laboratory for the conservation and study of works of art. He was Ned's sole 'graduate' of restoration techniques established at Lewes House under Gearing and furniture restorer George Justice, whose establishment is still around the corner. Young remained at Boston for forty-seven years and still remembers Ned 'always carrying amber worry beads wrapped around his left hand'.

But who carried out the 1960s' investigation on the Boston Throne? None other than William Young and another friend of Warren and Marshall, Bernard Ashmole. The latter's expertise is above any suggestion of reproach. He was a brilliant scholar, but Ashmole could never bring himself to suggest that his friends might have fallen for forgery. We will see that later in Marshall's battles with forgery. If nothing else, there was a vested interest of sorts in the 1965 report, and that point has never been observed by the throne's defenders. As to the encrustations and root-marks, any visitor to the 1990 'Fake?' exhibition at the British Museum could have seen the marble portrait bust of 'Clytie' with its encrustation on the underside of lotus leaves, an ancient piece of marble which was reworked by later sculptors.[70] It is an old device in the forger's repertoire. And as Arvid Andrén reminds us, there were in the latter part of the nineteenth century in Rome 'tempting examples for imitation in the many museums and good chances of procuring ancient blocks of Greek or Luna marble at reasonable prices'.[71]

Almost hidden among the papers of John Marshall is a curious memorandum. In his usual thorough investigatory manner, Marshall set out some of the information he had gathered concerning the D.R. – the throne. D.R. was his preferential term – from the German *dreiseitiges Relief*.[72] Marshall related:

In 1894 Bianchi, Ingeniere [engineer/overseer] for the Piombino Ludovisi family, lived in a house he had built for himself at the corner of the street immediately behind the present Excelsior hotel. In his garden was the D.R., used to fence round some pots containing flowers. Close by lived the old Pacifico [Piroli] with his wife, parents of the young men who now have a shop near the Foro Romano. The wife mended chairs: the old man dealt in antiquities and was a sort of *mediatore*. He it was who first noticed the relief and called Valenzi's attention to it. Neither he nor Valenzi had the money to buy it, and Valenzi approached the brothers Antonio and Alessandro Jandolo. An arrangement was made according to which either Pacifico or Valenzi bought the

piece from Bianchi; then Valenzi sold it to the Jandolos for 2,000 lire. In the books of the Jandolos it is said that payment was made partly in money partly in pictures. The piece was then sold to Hartwig and Martinetti. When Francesco Martinetti died he had not sent the marble out; his brother came to the Jandolos with Hartwig and wanted Jandolo to give him a new receipt for it. Jandolo could not understand why they wanted a new receipt, but as they paid him 2,000 lire for making it, he let them have it.

The old Pacifico is dead long ago; his wife still lives. Valenzi is reported to be dying [as of 1 May 1923 when Marshall wrote this]. In the papers of one or other of them if anywhere must be Bianchi's receipt for the 2,000 lire.

Alessandro Jandolo did not know Bianchi but his father and his brother Antonio had many dealings with him.

Several points are significant regarding this memorandum. The fact that Pacifico Piroli's name is mentioned in connection with the throne, and that it was he who first 'noticed' the relief. That speaks volumes. Other persons involved also appear – the Jandolos, and the previously noted arrangement between Hartwig and Martinetti. This, of course, adds credence to Guarducci's conjecture. As will be evident in Marshall's escapade with the Etruscan warriors, we should not be surprised by how easily Marshall could be fooled. And, of course, we also have to remember that we now know what Warren and Marshall did not know: that their trustworthy Helbig was in fact mendacious.

The possibility of acquiring the Ludovisi collection weighed heavily with Marshall who viewed it as the great challenge of his career: In 1892, he expressed fears 'lest his linguistic and personal limitations should be too great for a matter of such consequence.'[73] Earlier Marshall had warned: 'You would need to save up for a few years to be able to buy the 3-sided relief' (the Ludovisi Throne). He also reported in 1892 that he had 'gone through the Ludovisi collection for about two hours and liked the [Ludovisi] throne better this time.'[74] With hindsight his hesitancy is interesting.

Warren was busy dealing with Jacobsen. In 1898, he went to Copenhagen to strike a deal with Carl Jacobsen concerning the Ludovisi collection. Both were contending for it, and Helbig enjoyed his position of being the intermediary for either client. According to Moltesen, Warren devised a plan of *twenty-four* different ways he and Jacobsen should divide the Ludovisi collection. Ned's views of Jacobsen's collection are telling. To Marshall he reported: It is the kind of

collection I might have made without you to keep me up to standard; there are only three or four things I would like. I passed home by the brewery thinking how his generous purpose – he is a very sincere man – and the huge expense, have been frustrated by the unscrupulousness and failures of the men we know, and how I, in five years, with good helpers, have done more to acquaint my people with Greek art.' Comparing his collection to Jacobsen's, Ned concluded Jacobsen's was like 'a Dissenting chapel set against [his] Cathedral'.[75]

Apparently, Jacobsen and Warren arrived at an amicable division of the Ludovisi collection between them. But it was all an exercise in futility as the Italian government moved in and took the collection into its possession – the majority of which is on display at Rome's National Museum across from the central station. In his papers, Marshall stated that by 1898 his and Warren's relationships with 'certain' German agents needed clearing up.[76] There does not appear to have been an outright break with Helbig and Hartwig, but there certainly was a cooling-off in involvement. In time, neither name appears in any of the letters which remain. A dispute with Hartwig is mentioned but was, according to Ned, settled 'by the use of [Hartwig's] special instrument, money'.[77]

It is easy to see potential difficulties arising from the ingenious methods Helbig and others devised to get antiques exported from Italy. From Warren's papers we have:

> About the Eleusinian vase and the Polygnotus . . . pay duty. The Polygnotus I shall doctor myself, just painting the name out with something that will wash off. That will go by Roessler Franz . . . The Eleusinian, Helbig thinks 'a man he knows' can put through Customs for about a hundred lire. The man is a rogue of course, 'but there is no danger' . . . it is very strange, but 'the dirtier the business the more secure you are in trusting to the honour of certain Italians . . . The reason is that the priests to whom they always confess such things, always bid them to carry the matter out and keep their word.' The same man it was who got the Copenhagen busts out of Rome for almost nothing when Tyszkiewicz was in despair as to how he could pass them. 'He covered the noses and chins with stucco as though they had been repaired, and made them look so bad the authorities thought them valueless'.[78]

The words Warren is quoting are Helbig's. It appears Warren and Marshall were learning all manner of deception.

Another dealer used by Warren and Marshall was far less tainted than the others. In fact, in 1923, when Alfredo Barsanti was honoured for his outstanding career, the elaborate commemorative book presented was filled with greetings from every major art expert and connoisseur in the world. Both Warren and Marshall contributed with Warren remembering Barsanti's many years of productive collecting of treasures in Italy and Marshall speaking of Barsanti's splendid bronzes: 'How difficult it is to find such things I do not know, but judging from my own experience in similar lines, I think you have been fortunate.'[79]

Barsanti started in the trade at 20 at an elegant antique shop in the Piazza Barberini. He was described as 'intelligent and violent'.[80] Barsanti knew Martinetti but despised him and was also connected with Helbig and Hartwig. For eight years he had a partner, Eliseo Borghi, and they worked well together until one day Borghi questioned a marble Barsanti was planning to sell. Borghi said it was worthless. To show him up, Barsanti took it to Warren who liked it, and asked, 'How much?' The price was 50,000 lire, and Warren offered 48,000. Barsanti agreed and told Borghi of his triumph. This account is given in Augusto Jandolo's gossipy memoirs. Augusto was the most cerebral of the large Jandolo family antique enterprise and he often groups Warren and Marshall with Helbig and Hartwig as 'kindred spirits'.[81]

The marble which Warren purchased from Barsanti for the Boston Museum was a 'Flora' (Roman goddess of flowers), an image well liked by Leonardo da Vinci. Warren's 'Flora' went to Boston where L.D. Caskey, in his catalogue of Greek and Roman sculpture, described it as one of the Boston collections 'crowning glories'.[82] All this is related by Jandolo and often repeated in other books. Interestingly, my queries at Boston have brought forth no other response than: 'If it should have resided here for a while, it is long gone; there is no record of any kind of such a sculpture.' Another 'Flora', a wax one purchased in 1909 by Wilhelm Bode for 150,000 marks as a work by Leonardo da Vinci, created a great deal of controversy. It had not long been in Berlin before charges circulated that Bode had spent a great deal of money for a fake. *The Times* reported that it had been created by a minor English sculptor, Richard Cockle Lucas, and his son stated how he had helped his father with the bust. The 'Flora' remained on exhibition, however, and still does despite the 1984 tests by Josef Riederer which showed that the wax contained a synthetic organic acid which was not produced until 1833.[83]

Warren and Bode's 'Floras' were not the only ones around; Duveen purchased an even more questionable one – and it also came from Barsanti. During the early years of collecting, Marshall often suggested that his friend's judgement in selecting was worrisome. A carved agate for which Warren paid a great deal was taken by Marshall to the Geological Museum in London, where it aroused the suspicions of one expert. Marshall tracked down the dealer in Jermyn Street where Ned had made the purchase, and was told that he could make 'any amount of similar gems' if Marshall's friend wanted them. The 'agate' was not agate.[84]

Most of Ned's questionable purchases were made when he was on his own, but one event occurred when the two were travelling together in Greece in the company of Charles Murray West. Later, Marshall wrote Robinson a private letter about what transpired. He said they were shown a number of articles in Athens and 'of everything' Marshall 'had first choice'. At the time, Warren was buying mainly coins and was running low in his funds. After they had already booked their passage home from Greece, a dealer told Marshall of 'a very important archaic Apollo' he was anxious for him to see. They delayed the trip and were shown the statue. At first glance, Marshall disliked the piece and said he noticed a mistake with it: 'the left leg was advanced although from the line of the buttocks behind, the weight must have been on that leg . . . The more I looked at it the more settled did my opinion become. We were there a long time till I grew quite tired of the thing.'

Warren and Murray West, however, quite liked the statue. They had a long argument about it and 'came near a quarrel'. Warren convinced Marshall that they should come back the next day and see it again. Marshall hated it even more, and condemned it as having no patina on the body 'save a yellow stain here and there – such as forgers add to their work'. Marshall didn't think it was Greek; more likely it was the product of an Italian or French forgers's workshop. Warren saw none of that and was more convinced than ever that 'the statue was right'. Marshall begged him not to buy the piece and at least 'consult some person in whose judgment he had confidence'.[85] We hear no more of the statue but the episode indicated some growing differences of opinion.

Aside from these occasional arguments, Marshall was becoming frustrated as to the direction their collecting was taking: too much depended on Ned's whims and fancies. From Rome he complained to Ned: 'I feel so weak here; I am rather down – I can do nothing. I go

round and round seeing worthless things. I suspect everybody . . . I am sick of being alone and Puppy dear, it is bad for me. I would sooner do anything than live alone. Do, therefore, if you can, hurry up the business here. I am a bit unhappy.'[86] This is one of the most personal outpourings we have from John Marshall. In his enthusiasm to amass a great collection, Ned appeared to be taking his friend for granted, and his response was decidedly weak: 'You speak of coming here, and I rather advise it, or else a journey to Athens . . . If you feel uneasy under this arrangement, you can certainly return.'[87]

During these frantic days of purchasing, Marshall went back and forth from Rome to Greece. Warren was occasionally in Rome, but only when it seemed to suit him. From December 1895 to March 1896 and again during the first four months of 1897, Marshall was in Greece and made his most outstanding finds then. The year 1897 was the best one for Marshall, and though he continued to complain of being 'weak' and having 'an increased sense of failure', he was satisfied that he had more than earned his pay. Reading their letters from this period, one has, on the surface, the feeling that Ned appears uncaring towards his friend. Ned was caught between two conflicting desires: that Marshall should stick it out and succeed in purchasing the antiquities they both loved; and that he also wanted Marshall by his side in Lewes. Ned's strategy was to push Marshall to continue acquiring as much as he could while the pickings were so good. Then he could return to Lewes and write about his findings. Ned underestimated one point, which was just how lonely Marshall was at this time.

During the winter of 1897-98 Ned participated more in the actual business of purchasing art objects, joining Marshall in Greece for a while. In Greece, there was no Helbig or Hartwig to act as go-between with the local dealers who if anything were more devious and corrupt than the Italians. Often Marshall dealt with *tumborrouchoi* whose sole trade was to excavate and divide their spoils among themselves and offer them directly to buyers who happened to be on the spot. Marshall had heard of some promising finds in a tomb in Eretria where a fine terracotta in a large tomb had appeared plus 'a number of swords damascened with gold, a gold vase with scenes on it, and shields'. The authorities, who usually took an interest only when precious metals were involved, heard about the finds, so the peasants buried the gold vase and swords before they could be confiscated. A dealer named Lambros told Marshall he thought he could lay hands on the items, including the terracotta, which had been confiscated

earlier by the authorities. The peasants were offering their buried treasures at 5,000 drachmae 'guaranteed'. Marshall commented wryly, 'But everyone is afraid of six months in prison – six months in a Greek hotel is enough to deter me.'

Lambros was certain he could get the terracotta from the authorities with an offer of 5,000 francs. The amount was far more than originally estimated and Marshall refused to go higher. Then he discovered that Lambros's agent had already paid the 5,000 francs for the terracotta – assuming that Marshall would come round. Not only that, but the agent had been tried in connection with the sale and imprisoned for ninety-three days.[88] In disgust Marshall left to meet Ned in Athens where they received word there were some interesting vases and terracottas to be had near Thebes. Off they went. The terracottas were Tanagras, fourth-century BC statuettes of elegantly draped women. They came from ancient cemeteries at Tanagra, east of Thebes which were plundered greatly during the time Warren and Marshall were collecting in Greece. Tanagras became so popular with collectors that it was not long before talented forgers were supplying the demand.

Count Gregoire Stroganoff, the old friend of Helbig in Rome, loved the figures and had a prized collection of twelve which he kept in a specially constructed case. The Count found that his collection had become so large – with the help of Helbig and others – that he built a new house in the Via Sistina to give him more room for more treasures. This was near where Marshall lived. When the foundations for the great house, which still stands, were being dug a wonderful Roman marble copy of Myron's famous bronze of Athena was discovered. Marshall longed to purchase it, but Warren was unable to raise the money for it. It was one of their greatest disappointments.[89] In the bidding which consumes dozens of letters left in the Ashmolean Library, Marshall was up against Helbig acting for Jacobsen, the British Museum, Berlin interests and others. Finally, it went to the new museum at Frankfurt where it remains a centrepiece.

Stroganoff's personal collection was an eclectic one, though he was inordinately fond of his Tanagras. Marshall had a mild interest in them, and due to Stroganoff's obsession, he recognized a potential investment. At Thebes, Marshall and Warren were met by a dealer named Lekas who had been highly recommended. The two soon discovered that Lekas was having some difficulty gaining control of what was rumoured to be a large cache.

On the morning they were going to be shown the treasure, Lekas had ordered a carriage for them, but spent most of the time arguing

with his father who also claimed control of the cache. When the carriage arrived, Lekas took off with it, leaving Warren and Marshall behind. The dealer was going to make certain he was totally in control before Warren and Marshall saw any of the Tanagras. A new carriage was ordered and the scene which followed (written by Warren in his diary) sounds like a chase from a film.

> In half an hour, we were after him. We had better horses and soon caught up, and drove by. But he got ahead again where the road turns into a downlike country, and then began a race. Our team was the better, but his was the better driver; and the art consisted in picking out the smoothest lane. We were often just behind one another but we failed to get ahead, and at last were so delayed by a complication of ruts that he got a few furlongs ahead. We put to it, but not well enough, when to our immense delight one of his horses fell. We drove ahead and had seen and rejected the treasures by the time he arrived.[90]

The incident was embarrassing for Marshall as he had assured Warren Lekas was 'one of the best'. The reason Marshall advised against purchasing the Tanagras was his suspicion that they might be fakes. As it turned out, he was right. There was, however, some consolation. Shortly after this, Marshall heard that Count Stroganoff's beloved twelve Tanagras were from the same cache – and also fakes.

Then there was the occasion when Ned Warren entered a major archaeological fracas, and it was to be the only time in his career as a collector that he was to involve himself publicly in any sort of scandal. 'Scandal' was just how Ned termed the goings-on at the museum of the Villa Giulia. In 1902, in the English periodical, *Monthly Review*, he brought certain dubious practices in the name of archaeological research to public attention. In customary Warren fashion, however, the article was published under a pseudonym.[91]

The Villa Giulia, near the Borghese Gardens, now houses an important collection of Etruscan art. In Ned's day, it was on the road to becoming a significant depository. The villa was built for Julius III between 1551 and 1553, and is one of the most attractive examples of late Renaissance architecture in Rome. Visitors can now view two magnificent Etruscan pieces there: the wonderful Apollo of Veii and a superb sixth-century BC sarcophagus of a bridal couple. After serving as a powder magazine under Pius IX, and after 1870 as a military warehouse, in 1889 the villa was turned into a museum for pre-

Roman antiquities. Due to the efforts of the archaeologist, Felice Barnabei, new collections from excavations began to arrive and the museum soon took shape.

Ned's attack in *Monthly Review* was largely directed at Barnabei and how ruthlessly he had handled the excavations. In the letter Ned directed Harry Thomas to write to the President of Corpus Christi College, Barnabei's policies were called 'domineering' and 'represented as patriotic . . . but in reality it not only deprived foreigners and the world of scientific excavations and handed them to the lowest Italian hucksters, but also imposed on the Museo di Villa Giulia a collection of faked provenances. The Director [Barnabei] encouraged thieves to bring him things, which he then published as from special tombs and as found by certain people whose payments for the work may have gone to himself.'[92]

In his article, Ned did not mince words:

> Never, perhaps since the forgeries of Mr Shapira has a greater archaeological fraud been perpetrated . . . Seldom have false accounts been published and original documents suppressed with greater levity. In no country but Italy would it have been possible for a small band of public officials to dispose of the whole machinery of Government for its own private purposes, to seize the honours due to excavators, to garble their reports, to exhibit their finds as its own, to hush rumours of its malversations, to throw dust in the eyes of students, suppress their inquiries and investigations, present false materials for their studies, while denying them all verification and proof of this material, and boldly to claim this mystification as a laudable and suitable achievement of Public Instruction.[93]

The matter was far from simple and in the middle of the muddle were two friends of Ned's, Wolfgang Helbig and Fausto Benedetti. In the introduction to a new edition to his Baedeker guide to Roman archaeological sites and collections, Helbig had brought the scandal to the attention of a vast reading audience. That infuriated Barnabei and the Administration of Public Instruction which was in charge of Italy's archaeological sites and investigation. They suggested that Helbig be expelled from the archaeological offices he held – these were those he still retained from his days at the German Archaeological Institute. According to Ned, it was Barnabei who should be expelled. Ned was treading on thin ice in his defence of Helbig, and

he obviously had no idea of the full extent of Helbig's misdeeds which were well known to Barnabei and his associates.

In unpublished notes at the Ashmolean Library, Ned said: 'The Commission [of Public Instruction] falls heavily on Prof. Helbig for citing him . . . [on questions] not connected with the Villa Giulia.'[94] Ned's notes also gave the Benedetti involvement in more detail than in his article; in fact Benedetti's name often appears in Ned's papers. He visited Lewes House on several occasions but by 1909 John Marshall 'was no longer on speaking terms' with Benedetti, and Ned enlisted Harold Parsons 'to reconcile the quarrel'. Benedetti was only 15 when he began to excavate and 'under no supervision'. As Ned observed, 'He learned by experience. He had only a common school education – no archaeology at all.' Benedetti was also very handsome – just the type of youth to attract Ned's attention. Despite his inexperience, it was Benedetti's reports on excavations which were published by Barnabei. Benedetti went on to become 'one of the most conscientious, professional *scavatori* in Italy'.[95] But later, his reports were altered, rewritten and some were destroyed. Ned's notes admitted even more damning evidence. Benedetti forwarded his finds to his father, Annibale, who, knowing nothing about what was going on, sold them to the government: 'The receipts for the sales were drawn up by Count Cozza, assistant to Prof. Barnabei, and signed by Annibale.' Contents of various tombs were confused, and on some occasions Annibale threw in various other objects to make the bargain. Blindly receipts were signed with no thought that 'scientific inaccuracy' was being committed. One of the tombs listed in Barnabei's final report of excavations never existed. It was a hole in the ground filled with left-over objects for which there was no accounting.[96]

Benedetti was furious when he learned how his reports had been used, and with Ned's prompting, he published his version of the excavations simultaneously in London and Turin. The Roman authorities reacted to it as to the frustration of an amateur. That reaction prompted Ned's article a year later. Ned's conclusion on the affair was that if the archaeologist were to arrive at scientific results from the Museo di Villa Giulia, he 'must fish in very muddy waters'.[97] These remarks and others had not endeared him – or by association, John Marshall – to the Italian authorities. Ned ruffled the feathers of national pride with the last words of his article:

Truth to tell . . . on matters pertaining to knowledge, Italians are

grossly apathetic . . . To the Italian it makes no difference that a copy of the nude youth pouring oil attributed to Praxiteles is first cleaned till it is ruined, then provided with a plaster head portraying a Roman model, and thus disfigured, set up in the Museum of the Conservatori, when it would have been perfectly easy to place on it a cast from the proper head, a copy of which exists in Naples, mounted on a draped Dionysus. The Italian does not trouble about such things. The foreigner does.[98]

Not often was Ned so furious. Nevertheless, John Marshall would later have to pay for such outbursts.

Harry Thomas wrote that Warren and Marshall's great collecting period lasted a decade. Thomas gave the end as March 1902, one month after Ned's article appeared in *Monthly Review*. Though his reputation was tarnished – especially outside Italy – Barnabei was basically able to survive the scandal. For collectors like Warren and Marshall, he used all the influence he could bring to bear to make export licences practically impossible to obtain. There were other problems as well. In 1901, Matt Prichard and Richard Fisher had gone to Boston to work in the museum; an act which Ned interpreted as their 'going over to the enemy'.[99] As we will see in the section on Prichard, he was to become quite close to Sam Warren and Fisher was to become a tutor for Sam and Mable's children. Ned's brotherhood was breaking up.

In September 1901, Ned's mother died. He became an even richer man, but he also wanted to be appointed a trustee in the family business in her place. Ned was not able to get to America until November and it was on board ship that he wrote his *Monthly Review* article. In Boston, Ned discovered that Sam wanted their sister Cornelia as a trustee. As it turned out, no new trustee was appointed and with brother Fiske totally preoccupied in his own world of politics and travel, Sam was in fact the sole trustee and in control of both the trust and the partnership. Ned set himself to find out just how the Mills Trust operated and how S.D. Warren & Company was run.[100] Marshall suggested a plan whereby Ned and Fiske would sell out their interests to some magnate like J. Pierpont Morgan, whom Marshall would soon come to know fairly well. Nothing came of the suggestion.[101] In 1902, Ned hired lawyers to look into the family business, thereby setting himself upon an irrevocable course.

In Boston, at 42, Ned was finding that everything appeared to hinge

on his brother Sam: old friends Prichard and Fisher were in Sam's camp; the Boston Museum (under Sam) was more interested in new building than in his and Marshall's acquisitions; and Sam had recast his father's business in his own image. Ned lamented: 'I can act on no single point without considering the effect on Sam's opinion of me. He is not keen on the business (Fiske says that); he is not keen on me; he is not keen on the collecting. He is keen on a conservative financial policy; he is keen on the family dignity! He is keen on Mamma's memory. He has a strong mind, but no forth-putting nature. Whatever he is, he is a man who fails to see the bigger bearings of questions.'[102]

Marshall tried to help and was supportive: 'What you ask is so obviously fair that if there are not good reasons why it should not be granted, there seems a *prima facie* case for strong measures to establish your rights.' There was no solution offered to Ned in 1902 and the breakdown was probably unavoidable. It was Ned's watershed year and he knew it: 'It comes to this; we have arrived at that age when a man usually wins success if he deserves it. We have deserved it and we have not won it because we are dealing with the new American world, unprepared to award desert on our lines.' Ned wrote these words to Marshall from Boston but, increasingly in his letter, it sounded more as if he were talking to himself:

At forty, one may turn bitter or remain sweet. I come near getting bitter! We knew that we were destined to do good work without rousing corresponding appreciation; we were willing to do so. That was romantic; my romanticism. If we blink the facts and expect appreciation, we undo our romance and become no finer . . . I in the last few days have been examining myself for evil speaking. Now that I am sure what Sam is, why not accept him? My wish to slang him comes from the fact that I am not successful. I have done as good work as he; I deserve success as much; I don't get it. But I knew this, and my romance should be a bet that I can stand it. At forty, one should be able to take a stand, to measure by facts when, owing to the nature of the case, they are not measured by success . . . So the case is, can we win our bet? Can we face the music we have romantically welcomed? If we can't, we belittle ourselves. If we can, we are, according to the stock correct phrase, superior to circumstance.[103]

Ned would win against Sam – but not in a manner he could ever

have desired. His success over his brother would cause him to be damned even further by his family and Boston, and the struggle would in part cause him to lose the very one he thought most understood his 'romance'.

PART III

Edward Perry Warren –
The Prince Who Did Not Exist

1

Marriage and Suicide

People answered questions before they were put, and fell in love with each other after they were married, and behaved altogether in an extraordinary manner.

Ned Warren in *The Prince Who Did Not Exist*[1]

In 1900, Ned privately published an odd little fairy tale, *The Prince Who Did Not Exist*, and dedicated it to John Marshall's future wife, Mary Bliss. Only 350 copies were printed, and few of those survive. The book is not referred to in any of the Warren-Marshall papers or in Burdett and Goddard's biography. Curiously, Berenson's biographer, Ernest Samuels, notes a manuscript by Berenson entitled *The Princess That Did Not Exist* which Berenson thought was 'the cleverest he had ever written'.[2] I asked Samuels about the story and he wrote that he knew no more but also felt it an extraordinary coincidence (if no more) that the two friends used so similar a title.

The Prince Who Did Not Exist is quite short and the first page or so give its flavour:

There was once a prince, who did not exist, and the reason why he did not exist was this: he was a prince in a fairy-tale. Now princes in fairy-tales do not exist; but they are nonetheless very useful and respectable people as I hope you may be. This prince was in love with a young lady, who unfortunately, did exist. For the existence of a young lady is sometimes unfortunate, though she may be a very useful and respectable person, as this one indeed was. It was unfortunate because the prince fell in love with her, and she . . . could not accept his hand; because it was against her principles to marry people in fairy-tales, not being in a fairy-tale herself.[3]

As Ned dedicated the tale to Mary Bliss before her marriage to John Marshall, the reader is aware of several apparent intimations. According to John Fothergill's memoirs, Ned's spinster cousin was in Lewes

75

before Ned returned to Boston in 1901. She did not take very well to the fairy tale existence of Lewes House. Fothergill described her as 'a middle-aged cousin of Ned's who came to stay with us: she didn't like me, and courted Ned and Marshall, either of which she was well prepared to marry. But Ned never touched a woman in his life, nor, perhaps had Marshall . . . Naively Mary thought the marriage would unite Johnny more closely to Ned.'[4] Little is known of Mary Bliss, but Mrs Warner describes her as a hypochondriac with a nurse always in tow. She had special diets and 'checked every morsel Martha served from the kitchen'.

Ned's description of the young lady of his fairy-tale could not be a truer description of Mary Bliss: 'a very useful and respectable person'. Neither love nor sex had anything to do with the union of Mary and John Marshall, but she was an extremely beneficial help-mate in his collecting at the Metropolitan Museum. The statement that 'the existence of a young lady is sometimes unfortunate' is telling. It was surely for Ned. But Ned's prince never fell in love with his young lady – he simply carried out this threat of 1893 that he 'would sooner do anything than live alone'. He certainly did.

Ned has his two fairy-tale characters falling in love with each other after they were married, which never really occurred with the Marshalls, but they were happy and contended with the life they developed, and, again, Ned Warren, as in his *Tale of Pausanian Love* was able uncannily to divine the future. The story is clever and it is a pity we do not know much about its origin or its relationship to Berenson's writing.

John Marshall did not marry Ned's cousin until 5 November 1907. Near this time, Ned became more and more involved with family interests back in Boston. He thought he might live at Longley House, just across the street from the Cumberland Mills, where he could snoop on managers' conferences and investigate the welfare of the mill workers. His overriding concern was not altruistic but quite practical: in a last ditch effort he wanted to see just how his brother Sam was running his father's business. Sam objected to the idea of his taking up residence so near the centre of activity. Ned compromised and installed himself at a more discreet distance at Fewacres – a mile away from the mills. Since the collecting for the Boston Museum was basically finished, he also decided to spend six months of the year at Fewacres.

This created further tension with 'Puppy' who complained: 'It is your business, I suppose. If you care to spend your life at Cumberland

Mills for six months of the year, I at least could not do it. The place is dreadful and the people worse. You run your own affairs and expect me to follow like a slave any move you make. You think your duty lies in Boston, and I know you too well to try to stop you.'[5] This was one of Marshall's sharpest criticisms of Ned's behaviour. Not only did he feel he was playing second fiddle to Boston, Marshall was also aware of the growing importance of Ned's new set of friends. One, Harold Parsons, Marshall came to despise. Of the other, Harry Thomas, he was bitterly jealous. In 1906, Ned paraded his young and handsome protégé, Harry, around Boston and Fewacres. This was especially hard for Marshall to swallow as some saw Harry as 'Ned's new boy friend'.

There were other factors at work in the growing alienation between Warren and Marshall. Marshall had remained in touch with Edward Robinson who, in 1905, resigned as Director of the Boston Museum to be immediately offered the position of Assistant Director of the Metropolitan Museum in New York. One of Robinson's first acts was to get Marshall to be the Met's purchasing agent. He wanted Marshall to do for the Met what he had so auspiciously accomplished for Boston. In June 1903, Marshall visited the museum and wrote that it was 'better off than Boston for pictures but hopeless with respect to antiquities'.[6] Marshall was hooked, and Mary Bliss waited patiently to be just the right help-mate he needed for a new challenge.

While Marshall was busy in Lewes planning new acquisitions for the Met, Ned was at Fewacres going over the records of the family business. Marshall distrusted the outcome and had no faith in Ned's 'capacity to deal with trained and skilful business men'. Just what could Ned offer the mill people he asked: 'Byzantine swimming baths . . . lectures on Shelley?'[7]

In 1906, Ned's attorney, William S. Youngman, produced a seventy-page document answering Ned's multitudinous questions about S.D. Warren and Company. Youngman concluded that the Cumberland Mills Trust which was set up by Louis Brandeis – a lawyer despised by many of his Boston counterparts, and Sam's best friend – had greatly benefited the partners and cheated the heirs. Youngman claimed that the administrative charges which exceeded $40,000 a year were excessive and had been reserved by the partners as payment to themselves. More alarmingly, the partners owed the heirs $1.5 million plus interest.[8] This was fuel for Ned's fire.

Back in Lewes where he was often left alone to handle the household, Marshall thought three weeks was enough for Ned to finish his

business in America. Ned replied: 'Can you expect a man to decide finally, in three weeks, what property is worth and whether he will sell it?'[9] While Ned was assessing his financial standing in America, he was also coming to enjoy Fewacres. Harry Thomas was there much of the time, and Charles Murray West kept things in good order. Ned's old crony, Ernst Perabo, was also often a guest writing music and 'tinkling motifs on the piano'. Ned's letters to Marshall bristled with the glories of Fewacres. He wished Marshall could enjoy 'the scenery, the trees, the light'. Ned's favourite room contained his best Chippendales; on his bookcase was a Galatian capital and in the window a fourth-century statuette of Artemis. Ned proclaimed: 'It is a very civilised hermitage.'[10] This was not what Marshall needed to hear. Later, he referred to 'that terrible autumn'. Absence at Lewes House was doing anything but make Marshall's heart grow fonder. He was ready to accept the future offered by Edward Robinson and Mary Bliss. He called them his 'only loopholes of escape'.

Ned sensed what was transpiring but, fatalistically, did nothing about it. By the spring of 1907 it became clear that Marshall would marry. Though he told Marshall this was a 'betrayal of their common ideal',[11] Ned said he would stand by his friend 'married or unmarried'. Marshall's letters at this time intimated he expected Ned to react more strongly but, at the same time, desperately wanted a radical change in his life. On his part, Ned seemed so consumed by his new interest in Harry Thomas and his unravelling of the family business that he submerged his feelings for Marshall. Later, he would painfully recognize his short-sightedness.

After the marriage, however, Ned was as good as his word. He set the Marshalls up in a magnificent flat in Rome as a centre for their purchasing activities for the Met, and subsidized their income from the museum. By this time, though, Ned had about twenty financial dependants, and it was no wonder that he determined to spend the next few years finding out just how he stood financially regarding his father's legacy. Of the forty years during which Warren knew Marshall, half were after his marriage. During the last twenty years Warren did most of his writing and became acquainted with a varied circle of individuals. These segments of Warren's life will be discussed in sections to follow.

The year after Marshall married, Harry Thomas followed suit. We know little of his wife, Hannah (Nan) Devey, neither do we know exactly where or when Ned first met Harry: not even his daughter and granddaughter are aware of the circumstances. They assume it

was at Oxford. After a brief period at Heidelberg, Harry spent a year at Ned's alma mater, Harvard, where the records say he was a 'special student' from 1903 to 1904. He gave Lewes House as his address. Initially, Harry Thomas came from Birkenhead and was the son of Asa Thomas and Ellen Hardy, and attended Ashford House School in Cheshire. Following his year at Harvard (he would have been 21 then), Harry became Ned's private secretary. In many ways he was the antithesis of Ned: athletic, heterosexual, sports-loving, and not' very intellectual. His interests were hearty: hunting, shooting, racing and tennis. Harry was a member of the Royal Thames Yacht Club as well as the MCC. He became obsessed with cricket, and almost every page of a diary indicates that he found release from his secretarial duties at Lewes House by being with the boys.

In a trunk in the attic of Harry Thomas's old farmhouse at North Chailey is his diary for the year 1910 – a Collin's Scribbling Diary – '7 Days to a page – Interleaved with Blotting – Price 6d'. There are diaries for no other years. The entries actually begin in December 1909 with Harry sailing on the *Mauretania* alone on 22 December from New York to Liverpool. He noted that this was the last voyage of Captain Pritchard and he celebrated Christmas Day at the Captain's table. When he arrived at Liverpool, Harry was greeted by his wife Nan and his sister Queenie. By 5 January, Harry and Nan were back at Lewes. There were four other sailings back and forth to America in the diary. The one Harry made on 5 March to New York on the SS *Baltic* was in answer to an urgent cable from Warren. Sam Warren had killed himself.

Leaving no suicide note, and being in apparently good health, the death remains a mystery. Not until 1983 was Sam's death actually acknowledged as suicide. Lewis J. Paper revealed the truth to the public in his biography of Sam's former law partner, Louis Brandeis. Before this, it was circulated among Ned Warren's friends that Sam had died of apoplexy. The death certificate (apparently unnoticed by Ned's friends and others) stated that Sam had died of 'cerebral haemorrhage due to physical exhaustion'.[12]

Brandeis's role in the drama also remains something of a mystery. The 1916 US Senate confirmation hearings on Brandeis's being appointed a Supreme Court justice resurrected the events leading up to Sam's suicide. It was then suggested that Ned Warren had never received from Brandeis all the information he should have had regarding the set-up of the Cumberland Mills after the elder Samuel Warren died. It was also clear some senators felt that Brandeis could

not have ethically represented all members of the Warren family concerned, since their interests were in potential conflict – and he had been Sam's partner in law. However, Brandeis survived what some considered to be 'the most gruelling confirmation fight in the country's history'.[13]

In 1909, Brandeis was too busy in Washington to appear in court so his partner, Edward McClennen, took his place. Many in Boston who despised Brandeis interpreted this absence as the betrayal of an old friend. McClennen did his best to bolster Sam's side and insisted Ned should not be a trustee in the business as he lived in Europe. In addition, he said Ned had no business sense and his complaints about being cheated had come ten years after his father's death – after he had signed all those papers Sam had sent him.

Ned's attorneys, Youngman and Bailey, however, appeared to have the better case – and Sam began to recognize this. Their unravelling of the facts concerning the discrepancies in income among the Warren heirs was a revelation to Boston. The trial went on for two months, and more and more dirty linen was washed in public. Brandeis's absence, the potential disgrace of being found out in the face of a Boston society he and his wife had so carefully wooed, the conflicts at the Boston Museum over which he had presided, and the fraternal ruptures which had been created bore down heavily upon Sam. In mid-February, Sam went alone to his Dedham house to spend a few days. Dedham is a suburb south-west of Boston, and there he and Mabel created their estate, Karlstein, with a polo field, a trotting track and elaborate stables. Mabel and her Bayard relations especially loved Karlstein and some of the most socially prominent of Boston were regularly invited there for week-ends.

On 18 February 1910, Sam caught a train from Boston and walked from the nearest station to Karlstein. After an afternoon of log-splitting on the estate, he took a gun and shot himself. No attempt was made to disguise the suicide as a shooting accident. Sam Warren's son discovered the body and concealed the disgrace. Despite rumours in the press and elsewhere, the concealment by the Warren family persisted over the years. Responding to the claim that Sam Warren was physically exhausted, a Boston reporter noted: 'Warren was not too exhausted to walk the two miles from the station to spend the afternoon chopping wood.'[14] The press made much of the Warren's social position (the value of the estate was given as between $4 and $5 million) and the pending law suit. Soon after his arrival from

Washington, Brandeis acted as a buffer between reporters and the family.

Harry Thomas's diary shows that he was at Fewacres with Ned at the time of the suicide. There is, however, no indication whatsoever in any of the papers of Thomas, Warren, Marshall or Fothergill that Sam's death was suicide. Not even the gossipy Harold Parsons ever gave any indication of that. Immediately, Ned suspended the law suit, but many in Boston received the impression from the Warren family that it was Ned's action which in large measure brought on Sam's death.

Ned stayed at Fewacres until late March where he 'spent the time in recounting his faults' and writing more of his *Defence of Uranian Love*. After meeting his lawyer, Youngman, in New York on 29 March Ned and Harry sailed to Liverpool on the *Lusitania*. When they arrived on 5 April, Warren went straight to Lewes and Harry joined him two days later. On 17 April, Marshall arrived at Lewes but only stayed for a week. He then went off to Paris and Rome with Ned following on 28 April. When Marshall heard about Sam's death, he had sent some rather stern observations to Fewacres:

> If I were to criticise your character, I should say one of your qualities was mysticism. Why you pray, why you go to church, why you cross yourself, is not that you believe any fact or doctrine, or any god believed in by the church, but that you wish to identify yourself and your will with the will, or the spirit, of the universe. The result is an odd one. When you have been left alone a couple of months, you have invariably got into your head a scheme which no amount of arguing will ever drive out of it. You made up your mind . . . I could do nothing to get the things out of your head. You had identified your will, which resulted from your blood, your bringing up, your thinking, with the will, so to say, of God. Not the devil himself could move you. This makes you wonderfully strong, but also, to most people, dread-fully uncanny. Determination, resolution, endurance, virtue . . . but what does it cost? You won't bend aside. Things must go down before you; you advance to your end in view, pitilessly, though no man is more pitiful, cruelly, though no man is more tender, recklessly, though no man is more patient.[15]

On 13 May, Ned complained of a pain in his right kidney, and decided later in the month to go for a four month's cure at the spa at

Contrexville, south-west of Nancy. He did not stay the full four months. In November, Warren returned to Boston but by the end of the year he and Harry were back at Lewes just in time to celebrate Harry's twenty-sixth birthday.

2

The Wild Rose
and the *Defence*

When he considered the poems, he knew they were not of a kind
with the volumes of minor poems he read . . . But he did not
know what would be thought of *The Wild Rose* in fifty years'
time. Nor could his friends help him much towards a valuation,
since their praise seemed to run mostly on precedent.

Osbert Burdett and E.H. Goddard in *Edward Perry
Warren: The Biography of a Connoisseur*[16]

I have had much happiness in the thought of three things done:
the Bostonian collection, *The Wild Rose*, the *Defence*.

In one of Ned's last letters to J.D. Beazley[17]

Ned changed considerably following his brother's suicide and Mar-
shall's marriage. Collecting was no longer a passion and he said
'cosmopolitans' like Berenson 'tired' him.[18] His interest in writing
verse and Uranian philosophy became a new obsession, and he told
his friend Beazley that the things he was most proud of were the
Boston collection and two of his writings. Few of Ned's contemporar-
ies knew of his writing exploits under the *nom de plume* of Arthur Lyon
Raile. The present-day reader finds *The Prince Who Did Not Exist* and *A
Tale of Pausanian Love* amusing and diverting. However, the two works
of which he was proudest, *The Wild Rose* and *The Defence of Uranian
Love*, are impossibly self-indulgent, diffuse, and in the case of the
Defence, sluggish reading. Ned once asked what readers would think
of *The Wild Rose* in fifty years' time. The answer is grim: most of the
copies remain gathering dust in a trunk in Harry Thomas's attic at his
house in North Chailey. Warren spared no expense in paying for the
1910 publication; his poems were bound in dove-coloured suede
marked with gold letters.

Ned's friends rarely spoke of his writing. Only John Fothergill said
what many of them were thinking. After reading completed portions

83

of the *Defence*, he remarked that whereas Oscar Wilde's *The Picture of Dorian Gray* was 'humorous and fantastic and vulgar; your work has none of these qualities. Therefore you will accomplish nothing by your philosophical writings except to make things uncomfortable for those that know you.'[19]

One who became uncomfortable about the implications of Ned's poetry was Robert Bridges, named Poet Laureate three years after *The Wild Rose* was published. The two met at Corpus Christi College, Oxford where Bridges was made a Fellow in 1895, and where he aided Ned's being elected Honorary Fellow in 1915. As with Ned, few of Bridges's friends knew that he wrote verse, and it was not until his thirtieth year that much of Bridges's poetry was published. For a long while as he prepared for a career in medicine, Bridges lived in London with his mother and long-time friend, Harry Ellis Woolridge. Due to an eighteenth-month illness, Bridges gave up medicine, married (he was 40) and settled down to writing verse. From 1903 to 1904, Bridges corresponded with Ned about the poems which were to be presented in *The Wild Rose*.

In his first letter Bridges wrote:

I have read the poem *Itamos* several times and with increasing admiration: and I feel at home with most of the hymns and meditations. I carry it in my pocket for study at leisure. I find many splendid things in it. But if, as I suspect, your interest is chiefly in the main argument, my general condition of mind may not satisfy you. I hope that you sent me the poem with some confidence that I should appreciate it: as I can assure you that I do, *very much*. It is rarely that poetry has definite philosophical meaning: such a sustained and high-pitched effort as yours is of the rarest.[20]

A year later, Ned reported to Marshall about being with Bridges at his home:

Bridges received him in a casual way I took to be affected: gruff, honest, careless. He is a long thin man with a face not wholly unlike the buttered portraits of Carlyle. He began talking metre at once and for hours . . . stress, accent, the Greek accent, arsis, thesis and bars . . . Much about Blass and the Orators, much more than I understood, interspersed with 'Don't you think so?' and 'Don't you see?' to which I made intelligible rather than

intelligent answers. Then supper, then metre again and a prom-
ise that we should have a big jaw about the poetry on Sunday.
But would I go to Church? he was precentor . . . (Later) he asked
me my ideas of love – he did not know how much to read into
the verses; he understood and had felt romantic passion in
youth. And then suddenly 'what did I think of the sacrament of
marriage?'[21]

In time, Ned had to reveal to Bridges the intent of his poetry, and
Bridges's response was choice and must have given Ned rather a start:

> In your book of poems I think you have really succeeded in
> blending the carnal with the spiritual, and, as I think I said
> before, it is my 'feeling' that they need to be blended in any
> satisfying religion. And this is my sympathy with Greek notions.
> What seems the difficulty to me is that men differ so, and the
> average runs so low, that such a doctrine is not fitted for all and
> becomes esoteric. What the true esoteric doctrine is I don't quite
> know . . . Your real meaning is therefore a great shock to me,
> and among all your enemies you will not find a more stubborn
> foe than me. I wish I could persuade you to confine your *verse* to
> controvertible terms. It would be then of the greatest value in my
> opinion.[22]

Bridges had been charmed by Ned's proficiency in composing
verse so similar on one level to his own, but the intent was another
matter; Uranian love was not to his taste. In the preface to *The Wild
Rose*, Ned explained the significance of the title. Whereas the garden
rose signified the married love in Christendom; the wild rose was the
symbol of the higher love of the Greeks. Without this preface the
reader could never comprehend Warren's symbolism in his poems.
Even then, some of the symbolism remains obtuse. For example, in
his poem *Naiads*, a waterfall is supposed to symbolize the peculiar
mores of Italian dealers in antiquities. There is, however, little doubt
about the intent of some poems. One example is entitled *Lad's Love*:

> Down to the deep
> of sorrowing hope from which thy life arose,
> sink back, my soul, in sleep,
> that youthful dreams may echo round its close;

or deeper still,
even to the fountain of thy youthful dream,
whence the live blood's deaf will
gave forth the end, and loosed the fatal stream . . .

Jest at his word,
the stammering symbol of a faith unknown;
show where the lad has erred;
the truth springs upward from his love alone . . .

love precious now,
the bloom of boyhood and the flush of Spring.
O gentle, flowery bough,
I hang thee on my lintel wondering.[23]

Even omitting a couple of stanzas, it is not hard to see the drift of
Lad's Love. There are a number of these homo-erotic poems. Another
is *The Lover* which involves the 'suffering poet' and was written near
the time when Ned met Harry Thomas. From it we read:

Thus grows
the lover, tenderest of all to foes
he will not shun,
by suffering poet, and the poet shows
that love is won . . .

Eros, abides
until
thou come redeemer momently from ill.
Then, seeing the fair
blossom of youth, though it were born to kill,
'tis his to dare.[24]

In his preface, Ned said that a large number of his poems were 'love
poems written in maturity'. The dedication for *The Wild Rose* was to
J.M. – John Marshall, but as Ned's biographers, Burdett and Goddard,
commented, he was 'not the subject of most of the love poems'.[25] That
was H. – Harry Thomas. Having said this, Burdett and Goddard felt
compelled to add: 'The biographer especially must be wary of precise
personal inferences.'[26] That comment is about as effective as the
judge advising the jury to disregard a provocative statement made in

a trial. The earliest poem of the collection is dated 1882, the latest 1910, but most of the poems were written from 1902 onward – after Ned had met Harry Thomas. The year 1902 also marked the end of Warren and Marshall's collecting, and in one of Ned's diaries he remarked that his health had suffered in the several years up to that period. He also had written little poetry. Then 'the floodgates were burst' as he put it. Burdett and Goddard say the 'relief' came 'soon after the arrival of another and much younger friend' – Harry.[27] The poetry flowed from 1902 until 1906 – the year before Marshall's marriage. Only a few poems came after that and Ned turned his energies back to Uranian philosophy.

Ned always referred to his *Defence of Uranian Love* as his magnum opus. He laboured over it longer than any other writing and it ran to three volumes. Very few copies of it survive. The first volume was printed just before Ned's death in 1928, and the last in 1930. Few of Ned's friends ever referred to the work. Burdett and Goddard said they refrained from criticising the *Defence*, citing 'the author's wishes [his biographer] abstain from a detailed criticism'.[28] Obviously, Ned was aware that his enthusiasm for it was not shared by his friends. Fothergill was the only one with the guts to say just what he thought.

Ned's espousal of Uranian love was hardly new or startling, and by the time the *Defence* made the rounds among his friends, it appeared quaint and reminiscent of Pater's period. Many of those Ned hoped to convert probably agreed with John Addington Symonds's assessment that Greek love 'finds no place in modern life and has never found one. It is a special Greek compound of chivalrous enthusiasm and perverted sexual passion.'[29] What did irritate some of Ned's church-going colleagues was his setting what he called 'a superior Greek masculine ideal (aristocracy, nobleness and secondary position of women) against a Christian feminine ideal (democracy, purity and equality of the sexes)'.[30] Ned argued that his native America had created a predominance of women and stressed the feminine virtues, but the pagan ideal was rooted on Earth and content to make the most of present existence. The Christian ideal was sublimity and not centred in this life and therefore unwholesome.

Ned never discussed moral objections to homosexuality, believing that it 'had its own justification'. Burdett and Goddard commented: 'Isolated by the centuries that divide us from the Greeks, his book remains the lonely monument of a lonely man – but a man convinced of the validity of his contentions and sure that the day would come again when their value might be recognized.'[31] The first part of the

Defence is interesting in that it has an autobiographical basis. Ned wrote of a boy much like himself 'brought up mostly at home, more ignorant of sex than schoolboys, but not callous and commonplace'. He traced the boy's developing sexual philosophy: 'it puzzles him that all extra-marital union must be base and marital union a thing hardly to be mentioned . . . His physical nature is unquiet; but his unquietness condemned by the Bible is symptomatic of the emotion approved and exalted by the Bible which quiet people seem to him not to possess.'[32]

The boy matured and his friendships 'confirm him being what he is, in his tendency, and lead him to exult in the masculinity that he enthrones'.[33] The youth recognized the gentle side to the male as complementary to the strong side, and Ned's chapter on 'Gentleness' evoked what he had hoped would come about at his brotherhood at Lewes House:

> Rough and careless he may be in the things about which women are particular; reckless of flummery and fuss; hater of ceremonies and needless courtesies . . . his home-life has a different colour from that of most homes which women control, but it is, none the less, a home-life . . . The shocks, dissonances and complements of married life are not there to provoke, to fortify, or to annul passion. Men who constitute their own society and yet find love in it, become masters in what women usually count as their own arts, but applied homogeneously; in the suppression of ill-timed subjects of talk, in pretty ways of speech, in personal attentions such as are really wanted. They can speak so as to elicit the personal expression, or forward the embarrassment of an answer refused; their own conversation has its modesties and reticences, its own confidences and silent confidence . . . pandemians, entering this circle, will at once note a warmer atmosphere and perhaps will not like it.[34]

The youth became an adult and the next stage for the boy, who has become the man, was exactly what Ned sought – but never attained. The man became a guide to youth. Ned dreamed of retiring to Oxford as a latter-day Socrates to undergraduates: 'There is no education like that which an [elder] lover can give the young.'[35]

Ned agonized over the completion of the opus. From Corpus Christi College, February 1915, he wrote to Marshall:

Snow all the time . . . I'm glad because I ought to exercise and rest my mind, but I want to do my discourse, and may by permission of the snow. I've been hunting for a part which I had written out, but I think, not well. Further I think it doesn't suit the discourse and that I ought to insert only a paragraph which would cover all that really belongs in the discourse of this matter. My trouble . . . is the mass of Ms. It is pretty well in order and there is a clear idea of the march of my argument. If I didn't have faith in myself, that I have a bit of instinct, I should fear to flop in a morass of words.[36]

Ned's conclusion to his work was brief but definite in proclaiming that the Uranian doctrine, by assigning a high value to masculine qualities, would give authority to man:

The Christians disregarded the Pagans; modern thinkers disregard the Christians. The Greeks disregarded women; we have disregarded men. The theory and conditions of our time are contrary. Our theory is not masculine; men are small units in a nation; friendship is so little understood that we deem ourselves to possess it. What lies behind our thought, our primary assumptions, are unfavourable to the whole Uranian doctrine.[37]

Ned was more than offbeat, and his quixotic *Defence* was as futile as his attempt to create a brotherhood of like-minded aesthetes at Lewes. The saddest feature of both the *Defence* and *The Wild Rose* was that he felt they had brought him 'much happiness'. His friends could hardly agree. Ned might have had faith in himself, but his 'fear' was yet another example of a correct divining of the future: he would 'flop in a morass of words'.

3

Guests in the House

Unlike B.B., neither Warren nor Marshall cared about society.
But there were often guests in the house, Roger Fry, the elder
Rothenstein, Rodin, Oxford Dons, museum men from London,
Cambridge, Oxford or from France or Germany.
Letter from Harold Parsons,
to Henry Sayles Francis, 14 March 1967[38]

During their days together at Lewes House, Warren and Marshall had
a number of friends in common, and following Marshall's marriage,
Ned became closer to a number of them. As with his intimates at
Lewes House, this odd assortment of acquaintances not directly
connected with Lewes, largely refrained from commenting on Ned's
excursions into poetry and philosophy. None was more personally
inclined towards Uranian love than Oscar Browning, the one-time
master at Eton and long-time Cambridge don. Rupert Brooke des-
cribed OB, as he came to be known, as 'a man of bad character and
European fame',[39] and Santayana said he 'openly flaunted the banner
of gluttony and pederasty, neither of them suitable for a teacher of
youth; yet everybody laughed, and the authorities effected a calm
indifference. He was obviously a good soul; kind but club-footed, fat,
self-congratulatory and licentious. His warm affections ranged from
Royalty to the lower decks of the Navy.'[40]

Early in 1876 when Oscar Wilde heard that OB had just lost his job
at Eton (December 1875) because of pursuing good-looking boys like
George Curzon (son of the 4th Baron Scarsdale), he wrote to Brown-
ing asking to meet him as '[I have] heard you so abused that I am sure
you must be a most excellent person.'[41] We do not know when Ned
first met Browning, but he was well known to several of Ned's
friends, including Robbie Ross and Roger Fry. In 1911, Ned made a
special effort to see OB in Rome where he had retired, finding it
cheaper than living on his pension in England. It also appears certain
that Ned gave OB money to help his nephew Arthur when he was
released from prison. This was after Arthur had run away with the

last of the money from a liquidated Browning family distillery in Lewes. Quietly, OB used the money to spirit Arthur off to America.

Despite his well-known homosexuality, OB was popular with undergraduates. He was always accessible and entertained lavishly – far more so than Ned at New College. OB's unpaid bill at his wine merchant amounted to £800. Roger Fry's parents were rather nervous when they heard that their son was invited to OB's Sunday salons at King's College. Fry survived unscathed: 'The rooms are gorgeously furnished and crowded with books (which I don't think he reads) and pictures and silver and gold and china ornaments displayed with, as I think, rather a want of good taste. Still he is, I must say, very kind and most energetic.'[42]

The amazing thing was that OB was able to get away with so much. He openly pursued sailors, and on one occasion Robbie Ross and OB spent 'a merry week-end' on the Isle of Wight with 'the fair sailor, Matthew Oates'. More serious than this outing was the claim that Ross, who was one of Ned's closest associates, had seduced OB's nephew, Philip Wareham. Unaware of Browning's proclivities, Philip's father, the Reverend Biscoe Wortham, wrote to OB: 'Ross is simply one of a gang of the most absolutely brutal ruffians who spend their time in seducing and prostituting boys and all the time presenting a decent appearance to the world.'[43] This charge would haunt Ross for a long time as would his association with Oscar Wilde. Ross was Wilde's literary executor, and his ashes were interred with his old friend in Paris. Ross's name appears often in Ned's papers, and Fothergill wrote that he was one of the few friends outside the Lewes House group with whom he regularly communicated. Ned was quite involved with Ross in the establishment of the Carfax Gallery, and it was Ross who introduced Fothergill to him.

According to one source, 'Both Ross and Wilde told friends that their homosexual encounter had been Wilde's first' (Wilde was 32). Ross said to his close friend Christopher Millard that he felt responsible for Wilde's two sons because he had led their father into homosexual activity.[44] In her recent biography of Ross, Maureen Borland uses Ross's friendship with Wilde's sons as proof that he was never responsible for Wilde's initial debasement. Throughout her book, however, Borland goes to painful lengths to give her subject as clean a slate as possible. Ross's seduction of Wilde occurred in 1886 when Ross was but 17. According to one observer, Ross was 'the only man who ever admitted with any pride to having been Oscar's lover'.[45]

Robert Ross was the son of a former Attorney-General of Canada, but like Ned spent most of his life in England. Little correspondence exists between Ned and Ross, but after John Marshall left, Fothergill maintained that Ross took on a new significance as one of the few of his old associates in whom he could confide. The two had remained fairly close since 1898 when Ned provided the money for John Fothergill, William Rothenstein and Arthur Bellamy to open the Carfax Gallery. The Carfax was far from Ned's usual interests in art, but he went along with Fothergill's desire to have a place where works of new English artists like Augustus John, Walter Sickert, William Orpen, Max Beerbohm and Rothenstein could be displayed. Later Rodin sent a collection of his early drawings and small bronzes. The Carfax Gallery could not have occupied a more central place in the art world at that time, and it was to Warren's credit that he was willing to add much needed financial aid at exactly the right moment. More than Marshall – who basically limited his interest in modern artists to Rodin – Warren recognized there was more to the art world than collecting the best from the past.

Walter Sickert's brother, Robert, was engaged as Carfax's business manager and things went well for a couple of years. Then Fothergill and Rothenstein became frustrated with the business side of the art world, and in 1900 Robbie Ross bought out their interests and with More Adey managed the gallery until 1908 when Ross left to become the art critic of *The Morning Post*. Ross took Ned's side in his estrange-Bosie Douglas. Arnold Bennett said Ross 'had a weakness for looking after people in adversity'[46] and both Ned and Fothergill admired his sticking with Wilde when he was ruined. As a resident alien, Ned must, however, have been rather nervous when Douglas charged Ross as being not only a sodomist but also an anarchist and a socialist. The ment from Marshall, as did Ned with Ross in his many squabbles with Ross Ned knew was complex: on one level, civil and devoted; on another, possessive and moody. Their friendship ran hot and cold. Maureen Borland summarized Ross and Douglas's antipathy well: 'If Douglas was a Jekyll and Hyde character then it must be said so was Ross. And there perhaps is the cause of their quarrels. They were both so alike, spoilt, arrogant, charming, generous, witty and utterly unforgiving of each other's faults.'[47]

On several levels Ross was like Ned: both in later life affected wearing intaglio rings (Ross's was a Renaissance object); both loved

to write (Ross was far more successful and adept at it); both took on the cares and worries of others; both were expatriates; and both were basically unhappy in long-term relationships. In both cases, the last years of their lives were the least fulfilled.

Sir William Rothenstein (Will to his friends) was a frequent guest at Lewes House and wrote the best description of its atmosphere which has been published (quoted earlier on p.45). It appears that he first knew Fothergill and the two studied at the Slade School of Art. Ross and Fothergill were godfathers to Will's son, John. Rothenstein had a varied career: painter, writer, lithographer and Principal of the Royal College of Art from 1920 to 1935. He was the son of Moritz Rothenstein who emigrated from Hanover to England in 1859. After the Slade, Rothenstein studied in Paris where he was influenced by Whistler, Degas and Millet. His skill in portraiture culminated in the production of over 750 portrait drawings and 185 lithographs. Will's wife, Alice, was a former actress and sister of John Knewstub, who ran the Chenil Gallery in Chelsea.

Rothenstein was of the best breed of tolerant intellectuals and when Oscar Wilde was imprisoned, he, like Ross, was among the few who continued to support him. When Aubrey Beardsley was dropped by the publisher John Lane (the two were linked together in the public mind), Rothenstein dropped John Lane. At the sale of Wilde's effects (which were removed by bailiffs from his Chelsea house), Rothenstein purchased a painting by Monticelli for £8 which he then sold, using the money raised to help Wilde.

Robbie Ross seemed touched by Rothenstein's gestures, but the two did not always see eye to eye – and matters worsened since their falling out over the management of the Carfax Gallery. Their disagreements were probably due more to personality clashes than anything else. We are not certain just what Rothenstein made of Warren's obsessive collecting, though, as we have seen, he suggested that some of Ned's purchases had been taken from Italy and Greece 'by hook or by crook, rather, I think, by crook'. It was Rothenstein who introduced Warren and Marshall to Rodin's work, and later he took almost all the credit for Warren's coming to possess Rodin's *The Kiss*.

In the spring of 1897, the French artist, Alphonse Legros, brought Rothenstein, his ex-pupil, to see Auguste Rodin. Rothenstein admitted he 'had long revered Rodin from afar'.[48] He described Rodin as always drawing: 'He would walk restlessly round the model, making loose outline drawings in pencil . . . And how he praised her forms!

93

caressing them with his eyes, and sometimes with his hand, and drawing attention to their beauties.'[49] Rothenstein was certain he could find a market for them in London. Soon with the Carfax in full force, he selected several small bronzes and drawings.

On a subsequent visit to Rodin, Rothenstein learned of his financial difficulties; in part due to the cost of casting his bronzes and the price of the marble he preferred. Rodin's *The Kiss* was then on show in Paris, and Rothenstein thought its pagan sexuality might appeal to Ned. It did, and on a visit to Rodin Ned asked for a replica to be carved to his specifications: Rodin was to choose the marble. Cost was no object. The genital organ of the man was to be seen in its entirety. The work was not to take longer than eighteen months. Warren agreed to pay £1,000 for the work, and the two signed a contract in December 1900.

Rodin confided to Rothenstein that his 'archaeologist is not an ordinary man',[50] and warned Rothenstein that 'accidents' could happen in the execution of the piece.[51] Rodin persuaded Ned to go for a block of Pentelican marble which cost three times the original estimate for the marble. Not only that, it would not be until 1904 that the piece was finished, and the man's genitals though visible were hardly distinct.

A year before completion, Rothenstein brought Rodin to Lewes to see Ned's Greek treasures. Rothenstein recorded the event:

> At table the talk naturally led to the subject of beauty. Warren, like so many archaeologists of that day, believed beauty to be a monopoly of the Greeks. Rodin, who would go into raptures over Greek marbles and bronzes, but was a creative artist first and foremost, getting somewhat impatient with the table talk, said, 'Let me go out into the street, and stop the first person I meet; I will make a work of art from him.' 'But suppose he were ugly,' Warren replied; to which Rodin: 'If he were ugly, he would fall down.' This was beyond Warren, and the talk took another turn.[52]

During Rodin's work on *The Kiss*, Ned wanted to see the sculptor at work in Montparnasse. Rodin said of his visitor: 'I was amused by Mr. Warren's appearance; informally clothed in English tweeds with a Baedecker in one pocket and the *Odes* of Horace in the other, and during the train ride from Meudon reading his Horace like a priest would read his breviary.'[53] Ned bought at least four other sculptures from Rodin. One was a marble bust of Henri Rochefort, the French politician and adventurer, and another was a favourite of Rodin's

himself, *The Man with the Broken Nose*. This was the sculptor's first masterpiece, but was recognized as such only after an initial rejection by the art establishment. On his side, Rodin actively pursued an object of Ned's the Chios Head, a magnificent fourth-century BC head of a Greek maiden once thought to be by the great Praxiteles himself.

According to his biographer, Frederic Grunfeld, Rodin was 'sent into transports of delight when he saw it at the Burlington Fine Arts . . . "All my life I shall remember the definitive impression it made on me the first day I saw it. This immortal bust entered my life like a gift of the gods." '[54] Rodin dictated his reactions to the editor of *Le Musée* in an article entitled *La Tête Warren*. He said that the head was a masterpiece which helped him understand Praxiteles. He had to have her, and a number of letters from Rodin to Ned and Marshall indicate just how far he was willing to go to get the head. In one communication Rodin remembered his visit to Lewes House and despite their slight disagreement, he spoke of the 'common religion' (Greek art) they shared.[55] Earlier he told Ned on 13 August 1903: 'I have found it so beautiful that I have dreamed it belonged to me, and my dream remains always with me. I venture to ask you therefore if you would agree to an exchange – If so, please let me know which of my marbles would please you and perhaps we could come to an understanding.'[56]

A month later, Rodin tried Marshall (whom he came to know quite well). Rodin was pleased Marshall and Warren were satisfied with the progress of *The Kiss*, and was still smitten with the maiden, suggesting a specific exchange of goods: the Chios Head for 'the figure with legs apart in bronze and the marble of the *Danaïde*. Would this combination tempt you or perhaps another?' In this letter Rodin said that as he 'did not know Greece', perhaps Marshall 'would allow me the pleasure of being your companion in the future'.[57] Rodin's last try came the following month, 5 October 1903. Again he wrote to Marshall: 'Among the proposals I suggested in the course of our conversations on the subject of Aphrodite [as Rodin called the head], there is one about which I wasn't able to talk with you and that I am now passing to you so that you can communicate it to your friend, Mr Warren.' Rodin said that if he were allowed to obtain her he would keep her 'only so long as I live, and when I have disappeared it would return to you'.[58]

Unfortunately, we do not have Ned's reactions to these overtures, but we do know the result. Ned did not budge, and the Chios Head was soon to be seen at the Boston Museum where it remains as one of its finest pieces – some critics say its very finest.

4

An Unexpected Air of Domesticity

Just before the outbreak of the Great War, Lewes House took on a previously unknown domesticity. The top floor was turned into a nursery for the two Thomas children and Ned's adopted son, Travis. This novel, and for Ned, unreal experience was slightly alleviated by his return to scholarly pursuits with the visits of another latter-day friend, John Davidson Beazley. Beazley was to become the most important scholarly interest in assessing Ned's Greek collection. It was Ned who started Beazley on his brilliant life-time academic obsession: the iconography of Attic vase painting. Beazley catalogued Ned's vast ancient gem collection in 1927, and wrote the tributes to Ned upon his death. It would be to Beazley that the Warren and Marshall papers would go. He was a remarkable scholar, and as Charles Calhoun remarked: 'It is only a slight exaggeration to say that Beazley invented the study of Attic pottery.'[59]

John Beazley was born in Glasgow in 1885, and at Balliol College, Oxford, he took Firsts in both Classical Moderations (1905). Three years later, he was tutor of Classics at Christ Church, a position he held until 1925 when he became Lincoln Professor of Classical Archaeology. Six years earlier he had married Marie Bloomfield, who according to Martin Robertson (author of a biographical piece on Beazley) 'devoted her powerful personality entirely to serving her husband and his work. She learned to photograph vases, took over the practical side of his life completely and was his guardian dragon.'[60] Marie paid a high price for her devotion: on their wedding day after greeting the guests, Beazley went off to do some research at the Ashmolean. Harold Acton was extremely close to both, and travelled to Spain with them. He says Marie mothered Beazley who was 'an impossible purist and hypercritical'. C.M. Bowra described how Acton first encountered the Beazleys:'[They] kept a goose at Christ Church, and one day Mrs Beazley was exercising it in Tom Quad. Between them they more or less filled the path, and when Harold

came in the opposite direction, he not only jumped over the goose, which was to be expected, but at the same time took off his bowler in salutation, and Mrs Beazley knew that he was a true gentleman.'[61]

Bernard Ashmole, who in 1956 succeeded Beazley as Lincoln Professor, once remarked that Ned envied Beazley more than any man he had ever met. Beazley was the academic success Ned could never become, and his life appeared remarkably free from emotional stress. The vital ingredient, of course, was Marie; something Ned never could realize. They had no children, and when Marie died in 1967 he never recovered and further isolated himself from his former associates. He died three years later. Beazley's monumental achievement came from a love of things Greek, which he always said was initiated by Warren and Marshall. He wrote of Ned: 'Greek art to Warren was not one art among others. It had a nobler beauty, and represented a civilisation more masculine and in some ways greater than our own. He thought that America had special need of what the Greek art could give.'[62] Beazley took the two collectors far more seriously than did other academics at Oxford. He also recognized that 'Warren did not consider himself an archaeologist. Marshall was the archaeologist, and it is certain that Marshall was the more learned of the two.'[63] Beazley regretted the fact that Marshall 'wrote so little, for he was one of the acutest and most experienced archaeologists of his day'.[64] For a serious archaeologist not to be published was more than a personality quirk. He knew Marshall was 'too critical' and consumed by the business of purchasing. As a result of their combined efforts, Beazley said Warren and Marshall once had 'complete control of the market in classical antiquities. Almost everything that was good, whether a new find or an old, came to [them] for the first refusal. Competition had all but ceased.'[65]

While Ned entered the domestic phase of his life, and Marshall ran helter-skelter over Europe chasing down new treasures for the Metropolitan, Beazley perfected his study of Greek vases. He was able to sort out almost all extant Attic vases of his day – running into several thousands – and ascribed to them individual painters and schools. According to Bowra, he did this so thoroughly, 'it need never be done again'.[66] Today, some classical scholars have reacted against Beazley's domination of the field and suggested that he 'overdid the whole thing'.[67] This reaction sounds rather like sour grapes considering Beazley's monumental effort. Without the aid of cameras and computers, he made hundreds of thousands of drawings of what he saw in various museums and private collections. Often he was not

allowed to make sketches of what he saw, but he was not put off and memorizing what he viewed, went outside and immediately put it on paper. Not only that, Beazley developed an encyclopaedic knowledge of the relationship of various vases and fragments from Rome to Heidelberg.

Bowra said of Beazley that he never 'put on airs of a great man'[68] and was always willing to answer endless queries from other scholars. Unlike Berenson he never charged a fee when answering requests for authentication or attribution. If Beazley had not entered Ned and Marshall's lives, even less than is now known of their collecting achievements would be recognized. At Oxford, they were often viewed as overly wealthy collecting dilettanti; Beazley helped redress the balance. He only partially succeeded, however. Their copious notes and correspondence were dutifully kept by Beazley and his successors – but they only gathered a great deal of dust.

Nevertheless, visible memorials remain at the Ashmolean Museum of the days of Warren, Marshall and Beazley. In 1966, Beazley presented 800 objects to the museum, and had already given 400 previously. These were largely Greek vases and fragments. Ned's benefaction was not quite so numerous; it numbers about 110, and many of them are also fragments. As Michael Vickers, Senior Assistant Keeper at the Ashmolean says, 'What Warren seems to have done was to put the Ashmolean's way, material which was not thought to be quite up to scratch for the Boston Museum.'[69] Some of the material, however, is significant: in particular, a beautiful hydria (with a rather 'camp' bridal scene in which bride, attendants and Eros are fanned by two beautiful nude youths), and also one of the most perfect fifth century bronze heads in existence.

The most bizarre – and perhaps forever unresolved – aspect of Ned's latter days was his adoption of the boy, Travis. Mrs Warner and the rest of the Lewes House staff assumed – and were led to believe – that 'Mr Warren' had 'adopted' any number of Lewes's youth. In 1911 (the year he adopted Travis), Ned wrote:

I have often given thanks to Papa, especially when the money that he earned enables me to make a gift. I wasn't good to him when he was alive but he was big enough to pardon me, and I have done amends since his death . . . I have had the pleasure again, due to Papa, of planning the further training of a boy whose expenses at school I have been paying, of sending money

for a second boy, of settling some matters with another; the third case; of hearing from a fourth and from a fifth who will take his place. This education, which some think good of me and others foolish, is neither the one nor the other.'[70]

Oscar Burdett maintained there was seldom a time when Ned was not paying for the expenses of five or six young men.

When Ned died a large number of Lewes townspeople paid tribute to his generosity to local youth. It was, however, Travis Warren, upon whom Ned showered the most. According to Mrs Warner, when he first appeared on the scene, in 1911, the staff was given the impression that Travis was French. Ned had just returned from Paris, but it was not long before they realized the 4-year-old was English. Ned never told anyone in Lewes about Travis's background, and to this day even his sons do not know the full story. What has surfaced is that his mother was Muriel Murley, daughter of the vicar of St Day in Cornwall, who was sent to Paris by her parents to have her illegitimate child. St Day was a tin-mining town with only two families of any importance: the Murleys at the vicarage and the Williamses at Scorrier House. The Reverend John James Murley was vicar from 1891 to 1912, and in parish records he complained that during his tenure fortunes were made in the local mines by a group of outsiders – 'adventurers' who subsequently became important in the county. Often Murely spoke of 'the curse that came upon us'.

Father Murley was a strong figure, high church and authoritarian. They had independent means so were able to take care of Muriel's predicament. According to one story, she was seduced by 'a member of the landed gentry' who taught her to play the piano. Who he was is still a mystery as is the means by which Warren ever came to adopt Travis. Harry Thomas's 1910 diary shows that both he and Ned were in Paris on several occasions during that year, and the entries suggest that those visits had nothing to do with collecting. Locating any adoption records in Paris or elsewhere has been fruitless, but Ned's will stated that on 31 October 1911 a deed was drawn up between him and Muriel with the provision that in the event of his death, Harry Thomas, Osbert Burdett and Reginald Schiller would be Travis's guardians.

Mrs Warner remembers how Ned indulged Travis. One Christmas he had his furniture restorer, George Justice, create a huge Noah's Ark with hundreds of animals to amuse Travis; a year later the music room was turned into a pirate ship. Justice also made the boy an

elegant Neapolitan-style donkey cart, but Travis wanted to ride the horses like the grown-ups. At the age of 6 he was taught how to ride, and told his own sons that when Rodin's *The Kiss* was kept in the stables he carved his initials in the foot of the man.

Up until his death Ned corresponded with Muriel who apparently pleaded with him to let Travis learn a trade. That proved far-sighted as Travis did not take well to the high-flying education his foster father provided for him. After Summerfield preparatory school, Travis was enrolled at Winchester College which was much too academic for his abilities and he transferred to Tonbridge School where he did a bit better. When he was 18, Travis followed Ned's wishes to study music at Leipzig where Perabo had been a student, but achieved little except a good command of German which would become useful later.

On 26 May 1928 (six months before Ned died), Travis was 21 and a rich young man. Ned's will, however, placed some restraints on Travis's use of his inheritance. He was left an income of £3,000 annually until he became 28. Then he would receive $20,000 and $200 monthly with the right to invest $30,000 more when he became 32. That was as stated in the will; only if in the opinion of Harry Thomas and Osbert Burdett, Travis 'showed sufficient business acumen'. Even with that generosity, Travis was displeased. He never could understand the preferment given to Thomas, and later told his sons that he should have received The Shelleys, the great house not far from Lewes House to where the Thomases eventually moved. When he was 21, Travis tracked down his natural father in Cornwall and wrote to him. That brought a response from the man's solicitors denying the paternity claim and a stern warning that if Travis persisted he would face a law suit. The threat worked and Travis never divulged the identity to his sons. His third wife who lives in Australia claims to know the truth – but she will not tell.

After Ned's death and sale of Lewes House, Travis moved to an expensive hotel in Brighton but soon found his capital running low. In Brighton, he met Dorothy Pienn, a beautiful usherette at a local cinema. They married and had two sons: John who became a missionary in the Philippines and Perry who lives in Devon. After divorcing Dorothy, Travis married Margaret Hailey and they had one son, Fiske, who now works for the Church Commissioners. Margaret died in 1968, and Travis remarried but had no children by his third wife. During the Second World War, Travis was in the Royal Air Force and because of his command of German, he was posted to Egypt and Ethiopia to decode messages.

After the war Travis became an electrician and was particularly proud of having installed the speakers at Truro Cathedral. According to his sons, he was always aware that he was not the success Ned would have wanted. However, he was good at sports and loved to ride on the Downs. His sons were better students and all three were educated at Tonbridge School. Travis died of lung cancer in May 1978 at Fareham in Hampshire. Apparently, he held on in the hospital just long enough to speak to his half-sister, Barbara Wheatley (Muriel's daughter by marriage to Reginald Wheatley). She knows the full story of Travis's origin, but to this day keeps it to herself.

When Travis became older and was away at school, Ned turned his interests again to Oxford and spent long periods there. During the First World War and following, he had rooms at Corpus Christi College. His old dream of a Hellenic brotherhood took on a new dimension and he wrote that the 'monastic seclusion of Oxford might become the best atmosphere for the encouragement of the Hellenic ideal'.[71] That ideal would 'foster real sympathy and love between the younger and older', and as always he was determined that 'women should be kept out'.[72] Now that his experiment of an aesthetic brotherhood at Lewes House was only a memory, Ned began to discuss various plans for something like that at Oxford. He shared his ideas with a number of Oxonians and H.A.L. Fisher left his view on one of them:

> [Warren] had been impressed by the lack of post-graduate work in Oxford, and with characteristic audacity set himself to repair our English deficiencies. His plan was to found in Oxford a graduate college on some such model as that which has since been so brilliantly established at Princeton. He used to talk about this scheme with his friends and infected them with enthusiasm for his idea. His plans were laid. He had set his heart on the acquisition of a site beyond the Cherwell, nearly opposite Magdalen, and there at his own charge was determined . . . to build a new palace for research. After consulting Alfred Robinson (at New College) he settled the price he was prepared to offer and beyond which he did not think it worth going. He was, however, outbidden by a wealthy and powerful foundation, [the new buildings of] Magdalen College now stand upon the site which might have been the Warren Graduate College. This rebuff disgusted my American friend.[73]

Ned gave up that idea, but his long-time friend Thomas Case, President of Corpus Christi, who was always alert to generous benefactions, pushed Ned towards another solution. Case's idea was the revival of a praelectorship in Greek. As neither Case nor Fisher fully grasped, Ned had specific ideas in mind. He outlined his idea of a praelectorship in, of course, Hellenic terms: he was to be a Fellow of Corpus, but not an ordinary Tutorial Fellow. He was to do a limited amount of teaching so as to have time free for his own research. But his main job, however, was to take a friendly interest in undergraduates. Ned insisted that his praelector must be a bachelor who would live in college. When the governing body insisted that married men were also eligible, Ned stipulated that a married praelector was to live in the Aedes Annexae, houses within a short distance of the college, and was to have his house connected to the college by means of an underground tunnel. The tunnel was never built and due to the slump in the stock market at the time of Ned's death (the beginning of the Depression), the value of his shares plummeted. No appointment to the praelectorship was possible until 1954. The first holder of the position was Hugh Lloyd-Jones who says he was 'supposed to connect with the young men as Socrates did with the young Athenians. I don't think I could quite manage that; I was a kind of Senior Research Fellow . . . Clearly the praelector was an image of Warren himself as he was during the first war when Case gave him rooms in college.'[74]

E.H. Goddard said pretty much the same about Warren. He would have been the best praelector, and in a small way he had 'tried to realize the ideal when he moved into Corpus Christi in 1915'.[75] Ned was not allowed to teach in a formal fashion, but he certainly had his following among the undergraduates. His practice of inviting them to his rooms raised a few jealous eyebrows, since he was able to entertain in a fashion unknown to dons on very limited salaries. Ned's being made an Honorary Fellow in 1915 was a major triumph in his life but it had met some opposition in the college. In the eyes of some dons and Fellows, he did not have the usual academic standing for such an honour, and they viewed the election as recognition of his financial benefactions to the college. Ned turned a blind eye to the criticism, and though he was grateful for his 'rather Spartan rooms' at college, he told his friends he 'longed for the panelled rooms above the Gateway'. Ned said they were not available, but 'none of the Fellows, Honorary or Ordinary, would have graced them as well as I'.[76]

Ned was tolerated as an oddity at Corpus Christi. Fothergill described him at this period as 'with a big head, a long body with a neat paunch. He had been very good looking but now his face was rather dogged.'[77] He had also developed a habit of yawning in public which amused the dons. Ned had little time for many of them whom he described as having few interests outside their special fields: 'It was inconceivable to me that dons who had the good fortune to live amid the beauties of the most beautiful city in Europe should be blind to art.'[78] They were particularly amused by Ned's oft-discussed idea of purchasing some land adjoining the Corpus Christi playing fields as a reserve for bathers. Ned had said that swimming 'afforded the one opportunity under modern conditions for the display and exercise of the naked human body, and for something like the atmosphere of the [Greek] Palaestra'.[79]

An interesting view into Ned's days at Oxford was given by George Santayana whom Ned had known through Bernard Berenson at Harvard. Santayana and Warren had corresponded over the years, and in 1919 Robert Bridges tried to induce Santayana to settle in England. Santayana was tempted as he 'loved England only too much', but he was nervous that he might lose his 'philosophical independence' by settling down in Oxford. Corpus Christi College was familiar to Santayana not only because of Ned but also through the English pragmatic philosopher Ferdinand Canning Scott Schiller who also had rooms at the college. In his autobiography, Santayana said Ned 'always invited me to his rooms, where we might be *tête-à-tête* and discuss Boston and other subjects'. Bridges induced the authorities at Corpus Christi to invite Santayana to a luncheon where hopefully they would also recognize his potential significance to the college. Santayana said that apparently he had 'passed muster' because in a few days Warren was sent 'with a confidential communication' to sound Santayana out on the subject of residence in Oxford. Would he like to become, for life, a member of the High Table and Common Room at Corpus? As Santayana put it:

> For the moment, and during the war, they could let me have rooms in College, but in normal times all their rooms would be needed for undergraduates, and I should have to live in lodgings. When I politely shook my head, and gave merely civil reasons for declining, Warren asked – so little did he or the others understand me, – whether I should prefer to teach. Oh,

no: I had never wished to teach. I had nothing to *teach*. I wished only to learn, to be always the student, never the professor.[80]

Later Santayana admitted there were other 'far more decisive reasons' for not accepting the invitation. If at the time he had had more money he 'might have been seriously tempted to accept: but not at Corpus'. He did not like the idea of being 'ushered in there, as it were, by Warren, a Bostonian, with Schiller every day at dinner, as my only other friend'. Santayana said they were 'both individuals that a novelist might like to study, interesting cases; but to be sandwiched between them as if intellectually I were such another tramp . . . would have been a perpetual mortification'. Santayana found Schiller particularly hard to take, but of Warren he said: 'Warren was unfortunate, yet I objected to him less than to Schiller, because I pitied him, and our connection with Boston was a true link.'[81]

That was the last link we have between Warren and Santayana who, of course, went on to spend highly fruitful days in Rome. In his memoirs, Santayana intimated what others at Oxford expressed more directly: Warren's obsession with his Hellenic ideal was something of an embarrassment. Oxford maintained its hold on Warren but it was an Oxford seen through his eyes: 'If there was anywhere in the modern world that Greek masculinity could still find its devotees, it was there' – with young men working and thinking under the supervision of older men; with the games and what Ned termed 'the unsophisticated worship of physical health'.[82]

Ned disdained the 'invasion' of women in Oxford in the 1890s; he was disgusted by what he viewed as a 'landslide' of the opposite sex after the First World War. E.H. Goddard said the post-war Oxonian 'did not quite know what to make of this American'[83] and perhaps even Ned was beginning to see (if not accept) the observation Goddard also made that: 'There is in the modern world no place which can be, or probably should be, the home of the Greek Idea.'[84] Even Ned's modification of an endowment of his dream of Oxford, the praelectorship, would not be effected in any sense until twenty-six years after he died.

PART IV

*John Marshall's Story –
Life without Puppy*

1

On His Own

Dear Johnny,

Johnson says that you were at Marseilles; so you may be in Paris. I hope you are coming here, not for the month proposed, but for the summer, and above all that you don't plan only a few days and a speedy return to Rome. I have everything arranged for every contingency except an absolutely sudden arrival here. Therefore I should like a wire from you a few days before and a letter to let me know what the contingency will be. I know that you will adapt yourself to anything, but, if the best for which I hope is true, I should much prefer to begin as we are to go on, Travis, you and I for some days, now (or later). I hardly hope that you have left Rome for the summer. If you have, do wire me the news at once.

Your

Puppy

<div align="right">Letter from Ned Warren at Lewes House
to John Marshall, 4 May 1914.[1]</div>

After a short time at Lewes House, John and Mary Marshall settled in Rome. As a bachelor Marshall had had several flats there, and they all were near the Spanish Steps in order to be near the dealers of Via Margutta and Via Sistina. The last establishment which he shared with Mary was the finest and – as always – made possible by Ned's generosity. Augusto Jandolo described it as 'one of the most beautiful in all of Rome'.[2] Bernard Ashmole visited the Marshalls often there and said the setting was 'literally overhanging the Spanish Steps . . . and less than a stone's throw away from the Hassler [Hotel] where they welcomed many guests'.[3] The flat was filled with antiques and classical antiquities and a large pet crow roamed freely in its rooms. That was at the beginning of the marriage. Later, Mary insisted that her husband place his pet in a large cage in his study. Ashmole liked Mary and said she was 'the gentlest of people, but full of character and of independent interests'.[4] That was in print. He later confided to

me that she was extremely neurotic, rather possessive and 'a bit unsure as to how Ned was going to fit into Johnny's future life'.

Marshall's estrangement from Ned was odd. Though Ned told friends that their 'common ideal' had been betrayed by his marriage, he readily supplemented Marshall's meagre income as purchasing agent for the Metropolitan. Dietrich von Bothmer says that Marshall was a salaried member of the Met's staff and had 'complete authority to initiate and conclude purchases for the Museum out of his annual appropriation',[5] but the records indicate that that could not nearly cover the kind of lifestyle the Marshalls set for themselves in Rome. It was Ned who made their Roman existence so attractive. Meanwhile, in his letters to Marshall, Ned appeared to be waiting back in Lewes for his friend to return somehow or another. In these letters he almost never mentions Mary.

Despite what was a virtual marriage of convenience, John and Mary established a brother/sister affection towards one another, but the real strength came from eighteen successful years together in the collecting business. Mary had an extraordinary ability for organisation which was her husband's fatal flaw. It was Mary who directed most of the communications to the Metropolitan. John found it difficult to come to the point with Robinson. In the stacks of letters at the Ashmolean there are endless variations of the same letter. I once counted twelve attempts at beginning a particular communication to Robinson. Mary took her husband's ramblings, asked him exactly what he meant, then cut that down to size and sent it off to New York.

Those who knew Warren and Marshall well found Marshall's marriage curious, Berenson wrote to Isabella Gardner: 'Mrs Molly Osgood Childers came the other day, and told me that John Marshall had married Ned's cousin! Poor Ned!'[6] Marshall's letters to Ned were a mixture of feelings that nothing had really changed and regrets that he had not always been terribly useful when they had lived together: 'When I am away I am always dreading that you may some morning discover how little I really did at home [Lewes House] . . . I often dread that some day your eyes may be suddenly opened.'[7]

On 23 July 1909, Marshall wrote to Fothergill after he and Mary had put the finishing touches to their flat, saying he had heard from Ned 'who seems happy'. The reason was that Mary 'consents to the *putto* and I if it will make him contented'. Then Marshall added: 'But the baby will, I fear, have some of Youngman's blood in him, and that does not promise well.'[8] Youngman, of course, was Ned's lawyer at the trial and apparently a distant relative of Mary's. Marshall never

liked him and felt that the action against Sam was partially due to Youngman whom he considered 'over-zealous'. This is an extraordinary letter but coupled with a similar note in Marshall's 1909 diary we learn that a baby (half-Bliss-Warren and half-Marshall) was considered a blessing for all'. Ned liked children and two years after this letter he adopted Travis, and in the future treated Harry Thomas's offspring as his own. Mary Marshall, however, soon put stop to any idea of a Marshall baby. The idea of pregnancy was distasteful to her' and her general hypochondria was well known. Mrs Warner describes Mary as totally dependent upon a nurse whom she had by her side throughout her days at Lewes House; and presumably in Rome as well. Also, according to Bernard Ashmole and John Fothergill, it appears unlikely that the Marshalls had any sexual relationship at all. Interestingly, in the same letter to Fothergill, Marshall mentioned that Harry and Nan Thomas were 'settling down well' at Lewes House. Their children, though, were not born until 1912 and 1914.

Nothing more was said about the *putto*, but Ned wrote to friends that he did not expect Marshall to stay long as the purchasing agent for the Metropolitan Museum. He gave the enterprise 'five years to run by which time the strain . . . would have told irrevocably on Johnny's health'.[9] Ned was wrong about the five years but not about the health hazard of the collecting; Marshall stayed with the job until his death. As noted earlier, the Marshalls and Ned shared a common hypochrondria, all three of them spending much time at the spa at Bagni di Lucca, north-east of the ancient city of Lucca in Tuscany – and it is there that the three came to rest in a common grave. The Marshalls rented rooms at the Villa Buonvisi which was directly above the old thermal complex used to cure arthritis, neuritis and rheumatism. Mary complained of the latter; John of liver ailments he attributed to too much rich food and drink during his days at Lewes House.

Berenson once joined his doctor there, describing it as 'a delightful summer resort of the days before Switzerland was discovered, a resort frequented by Byron, Shelley, and many others famous in song and story. It is not particularly high, yet hilly, thickly wooded, refreshingly watered, beautiful to look upon and enchanting to drive through . . . Would it were peaceful, but although the season has scarcely begun, it already is pandemonic.'[10] During those days, Bagni di Lucca also had Europe's first legal casino, roulette being invented there. The Villa Buonvisi was once graced by James Edward Stuart (King James III to the Luccans) and his wife Princess Maria Clemen-

tina who suffered from excruciating headaches. In the Marshalls' days, the villa was noted for its excellent cuisine, ready access to the healing waters and hospital-style beds. It was also expensive: rooms cost £7.50 a day.

Despite Marshall's complaints about poor health, Ned was surprised by his friend's new success at collecting. Though he and Mary spent much time at Bagni di Lucca, even there, interesting pieces were brought to them. Marshall's reputation among dealers remained strong and he was able to deliver important objects to the Met, thus developing a good relationship with its president, John Pierpont Morgan. To his death in 1913, Morgan's appetite for art was insatiable, and in Italy, Morgan, nicknamed *il Bobo Morgo*, made triumphant progresses through villages with impoverished aristocrats scouring attics for treasures they hoped would attract his attention. Generally, Marshall was able to please Morgan, but his friend, Roger Fry, was to have a stormy tenure at the Met as curator of paintings. Fry wrote to his wife that much of the collection of paintings was a nightmare: 'The blatant forgeries done by any hack Royal Institute man that [dealers] could lay hands on are enough to make you stagger, and all these things have been accepted without a murmur.'[11] Fry's view of Morgan was that he behaved like 'a crowned head and everyone else behaves accordingly'.[12] He was 'the most repulsively ugly man – with a great strawberry nose'.[13] Morgan thought he could 'Amercanize' Fry, and Fry did admit to Marshall that he enjoyed the power and excitement of his new home. Eventually, Morgan's practice of buying pictures for the museum without troubling to consult his curator became too much for Fry and he returned to England without his contract being renewed.

Marshall was well aware of these difficulties – and very nervous because of them. Fortunately for him his immediate superior, Robinson, was able to handle Morgan far better than had Fry. Morgan was also less inclined to take much interest in the purchase of classical antiquities. Marshall wrote to Morgan on several occasions and one letter gives an indication that the great financier must have taken Marshall's suggestions seriously: 'Here are photos of a large and magnificent bath in Pavonazzetto. Till last week it stood in the Colonna Gardens, near the Temple of the Sun, and must have belonged once to the Baths of Constantine.' Marshall went on to describe how the piece could be accurately restored and that 'the whole seems to me a grand ornament such as is very seldom found'. It was offered at 30,000 francs – 'a very good price'.[14]

Soon after the Marshalls married in Boston, in 1907, John wrote to his friend Hauser, the archaeologist, that he had

> had very little time to attend to business, but went, however, to Mr Morgan's office. This was in the middle of the bank panic. There were several 'financiers' waiting for him, and his secretary told me he had been up that night till after 4 o'clock at a conference about the panic. He would be in a bad temper. I did not ask to see him, but went in to Mr Laffan (an assistant), who told me that to talk at that moment about Greek art to Morgan 'would be like discussing metaphysics to a man in a runaway balloon'.[15]

Undoubtedly, the most exotic episode in the Marshalls' lives at 25 Via Gregoriana was their involvement with Rodin and the Duchesse de Choiseul. Biographers of Rodin have learned much about this episode from the letters and observations Marshall left. Some reading between the lines, however, is necessary to get the full flavour of the characters involved. Unlike Harold Parsons and John Fothergill, Marshall was not a very good storyteller.

Mary Marshall took an unusual interest in the bizarre lady, perhaps because they shared real and imaginary poor health. The Duchesse de Choiseul was born Claire Coudert, the daughter of a well-known New York lawyer of French extraction, and she acquired her title by marrying the Marquis (later Duc) de Choiseul, in New York, in 1891. The Duchesse has been roundly damned in many accounts as 'rich, wildly amorous and demanding . . . She was destined to unsettle the peace Rodin sought in his advancing years . . . She was squat, heavily painted, noisy and alcoholic . . . She was an international tramp.'[16] Those are but a few observations. For her part, the Duchesse declared herself to be Rodin's 'Muse'. If so, she was a rather inebriated one since she was apparently drunk during half her waking hours, and her relationship with Rodin alienated the artist from most of his most important friends. The affair came to an abrupt end in 1912.

It is unlikely that the Marshall knew much about this, and John Marshall is quite sympathetic to the Duchesse as he generally was to Rodin. Two years after *The Kiss* was finished (1906), the Duchesse was in charge of Rodin's Paris sales and had 'put all his money in the bank and made sure that he shall have money in plenty during his old age'.[17] Six years later, Rodin was doing better financially, and he and the Duchesse were in Rome visiting the Marshalls:

Rodin arrived to-night from Genoa, Madame de Choiseul with him. They came here, but the lady being very ill, they went for the night to rooms I had engaged at Hassler's. I fear they will hardly stay there, for she seems accustomed to luxury. She is a fascinating talker, and told of her visit to the Pope [Pius X] during her last stay in Rome, in an inimitable fashion; the mistakes she made in etiquette, how the Pope patted her cheek and how she actually asked him to make a certain priest a *monsignore*. The Pope hesitated, but she wasn't a bit scared and pressed her case. He said he would do it if Monsignor Bisleti recommended him in writing. 'Oh, yes, he'll do that' (and he did, that very day). How the Pope in talking held out his hand to her, and she, thinking he meant her to kiss it, did so. Thereon he laughed and stroked her cheek. The interview lasted 20 minutes and the Pope told her to come again. She described the rooms, the furniture, the attendants, everything in a wonderfully vivid way. Bisleti asked her what she thought of his Holiness: she answered that he was like a great slice of white bread: meaning plain, white, and wholesome . . . After talking like this for an hour, she suddenly got up, rushed to the W.C. and vomited. Then came back and began again. It was a wonderful exhibition of talk. Rodin sat listening to her and enjoying our appreciation of her. When she returned to talk, she said in excuse that she had had the Caesarian operation performed on her seven years ago, and that ever since she has been unable to retain anything she ate for more than a few minutes. She eats, she says, every hour of the day, and is always hungry. But not a bit can she retain. At night she runs danger from fainting fits and cannot be left alone. Well, that is Madame la Duchesse de Choiseul: small, very thin, and evidently once a beauty. Rodin had to play second fiddle to her, and evidently liked doing it. He was delightful and simple as ever: but she, I fear, is too gay a bird for this cage. She says that she means to go to the Vatican again and I hope that she will take one of us when she makes her visit. But, unless she knows where the W.C.'s are in the Vatican, she had better fight shy of that coffee. Mary acted admirably and, in spite of the Duchesse's reputation, was fascinated by her . . . There is no question about it that she is quite devoted to Rodin; and he is like a big baby with her. She has managed, so she tells Mary, to get the French government to grant him the *Hôtel Biron* for life . . . Rodin sent me a small bronze – the only one made – of a dancing woman. I

112

had it mounted, and it was in the middle of the table as we dined. The only mistake was that there was hardly enough to eat: we had not reckoned upon the Duchesse's abnormal appetite.[18]

A few days later, the two returned for another call. The Duchesse had seen a doctor the Marshalls recommended and was told there was nothing to be done for her but to go into a sanatorium for some months: 'The life she was leading was bound to be fatal; the end would come suddenly; she might go off any day. She listened to him and then acted as before.' The Duchesse had gone out to lunch at Count Primoli's and was disgusted as '20 people asked to meet Rodin'. Mary made her some mulled wine and then they all went for a ride. Apparently, that helped as 'she grew sleepy' and later at supper ate well, and 'talked brilliantly all the while'.[19]

Towards the end of their stay, Count Primoli and his friends got their wish to meet Rodin, and following that the Mayor gave a tea in his honour in the Capitol. Marshall related how the Capitol

was all lit up for him: both Museums and the Senator's Palace. Plants all over the place, a very fine buffet and God knows what. The Mayor took Mary and the Duchesse around while Rodin was with a number of other men very anxious to talk with him. I went with one group, then with another, feeling a bit out of place. Rodin stands flattery very well and he got a lot of it, but after an hour we left down the grand staircase accompanied by the Mayor. The Mayor said they never lit up the Capitol save for very important visitors. Also he made himself specially amiable to Mary, whom all the servants thought to be the Duchesse, somewhat to the Duchesse's annoyance. Mary might have been the queen herself, the way she went round. The Duchesse is very small, hardly dresses elegantly, carries too many jewels, and is best when she speaks French. Mary beats her hollow, because she is always simple and graceful and never tries to be witty. For once in her life the Duchesse was outshone; but she took it prettily, and made afterwards some compliments to me about Mary's manner which were pleasant to hear. At 7.30 supper, and then to the station where there were a few people to see him off. He left calling me John (which he can't for the life of him pronounce, and cannot write however often he tries: the 'h' is always in the wrong place). I have great admiration for him as

113

a man. He is good, good tempered, amusing at times, likes long silences, is very strict in his food, scarcely touches wine, is generous in his praise of others, looks like a great lion, speaks when he wants to speak with great precision, loves simplicity and honesty . . . She leads him a life at times, I think, but he recognises her devotion and repays it fully. It is beautiful to see them walking together, like father and daughter, or husband and wife. She did not want to come to us, fearing that we might not understand her. He said to her, 'Marshall is my friend, I am sure. Just go and treat him and his wife as though they liked me and they will recognise what you are.' Well, it all turned out so: both Mary and I have had a splendid fortnight, and have made them, I think, pretty happy.[20]

Two years later, there was another recorded meeting of Rodin and Marshall. By then the relationship with the Duchesse was at an end and Rodin arrived with the mistress of his youth, Rose Beuret.

It was on 12 November 1914 that Rodin and Rose stayed with the Marshalls. Rodin told reporters: 'I have come to Rome because I must find a place to work . . . It is impossible to work in Paris or in London, for the barbarians are too near.'[21] While he was in Rome, Rodin sculpted a bust of the new Pope, Benedict XV. He had wanted twelve sittings but got only three, but he was pleased with the result. Marshall carried the fragile clay bust, uncrated, to the railway station for him, and Count Bori de Castellane, who happened to be on the same train, says in his memoirs that 'as a favour to Rodin, he held the bust in his arms "like a holy relic" during the entire trip to Paris.'[22]

Records at the Metropolitan Museum indicate that Marshall was instrumental in the museum's acquiring a large number of Rodin's sculptures. In 1917, a special Rodin gallery was opened, but due to the distaste the sculpture evoked the art pages of the *New York Times* were silent on the event. Thomas Fortune Ryan, a well-named and self-made entrepreneur provided $25,000 for purchasing Rodin's work, which he came to champion. On 6 January 1908, Marshall wrote to Robinson that he had spent three mornings with Rodin at Meudon and had seen 'much of his recent work'. Marshall wisely stated that the museum was 'sure of getting good pieces if it makes a selection from his works now, while he is still alive, instead of waiting – he is now in his 68th year – until his works be divided up between the state and a few dealers: also, what it brought now would be much cheaper'.[23]

Marshall gave a list of twenty-four possibilities and presented his personal choices. He even made a photographic catalogue of what he was shown and was not reticent about pushing several favourites. He loved the *Grande Baigneuse*, a charming figure by the sea which could hardly arouse antagonism. His comments on the model of the *Triton and Nereid* indicated his proclivity for Rodin's sculpture which followed classical form: 'It is one of his most attractive works; it challenges no one; has nothing eccentric. The front of the Triton is absolutely antique in the modelling; the girl is free and rigorous; the grouping decorative from every point, and the whole work might easily pass for some Hellenistic monument.'[24]

During the period between the two world wars, Rodin's sculpture was considered by many critics to be old fashioned and sentimental, but a more objective interest came in the 1950s and since then his work has been favourably reassessed. Marshall had been clever in going for the sculptures at exactly the right time, and the Met was far-sighted in agreeing with him.

2

'The Most Outrageous
Forgeries of All Time'

Marshall once admitted that the two pieces he was most disappointed
in not obtaining were the Ludovisi Throne and the Stroganoff Athena.
There is a longer correspondence about the latter in his papers at the
Ashmolean than on any other item. Marshall agonized over the
developments and we can see how this wore down his health. At one
stage he was competing with the Berlin and British Museums and
Carl Jacobsen. He was depressed that Robinson dragged his heels
about the Athena's price – in the region of £150,000 which was small
compared to what Morgan was willing to pay for a painting which
caught his eye. Marshall did not want the Athena to go to Jacobsen (for
whom he maintained a dislike after the Ludovisi fiasco), so he wrote
to the British Museum: 'I have wired Robinson asking if there be any
chance of reconsidering the Athena saying I should pan the offer on
to you in case he refused. The answer I hope will be favourable. I
expect another refusal. Partly he does not regard the piece as that
good and partly, no doubt, he is nervous about the price.'

This is typical of John Marshall at work: every possible contingency
covered and explored – but also revealing too much to the opposition.
Often he trusted other collectors far more than was judicious. He told
too many the truth and less scrupulous agents benefited greatly. (As
we will see, Harold Parsons, who was then his novice, witnessed
Marshall's being too much the gentleman.) Marshall was stung by
Robinson's final refusal: 'I am sorry about the decision about the
Athena. It is a delightful figure, and whether Myron's or not, is of
Myron's date . . . It is a pity that so interesting a piece cannot be given
by someone to the Museum.'[25] In a letter to Ned, those were the
words he described as his 'rage to Robinson'. Rage he may have felt,
but he could not transfer it to paper.

A far more serious problem Marshall had at this time was with
forgery; so much so that Marshall's life 'without Puppy' became one
with forgery. Marshall had always been touchy about implications

that pieces he had suggested or purchased with Warren had been over-restored or fabricated. In 1903, Warren lent the Chios Head to the Burlington Fine Arts Club where Rodin saw it. When one critic suggested it was 'worked over' Marshall exploded and took the remark personally. He wrote a paper defending the piece, unfortunately one of the few times he did so. Warren and Marshall's respective attitudes towards forgery were quite different. Ned moaned that the collector 'always loses his time . . . and daily sees forgeries . . . which he must on no account buy'.[26] Marshall, however, loved to track down forgers and once said: 'There was only one way of learning to distinguish between a forged antique and a genuine: to buy one, pay plenty and find it false . . . You learn more by one such incident than by poring for years over selected antiquities in a museum.'[27]

Marshall certainly practised what he preached. On his own, he came to encounter what Harold Parsons once termed 'the most outrageous forgeries of all time': the Etruscan warriors which once graced the Metropolitan Museum in New York. Many of the contacts he had known when he and Ned were collecting together were gone and Marshall discovered a new breed. A new contact was Pietro Stettiner who was an official high up in the post office, and Marshall first met him at his house in Rome. Stenniner had written a popular book on Roman monuments and dabbled in collecting antiques. He was the official vendor of two of the Etruscan terracotta warriors Marshall purchased for the Met: the old warrior (6 1/2 feet with a white beard) and a colossal head (4 1/2 feet, resembling Mars, god of war). These two were bought in 1915 and 1916 respectively. The third figure, an armed warrior (6 1/2 feet) was purchased in 1921.

Before his involvement with the warriors, in fact, the very day he first met Stenniner, Marshall expressed doubts about a piece Stettiner offered him – a bust of a goddess. Despite his uneasiness he nevertheless acquired it for the Met in 1916. Marshall also stated that Wolfgang Helbig told Stettiner that both Marshall and the collector Carl Jacobsen had expressed doubts about it. This is the only incidence we have of Helbig's link with Marshall's latter-day troubles with fakes, but considering Helbig's track record it is enough to raise an eyebrow or two. Why, with Jacobsen's doubts, Marshall changed his mind and purchased the bust is not known.[28] Anyway, the goddess went to New York just in time for the scholarly Gisela Richter (Curator of Greek and Roman Antiquities from 1910 to 1948) to include it in her *Handbook of the Classical Collection* in 1917. It was discovered to be a fake ten years later.

117

Marshall's communications to Miss Richter about the Etruscan 'old warrior' were ecstatic: 'It will make you groan to hear of it: the biggest T.C. [terracotta] you or any reasonable being ever saw.'[29] Concerning the 6 1/2-foot warrior, Marshall cabled: 'Have seen the new find. Mars fighting. Wonderful preservation. Same artist as big head. Most important thing ever offered us. Cannot get photographs. Price asked quite fantastic – $40,000.'[30] While Marshall was negotiating the price, Italian archaeologists excavating in Veii discovered the foundation walls of an Etruscan temple and fragments of archaic terracotta statues of gods. No wonder he felt his warriors might be related to a great Etruscan discovery. Unfortunately, Marshall's efforts to nail down the provenance of the warriors led to a dead end, and he never knew that he had been the victim of one of the most convoluted and contrived forgery scandals of all time.

The fuller story of the creation of the warriors is connected with earlier forgery deceptions. At the British Museum's fakes' exhibition, in 1990, a centre-piece was their 'Etruscan' terracotta sarcophagus created by Enrico and Pietro Pennelli in 1873. It was discovered to be a fake in 1935, having been sold to the British Museum by Domenico Fuschini and another dealer in reconstructed vases in Orvieto. After the sale of the tomb, Fuschini fell out with the Pennellis and looked for other artists who could create Etruscan pieces like the sarcophagus for unsuspecting foreign museums. He soon discovered two brothers, Pio and Alfonso Riccardi, who were very clever at reconstructing old ceramic pieces. Significantly, Pio once worked for Francesco Martinetti who had supplied so many objects for Helbig.

Pio died and his son, Riccardo, with his cousins, Teodoro and Virgilio Angelino, turned their energies to large projects. Riccardo became the leader, relying heavily on his boyhood friend, Alfredo Fioravanti, who was just a few months younger than himself. Firoravanti has been apprenticed as a tailor, but was far more interested in art, and in Riccardo. The two were life-long lovers and served in the same army regiment.

Riccardo and Alfredo decided before the outbreak of the First World War that the time was right to launch into the big time, and their first creation was a thin, old warrior in terracotta. No model is actually known for the piece, but it has been suggested that they used a photograph of the lanky nude male of the Pennelli tomb. That would make their creation a fake of a fake. Fioravanti said the old warrior and the colossal head were finished before he and Riccardo went into the army together. They were made and fired at the Riccardi

workshop in Orvieto. Though otherwise intact, the old warrior has no right arm, and the interior of his trunk is so thin in places that a crack soon developed after it came to New York. Fioravanti later explained that he and Riccardo could not agree on the position of the arm, so their solution was to break it off.

The old warrior arrived in twenty fragments, in February 1916, in the middle of the war. German U-boats were active in the Atlantic but, as with other treasures Marshall shipped, he must have felt they were safer on the high seas than in Italy. Miss Richter notified Marshall: 'The Etruscan terracotta statue has arrived safely, and at present is being put together.'[31] At the end of her communication she asked: 'Do you know anything of its provenance?'[32] Marshall had to stall on this query again and again, but Ned constructed a response for him: 'Please delay publication of terracotta.'[33] Communications between Marshall and the Met say little about the head, but it arrived on 25 July 1916 in 178 fragments placed in four cases. Putting it together began immediately. When finished the Met's Assistant Director, Robinson, cabled Marshall: 'When may terracottas be exhibited and published?' This time Marshall answered: 'Publication must be delayed, exhibition undesirable.'[34] In the meantime, the museum was satisfied by a chemical analysis of the warriors made by a New York ceramics expert.

As the war accelerated, Marshall found it increasingly difficult to maintain contact with the museum. Back in England, even Ned was having a hard time keeping in touch with the United States. In 1917, Marshall was given permission from the authorities to go to England for the sale of the Hope collection of antiquities. While in London, he posted a twenty-two-page letter to Robinson about the old warrior and the colossal head. He said the head had been found at Boccaporco, just off the main road from Orvieto to Bolsena, and that the excavators had reported that they had also found large tiles coming from what was assumed to be a huge temple. This fired Marshall's imagination about discovering terracotta figures corresponding to Pliny's dimensions which included a Jupiter 25 feet high.

There was a snag, however. Local farmers demanded that the site had to be covered up and sown with wheat. Nothing could be done until the harvest was completed. This was a clever delaying tactic and Marshall, still unaware of any chicanery, wrote to Robinson: 'This business has occupied most of my time.' But he also reminded his employer: 'At any rate the head is pure Ionic work . . . I can find

nothing approaching it in importance . . . The discovery of your head simply demolishes whole volumes of Paio's *History of Rome*.'[35]

Immediately after the armistice of November 1918, Fioravanti and Riccardi embarked on what would be their last joint effort – the colossal warrior. It was a logical combination of the old warrior and the head – a great Etruscan god of war. The inspiration for this piece was tiny: a genuine bronze warrior barely 5 inches in height which is in the Berlin State Museum. The new statue was made in a small room on the ground floor of a rented house in the Via dei Magoni in Orvieto. During the winter, Riccardo Riccardi, though an expert horseman, was thrown from his horse and killed instantly. This was a devastating blow to Fioravanti. Of the offspring of Pio and Alfonso Riccardi, Riccardo was the only one with any real artistic ability or business sense. Fioravanti was left alone to complete the new warrior with Teodoro and Virgilio Angelino Riccardi. They were not noted for much other than acting as errand boys for Riccardo.

One story has it that Teodoro posed for the big warrior, but that the statue's genitals (the figure is naked from crotch to thigh) were those of the well-endowed Riccardo. Those who remember the warriors on display at the Met recall how school children were delighted to see so much of the male figure. Apparently, for a long while, the phallus was not on view because one curator (not Miss Richter) kept it hidden in a drawer. Her successor discovered it and had it attached. Months later when the new curator passed the statue, he found it missing again. As Alfred Frankfurter mused in 1961: 'Its present whereabouts are . . . unknown; it is left to conjecture how shocked must be some nameless fetichist at the news he now possesses merely a part of a fake.'[36]

The Riccardis and Fioravanti spread rumours soon picked up by Marshall that a colossal piece had been excavated in the region of Orvieto. By August 1919 he had been shown the fragments of the new Mars, and by February 1921 the purchasing committee of the Met allocated the $40,000 being asked. Previously, the Riccardis and Fioravanti had received only a few hundred dollars from Stettiner. Apparently, he had died in 1920 and Fioravanti decided the time had come to eliminate the middle man.

While the last warrior made its way to New York, Marshall's health deteriorated and he went to Chianciano, a fashionable thermal spa north of Orvieto known to the Etruscans and Romans, and used by them to cure disorders of the liver. While there Marshall hoped to explore the countryside down towards Bolsena and Orvieto, thinking

he might be able to discover archaeological clues for the terracotta warriors. His notebooks are crammed full of possible links.

Ned was worried by Marshall's state of health and pressed him to leave the purchasing to someone else. At one stage, Marshall said he was going to resign and even drafted a letter of resignation to Robinson, but in the end could not bring himself to send it. Ned also knew Mary was far from well and asked: 'Would not she be better elsewhere? I stand outside and see your life: [the tracking down of forgeries] which doesn't better your liver, the dealings with people who don't interest you for themselves but for their antiquities, the want of freshness and freedom.'[37] Then Ned struck an even more tender nerve by speculating on the married couple's conversation: 'In the afternoon you ask each other "Do you feel well?" and in the evening, "Are you tired?" and in the morning, "Did you sleep?" Mary has an excuse, never having been strong. You, my dear, have a constitution of iron which you treat as an absolute monarch treats a constitution imposed on him. Seldom, save when you take a cure, do you sacrifice a month to putting yourself in order.'[38] Not long after, Ned pressed Marshall to resign with a new incentive: 'In January all my debts will be paid . . . The new order is at hand . . . You have now the chance to make things easier, and if I don't deserve it, well, I shouldn't mind getting my ease all the same. You have power to detach me from you in every way, but not in the matter of solicitude; that our lives are irretrievably joint lines.'[39]

Marshall must have been moved by Ned's frankness and concern – but he was determined to persevere. By the end of 1921, Marshall had yet to see the spot where the warriors were said to have been found; five years later he told the museum he had 'cut all relations with my Orvietans for good'.[40] Marshall never discovered any more about the warriors which, in 1933, were placed in the Met's new Etruscan gallery as star attractions. Marshall's secretary, Annie Rivier, spent the next few years trying to unravel their provenance, but the 'Orvietans' had moved elsewhere. Gisela Richter went ahead with the definitive monograph on the warriors, and then on 7 April 1936 she received an odd communication from an Italian dealer, Piero Tozzi, who had a gallery in New York: 'If sometime you happen to be in the neighbourhood, I would appreciate very much if you would come to see me . . . I have something to tell you [about the warriors] which will interest you.' At the bottom Tozzi mysteriously added the words: 'Fioravanti – Riccardi brothers – Teodoro'.[41] Miss Richter was unaware that the truth of the provenance had been laid in her lap. After

seeing Tozzi, she told Annie Rivier: 'There is an absurd story going around that our terracotta dollies are modern and the work of Fioravanti . . . It is easy to see why such a story should be told, as it makes it more comfortable for many people. I don't propose to pay any attention to it except to ask you to find out who this Fioravanti is.'[42]

Annie Rivier did. She wrote to Miss Richter: 'Fioravanti began work as a tailor, went on as a car driver; for some time he had a small business in old furniture; went back to his cars; he has been for many years, and still is a taxi driver in Rome. He does not sound much like an artist.'[43] She had found out the truth, but did not discover that Fioravanti had been *Alfredo Barsanti's* tailor, his chauffeur and his protégé. It will be remembered that Barsanti (close to Warren in their joint days of collecting) sold two fake 'Floras' and a few other dubious pieces over the years.

As another postscript to the story, Harold Parsons wrote to his friend, William Milliken, Director of the Cleveland Museum, in 1948 that while looking through his files of suspected pieces he came across photographs of some ivories owned by Warren. He had purchased them for 'his own private collection in Italy about 1910'. They were promptly condemned as fakes by the Victoria and Albert Museum and discovered to be the creations of the Riccardis of Orvieto; as Parsons added, 'through whose hands and *from* whose hands many false ivories, enamels, ceramics and terracottas emanated'.[44]

Miss Richter paid no attention to Tozzi's warning – nor did the Met to Parsons's. Tozzi's note to Miss Richter was probably a last gesture of respect to Marshall whom he greatly admired. Miss Richter's monograph never mentioned any of the suspicions and gave an imprimatur to the work of an ex-tailor and the enterprising Riccardis. It would not be until 1961 that the Metropolitan Museum would admit the warriors were fakes.

3

Dying in Harness

Today, it seems almost preposterous that someone like John Marshall, who was responsible for acquiring some of the most significant antiquities which grace the Metropolitan and Boston museums, could have been so outrageoúlsy taken in by the warrior forgeries. How the otherwise brilliant observer, Gisela Richter, could have stood by them for so long is equally puzzling. Harold Parsons gleefully described the warriors after their exposure as having 'inharmonious proportions, their ferocious gestures are static; their faces are but death masks. They could not possibly roll their eyeballs or unstick their frozen lips or flex a muscle; they are lifeless.' Parsons added that those who admired the warriors should go to the Villa Giulia and look at the Apollo of Veii to see 'genuine Etruscan sculpture'.[45] Miss Richter had in fact prefaced her monograph on the warriors with an account of the discovery of the Apollo in 1916, and went on to say that the warriors 'enlarge the experience given us by the . . . Veii Apollo'.[46]

It must be said that when she wrote that very little was known about Etruscan art, and just about anything could be imagined as possible. It would take the Met's extraordinary fakes to make this clear. *Apollo* magazine announced the warriors as 'first-rate examples of Etruscan statuary of the very first rank of merit'.[47] In our own day, museum director Samuel Sachs II has wisely observed: 'Forgeries are obvious only with 20-20 hindsight.'[48]

The warriors were not Marshall's last encounter with art forgery. Not long before he told the Met that he had cut his relation with the Orvietans for good, he was on another trail which would involve him to his deathbed. Ned had warned his friend that these exploits were damaging his health, but in 1925 his wife Mary died and Marshall had an increased desire to prove his worth. We know almost nothing of the circumstances of Mary's death, but despite the couple's imagined and real ailments, they accelerated their purchasing for the Metropolitan. Marshall buried his wife at Bagni di Lucca, and more and more divided his time between the Villa Buonvisi and Rome for his operations.

John Marshall's last encounter with purchasing a major forgery occurred in 1926 and involved an Italian forger, Alceo Dossena, who is regarded as the most versatile art forger of all time. Dossena's creations duped not only the Metropolitan Museum, but also the Cleveland, Boston, Saint Louis museums and the Frick Collection in New York. It was Dossena's singular achievement to have had works from his own hands attributed by experts to Donatello, Vecchietta, Mino da Fiesole and Simone Martini among others.

When Bernard Ashmole visited Marshall, in Rome, in 1925 (not long after Mary's death), he said that Marshall enjoyed telling him stories of the 'ways of Italian antique-dealers, how some of them tried to pass off forgeries of skilful patination – rolling them in the gutter of the Via del Babuino or burying them under under the vines at Orvieto'.[49] Marshall had not yet encountered Dossena's more sophisticated methods of patination which included chemical baths, the secret of which he took to his grave. The full extent of Dossena's talents are still emerging, but in 1961 Ashmole delivered a lecture on art forgery at New College, Oxford, and asserted that the reason Dossena was exposed was due to 'the fine judgment, integrity and perseverance of one man, an Englishman and a New College man, John Marshall'.[50]

That was not quite the case. In 1961, Ashmole was unaware of some of the intracacies of the case. Dossena was not exposed quickly and some of his most important works were not even guessed at until Harold Parsons and Pico Cellini published a catalogue of Dossena's *oeuvre* in 1955, and it was some time after Ashmole's lecture that the implications of that book were recognized.

In May 1926, when Dossena's productions in archaic Greek style were first coming on the market, a 3-foot high statue of a Greek maiden (kore) was brought to Marshall in Rome and the dealer swore it came from an ancient Etruscan site. It now appears that the dealer was related to the Jandolo brothers who were next door to Dossena's studio on the Via Margutta. All this, however, would only surface after Parsons's sleuthing in the 1960s. Marshall did not like the statue, but as before he did not let his doubts stand in the way of its going to New York. He thought it related to other pieces he was being shown – and he was right. They were all by Dossena. By this time and after the Etruscan warrior fiasco, Marshall was becoming increasingly weary and feeling that he had been duped by even the closest of contacts. Ned had warned him, but he still refused to give up.

Marshall had no idea of the full extent of Dossena's creations being

offered to the American market: a 'Mino da Fiesole' tomb was purchased by the Boston Museum for $100,000; Cleveland went for two Dossenas (with Parsons's endorsement). One was a Greek marble 'Athena' for $120,000 (Marshall had seen it for the Met and turned it down). The Frick Collection purchased a 'Simone Martini' Annunciation in marble for $225,000. Once the Dossena story broke – in November 1928 – the authorities of the Metropolitan Museum made a great point to the press that they had never been taken in by Dossena's forgeries. A representative of the museum declared to *The New York Times*: 'We have never owned a Dossena even transiently.'[51] A week later, the Met had to eat those words as an enterprising *Times* reporter 'made his way into the nether regions of the Met and discovered a skeleton in the closet in the form of an archaic lady . . . In the basement of the Met stands a little (Dossena) statue smiling. Perhaps because it slipped into America's greatest museum past all barriers raised to keep all apocryphal works of art out.'[52] The reporter had found the kore which Marshall had bought for the Met.

When the dealers sold Marshall the Dossena kore, he was told that there were other 'interesting pieces' which he might want to see. In July 1926, while Marshall was at Bagni di Lucca, dealers brought him some fragments of sculpture. There were two heads (one male and one female) and a woman's shoulder. The dealers said they were part of a large group and more of it existed. Marshall insisted upon seeing all there was. The dealers took away the fragments and promised to bring him everything in the autumn. Nothing happened until April 1927 when the 'Athena' he rejected was offered, and went, to Cleveland. Marshall was also shown a group consisting of the upper part of a woman, and the head and shoulders of a man which was said to come from a larger group. It looked interesting. The dealers maintained it had come from state excavations in southern Italy, but as 'persons in high positions' were involved no papers could be provided, though the dealer said he could get them out of Italy. Marshall turned the group down. Harold Parsons's friend, the dealer Jacob Hirsch, handled not only the 'Athena' which went to Cleveland but also the questionable group. He took it to Munich and it came to be called 'the Munich group'. It was accepted as genuine by Franz Studniczka, a German professor and expert on ancient sculpture. Like Marshall, Ashmole thought the group 'detestable'. But Hirsch, having paid £40,000, believed in it as did Studniczka's friend, the practising sculptor, a Professor George.

Marshall continued to investigate the relationship of all the pieces

which had come to him. While the negotiations for the sale of the Munich group was going on, yet another piece of alleged archaic Greek sculpture appeared. This time, the dealer was selling it as a Dossena and he said that the 'Athena' and the Munich group, as well as other pieces shown to Marshall at Bagni di Lucca, were all from Dossena's studio. Naïvely he thought that because so much of Dossena's work was on the market, he had no reason to present them as otherwise.

By now Dossena also decided to blow the whistle on the dealers who had paid him a pittance for works which had brought them a fortune. Few were willing to believe him, however. It was impossible that one man could have created so many convincing works. It would take years for the full extent of his *oeuvre* to be recognized. Marshall began to see that a master forger was at work, and against his doctor's advice proposed a meeting in Munich with Ashmole, Beazley, Studniczka and Professor George. At the gathering, the two Germans remained in favour of the Munich group. Ashmole said: 'Marshall and I were equally against it. Beazley reserved judgment. He did not like it, but felt that he had not evidence enough to condemn it out of hand.'[53] Without Beazley's support, the meeting got nowhere – and it was fruitless for Marshall to interject his suspicions about other pieces. Marshall was crushed by the confrontation. As it turned out, the Munich group was a part of one of Dossena's most ambitious projects: a recreation of an entire mythological gigantomachy – the battle between gods and giants as would be seen on a temple pediment.

Marshall returned to Rome, and Ned was there. He had been alarmed by some of Marshall's communications and the two shared a flat they had lived in during their collecting days. At first, Marshall appeared to be better but Ned insisted he see a doctor. The doctor said that he was in 'a bad way' and recommended what he told Ned was 'a five-day treatment' which was then followed by a second session. As Ned recounted, Marshall only had 'a part of the second treatment' when he died. Ned gave a vivid account of his friend's last hours to John Fothergill:

On the evening of the 15th Johnny went to bed early, say towards nine. He looked into my room, saw that I was writing (I was doing this by exception; usually I stayed with him in the evenings but that night he had companions), made a face because I was occupied. I replied . . . to the face . . . that I would

be with him soon. I went to his bed and kissed him good-night; he said that he was going to sleep; usually he read a little in bed. Our rooms were connected by an open door. I woke up about 20 minutes past midnight; whether by his light or by himself afoot I do not know. When a noise wakes me, I do not know that there has been a noise. I called, but got no answer, and again no answer to a second call. Then I saw him pass through my room to the W.C. Soon I heard a faint call and sprang up to find him complaining that he could not breathe. I got him to the open window, but presently he wanted to go back to his bedroom and sent me to get some digitalis. I awoke the servants as I did not know where it was kept; it was prescribed only after morning coffee. He also asked for a rocking chair, which I brought in. All the time his breathing was contracted and was not to be seen. He said: 'I am dying', and wanted brandy of which he took two doses. Presently he went to bed, at his own request, and was propped up so as to breathe. All this may have taken half an hour. Before getting into bed he looked wild and said good-bye to the servants and said 'good-bye Puppy' several times to me. Once in bed he was perfectly quiet. I lay on the other side of him propping up his head. In ten minutes he was dead. I got up and looked at my watch; it was five minutes past one. The doctor could not be reached, but an apothecary came and after examining him told me that he was dead. If there is any error in the times mentioned they were a little shorter. He never gasped. It must have been a smaller amount of suffering than might be expected from Angina Pectoris.[54]

Beazley, who had offered him so little support at Munich, later spoke of Marshall as having 'died in the harness, displaying to the end his extraordinary skilful judgment of classical antiquities'.[55] Ned was full of remorse. Although it had been 'a great consolation to be with him alone after the separation and misunderstandings', there was still the feeling: 'I ask myself whether I ought to have been with him more: did I guess what strain he was undergoing?'[56]

In another letter to Fothergill, Ned spoke of Mrs Helbig's grandson coming to console him, but saying that 'Johnny had been in haste to rejoin his wife'.[57] That was not what Ned wanted to hear, and he took the inference to imply 'that life with me was not good enough for him. I broke down. The remark turned out to have been purely his own guess or interpretation . . . I did not at any moment believe it (nor the

inference) but the suggestion was terrible . . . I was shaky for a few days afterward.'[58] Travis and Harry Thomas arrived to help put Marshall's effects in order. Miss Rivier took care of the museum papers, but the remorse would not leave Ned:

> When and how did I treat Johnny badly? An old question, but revived by his death. Now I have succeeded in laying it aside. It will come up in the autobiography. In body, I am well. I sleep well. My symptoms are good, though, for the moment, I have dropped medicine. I am said to look tired; but I am no longer shaky. I want to be rid of Rome and of reminders of Johnny's life without me. I come across such or such a thing, poor or bought cheap. Did he think that he had too little money and therefore just put up with it? Did he blame me? He did. Yet he had more income for his expenses that I did for mine. Also he did buy expensive books of the 15th-century. He cared most for them, not so much for silver, for instance. You see how I want to defer all self-questions for the autobiography and that the things suggest them.[59]

That last letter to Fothergill reveals Ned's shattered emotion regarding his great love. Why at the end would his 'self-questions' be occupied with Marshall's financial condition? At the hour of death who gives a damn about fifteenth-century books? But it had been the issue of money which darkened his relationship with his brother Sam. Of course, Ned never did get round to explaining himself further as he projected, but the surviving letters from this time suggest his inner state. After Marshall's death, Ned said he was restless and could not stay in Rome and he didn't want to travel either. He wrote: 'Now I wonder whether I shall ever want to see again a place where I was with him.'[60] After the estate was settled (he told Fothergill he was 'left with powers'), Ned thought of giving up Lewes House and living at Fewacres:

> Now I ask where and whether I shall have the ease: in Lewes? in Maine? I puzzle too about love. It makes so much disturbance; people suffer from it; yet the good things of life come chiefly from it. Should I be content to remember only that something has been done for the Museum, content with the less personal result of love? For the Museum was truly a paederastic evangel. It must be counted as a result of love. All goes together, the

suffering, the Museum, and perhaps my mistake towards my people and towards Johnny.[61]

To equate Marshall and the Warren family with the collecting of art is clearly an unbalanced assessment of love. Calling the Boston Museum 'a paederastic evangel' takes us back to Ned's original difficulties of attempting an aesthetic brotherhood at Lewes House. Ned's understanding of Greek art and thought was never fully shared by his companions, and Fothergill, for one, shot down his attitude by saying: 'It is futile to sigh for the world of Pericles. We are here and not there . . . There is a sort of presumptuousness in your whole position.'[62] Oscar Burdett, otherwise not noted for criticizing Ned, declared 'he would be better off for more common sense'.[63] That basically was what led Ned to a collision course with his brother and to misunderstanding John Marshall.

Kenneth Clark's answer as to why men collect appears poignantly aimed at Ned: 'Why do men . . . collect? As well ask why they fall in love: the reasons are as irrational, the motives as mixed, the original impulse as often discoloured or betrayed.'[64] Ned, however, carried that a step further: if falling in love was confused with his collecting then Marshall and the others were, in a sense, an extension of his obsession to collect. More than loving Marshall, Harry, Matt and Fothergill, he wanted to possess them.

Whatever the final truth regarding his motives, Ned was ready to die after Marshall's death. Beazley said that after that Ned 'had the air of a man who is quietly putting his house in order before departure'. Beazley went on to relate that Ned spent the summer term at Oxford and 'spoke of it as his last visit. His mind was as keen as ever: but he was getting deaf, and in several places the machine gave signs of running down. The last time we were together our talk fell on the magnificence of Pindar's tree in the fourth Pythian ode. Whether Warren was thinking of himself no one could have told; I was thinking of him: The oak, ever when cut down and shorn of its branches, shows its worth.'[65]

Ned willed himself to die, but he made one last visit to Boston and Fewacres only a month before his death. On 21 November 1928, he visited Bowdoin College in Maine to which he had given an impressive collection of antiquities. It is not known exactly when he left America but Ned was dead on 28 December 1928. After an abdominal operation, he entered the Cambridge House Nursing Home at Dorset Square in London where he died. Ironically, John Marshall's will was

filed in Portland, Maine, only days before Ned's death, and was managed by Mary Marshall's relatives, Henry W. Bliss and his son Henry M. Bliss, both of Chestnut Hill, Massachusetts. The local Portland newspaper carried an account of Ned's death under the banner: 'Estate of $1,204,000 Disposed of in Will of Edward Perry Warren: Pioneer in Westbrook Paper Making: Distributes Property to 73 Beneficiaries Here and Abroad'. The article went on to relate: 'Mr. Warren died in England, where he had spent much time in recent years, Dec. 28, just a few days after having been named executor and residuary legatee in the will of his warm friend, John Marshall, an expatriate in Italy, who passed away in the latter country in February, 1928.'[66]

Ned told Osbert Burdett that he had wanted Marshall 'to be buried with me, but he had made his will just after his wife's death and before he had begun to understand me again.'[67] We do not know where Ned originally planned to be buried – probably at Lewes or Oxford – but he instructed Frank Gearing (his last secretary) to take his ashes to Bagni di Lucca. That occurred in the spring of 1929. There an earlier and simple monument to the Marshalls was removed to make place for a larger one which had at its base the names of Mary and John Marshall and Edward Perry Warren with their birth and death dates. Appropriately above the base was a plain Grecian urn.

PART V

John Fothergill's Story –
The Architect of the Moon

1

Rather a Lack of Care

Of all Ned Warren's companions, the best known – in Britain at least – is John Rowland Fothergill. This is because of his latter-day career as innkeeper extraordinaire and the success of his innkeeping diaries published in the 1930s and 1940s. Fothergill was born on 27 February 1876, the son of George Fothergill, of a fairly well-off Westmorland family. His mother died of scarlet fever when he was two days old.

We learn little about Fothergill's early life from his diaries and have only snippets of information about his connection with Lewes House, Oscar Wilde, Romaine Brooks, Augustus John and James Dickson Innes. However, there is Fothergill's unpublished eighty-one-page memoir written in 1954,[1] three years before he died. Meryle Secrest used material from it, regarding Romaine Brooks, in her admirable biography of that eccentric artist in 1976.[2] Nothing else from those revelatory pages has yet appeared. What has been presented about Fothergill in the biography of Oscar Wilde by Richard Ellmann and that of Augustus John by Michael Holroyd has been limited. Part of the problem has been that he was called Rowland by some of his friends and Roland or Ronald by others. Ellmann refers to Rowland Fothergill as the recipient (among fourteen others) of *The Ballad of Reading Gaol*.[3] In researching her work on Romaine Brooks, it was some time before Meryle Secrest realized that the Roland of Brooks's memoirs was John Rowland Fothergill. Michael Holroyd had much to say in an uncomplimentary manner about Fothergill: 'a misfit in modern civilisation . . . possessivly homosexual'.[4] Perhaps the larger story from Fothergill's own memoirs will help redress the balance.

Fothergill never finished his memoirs and what we have is highly disorganized. There are few dates given and often Fothergill leaps ahead in his recollections to events occurring a decade or two in the future. And like many other loquacious storytellers, Fothergill continually digressed from the topic at hand. There are many gaps in his story as well.[5] Apparently, he did not want to tell us about certain aspects of his life. Despite all this, we learn more of the inner feelings of this friend of Ned Warren than any other. In old age, recalling his

133

relationship with Ned and the others, Fothergill was hard on himself, but nowhere else are the curtains of Lewes House pulled wider apart. Fothergill's earliest recollections centre on his school days. At 9 he was attending a local school with his two elder sisters and his half-brother, Reggie, who was three years younger, but certainly the more dominant. John's stepmother left the control of the obstreperous Reggie to her stepson. Reggie had angry passions which John tried to subdue: 'I had to get him down on his back, lie on him and hold out his arms.' On one occasion, Reggie kicked John so hard on the shins that the 7-foot gardener, James, arrived to stop him from going further. A few years later, the stepmother died, and Reggie and John were left in the care of the two older sisters: 'We rarely saw anything of them as they left us to play in the woods all day long.'

Apparently, George Fothergill saw little of his children as well, but John recalled that when he was less than 6 his father forced the multiplication tables on him. 'He was a kind man and never hit us, though we were rather afraid of him save Reggie who could almost cheek him at times.' When John made the mistake with his tables, Father would flip his ear. Many years later, John's sister told him that often he came out of the library with his ears red and swollen. Father would time John with his gold hunter's watch, intent that his son would get quicker and quicker with 11 X 11 and 12 X 12. He failed to measure up and was sent out again and again so that John 'had difficulties with the tables forever after'.

Equally gruelling was the education from General Raike's Old College in Windermere where he was sent at the age of 11. Especially horrendous were his experiences with Latin 'about which I knew nothing'. When John read *Horatius cocles* as cockles: 'Up sprang Raike. "Enough of this old joke," he shouted, and snatched up the cane lying before him and slashed it over my shoulder and down onto my back.' Other boys were humiliated in greater fashion. One, the son of a respected shopkeeper, ran away from school, but when he was found, Raike had the father appear together with thirty boys from the school: 'A chair was put at the end of the room, the boy's coat was taken off, his hands were placed on the back of the chair and the fun began.' The father was first – 'I felt he hated it but was frightened by Raike.' Raike's lashes which followed were pretty dreadful but the boy remained motionless.

At Raike's school, John first learned about begetting children from a pretty chubby-faced boy, but the next morning he put it all out of his mind. From Raike's, Fothergill went to Bath College where Robbie

Ross used to visit him. According to Ross's records, they had first met in May 1897 which would be the year before he entered Bath College. Fothergill recalled that on the first evening at the college:

> I was tenderly mauled by one of the masters and taken up and kissed by an upper boy. Having always been called ugly in the family I felt some satisfaction as well as embarrassment. The big boy continued with me – quite innocently as I remember, but, when he left at the end of the term I was surprised to find myself scorned and unpopular everywhere. I didn't feel the injustice of it; I merely wondered and accepted it.

Fothergill was at Bath College from 1888 to 1895 and by his own admission did not distinguish himself at all. However, he did draw 'beautiful maps of Greek battles in the study of one of the masters' and also designed programmes for concerts. He said of the latter activity: 'perhaps in this scholarly place, that didn't make for popularity'. Fothergill also recalled many crushes on boys at the college. One with a boy he calls 'B.McC.' was 'the only real and able love of my life'. Fothergill had made up his mind to keep the relationship platonic, and for a year 'with heroic effort' he had. Unfortunately, an older boy took 'B.McC.' away 'and seduced him properly'.

From Bath College, Fothergill went to St John's College, Oxford. His career there was short – only the Michaelmas term, 1895-6, and academically unsuccessful. He admitted it was his fault. Fothergill shared little of Warren, Marshall and Prichard's love of learning in a formal sense. Ned's accounts of life at New College were alien to his own experiences at St John's: 'I learnt nothing there. I had a tutor whom I saw only once. I sometimes wandered into a lecture in some other college and dressed extravagantly. One suit was a beautiful grey hop-sack but the tails were about four inches longer than had ever been, or were to be seen.' Fothergill wore it with a gold hunting horn in the button hole: 'Pheasant tails they called me.'

Fothergill said he had only one friend at St John's – a high church undergraduate. With him John shared for a fleeting time 'a religious mania . . . Draped in blankets I used to meditate with a candle under the bed . . . My mind was a muddle of inhibited ambitions, desires and love.'

As Fothergill had not passed his 'smalls' (first of three examinations for an Oxford BA – abolished in 1960), he had to leave. The morning Fothergill left he was sitting alone in the empty college garden and

was smoking. The President of St John's ('a horrid little man') came by and fined him ten shillings. 'That was the end. He hated smoking.'

The next few years are extremely difficult to arrange in exact chronological order. After leaving St John's, Fothergill drifted, waiting for one thing – his 21st birthday, when he would receive an inheritance from the family. Fothergill said he 'wandered for a year or more', and his brother-in-law (Harry Hannay married to his favourite sister, Angie) told John's father his son was 'a homosexualist'. Apparently, Hannay disliked John greatly, giving out the story that a friend with a house above a lake (probably Windermere) had seen Fothergill and the friend's nephew 'through a telescope in a boat below'. Fothergill did not say what they were doing but added, 'upon these facts grew a great myth about me . . . I was now an outcast'.

Fothergill admitted that this 'feeling of superiority' had not allowed him to be friends with his father, and they were not reconciled until George Fothergill was 80. His father did send John a tiny allowance which was enough for him to get a bedsitter just above Marble Arch at Seymour Street: 'It cost 10/-a week, and the rest of the allowance went for cigars and cabs.'

Robbie Ross, who over the years had remained in touch, heard John was in town and asked him to come see him at Redcliffe Gardens at seven one evening. Fothergill assumed that meant dinner. As his allowance for the week had run out and he would not be getting any money for two days, John 'starved cheerfully for the next 20 hours'. When he arrived Ross was seated in his usual position – legs and feet tucked under him. They talked before a big fire, then Ross got up suddenly and said he must go and dress for dinner. That meant his mother's house. Fothergill was left without any dinner and he tried to work out how to get back to his bedsitter. It took him four hours to get to Trafalgar Square and he couldn't go any further. He asked a policeman where he might spend the night since he had four pence in his pocket. The policeman took him to The Seven Dials 'which took me and my four pence in'. He got into bed and, at once, was devoured by fleas until dawn. Unable to stand it any longer, Fothergill left and watched for buses with the conductor on top, and in two short rides was having his breakfast at Seymour Street.

Fothergill's small allowance meant he had to pawn his initialled gold cuff links, and 'for another year I wandered waiting for my inheritance'. It never occurred for him to look for a job: 'my father and his ancestors had never had one, and I hadn't any qualifications for a profession'.

When Fothergill was 19 he had met Oscar Wilde through Robbie Ross and Reggie Turner. In 1897, he was 21 and came into his inheritance. That year Wilde was released from prison and the following year Augustus John completed his study at the Slade School of Art. By that time Warren and Marshall were actively engaged in collecting art on the Continent. Much was to happen to John Fothergill as the nineteenth century turned into the twentieth.

2

Two Loves Have I

When Fothergill came into his money, 'business began'. The first enterprise came through Ross's brother Alec who told Fothergill to put £500 on Welshbach oil lamp mantles, but to sell out immediately. 'And I did so. In a week, I made a clean £500 without even signing a cheque.' Fothergill was not as successful when advising others and quickly decided against speculation in the City. For a short time, Fothergill was at 30 Manchester Street 'to be near Sir Arthur Blomfield' as a pupil of architecture. This meant the London School of Architecture, and Fothergill's copy of Wilde's *The Ballad of Reading Gaol* was dedicated by the author 'To Rowland Fothergill, the Architect of the Moon'. Blomfield is remembered for his many restorations of English cathedrals and for having designed the Royal College of Music in 1883. The new interest did not satisfy Fothergill for long: 'As pupils we had no help or attention from Sir Arthur or his two sons, and their stereotyped patterns – Nos. 1, 2 and 3 as I called them for scores of suburban churches . . . bored me terribly.'

He put up with Blomfield's for a while and then 'wandered about again, by this time in the company of homosexuals whom I got to know at Robbie Ross's house . . . I did my best to play the part and keep up with their affectations. I found it silly enough. Oscar Wilde was in prison and they were without a leader . . . From their charming and witty behaviour it was difficult to know if they practised the art of Greek love.' Fothergill could not hold his own in their endless gossiping and games, but he knew they were attracted to him because of his 'good looks and youth'. Often Ross's clique spoke of 'the cause', but as far as Fothergill was concerned without Wilde's direction 'they simply didn't know where they were going'.

Ross told Fothergill he had written to Walt Whitman about 'the cause' and received a rude reply. Apparently, the two were not on the same wavelength. Fothergill – as usual – was looking for something but could not find what it was, or, as we will see, perhaps was afraid to commit himself: 'I had all the time a secret longing for a perfect friend, a thing which I couldn't define – something like a gentleman

138

protector – someone who would give me support, direction and place, for I had no thought of helping myself or how I could, but went on complacently spending my capital.'

Aside from a series of titillating anecdotes, we know little else about Fothergill's early dealings with Wilde and his set of friends. Wilde left Reading gaol on the evening of 18 May 1897. He spent the night at Pentonville prison and the next morning travelled to Bloomsbury where he changed and breakfasted at a friend's house. He left England for Dieppe by the night boat, and Turner and Ross had rooms for him at the Hotel Sandwich. He did not stay there long. With Queensberry so determined that his son should not meet Wilde that he had hired a private detective, Wilde thought he might be freed 'from pursuit and priggishness'[28] if he moved out of Dieppe.

By chance he came to discover the village of Berneval, five miles from Dieppe. It suited him well and soon a number of visitors came to see him, including André Gide, Sir William Rothenstein and John Fothergill. Fothergill's visit has gone heretofore unrecorded although Rupert Hart-Davis's edition of selected letters of Oscar Wilde contains veiled references to it: 1 June 1897, Wilde wrote to Ross that he wanted to continue to live at Berneval and 'send over the architect [Fothergill]'.[7] On 5 June, Wilde described the rooms at the Hotel de la Plage and what expenses might be expected for visitors like Ross and Reggie, but 'Architects, on the other hand, are taken at a reduction. I have special terms for architects.'[8] On 20 July, again to Ross, Wilde said he 'expected Ross on August the First: also, the architect'.[9]

We do not know exactly when Fothergill appeared and from his memoirs it seems he visited Wilde alone. Between 28 and 29 August, Wilde was reunited with Douglas in Naples ('My going back to Bosie was psychologically inevitable . . . ')[10] and on 21 September, Wilde wrote to Ross that despite several visits by friends to Berneval he was so lonely that he was on the brink of killing himself: in the last month there, Reggie Turner had given him three days, and 'Rowland a sextette of suns'.[11]

Ross had told Fothergill that Wilde wanted books, in particular Ermann's *Life in Ancient Egypt* which Wilde said he wanted 'only to find out how Pharaoh said to his chief butler, "pass the cucumbers" '. Fothergill described his arrival at Dieppe:

From the railings of the boat, as she got to Dieppe harbour, I looked down upon what must be a great man standing alone and looking up. I had seen a photograph of this beautiful looking

man and here was a huge and fat person in white flannels with a comical little red beret on top of it all. Rather vulgar I thought. My heart sank, but his sweet kindness put me right quickly.

After a drink at a restaurant, we went into the Cathedral. Running down into the big vestry was a fine and open staircase from an upper room at the bottom of which was a well made door. 'I think,' said Oscar, 'this is a charming idea, so that you can see your visitor coming before you say that you are in or out,' – and more of this pleasant nonsense. We took a cab. Passing over a shaking and resounding iron bridge out of the town, he likened it to something in Dante's Inferno, and then with my ignorance I felt uncomfortable. I wish I'd never come. But he talked on; anything to put me at my ease, I suppose. He thanked me for Ermann's great work on Egypt. It was quite dark when we arrived and the tree frogs were singing like millions of canaries. His chalet was in a row of others covered by trees and bushes. [Wilde had left the Hotel de la Plage and from 15 June had rented the Chalet Bourgeat.] He stopped the cab at one of them and when we were penetrating up to it he said, 'I can only find this chalet at night.'

We went on walking, Oscar surprised me by quoting a lot of Wordsworth which at least I knew. We ate in the little café on the shore, sharing expenses when I should have paid all and not only 35/-a week for Berneval. But I didn't know he was so hard up.

Fothergill went on to explain how later he heard the truth about Wilde's financial condition, and how 'George Alexander continued to show Oscar's plays but cut out the author's name!'. (At the time of Wilde's bankruptcy, Alexander had bought the acting rights of *Lady Windermere's Fan* and *The Importance of Being Earnest*. He made some voluntary payments later to Wilde and bequeathed the rights to Wilde's son.)

Once or twice Oscar pointed out men who who knew him, but passed on. People, Wilde said, he had been kind to. Of the other guests at Chalet Bourgeat at this time, Fothergill mentioned seeing only two: Leonard Smithers who, while still a solicitor in Sheffield, had written a letter of appreciation about *The Happy Prince*. Smithers later became a bookseller and publisher. He was known to have traded in pornography, but also published Wilde's last three books and much of Aubrey Beardsley's work. Fothergill described Smithers

as 'sea green now with absinthe drinking', and 'complaining that Aubrey Beardsley with whom he had a contract for all his work had sent him nothing . . . Oscar reproving him, replied, "My dear Leonard, you are a monstrous person. You have bought his soul and what more can you ask for?" This showed great generosity because Aubrey lived in Dieppe and wouldn't know him now.'

The other guest was the English poet Ernest Dowson. He had met Wilde in 1890, visiting him at Oakley Street in the dark days between his trials. Dowson was described as Wilde's 'first hyacinth since Douglas: But this flower was wilting, and had not much longer to live'.[12] Despite the wilting, Wilde looked for 'the green costume' which went well with Dowson's 'dark hyacinth locks'. Fothergill commented that Dowson was in love with the owner of the Café Royal, but was 'faithful only after his fashion'. Although Dowson was in the house he did not appear. Wilde said they had quarrelled and Dowson, to spite him, 'had had all his long curls cut'. Apparently, Dowson had also tried to persuade Wilde to try sexual relations with women again. After returning from a Dieppe prostitute, Wilde said to Dowson with distaste: 'The first these ten years, and it shall be the last. It was like chewing cold mutton.' Then as an afterthought: 'But tell it in England, where it will entirely restore my reputation.'[13]

With only Leonard Smithers and Fothergill as an audience, Wilde tried to keep up his old brilliance, but Fothergill added that 'he was too broken and friendless to do it well'. Both Smithers and Fothergill knew Wilde was troubled about Bosie Douglas who was either unwilling to see him or prevented by Ross. Fothergill said Wilde liked him and declared to him: 'Two loves have I: the one of comfort; the other of despair. The one has black; the other golden hair.' Fothergill commented: 'I don't think I could have given much comfort. I was too concentrated on myself. I've ever been incapable of sympathy, even with this sad thing.'

Following Wilde's profession, they went to a recitation soirée in the crowded school room. A little Frenchman leapt about 'in the old style, struggled, groaned and sweated'. Fothergill looked over at Wilde and watched his heavy face rapt and absorbed – 'like a child when listening, and on his big cheek a tear ran'.

When Fothergill returned home he received 'some charming letters with his lovely handwriting', but admitted that the feeling against Wilde and any knowledge of him was then so strong in England that he decided 'to drop him': 'I actually wrote that it was not "politic" to go on with it. What an awful expression!' Wilde replied saying he

didn't know what Fothergill meant by 'politic'. For Fothergill it was finished, but he said he had assimilated Wilde's manner – even his ponderous intonation 'so far as my voice allowed'. Back in England, Fothergill 'posed terribly – a little Oscar Wilde!' He stayed a few days with Ross's sister and family in Pangbourne, but continued to do his Oscar Wilde impersonation 'to such a degree' that Ross's sister told her brother he was repulsive and never wanted to see him again.

Fothergill added a sad footnote to his remembrance of Wilde. After he had taken up with Warren in Rome, Warren was well aware that a year before, Fothergill had had 'friendships with one or two boys'. Warren thought this might 'endanger the collecting for America by giving the police an excuse for suppressing us'. So Warren suggested that Fothergill should grow a moustache – 'a very fine masculine mass of it'. Then came what Fothergill called 'the tragedy'. One day he went down the Via del Corso and looking across the road at Aragno's Café he saw Wilde, sitting alone at a table. He stopped and watched him: 'He sat so still, looking at nothing, and had that same, sad friendless face . . . I wondered – should I go over to him or, would it once more be that awful word "politic", and a betrayal of my duty to Ned's work? I had to decide for this. I passed on, and never saw him again, but my tragic picture of it all sickens me still.' That feeling stayed with Fothergill to the end of his life, and both his sons say he regretted his decision not to have approached Wilde in Rome.

It appears that Fothergill was still pursuing some interests in architecture upon his return from Berneval; at least he went through the motions of attending classes at the London School of Architecture. In his memoirs he also recalled a 'silly indiscretion' which happened at this time:

At a Greek play at Bradfield, I gazed longingly at the charming face of a boy on the stage. I bought a photo of the group with the boy in the middle. Quite infatuated, I dined that night at the old fashioned hotel in Manchester Street and wrote to him on their note paper, and got a couple of nice letters in return. Then, in order to have him visit me I gave No. 30 Manchester Street as my address.

It was bank holiday, I suppose, when I got a letter from a firm of solicitors. They said, in the end that no man of the world reading my letter (which incidentally had been perfectly nice) could possibly form two opinions about my intentions toward the boy, and that I must undertake not to rewrite to him again,

otherwise they must put the matter before the police. I felt a fool and afraid. So I replied saying that they would be incapable of realising that by my giving this undertaking they would be cutting short what might have become a beautiful friendship. I wasn't going to give them anything more direct than that and I heard no more. Doubtless it sounded stuff and nonsense, but I was still full of my broken platonic love affairs at school and probably had no other intentions.

Fothergill added the following: 'Sometime ago, some sixty years afterwards I saw mention of that boy . . . in some official capacity; he too had retired.'

It was also the same year – 1898 – that Ned Warren provided the money to open the Carfax Gallery. It certainly seems that Fothergill's interest in the new art was a major factor in Ned's involvement, but oddly Fothergill says nothing about the Carfax in his memoirs. His involvement with its initiation occurred at the time when he was still somewhat wrapped up in architectural interests, and towards the end of 1898 he went off to the Continent. Despite this, William Rothenstein, who had met Warren through Fothergill, certainly gave credit for its formation to Fothergill:

Fothergill was not well off; but he was extremely generous, and of an adventurous spirit. Fired by the example of Hacon and Ricketts, he proposed to start a small gallery, where Conder's, John's, Sickert's, Orpen's, Max Beerbohm's and my own work could be constantly shown; a gallery in fact that would be a centre for work of a certain character. I was to be responsible for the choice of artists, Arthur Clifton for the business side. Premises were found in Ryder Street, St James's.[14]

The first artist to be exhibited at the Carfax was Charles Conder because the art establishment was not sympathetic to him. Following a quarrel with Conder, Rothenstein withdrew from the project and Ross took his place. A letter from Fothergill to Ross gave some of the difficulties:

W.R. is thinking of giving up the Carfax, although the gallery is doing well. You say that Conder's negotiations make life troublesome to you – but surely having once formed your opinion of the man – his ill behaviour only goes to strengthen you in your

judgment of him. If you think it easier – we are reckoning with a scapegrace. I am sorry that you suffer from the idea that you should be thought to be a dealer. In this I cannot pretend to be able to give you any consolation . . . You have found the work beyond you or beneath you – yet you have proved very successful.[15]

After consoling Ross, Fothergill wrote to Rothenstein reminding him to remember how the shop was his 'own suggestion', his 'own understanding'. Then he added: 'As for your hair, I'm very sorry about it.' Rothenstein was worried at this time about losing so much of his hair. Fothergill said Rothenstein shared the same fate as Ross who was nearly bald: 'Remember, Will, your strength is not in your hair – as in Samson's case – but in your smile and conversation.'[16]

Despite Rothenstein's break with the Carfax, he maintained a friendship with Fothergill and Ned, though he thought Lewes House possessed a stifling and unreal atmosphere. As a token of friendship, Rothenstein painted Fothergill's portrait and, according to Fothergill, he was presented as 'a beautiful young man in surprisingly a white mackintosh which I never wore'. The Carfax would also be an early link between Fothergill and Augustus John. The gallery was the scene of John's first one-man show. Of that John wrote: 'There is to be a show of my drawings . . . I hope to Gaud I shan't have all back on my hands.'[17] He did not need to worry: art critic D.S. MacColl deemed the show a success and John earned thirty pounds.

3

Losing the Romantic Look in His Face

After Rothenstein's leaving the Carfax, Fothergill had less enthusiasm for the project. Rothenstein and Warren had also instilled in him a desire to undertake 'the Grand Tour' of Europe and so he started out towards the end of 1898 on a tour which would have lasting effects upon him. Thomas Cook told him that all was arranged from Harwich to Germany, Budapest, Verona and Rome, but asked what class he desired. 'I had never been beyond Dieppe and Ostende, but replied, "I always travel first." And how I was to regret that little swaggering reply, not only because it couldn't have impressed Messrs. Cook but in the whole journey I scarcely ever had in my first class compartment anyone to look at.'

First Fothergill visited Dresden and Berlin. The latter he hated. A major reason for this was his seeing a cabman savagely beat his horse, and from childhood he had strong feelings about the ill treatment of animals. Munich was much more civilized, and it was there he said he made a fateful decision. It was the State Antiquities Collection at the Glyptothek which caught his eye. The Aegina Marbles, sixth-century BC representations of the battles for Troy in two pediments, were discovered as fragments in 1811 and later were purchased by Ludwig I who asked the sculptor Thorwaldsen to repair and refinish the stones. Most critics today consider them to have been excessively worked over by Thorwaldsen, but several of the figures – especially one warrior – are extremely impressive looking.

Admiring this handsome warrior and other figures, Fothergill said he 'decided to learn about Greek art and to live it, and I felt that here at last was an object to aim at. For a fortnight I was there when it opened till it shut – almost no one else came. It was frightfully cold in what must have been a record winter . . . and there was no heating. I stuck to it. Once I stood round a piece of sculpture for about half an hour and tried to force what I supposed must be its beauty into my brain.' It

would be this obsession which, more than anything else, later found an affinity with Warren and Marshall.

By the time Fothergill got to Vienna he was too tired to go on to Budapest so he went directly to Verona, and then on to Rome. In Rome he had two fateful encounters.

Beatrice Romaine Goddard Brooks was 25 when Fothergill met her in Rome. He was two years younger. She would become 'an adornment of la Belle Epoque' and one of the most eccentric women artists of the twentieth century. Her early life according to her unpublished memoirs, *No Pleasant Memories*, was just that – and quite a bit more. Her mother was a rich and terrifyingly unbalanced woman, and her brother went slowly mad between the ages of 7 and 16. When Romaine was 7, her mother left her in the keeping of the family washerwoman in a New York tenement. At 12, she rejoined her mother and brother in a life of endless travel, occultism and madness. Later Romaine was ushered off to a convent and a Geneva finishing school. Both were singularly unsuccessful, but through the family lawyer Romaine prevailed upon her mother for a stipend of 300 francs per month. Like Fothergill, age 21 finally gave her some independence. She went to Rome.

A favourite haunt was the Caffè Greco in the Via Condotti which had been opened in 1760, and later became the meeting place for artists and men of letters: Goethe, Berlioz, Wagner and d'Annunzio. It was there that Romaine and John Fothergill met. Meryle Secrest says Romaine was aware that she was at once attracted to him: 'What she felt was a double tendency: clear eyes, smiling mouth, and an air of shining youth, juxtaposed with the clever Oxford graduate's overlay of cynical sophistication, which had already drawn fine lines around his mouth and engraved a frown between his strongly marked brows.'[18]

Fothergill said that by that time he had taken up with two Italian boys, and then met 'this most beautiful American girl'. He did not give her name, but described her as 'very poor and had studied painting in Paris where she told me she had tried in vain to seduce Clara Butt'. The latter was the brilliant English contralto with a successful career at Covent Garden. Romaine 'had a studio with fleas that introduced themselves to you almost before you had got across it'. She was described by Fothergill as 'tender and loving like a child. She had a pale sensitive face with great black eyes and warm dark curls.' But Fothergill also added abruptly: 'I with my old motto "no

146

time for love" got the lovely girl to agree that our affair should last only three months when I must go away to Greece.'

In her memoirs, Romaine did not imply what Fothergill suggested – that they lived together. She said rather that they were constant companions: 'There was not a single ruin, gallery or monument we did not visit.'[19] Romaine saw Rome through Fothergill's eyes, eyes which had been recently imbued with Greek and Roman art, but he 'laughed when she showed him the small edition of *Childe Harold's Pilgrimage* which never left her pocket, calling the book old-fashioned'.[20] Fothergill recommended Walter Pater and John Addington Symonds instead, to whom he had been introduced by Warren or Ross. Pater and Symonds were, of course, the two volumes mentioned by Alfred's Nanny in Warrens' *Tale of Pausanian Love*, and were favourites among turn-of-the-century homosexual aesthetes.

In her memoirs, Romaine also mentioned that Fothergill and a young English painter travelled by train with her to Assisi to see the Giotto frescoes. They went third class and each carried 'a piece of soap and a tooth brush as luggage'. The Giottos were a revelation to Romaine. She stared at them for a long while, then suddenly told her two companions she was wasting her time and wanted to return immediately to Rome to start working. That remark, Romaine wrote, 'my companions ascribed to an almost presumptuous faith in my own abilities'.[21]

Wanting to refuel his enthusiasm for Greek art which had begun in Munich, Fothergill left for Greece. Romaine was in despair at his departure: 'She didn't want to see anyone, or even to paint; everything conspired to remind her of [Fothergill]'. But as Secrest adds: 'she was able to discipline herself, and so at last set to work harder than before'.[22]

For his part, Fothergill said of the experience that they had 'parted painfully', but when he got back from Greece Romaine had left Rome. He related that her mother had left her a fortune. She went to live in what was described as a 'sumptuous studio flat in Tite Street' in Chelsea. In 1905, there was a reunion of sorts. At Lewes House Fothergill received a registered letter one morning. Inside it was £25 with a note from Romaine saying that it was what she owed him. Her address had been inked out, but with a little ingenuity Fothergill was able to make it out from the sunken obverse. They met at Lewes House, and their meeting was described as her realizing that the 'brilliant boy . . . had become dreary and faded. The young man who talked so brilliantly about the ideas of Wilde, Symonds and Pater; who

could discuss the origins of every ruin in Rome; whose curious mind was challenged by everything from Greek heads to cream puffs [Romaine's favourite food in Rome], and who had turned her world into an enchanted place, had become jaded, superficial. He spent the afternoon complaining that his friend E.P. Warren had become maniacal on the question of women.'[23]

Romaine began to paint Fothergill's portrait but the two quarrelled halfway through the execution. When Meryle Secrest worked on her biography of Romaine Brooks she was determined to find the painting which was not with the rest of the artist's *oeuvre* in America or elsewhere, and discovered it hanging in Tony Fothergill's cottage in Wells. She describes it as quite different from the portraits for which Romaine would become famous: 'It was a formal study in the late-nineteenth-century academic tradition . . . Romaine did not see [Fothergill] as a poetic, romantic figure, the way he saw himself. She caught, in the way the expression of the eyes contradicted the set of the mouth, a certain ambivalence, as if she sensed the inner bewilderment masked by the show of determination.'[24]

Sir Harold Acton says that Fothergill was undoubtedly the only man Romaine Brooks ever loved, and a letter from Sir Harold to Fothergill on 12 October 1948 relates: 'Romaine Brooks is now in Florence and often speaks of you with emotion. She is a great moral support and has written a fascinating book of memoirs for which I have tried in vain to find a publisher.'[25] The memoirs were never published but much of it was incorporated in Secrest's biography. Secrest was fascinated by the Fothergill and Brooks's affair and was probably right to suggest: 'Romaine was not quite ready to give up the idea of a relationship with a man. Nor was Roland, in 1898, quite ready to accept all the implications of a marriage. He was torn between homosexual attachments and heterosexual ones, just as Romaine was.'[26]

Later Romaine married John Ellingham Brooks, a poet and homosexual. Their marriage lasted only a few months and she dismissed him with: 'See I don't want to be made a domestic receptacle for you, go back to your boys in Italy.'[27] After that she was briefly attracted to Bosie Douglas with whom she 'flirted mildly'. Douglas was once briefly engaged to Natalie Clifford Barney with whom Romaine had an intense forty-year relationship. In the end, Romaine outlived them all. When she died in Nice at the age of 96, there was only one picture on display in her apartment. The servants assumed it was her brother,

1. Edward Perry Warren in his early thirties.

2. John Marshall in his Rome apartment with his pet crow.

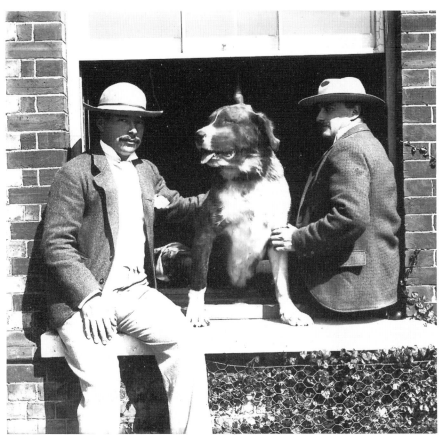

3. Ned Warren and John Marshall with one of their St Bernards (Edward Reeves).

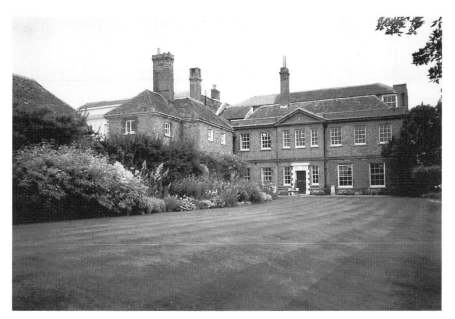

4. *Lewes House from the gardens.*

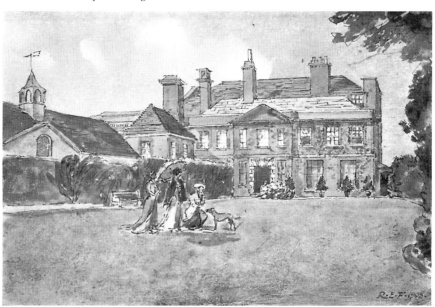

5. *Watercolour of Lewes House by Roger Fry, 1908.*

6. *Dining-room at Lewes House with James Shepherd, the butler.*

7. *Harry Thomas's study at Lewes House.*

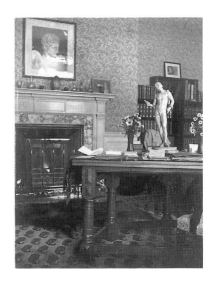

8. *Study once used by Matthew Prichard at Lewes House.*

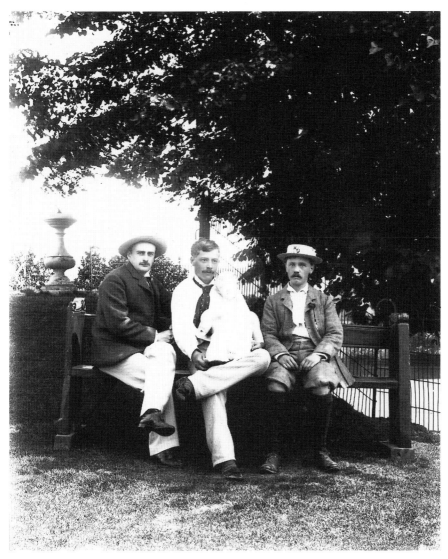

9. *John Marshall, Ned Warren and Lewes House workman. Note the sculpture in Warren's lap. It was shipped to Boston the next day* (Edward Reeves).

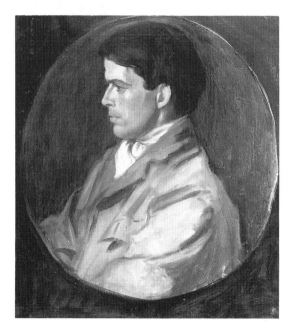

10. *Photograph of John Fothergill, 1898. This was the photograph Romaine Brooks kept to her death and upon which she based her portrait of Fothergill.*

11. *Romaine Brooks's portrait of John Fothergill.*

12. *William Rothenstein's portrait of Fothergill.*

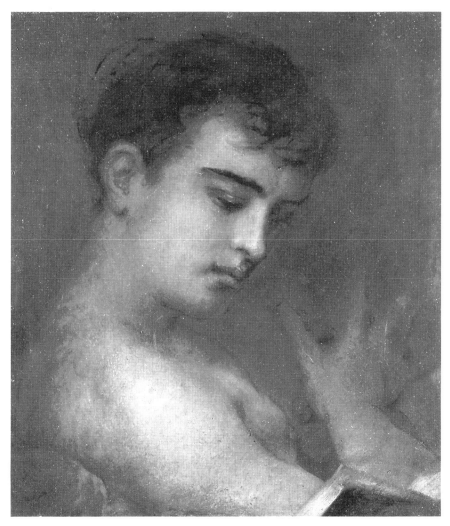

13. Luigi Galli's portrait of Fothergill.

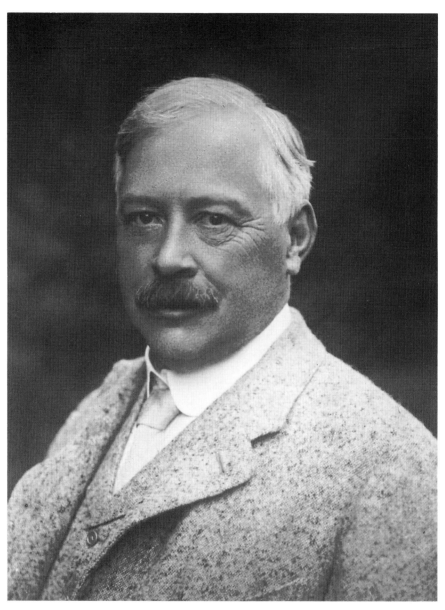

14. *Edward Perry Warren* (Edward Reeves).

but it was of a very young Fothergill and bears a decided resemblance
to Romaine's portrait of him.

In the back room of the Caffè Greco hangs a portrait of Fothergill by
Luigi Galli. When the impoverished artist asked to paint him, Father-
gill asked, 'How much?' 'Four pounds,' responded Galli. 'One pound
before starting, another when under way and the rest when finished.'
Fothergill had soon paid all and more when he left for Athens, and
when he returned Galli had finished: 'a head on naked shoulders
with the hands uplifted putting on a pair of gloves!' Fothergill said
Galli was a master of the old school, and his portrait 'might have been
done by Michelangelo'. It was the image he later expected from
Romaine Brooks. Fothergill gave it to the café owner: 'Appropriately
it was first hung where dirty old Galli sat most of the day.'

In his memoirs, Fothergill mused over these days: 'So, no wonder I
am not rich in memories of a place or of my feelings for it and its
people at that period. In fact, I am not much better than the American
couple who had toured Europe in three weeks and when asked back
in New York what they'd seen in Rome: "Why," replied the daughter
pondering, "wasn't there we saw the yaller dorg?" ' This anecdote is
also in E.M. Forster's *A Room With a View*, but any connection remains
unknown.[28] Fothergill also said of this period that forgetting
Romaine, he 'exchanged her for the Acropolis where I worked and
drew every inch of it, and the precious things in its museum. Here, for
the first time, save the Aegina pediments [at Munich], I saw Greek
sculpture, white and fresh, with almost the chisel upon it, and in its
sunlight too.' Upon his return to Rome in 1899, Fothergill was back at
the Caffè Greco where he met John Marshall. In his memoirs he did
not mention Marshall earlier, and it seems odd he did not know him
before. Fothergill said: 'Marshall had heard of me from someone in
Athens.'

This was his introduction into working with the collecting duum-
virate and his first job was bizarre:

> [Marshall] wanted to know if I would very kindly arrange for the
> emigration to America of a young Italian who was blackmailing a
> common friend. I agreed at once, the money was produced and I
> either gave it to him upon his word to go, or the ticket. Anyhow
> he never went, but we never heard anymore of him. I now
> became one of Ned's Lewes House collectors, and thus fulfilled
> my old prognostication and desire as well as a means of using

the flair and knowledge I had, as it were, subconsciously acquired for the purpose.

Before telling the reader more of his exploits in collecting, Fothergill presented some observations about the Lewes House community which remain the most incisive of any which survive. Fothergill's earlier expressed longing for 'something like a gentleman protector – someone who would give me support, direction and place' certainly appeared to be fulfilled in Ned. His feelings for Ned were strong: 'He became to me, as to the others, part of my being – or at least so far as my tyrannies and unsympathetic impetuousness allowed me to imitate his god-like love and tolerance . . . He has become more than a part of me, for I seem to live as one with him, a would-be memorial to him.'

Of the others, Fothergill said George Valentine Harding had been a failure, and 'liked cold meat, better than hot because one was given more of it'. Whereas Fothergill's inheritance was 'fast running out', Matt Prichard and Richard Fisher still had plenty of money of their own. Fothergill never took to Prichard and said he 'soon got jealous of me and Marshall: he took little Fisher with him and retired to the North Room at Lewes House, a big dark place on the ground floor, never to be seen again in the upper rooms, nor go riding.'

Fothergill told how at breakfast assignments were meted out to the secretaries, and Fothergill's first was to go to Malta to look at a 3-inch head carved in bluish chalcedony. Fothergill could not possibly know whether it was genuine or not. On the voyage back, he became very ill and had to stop at Catania for three days to recover. There he made friends with a young American who was travelling the earth for rare treasures for his place in California. Fothergill ate nothing but oranges all day long and grew weaker. He made for Lecce, went to bed and sent for a doctor: 'He came a little man of about four and a half feet with tiny hands'; and told Fothergill he had typhoid. Ned, who was in Rome at the time 'suddenly arrived complete with a valet and a German doctor'. Fothergill was removed from his room and taken to the great banqueting hall of the Orsini palace, a sumptuous baroque delight. It once belonged to the papal family, and Fothergill was placed in a 50-foot bedroom with four long windows curtained in yellow silk which went some twenty feet up to an arched ceiling 'brilliantly painted with balconies, fine ladies, negroes, birds, angels, clouds and blue skies'.

After surviving

several delirious days I had a sort of dream I was going to die and that death was sitting on me. Now or never, I said. I'll fight for it, and I struggled like mad then slept for, I suppose, a day. The first sight, when awakening, was to see Alfredo, the fat French valet Ned kept in Rome, making a Viennese steak. He had pinned the lump of meat against the door of this palace with a fork, and with another was scraping the meat till nothing was left of it save a bunch of fibres. Ned had chartered the only cow in the district, for the coffee, and then, he discovered, it came from Milan ready mixed with milk. I could hear it coming round with its bell and calf ready to be milked at the door.

At last, Fothergill felt he had to 'face the problem that had long been on my mind and after all Ned's generosity and loving care of me, I had to come out with it. I imagined that he must be assuming that I was rich. But my £4000 had now half gone. Was I going to tell him that I couldn't go on with him? Or could I ever be worth his keeping me? At once he said he'd give me £300 a year and my mind was fresh to convalesce with.'

As for the 3-inch chalcedony head, it was sent to Marshall, then at Lewes, who at once suspected it: 'It happened that soon after he had wandered into that rather dull geographical museum in Piccadilly of all places, and saw a little collection of trinkets carved out of this stone, including a small head. He got to work and traced our thing back to the author of these. I have forgotten whether it was sent back or not. It didn't go to Boston.'

Romaine Brooks was not the only one to notice a change in Fothergill once he had taken up with Ned and Marshall. Robbie Ross met him in London and told Rothenstein:

John Fothergill turned up the other day. He is very much changed [and] has lost that fine romantic look in his face, owing to his study of modern philosophy and archaeology at . . . Rome. He has become quite an expert with antiques, at least some of his purchases have been highly extolled by American and German savants. Let me, however, relieve your mind by saying that he bought them for his own amusement and does not expect Carfax to deal with them. He is much delighted with Carfax and the appearance of the shop, but that does not compensate me for his loss of romanticism. There is, however, no nonsense about art in him. Everything has to be B.C. [now] and good period and thoroughly battered with a certain amount

of secrecy as to where it came from. John takes it all very seriously and says, of course, what is quite true that I know nothing of philosophy of art.[29]

Ross had mixed views regarding Fothergill. He could never understand Lewes House's obsession with antiquities and missed Fothergill's spirited interest in new artists. He also thought Fothergill had a freer reign to collect than was the case. Marshall never allowed him to become as involved in the collecting as much as Matt Prichard, though Prichard even thought Fothergill's limited role was beyond his abilities. Fothergill became quite fascinated in some of the pieces; most especially the Boston Relief. It had arrived before he came to Lewes, and he said 'how it got out of Italy I never asked, though I knew it was an agonizing operation – its code name for all letters and telegrams was "the Hangings".' Fothergill set to work at studying the relief and was convinced it could not possibly be a throne as everyone assumed. He argued that it was an altar.

He considered his writing on the Boston Relief his great contribution to Lewes House and planned to present his theory in an art journal.[30] Just before he finished the article, he took it to Marshall to read. Marshall pored over the pages and at the end told Fothergill he had 'over-turned the thrones all right'. Not long after seeing Fothergill's draft article, Marshall published 'The Interpretation of the Large Greek Relief in Boston' in *Burlington* magazine and Fothergill's ideas were presented as Marshall's own. In his memoirs, Fothergill commented: 'Perhaps he had been disturbed that after all that time he'd not made these observations himself and left them to a newcomer with no learning.' The experience stayed long with Fothergill. In the papers he left his sons is a large dossier on the relief inside a handsome cover which he created for it. The dossier contains a massive correspondence Fothergill had over the years with various archaeologists and museums. He even noted that some authorities had suggested it was a fake. In his *An Innkeeper's Diary*, he noted with delight that one German archaeologist knew the 'altar theory' was his and not Marshall's, and had stated: 'As Fothergill has clearly laid down!'

Another work Fothergill admired was the Chios Head, and he said that Marshall 'paid an enormous price for it'. However, Marshall left it to Fothergill to 'smuggle it out'. It had been found by Antonios Xanthakes while searching for building material during the Crimean War. His son inherited it, and the son's widow presented it to J.C.

Choremes, from whose heirs Marshall purchased it. Fothergill went to Trieste to meet it, and described the city as 'a loathsome town, brightened only by a little Salvation Army band on the beach whilst I waited for the boat. I got rowed out, carried the head away wrapped in a brown camel hair rug and brought it back to Lewes.'

Doing these 'mean little jobs for Marshall' and constantly aware that he was not Marshall or Prichard's academic equal began to wear Fothergill down. He described Lewes House as a place 'not encouraging for original work'. Marshall had the whole library to himself 'where he sat all day . . . there he grew more and more nervous and fastidious. He could finish nothing. One day I came in and found him writing to Edward Robinson, the Boston curator. Before him on the table I counted ten sheets of Lewes House writing paper, none with more than six words on each: "Dear Robinson, I don't . . ." and so on. Beastly creature that I was, I laughed at him instead of comforting this pathetic case.' While Marshall was in the library, Prichard and Fisher weighed coins and gossiped in the dark North Room; Ned had his office at 'Thebes' where he wrote and rewrote his *Defence of Uranian Love*.

There was another aspect to life at Lewes which bothered Fothergill:

> The whole thing was too comfortable and all-providing. When any of us went to London which we never did save on business, there was the petty cash box in an open drawer in the bureau. We had only to dip into a heap of sovereigns and take out the regulation five. I confess I thought this proceeding too horribly heavenly . . . Yet there was also a pretty big correspondence to see to and we never felt secure at home against sudden departures to Italy and Greece.

Fothergill sensed that things were coming to an end at Lewes House. In 1901, Prichard and Fisher left to work at the Boston Museum; in 1902, Ned hired lawyers to look into the family business and was spending more and more time in America. As Oscar Burdett put it, Fothergill 'was running Lewes House'.[31] The years 1904-6 were 'the bad years' and Fothergill and Marshall agreed on one thing: neither liked Ned's new friends. In 1905, Fothergill had complained to Romaine Brooks of Ned's maniacal attitude towards women. Next Mary Bliss appeared and Fothergill was caught in the middle of a vortex. He was left to run the house, and though he did little to help,

153

Marshall was good at complaining about expenses. Despite this, Fothergill often defended Marshall to Ned:

> I suppose we all love one another for our own peculiar interests whatever they may be. Though I have known of Johnny Marshall's loveless nature and at times sentimental moments, I always gave him credit that he was a friend of yours though he will not be friend to anyone else. It would be too disturbing to my estimation of the Lewes House family to allow myself to be disillusioned in this; I must still believe that J.M. is fonder of you than of antiquity buying.[32]

Fothergill said that Ned was reduced to 'frenzied and unreasonable agitation' over the thought of Marshall's marrying. He tried to reason with Ned:

> You say that I don't look at things in the same way and couldn't . . . There seems to be a sort of presumptuousness in your whole position. What you are pleased to call romance, I call the supreme manifestation of love . . . There are souls that require the love of a woman for their development; there are others that thrive on friendship; others again are refreshed by the waters of a purely spiritual life. No man can live to the highest extent of his capacity without the particular watering which his whole being craves; and I believe that to a woman is given the means to satisfy man in the very highest sense. Your theory [in Ned's *Defence of Uranian Love*] strikes me as essentially un-Hellenic and un-Christian as well.[33]

That last remark hit Ned the hardest. Fothergill's understanding of Hellenic culture did not exclude women, and he had had the experience with Romaine Brooks. Ned was right when he said Fothergill didn't 'look at things in the same way'. Yet another of his chosen aesthetes could not follow his path. After a few months the Marshalls left Lewes House, and after settling in Rome, Marshall's letters to Fothergill were full of the virtues of marriage. At least in that respect, Marshall recognized a potential kindred spirit. For Fothergill, however, it would be some time before he worked out his own mixed emotions.

Fothergill has little to say about the period of his life after leaving

154

Lewes House. It is known that after a brief time, he studied at Leipzig and then was enrolled at the Slade School from 1905 to 1906. There he met his first wife, Doris Gillian Herring. She is never spoken of by name in Fothergill's memoirs or in any of his surviving letters. Romaine Brooks mentioned that after she had finished Fothergill's portrait in 1905, Fothergill 'was married briefly to a woman who refused to consummate their marriage'.[34] After the marriage, Fothergill had a nervous breakdown and had to 'retire to Church Stretton, to a sort of Farm House in the hills where they took mainly idiots'.[35] That was Fothergill's latter-day description in *My Three Inns*; otherwise he remained silent. Doris Herring Fothergill went to Rome where she worked as an artist until her death in the 1950s. Her self-portrait still hangs in the Caffè Greco where the present-day owner remembers her 'like a child . . . rather slender and eccentric, wearing long gowns which attracted the attention of the locals'. Fothergill said that Ned asked him why he wanted to get married in the first place, to which Fothergill replied 'with my usual bravura that it was the only experience I hadn't enjoyed'. John Marshall briefly mentioned Fothergill's wife in his 1913 notebook saying they had met on one occasion. With hindsight, it is interesting to note how soon after Marshall's marriage, Fothergill followed his rival to the altar.

Not long after his leaving Doris, Fothergill became involved with Augustus John and 'Dick' Innes. Perhaps as with Marshall, Fothergill thought that marriage was a good solution for him at the time, but as with his experience with Romaine Brooks, he was not yet ready to come to terms with the opposite sex. Fothergill had reacted against Ned's misogyny, but his own sexual ambiguities were far from resolved. In Michael Holroyd's biography of Augustus John, we read that in 1908 Fothergill was wrestling with John who 'nearly killed him'.[36] A year later, Fothergill joined John on one of the artist's many caravan journeys. Fothergill's friend, Rothenstein, had found John irresistible: 'he looked like a young fawn; he had beautiful eyes, almond-shaped and with lids defined like those Leonardo drew, a short nose, broad cheek-bones, while over a fine forehead fell thick brown hair, parted in the middle. He wore a light curling beard (he had never shaved) and his figure was lithe and elegant.'[37] Fothergill and John were equally attracted to each other, but it was with a common attraction – 'Dick' Innes – that the two would be most entangled.

In 1946, Fothergill wrote a tribute to Innes, but said little about his relationship with the artist except that they travelled together. Fother-

gill called Innes 'a lone star' He seems to have followed no one and no one followed him, though he had an effect upon Augustus John's landscape.'[38] Innes won a scholarship to the Slade in 1905, and two years later he met John. He has described as a striking figure – 'a Quaker hat, coloured silk scarf and long black overcoat set off features of a slightly cadaverous cast with glittering black eyes, wide sardonic mouth, prominent nose, and a large bony forehead invaded by streaks of thin black hair'.[39] It was during Innes's first visit to France that his short painting career really began.

In 1908, Fothergill and Innes travelled to Caudebec, Boxouls and Collioure where Matisse had worked earlier. In 1910, Innes abruptly broke with Fothergill. Holroyd maintains the reasons for this break 'have never been explained, but assumes that the break was due to Fothergill's being 'possessively homosexual'. He goes on:

> A misfit in modern civilization, Fothergill prided himself on his elaborately civilized manners, but seems to have derived most satisfaction from ticking off, and being abused by, the uncivi-lized. There was almost a self-destruction aspect to this artist's, gallery proprietor and classical archaeologist's decision to take up, of all occupations, innkeeping. Such a masochistic vein Innes, with his violent Swiftian imagery, was the perfect man to exploit; and there was soon much for Fothergill to lament.[40]

This is a rather one-sided viewing of the matter which leaps to personality quirks of Fothergill only in evidence after he took up innkeeping twelve years into the future. Also, there is no conside-ration given of Fothergill's pronounced sexual ambivalences. Unfor-tunately, we have no more record of the affair, but in 1911, Augustus John foretold that Innes 'will die innocent and a virgin intellectually which I think a very charming and rare thing'.[41] Three years later the promising young painter was dead of tuberculosis.

Before he became a writer, Augustus John's son, Romilly, worked for Fothergill at the Spreadeagle inn. John Fothergill Jr remembers romping around naked with Romilly at Augustus John's caravan in Hampshire, and Harry Thomas's daughter, Mrs Pamela Tremlett, recalls being frightened one morning on the stairs at Lewes House by the visiting Augustus John in a long dressing gown: 'He had the wildest eyes.'

Fothergill said little about his early association with John in his memoirs and diaries, but in the former he recorded what he called

'another instance of an artist's bad temper'. It occurred during John's decorations for Sir Hugh Lane's home in Cheyne Walk. John started work there as far back as 1909, and was at first enthusiastic, but later he tired of Lane whom he described as 'a silly creature and moreover an unmitigated snob'. Augustus John took Fothergill to see the wall paintings he had completed for Lane. They were let in by Lane himself whom Fothergill said was 'a neat, quiet little man'. They went into the drawing room which was in an upturned state and looked. John never spoke. Then Lane pointed out a few things which suggested he did not like what was transpiring. Fothergill felt embarrassed. 'Timidly, ever so timidly', Lane ventured: 'And those nude women. I'm not sure they go well in this kind of room.' Then, suddenly with a roar, John bawled out: 'I'll not have it! I'll have the whole lot taken away.' After that Lane took them upstairs to show them a picture he had just bought. Fothergill recalled, 'The air was then too thick to see it, and we went out. And later, so did John's decorations.'

The last artist with whom Fothergill became involved after leaving Doris was Jacob Epstein, the sculptor, who, though born in New York, spent most of his life in England. In his memoirs, Fothergill had great affection for him. They had first met around 1905 when Epstein said, 'I did his portrait in crayon, and he bought, and made his friends buy, some of my drawings.'[42] Epstein was greatly discouraged at the time and started destroying all that was in his studio. By sudden impulse, as he recalled in his autobiography, Epstein took passage to New York, 'going steerage'.[43] He did not stay there long and said: 'A friend I had met in London wrote to me, and in a fortnight I had made up my mind to return to London and work there.'[44]

In his biography of Rothenstein, Robert Speaight sheds a little more light on Epstein's coming back to England:

It was in 1907 that the young Epstein recently arrived from New York, came to William [Rothenstein] with an introduction from Bernard Shaw. Shaw could make nothing of his drawings, and either couldn't or wouldn't help him to get the work which would enable him to live in London. Epstein thought, correctly, that William would be more encouraging. William was impressed by his illustrations to Walt Whitman and promised to write to his parents, urging the advisability of his remaining in Europe. Epstein returned to New York, but was soon back in London, where he was assisted by small contributions from

William and others, and by a Jewish society that William had persuaded to help him.[45]

Omitted from these accounts is the fact that it was Fothergill who had written to Epstein in New York, and had also persuaded Rothenstein to do what he could to help once Epstein was back in London. Fothergill never took credit for this, but proudly told his sons about it much later in life. Interestingly, in 1941, Fothergill wrote to Rothenstein that Epstein had written a book of his memories: 'I do hope he gives you the credit for the making of him.'[46] Epstein did not give much credit to Rothenstein – or to Fothergill.

4

The Manic Innkeeper

The British public image of John Fothergill has little or nothing to do with the foregoing. Today, Fothergill means the manic innkeeper, or as his *Times* obituary put it, 'what used to be called "a character"'.[47] That well known life began when he was 46, and two years after he had apparently resolved previous emotional ambivalences by marrying Kate Headley Kirby. In many respects, Kate was his salvation, and could not have been more different from either Doris Herring or Romaine Brooks. Plain and no-nonsense and described as 'masculine looking . . . with a leonine jaw',[48] she deserves as much credit for his success as an innkeeper as does he. Long-time friends like Harold Acton were surprised – if not shocked – when they met Kate. She was in most respects his antithesis.

In *An Innkeeper's Diary*, Fothergill said:

> I imagine that everyone who has had a career of any character has his amicological tree to the root of which he can trace his chief relationships and interests . . . My tree grew out of Robert Ross . . . and its two main branches were my friendships with E.P. Warren and twelve years' Greek archaeological study and surroundings, and with Will Rothenstein, his family and friends . . . This then with Westmorland blood, the most precious in England, has been the main source of what I have to give as Innkeeper, and even that is far from enough. But it was more than enough to disqualify me for any of the usual jobs when in 1922 I found that I must do something for a living, so I was compelled to take an Inn.[49]

Elsewhere Fothergill credited Warren for making it financially possible, and after looking at a great number of possibilities, he settled for the Spreadeagle at Thame. The little market town in Oxfordshire did not have much in its favour except its proximity to Oxford and the fact that four of its inns dated from the fifteenth century. After Fothergill showed the Spreadeagle (which dated back

only to the sixteenth century and had housed French prisoners in its cellars during the Napoleonic Wars) to 'dear friends Montie and Lady Pollack', the latter wrote to him that it was 'very shabby but very possible'.[50]

There were greater problems than the shabbiness. Fothergill inherited regulars, including one who had stored his fish stall in the inn's shed for twenty years, and an ill-mannered group of farmers who used his main dining room as their private domain when they arrived in town for the cattle market. Fothergill soon got rid of them. He told them they could no longer have the room for their exclusive use as he was remodelling it, and suggested they might want to use the archway instead. As that was near the stables, the farmers saw that as an insult. Fothergill suggested they might be happier at The Swan across the street.

Fothergill was after a different clientele, and, in time, with his former contacts in the art and literary world they began to arrive: H.G. Wells and Rebecca West (they occupied room no. 7 in 1927, despite the fact Fothergill turned away other unmarried couples); Evelyn Waugh (Fothergill kept an inscribed copy of his *Decline and Fall* on a chain in the lavatory as more readers would find it there); the Sitwells, G.K. Chesterton, Shaw, Augustus John (he never let Fothergill know when he would arrive), Wilson Steer, Henry Tonks, John Nash, and Field Marshall Smuts.

The *Times Literary Supplement* review of his first diary said that though he professed to cater for 'intelligent, beautiful or well-bred people . . . as his own clowning is one of the fine arts they are invited to study, those who fail to appreciate it expose themselves as failing to qualify'. Such sour grapes did not deter Fothergill, and hotel critic Hilary Rubinstein hails 'the Spreadeagle, under Fothergills' aegis, as Britain's first Good Hotel'.[51] The first diary was also a success, running into four impressions within the first year. It was recently reissued by Faber.

Much of the favour the Spreadeagle received was due to its extraordinary food. Fothergill defined three kinds of kitchen in his first diary: '1/The French, where the food doesn't taste of what it is, or ought to be, but tastes good: 2/ English hotel, where the food, when even it is food, doesn't taste of anything, or tastes badly: 3/ Our own kitchen, and the true American, where the food is food, tastes of it, and tastes good.' Kate regularly paid for bills for foodstuff from Athens, France, Norway, Jaffa and Italy. 'And of English things we have daily from three different bakers, three different kinds of bread

made from flours that I have forced upon them, besides the breads we make ourselves, cheese from East Harptree, salt from Malten, mustard from Newport Pagnell and for sausages after a romantic search all over England, from the International Stores.'[52]

H.G. Wells described Fothergill as 'a fantastic innkeeper . . . dressed in the suit of bottle-green cloth, with brass buttons and buckled shoes'.[53] And Harold Acton echoed others' feelings that 'For a quiet dinner there was no alternative but to drive to Thame. At John Fothergill's . . . one could be sure of good food and better wine in congenial surroundings with a host whose affability and erudition revived a more liberal age.'[54] Acton still remembers Fothergill with fondness as 'a good conversationalist' and one who supported him when Acton had suffered from slander concerning his lifestyle.

In a letter to Fothergill of 12 October 1948, Acton says, 'It was so very kind of you to write and buoy me up, for I have suffered from accusations of malice, snobbism and what not, which look rather worse in print, and was beginning to fancy myself unpopular, to say the least . . . You cheer me immensely.'[55]

The élite may have loved him, but the general view was that Fothergill was an insufferable snob. Well broadcast were his ushering out of folk considered to be vulgar boarders, his attacks on those who came off the streets to use his lavatories, and his utter intolerance of Oxford college boys bringing unsuitable ladies to his bar, as well as the unruly behaviour of children in his dining room. They, with their parents, were sometimes told never to come back.

Fothergill's sons remember a different side; he was a devoted father and faithful husband; warm and outgoing. If he were a snob, he was an intellectual rather than a social one. He detested pretentiousness and loved to upbraid those who pretended to know all about wines. But considering his training at Lewes House, how could he be other than a snob? Fothergill finally came into his own at Thame. There he was at last master of his own world; no longer measuring himself against Warren and Marshall and Prichard. The image he gave of himself in his diaries and as innkeeper at Thame was a studied role he perfected to amuse his audience, sell his books and keep the right sort coming to the Spreadeagle.

Fothergill knew what he was doing, and had had a good preparation for it: once when he was in Boston with Ned he insisted upon being introduced to the guests as 'the Marquis of Grasmere', as he knew it would impress Ned's mother. After Berneval, he performed

as 'a little Oscar Wilde'. Fothergill's son, John, remembers other performances well. Upon seeing something horrid like a hideous nose, he would point to a building or a tree and whisper to John: 'Isn't that just dreadful! That is the ugliest nose I've ever seen.'

He was a clown – and paid the price for being a clown. And Fothergill was also totally impractical. With her sharp business sense, Kate tried to keep the Spreadeagle solvent. It was a battle lost. After their first year, they had £500 in the bank; after nine years, they were £1,400 in debt. Fothergill honoured bad cheques from Oxford students whose families he knew, and let Augustus John stay at the inn for two weeks without charging him a thing. Once, knowing Evelyn Waugh was coming to stay – and reminded by Kate that there were only five other guests at the time, Fothergill went ahead and hired a group of musicians for a musical evening. In the end Waugh did not stay for the performance as he decided to dine in college.

In 1932, the Fothergills were forced to sell the Spreadeagle. Accountants convinced them to look for a place nearer London. They managed the Royal Ascot Hotel for two years but it was not a happy experience. Though Fothergill was allowed to call himself proprietor, he was in fact in the hands of the brewers. They then moved on to the Three Swans at Market Harborough, where they stayed until 1952 when Fothergill was 77. The Three Swans gave an adequate income but Fothergill was unable to rekindle the atmosphere of the Spreadeagle. He continued to write, but his *Confessions of an Innkeeper, John Fothergill's Cookery Book,* and *My Three Inns* lacked the freshness or impudence of the first book. As Hilary Rubinstein puts it: '[*An Innkeeper's Diary*] remains the best book – perhaps a classic, certainly a claim to immortality.'[56]

Fothergill was the first to recognize the brutality and irreversibility of change. In *An Innkeeper's Diary,* he said:

be it now on record that I have, in the last five years only become ugly and rugged in the face, and the top of my head is nearly bald. Such a rapid break-up could only be expected after five years of this place [the Spreadeagle] . . . Fifteen years ago, I was the best-looking and worst-mannered gentleman in London, and now I am the worst-looking and best-mannered thing in Thame. 'Don't you know John Fothergill?' said Robbie Ross to someone twenty years ago. 'Why, he's the worst-mannered man in London, but when you know him well, he's far worse.'[57]

Today, the Spreadeagle has a Fothergill Lounge and Bar. The menu (Fothergill's Menu) includes items advertised as 'Fothergill's Vegetarian Dishes' and Fothergill's Children's Choice – but then there's always The Swan across the road.

PART VI

Matt Prichard's Story – One Bonnet, but Innumerable Bees

1

Sitting at the Feet of Buddha

Matthew Stewart Prichard, often described as 'the most individual character' of Lewes House and 'the keenest and most capable of Ned Warren's assistants', was also the most esoteric; an aesthete who appeared to think that just about every other aesthete was a fool. Unlike Fothergill, Prichard left no memoirs, gloried in anonymity, and rigorously eschewed publishing anything. There remains, however, an unpublished biography by Harry Rowans Walker and 285 letters to Isabella Stewart Gardner.[1] Largely dependent on those letters, the Walker biography is an unfinished draft and was written at the instigation of Dame Una Pope-Hennessy after Prichard's death in 1936. Dame Una was the mother of John Pope-Hennessy who was former Director of both the Victoria and Albert and the British Museum and from whom I was able to obtain valuable insights concerning Prichard.

Prichard's letters to Mrs Gardner and others in the Warren-Marshall collection at the Ashmolean, plus the valued insights of Prichard's last surviving relative, Charles Stewart in South Africa, are largely all that exist for the researcher. But we can see in them an individual who makes the young Fothergill bland by comparison. The usually tepid Frank Gearing, Ned's household secretary, gives a vivid demonstration of this:

> a kind, rather grave and studious man, ever with a book of some kind, who while shaving taught himself Turkish or Arabic by means of lists of words on slips of paper stuck in the frame of his mirror. Prichard was always courteous . . . with the workpeople and tradesmen who came to the house, and very liberal in tips when the work was done – a tradition which I had difficulty in breaking when, later I had charge of the petty cash. He taught many of the Lewes lads to swim, and even the burly George Justice, a local cabinet-maker . . . George would never have attempted to swim had it not been for Prichard's interest in the local swimming baths. Prichard never wore a costume (nor did

167

anyone from Lewes House . . . Prichard was over six feet tall, with spare athletic body, a long rather cadaverous face, and long, thin, nervous hands. He could ride, though I do not think he cared over much for horses. He was very thorough in all he undertook, and very precise in details. It was he who learned all about photography, trying different experiments; works of art were always being photographed in the house. It was he who took the interest in vase-cleaning and repairing . . . It was Prichard who studied chemistry in order to make experiments in cleaning the deposit from antique marbles. The household accounts were never so perfectly kept as when he had charge of them, and when coins became his hobby his Registers of them were a delight to see . . . After one of his trips to the East he developed a fad for Orientalism. In the streets of Lewes he wore a Turkish fez, walked in the middle of the road with an abstracted air, impervious to the jibes and jeers of the locals, salaamed on entering a room, used Turkish or Arabic phrases on greeting and departure, and gave the impression that he had a private working-arrangement with Allah.[2]

His individuality and overdeveloped sense of organization were eventually Prichard's undoing at Lewes House. The former was generally tolerated; the latter came to be viewed by the acutely sensitive John Marshall as an indictment of his own ability to fulfil Ned's art collecting designs.

Prichard's later days as the great friend of Mrs Gardner and Matisse, survivor of the First World War prison camp at Ruhleben and champion of fellow prisoners, were as far removed from the Lewes House days as was his childhood in the West country. Prichard was born on 4 January 1865 in the little village of Brislington just to the east of Bristol. His parents were Charles Henry Prichard and Mattie Stewart. The Stewart connection was something in which Matt took advantage with Isabella Stewart Gardner. From his mother's side he was descended from the Colonel Stewart who in 1745 defended Edinburgh Castle on behalf of the Young Pretender.

Matt was the sixth in a family of eight. His closest sibling, a sister, died when he was 5, and so close was he to her that he attempted to free her from the coffin at her funeral. Not long afterwards, his father died. Matt's memories of him were his travelling and refusal to sign his will because a certain piece of paper could not be found. Charles

Henry Prichard was also a collector of silver and eighteenth-century porcelain. His mother, a convert to Catholicism, had lived in Florence for a time.

Mattie Prichard moved the family to South Kensington where she regularly went to mass at the Brompton Oratory. After attending a preparatory school on the Somerset coast, Matt was at Marlborough College from 1878 to 1883. His career there was undistinguished. According to one of the masters:

> Though I should much like to find out that such remarkable promise was not unrecognised, his place in the form was low . . . I remember him as a slender quite normal physique, his face lean and with a very aquiline nose . . . his voice was high-pitched and with a drawling tone. I can see him standing up in class, much more at ease than the master. His figure slightly bent and with a somewhat ironic and provoking tone of voice as if the whole business did not very much matter. If taken to task, he was not easy to deal with, as he had a quick way of defending himself and generally contrived to make the criticism sound rather foolish.[3]

Early on, Matt acquired certain characteristics he would later use to great advantage.

One of his sisters remembered his obsession with buildings and museums: 'I think he used to spend more than half his days inside the South Kensington Museum [now the Victoria & Albert]',[4] and when he was 16 he took his sister's wedding guests on a 'self-appointed tour of the museum'. While still at Marlborough, his mother died in Rome, and Matt's Aunt Charlotte took charge of the children. They moved out to Somerset. Matt had great affection for her, and on her death felt 'almost the last link between me and my progenitors was snapped . . .'[5] After leaving Marlborough, Matt spent most of the next year with a tutor, F. B. Harvey, to prepare for Oxford. He was very close to the Harvey family and when they moved from Eynsham to a house at Blenheim, Matt organized their departure. The Harveys recognized his skill and Miss Harvey recalled 'the success of the operation, the chairs ending in one room, tables in another, and all the crockery in the right place'.[6]

In January 1884, Prichard entered New College only months after Ned Warren's matriculation. It remains unrecorded when and how the two first met, but in 1884, John Marshall, Harold Scott, Arthur West and

George Harding were all at the college. As at Marlborough, Prichard failed to excel scholastically, obtaining a pass in Moderations and a second in Jurisprudence. He often suffered from acute indigestion which led eventually to his becoming a vegetarian. He also did not make much of an impression on his tutors: 'A quiet, self-contained sort of fellow . . . he was one of the unassuming friendly spirits who made New College the pleasant place it is.'[7] That was more a plug for New College than for Matt. Another went a bit further – 'rather an eccentric with a languid manner and slightly supercilious attitude'.[8] As with the young Fothergill, Ned saw more in Prichard than this. Furthermore, he was pliable and definitely in search of something, and the teacher in Ned was certainly drawn to that.

Later in life, Prichard said he did not begin 'to think' until after his days at Oxford. It was then that he took rooms with George Valentine Harding in Bloomsbury.[9] Both received their BA on 10 October 1887 and had studied jurisprudence together. A year later, Matt took his BCL and worked for a while for an authority on libel cases. He was called to the bar in 1892 and immediately transferred to the chambers of Sir Harry Eve. Matt did not like court work and said that lawyers were like actors: as a result of assuming various roles they had lost their own point of view.[10]

Nevertheless, for three years Matt was a practising barrister at No. 4 Lincoln's Inn where he made between £150 to £200 a year. One of his associates, Greaves, a clerk to Sir Harry, said that no one was better liked than Prichard: 'I never heard him cross, or make a complaint, or utter an unkind word'. But Prichard had two idiosyncrasies. One was his genuine apprehension of women. One evening, Greaves persuaded him to look in at a party: 'No,' Prichard said. 'There are women. I shall tremble.' The other was his extraordinary generosity. The office boys got more from him for a trifling service than from others with five-figure incomes. He gave guineas where he could only afford shillings.[11]

By the end of 1892 (the Van Branteghem sale of vases was in May), Ned recognized the need for secretarial organization. What better than to have as two secretaries men he had known at New College and who also brought with them a knowledge of law, which would come in handy in when dealing with export licences and problems of authentication. At first, neither Harding nor Prichard knew exactly what their jobs would entail, but neither was really interested in

pursuing a legal career. Matt had a private income of £400 annually from his father's estate, so he could afford to take a chance.

Matt was useful to Ned in another respect. Just as he had helped the Harveys at Blenheim, he loved working on the furnishings of Lewes House. In a letter from Oxford Ned wrote: 'Matt says we must have dressing-tables, and so we must.' Apparently, he and Harding decided to stay permanently at Lewes almost on the spur of the moment. The two made the decision on the steps of the British Museum on Saturday when they 'felt like a walk'. The walk ended in a train ride to Lewes where at dinner they agreed to accept Ned's offer.

Three men in particular who often visited Lewes House felt that Prichard was the most vital member of the household. John Cowper Powys, the poet and novelist, said Warren was 'a man of quaint personality with a power of creating a circle of intimacy in which Matt was clearly supplying a strong virile element'.[12] Powys went further and said Prichard was 'the most stimulating figure of them all . . . When I dined there as often I did, Warren, Marshall and Fisher in discussing their plan of campaign would always say it was Prichard who supplied their "blood and iron" line of approach.'[13] Powys recognized difficulties ahead for Matt: 'As his thought and his career deepened, [Lewes House's] limited ideals may have seemed an unwarranted handicap to his incisive, questing mind.'[14]

New College graduate Sir Claud Schuster (1869-1956) is today largely remembered for his book on mountaineering, but he was also a lawyer, a clerk of the Crown and from 1915 to 1944 Permanent Secretary to the Lord Chancellor. Like Powys, Schuster could not comprehend – as he put it – 'the career change to Lewes House where [Matt] enrolled himself as another secretary'.[15] He said of Prichard that he had

> a great capacity for arousing the interest of others, also the curious habit of self-effacement . . . and a rather fierce spirit of what I can only call contempt for those who took lightly things he regarded as important. He was the most charming and delightful companion, but I must admit that I felt a certain awe of him which I never cast off throughout my life . . . There can be no doubt that if he had persevered at the law, he would have succeeded . . . However, for reasons which I did not then and do not now understand, he gave it up and disappeared.[16]

Prichard's brother-in-law, T.H. Lyon, also could not understand

Matt's new occupation, and found Ned Warren to be an 'over-lord' with those he had persuaded to join him at Lewes House. For Lyon the general atmosphere of Lewes House was depressing: 'an attempt to live again under a paganism long since dead must, I think, be charged with something very like make-believe'. He was often glad to be out of the house and again walking over the downs.[17]

Lyon was also irritated with certain inconsistencies in his brother-in-law's behaviour: 'How well I remember one marvellous head of Venus [the Bartlett Head] which only the privileged few were allowed to see. I took a young medical student one day hoping to win him permission, but "No" was Prichard's answer. "What does he care about art?" ' On Bonfire Night on 5 November (still celebrated in Lewes with some of the biggest bonfires and torchlight processions in Britain), Lyon walked over to Lewes: 'The whole town would turn out, mostly in fancy dress, and wind its way up the hill by the light of the torches they carried. It was most striking, but most clearly of all, I still visualize the figure of Prichard, as he stood, his Turkish cap on his head, his arms stretched between the door-posts of Lewes House, absolutely motionless. He might have been the tribal god of Lewes.'[18]

For his part Prichard was too absorbed in his new venture to worry at that time about the direction of his life. He enjoyed the role Warren had given him of introducing some order into the Lewes House regime. His work there, however, was not always appreciated by some of the men. Harding once admitted: 'he *did* initiate order and method into the machinery, but, by God, we had to pay for it.'[19] Marshall added more diplomatically: 'We did not always look forward to the time when the big ledger was added up at the last day by Matt.'[20]

Prichard clearly loved Warren who was like a father to him. He spoke of his relationship to Fothergill as Warren being 'a sort of Buddha at whose feet he used to sit'. Warren encouraged Prichard to pursue his own interests and at Lewes House he absorbed all he could about art and music. It was there he first read Nietzsche which Prichard said 'made me think I was super-charged'.[21]

Not only did Prichard have more responsibility at Lewes House than Fothergill, Harding and the others, he was also more involved in making purchases for the Boston Museum. Of course, Marshall was always the man in charge of how the purchasing was to progress, but he came to need and appreciate Prichard's aid and ability. Interestingly, it is more in Prichard's letters and the records of his friends that we receive a feeling of the nefarious character of some of the purchas-

ing. Schuster gave the earliest observation of Prichard's work with Marshall in Rome. In the winter of 1892 he was in Rome with the two of them:

> They were in an old-fashioned hotel, actively engaged, there is no harm now in saying, in evading the Italian law which forbade the exportation of works of art. These were, I suppose, for the most part copies in marble of Greek originals made for the Roman market. We had in particular very great fun with a marble torso which was conveyed in Rome from house to house, concealed from the researches of the police. [This torso of Hermes is now in the Boston Museum, and was lovingly photographed in the garden of Lewes House by Edward Reeves. See back cover.] In the course of the journey, I learned more about the general principles of criticism as applied to Hellenic things than I have learned before or since.[22]

Matt appeared to enjoy the intrigue. During these heady days of his involvement, he spoke of secret coded telegrams the three used to communicate across Europe and how diplomats were persuaded to smuggle small antiquities for them 'inside friendly legation bags'. Communications from Matt in this period indicate that he was as he boasted 'putting whole soul into the enterprise'. From Rome in 1896, Prichard said that an unnamed aristocrat had just been buried, and the very next day he was 'off like a vulture' to see if he could arrange anything with the heirs. Shortly after, (oddly writing in the third person) Matt reported:

> Little Master Matt is beginning to grow his wings and today has bought for £20 the heads of youths which can't be worth less than twenty times that sum. If he gets the statuette, oh, how content he'll be . . . Doubtless we stand on the threshold of great discoveries . . . I didn't dare look at the things, which are in the hands of an ignoramus, grazie . . . but the statuette I guessed in a moment to be a treasure. Too excited to think.

From another venture in Frascati, Prichard boasted, 'Our cup is nearly full.'[23]

Matt told his sister, May, in England that his life was a sort of whirl of excitement: 'No sooner is one thing finished than four things are recommended and five new things to fight for. Our net is wide and

there are many fish. I tug away merrily.' He did complain that he and Marshall were constantly in need of money, but added: 'The pain and grief of waiting for money fades quickly on the receipt of it.'[24]

Ned wrote to Matt that he regretted being away from the scene of action and preoccupied with getting his finances in order. Matt replied: 'It is wrong that you should be unhappy and I happy, but Heaven knows how long my glory will last . . . Please do not think of me, Ned, that I have tried to injure this business of yours, or that I could be so brutal as to try and draw profit from it.'[25] It would be interesting to know just what prompted this last remark, but the rivalries among Marshall, Harding, Fisher and Prichard often suggested that each felt the other might be taking advantage of Ned's benevolence. For his part, Ned was having difficulties facing unbalanced accounts due to high expenditure at Lewes House and an open-ended collecting enterprise abroad.

For nine months, in 1898, Matt was back in Lewes trying to keep on top of matters. He faced some odd queries: the telegraph people in London wanted to know why Lewes House was sending out so many cipher telegrams to Greece. Ned was also in the practice of sending Marshall blank cheques. He had Matt advise Marshall: 'Use them only if the matter is certain. If you use a cheque, telegraph to me at once that I may see how to meet it. By hook or crook it will be done, chiefly crook. Don't lose any of them.'[26]

Matt seemed content at this point, but the seeds of strain were being sown. An article on Nietszche sent by Fisher to Prichard became the occasion for him to analyse his and Warren's differing approaches to life. He told Ned: 'You and I shall not agree always. You are analytical, I prefer synthesis: you are metaphysical, while science appeals more to me. You are altruistic, I individualistic. You probably believe in freedom of action, I in determinism.' Nietszche and Prichard were abruptly and uncharacteristically dismissed in Warren's reply: 'Dear Ducky, Synthetic means sweeping, individualistic means masterful. Don't hoodwink yourself with phrases . . . You master your ethics, before they master you. You can't cram them.'[27]

It was becoming increasingly difficult for Matt to justify his actions philosophically. He ascribed 'freedom of action' to Ned, and determinism to himself, but in daily actions the reverse was true. On the practical level, he, like Fothergill, had his difficulties with Marshall. In October of 1892, Marshall asked Warren: 'Am I to leave Lewes? You are finding, I suppose, your work better done than when I was there;

you feel better. Harding and Prichard will probably advise you. You are in a better way.'[28] Two years later, Warren told Marshall that the plan of taking Matt Prichard and Harding was intended to afford him a greater chance to carry out Marshall's suggestions: 'We are all now banded together for one purpose, and you are in a way the head of the band. I hope we shall work together like one family.' Then Ned returned to Marshall's greatest fear: 'You think that by taking on new people I give you a sort of certificate of inefficiency. This is only true' for the less important parts of your work: things for which as a matter of fact I hated to call you off from more important things. You see I speak frankly, and you should trust me when I tell you that you are worth your salt.'[29]

By any count, Harding was not a success, but Marshall hinted at more in a letter in 1894: 'We should be very happy alone, without horses, without servants, with a piano and with some books, and far away from everyone. But if you will have Matt and Harder [Harding] and Fish [Fisher] and me, well – I am a bit sore.'[30] Though Prichard's and even Harding's assistance helped as the volume of collecting increased, Marshall was not ready to accept them as equals. Their growing involvement increased Marshall's paranoia that he was inefficient. He also viewed them as rivals for Ned's affection.

In one of the fragments of Warren's attempted autobiography, he admitted the addition of secretaries was a deathblow to his relationship with Marshall:

'I don't know whether Johnny would have been discontented if these people had never been in the house, but he did resent the presence of any one save Fisher. When I took Prichard and Harding as secretaries, I think it was then he said, "*Die Schone Zeit ist vorbei* [The good times are over]", a pathetic utterance, though I could not see its reason. Prichard at least was the foundation of sane collecting. With his help, our finances were made clear. That either he or Harding could ever take Johnny's place was out of the question and the fact indeed seemed to me to disappoint Prichard.[31]

That last remark indicates that Ned recognized the competition between Prichard and Marshall. Less effective secretaries like Harding and Fisher were never a threat to Marshall. Prichard was different, and for his part he must have known Marshall was jealous of him. It was only a matter of time before the two would collide. Ironically, in

the end, it was Prichard and not Marshall who came nearest to Warren's peculiar brand of aestheticism, and the only member of the brotherhood who was as openly misogynistic as Ned. Marshall was either too thick to see what was occurring or too preoccupied with his work to come to terms with it. In his letters to Ned concerning Matt, Marshall vacillated between 'Matt has made up his mind to tolerate me a little longer' and 'Matt is very quiet and good and sweet in every way and makes me feel a good for nothing by his constant working'.[32]

Prichard was successful in Greece. With the death of a well-known Greek dealer, Rhousopoulos, he was able to pick up some good items – a fine terracotta and some coins. His greatest achievement, however, was the negotiations for the Boston Museum's Bartlett Head. (Francis Bartlett, a Boston lawyer and trustee of the museum made anonymous benefactions to cover 290 items of the Warren collection. The most important piece was named after Bartlett: a fourth-century Praxitelean marble head, one of the most beautiful examples of Greek sculpture in existence.) As with the Chios Head and the Boston Relief, Marshall did all the writing about the find, but in his 1912 letter to the President of Corpus Christi College, Harry Thomas said the head was 'secured mainly by the execution of Mr. Prichard'.[33]

Matt soon mastered the intricacies of dealing with the Greeks and came to recognize lies 'which followed thick, sometimes ending with the local law-breaker's departure to gaol'.[34] One dealer masqueraded as an Orthodox priest and even swore 'on the Holy Gospels' that a particular piece was genuine. Houses of other dealers were sometimes surrounded by police. Matt wired to Ned: 'Come and take your Greeks. I can do nothing with them. They spend their days cheating, and their nights in calling one another buggers, and there is no health in them.'[35]

There were compensations. At a tennis party, Prichard met Mrs Pallis, the wife of the owner of what came to be called the Bartlett Head, and closed the deal. Matt exclaimed: 'The head is beyond words wonderful. If you can tell me it is by Praxiteles, I will believe you.' Four months later, it was unpacked at Lewes, Marshall exclaimed: 'It looks very beautiful. Matt was almost crying with joy, and I felt like crying myself . . . This justifies Matt's long stay in Greece.' Marshall also said to Ned: 'Certainly not I, and probably not you could have got it.'[36]

Matt carried on, with Ned claiming that if it were not for him 'the confusion would be hopeless and if he broke off now, no one will ever be able to make things out'.[37] Matt's last trip for Lewes House was to

Constantinople and Cairo. It was there that he acquired the 'Arabic' ways described by Gearing. Matt was delighted with his efforts at learning Arabic: 'What seemed an impossibility is beginning to make a noise within an egg. With an effort I can string together an Arabic sentence, but it is not yet understood by anyone.'[38]

With the Boston Museum concentrating on its building programme, interest in large acquisitions from Warren ceased. In 1900, the Trustees made no appropriations for the purchase of classical antiquities, and, as we have seen, Ned blamed his brother Sam for the change of policy. Matt joined Ned on his next trip to America. He hit it off well with Sam Warren – too well for Ned's liking. In 1902, he was asked to be the Secretary of the Museum, and Sam soon recognized the abilities which had been so appealing to Ned. Ned discovered that Matt – and Fisher who joined Matt – were enchanted with Boston and received everywhere. Ned said it was not hard to see why Matt was so 'contented': 'He always liked society and diplomacy.'[39] But soon Ned interpreted Matt and Fisher's leaving as going over to the enemy. He never forgave them for this action, and Matt and Ned never saw each other again. For a time the two kept in touch through a mutual friend, but even that link stopped when Matt discovered Ned had made some negative remarks about him to a friend.[40] Matt extended his icy reaction to Fothergill as well. In his memoir Fothergill said the last time he saw Prichard was in Whitehall where he was posting some letters. Fothergill greeted him, 'How do you do, Matt?' Matt lifted his 'curious thin face high into the air, and said, 'How *do* you do?' and walked away.[41]

2

Dearest Isabella

Prichard spent six years in Boston and made a lasting impact on museum management. He also developed a friendship which would continue for twenty years. Early in 1902, Prichard brought his sister, May, up to date:

> You will think me no end of a strange fellow for not letting you hear a word of myself during these long months. There has been much to tell of interest, but much about which it seemed to me better to keep quiet. The upshot of the whole matter is this, that it seemed best for me to part company with Mr. Warren, that having done so it was necessary to find other work to do, and that in consequence it is probable that my future will be passed in America. It all seems very simple, so simple that not a day has my work suffered and not a moment of real anxiety has been caused me. Mr. Fisher is in the same boat with me, but we are not without friends and somehow or another we have capacities to offer that may find us the means of supporting our existence.[42]

During the summer of 1902, when Isabella Gardner (or Mrs Jack as she came to be known) was at her house in Brookline, Prichard occupied a small flat on the ground floor of her Back Bay palazzo, Fenway Court. He joined her inner circle of friends almost immediately. Some of them thought Prichard was 'exceedingly handsome'; others referred to his Dantesque profile, curiously thin face and haughty manner. He was always dressed in dark clothes with the jacket buttoned up high. But by all accounts, at 37, Matt commanded attention. Mrs Jack, then 62, was enchanted by him, and his middle name: 'Was he a royal Stewart like herself? Indeed he was, he said.'[43]

Mrs Jack also commanded attention, and though far from being physically attractive, she knew how to take advantage of what attracted men to her. An anonymous reporter said: 'Mrs. Jack Gardner is one of the seven wonders of Boston . . . She is a millionaire Bohemieene . . . plain, and wide-mouthed, but has the handsomest neck, shoulders and arms in all Boston. She imitates nobody, every-

thing she does is novel and original.'[44] Mrs Jack always had a number of young men as admirers, and some were referred to as her gnomes. Those who bought antiquities for her were Richard Norton, Ralph Curtis and Joseph Lindon Smith. All three disliked Bernard Berenson (as he did them). Norton went so far as to say that B.B. was dishonest, but the great connoisseur soon had almost complete control of what was purchased for Fenway Court. Had he arrived in Boston earlier, Prichard was certain that he would have been involved in her great art collection. As he explained to his sister: 'It is probable that she would employ me herself, did it fall in with her wishes, but for the moment at least my aims are different.'[45]

Belle Stewart was the daughter of David Stewart, an enterprising New York businessman, and through Julia Gardner of Boston (with whom she attended a finishing school in Paris) she met Julia's brother, Jack. Jack Gardner was the heir of two Massachusetts families, the Gardners of Boston and, on his mother's side, the Peabodys of Salem. They were married in 1860 and settled into living as Proper Bostonians. In time, Belle Gardner shocked some of that society by her tight dresses, low necklines and showy display of pearls. While other Boston ladies had one coachman, she drove out with two in full livery. Her fondness for bright young men also caused gossip in the Back Bay. John Singer Sargent, who painted her twice (once with a string of pearls wrapped suggestively around her waist), was 32 and Belle was 48 when the artist chased her around the gymnasium floor of Groton School.

But Mrs Jack outdistanced and outlived all her Boston critics. Her lasting monument, Fenway Court, remains the most extraordinary house-museum in America. Before she died, she had acquired the finest collection of Italian Renaissance paintings in the United States, and it still ranks second only to the National Gallery in Washington. Mrs Jack also had the distinction of purchasing what Rubens thought to be the greatest painting in the world, Titian's *Rape of Europa*, acquired by her in 1896, making it possibly the first master painting of the highest order to come to America.

Henry James wrote her almost 100 letters and like Prichard's 285 they are still kept at Fenway Court. James's biographer, Leon Edel, described James's letters as masterpieces of 'epistolary persiflage'.[46] James indulged constantly in the mock-ironic and Isabella was flattered. He could respond to her letter that she shed tears for the failure of one of his plays by suggesting those tears were really pearls. She, a great collector of pearls, was exhilarated. Edel says

Such letters could only have been written by someone who, at the bottom, really liked the self-inflated, wilful and driven Mrs. Gardner. James could rail at her in the privacy of his notebooks, see her as one of the tide of transatlantic 'barbarians" overrunning Europe, carrying off shiploads of spoils – while at the same time he penetrated the facade and understood that Isabella's acute queenship concealed a certain strange shyness and timidity, a certain shyness no real Queen would have.[47]

Unlike Henry James, Prichard kept no private notebook which revealed his feelings towards Mrs Jack. We are left to guess. There is no doubt that each developed quite contradictory ideas concerning art and collecting, and Prichard tried over the years to convert her to his radically developing theories, but Mrs Jack was hardly of a philosophical bent. Despite their differences, however, he was utterly devoted to her. Theirs was an odd 'romance': most especially considering the fact that after he left Boston in 1907, they never saw each other again. In a manner, she became for Prichard a substitute for Warren. Until her death in 1924, Prichard poured out feelings and impressions he once had reserved for Ned. That relationship ended with Prichard's move to Boston; the New World blotted out Lewes House.

Ned Warren was never close to Isabella Gardner though the two were largely responsible for the $700 for Bernard Berenson's first year abroad. There were other connections as well. Ned took Mrs Gardner's nephew, William Amory Gardner, to Greece, and as earlier noted, William's brother Joseph (who committed suicide) was once close to Ned.

Mrs Jack's relationship with Matt was different from those she had with the gnomes who helped her with the collecting. Not only was he older than they, Matt was also experienced with the intrigues and inner workings of the art world. He had a special place in her scheme. On Christmas Eve, in 1904, at Fenway Court, Mrs Jack had only eight dinner guests. Prichard was to her left and Fisher was also present. She sent a diagram of the seating arrangement to Berenson, adding that this dinner was 'after four Christmas dinners on four successive days'[48] – a point Matt would not have appreciated. However, Matt was given full sway at Fenway Court to bring any who measured up to his standards, often more exacting than Mrs Jack's. The credentials that he offered Mrs Gardner for her forthcoming guests were often charmingly simple, as when he

described the future Beatrix Farrand as 'Miss Cadwallader Jones, of New York, a landscape gardener, knows about art, bright and no trouble'.[49] Matt vetted an increasing number of guests and gave good advice of how Fenway Court should be managed. After all, he was on the inside of her chief Boston rival, the Museum of Fine Arts, and was aware of their potential purchases and plans. Mrs Jack had Matt take her around the Boston Museum for instruction. He insisted, 'There is much I can learn from you, little in which I can instruct you.'[50] As with Henry James, she appreciated the flattery, and also took in more than Matt realized.

Towards the end of Prichard's stay at Fenway Court, he asked Mrs Jack for her photograph, 'not that it is necessary for me to possess any memorial of you. Your kindness is especially before me today, now that all my little property has been removed to Arlington Street. It will be pleasant to break my rule against property in this particularly attractive direction.'[51] Matt's schoolboy infatuation continued unabated, and soon he was singing her praises to Sam Warren. On 14 August 1902, Sam wrote to Mrs Jack: 'Mr Prichard leaves me to hope that the Museum Building Committee can obtain the benefit of your views as to the best mode of procedure . . . I can assure you the Committee will be very glad to give careful consideration to any suggestion you may be willing to make.'[52] She recommended that Sargent decorate some of the walls of the new museum building and he did so with rather innocuous Greek maidens. More importantly, Mrs Jack sided with Matt and Sam in the great battle over the Boston Museum casts.

Today the fuss appears nugatory, but the plaster casts of famous European works was to the Boston public the heart of the museum. With the casts they had their own *Venus de Milo*, *David* and Parthenon frieze. They filled the entire first floor, occupying half the exhibition space of the whole building. Edward Robinson (then Director of the Museum) and others associated with him had written books that used Classical and Renaissance casts as the basis for studying the history of art. Prichard detested them and said they were like the player piano and squawky cylinder-disk phonograph to real music. He wanted to clear the enormous space they occupied for the fine objects which he, and Marshall, had made available to the museum. The stage was set when Sam Warren and Edward Robinson went to Europe for three months to study various European museums. Prichard was appointed Acting Director and a great deal happened while President and Director were away. He had been busy since his arrival two years

earlier, and over the next few years devised a cataloguing system which has been cited as 'a valuable contribution to museum administrative method . . . now used by all the larger museums in the United States'.[53]

On 3 January 1904, Prichard wrote to Mrs Gardner: 'My new duties as Director pro tem., began yesterday, and I am still appalled at the amount, not of responsibility, but of work on my shoulders.'[54] He had, however, been prepared for some time. While Warren and Robinson were in Europe Prichard's essay, 'Current Theories of the Arrangement of the Museum and their Application to the Museum of Fine Arts', appeared. He had finished it within eighteen months of joining the museum, and it set into motion reactions which would eventually send Prichard back to Europe. It appears tame stuff today, but Prichard's ideas called into question many long-standing procedures by which the Boston Museum and other museums operated at the turn of the century.

At that time, there was no vast network of art scholars, curators and conservators. The attitude of museum directors and the trustees then was one of *noblesse oblige*. Art was an exclusively private and secret world; curators presided over collections as if they were their own personal turf. Prichard's first and great commandment for the museum was 'to collect objects important for their aesthetic quality and to exhibit them in a way most fitted to affect the mind of the beholder'.[55] All other considerations were subsidiary to this aim. The museum visitor should not be worn out by being offered too much to see. Prichard felt that the astute curator would recognize among his exhibits what was superfluous and eliminate it.[56] Put into practice that advice would mean many objects given by rich patrons would be headed for the storeroom.

Prichard took to task the notion that museums should serve an educational purpose: 'A museum is not a pedagogic institution or "manner garten", and the history of art has no more to do with art itself than the history of cooking with a good dinner. I do not say "Do not teach." What I say is "Do not exhibit the machinery." '[57] Prichard was also against the common practice of grouping objects as ceramics, metals, textiles and coins. They should be arranged by the cultures and periods which produced them. Prichard was just warming up. What he said in particular about the Boston Museum struck like a bombshell: 'Considering the application of these principles to our collections, it is necessary to be frank; our personal appreciation and devotion must not blind us to the facts. The Public does not look

at Greek vases. The Public does not look at Japanese Pottery. The Public does not look at any long series of small objects . . . It is a waste of effort and space to show to the Public what the Public does not regard.'[58]

The last words struck at the enthusiasms of Edward Robinson. There was more, much more, in Prichard's essay; indeed, as Boston Museum historian Whitehill writes, 'it is practically a blueprint for the planning of the new building and a foretaste of principles that were to become general in museums elsewhere some years or decades in the future'.[59] But Robinson was hardly pleased to be told by an Englishman – one once involved in sending over great hordes of Lewes House treasure – that 'The Public does not look at' his hard-sought Greek vases. Whitehill concluded: 'Prichard had said the right thing, at the right time, but to some of the wrong people.'[60]

On at least one occasion Prichard handled the Trustees and the Building Committee in Machiavellian fashion. Once, Mrs Jack detained Dr Bigelow (a supporter of Robinson) from a Building Committee meeting with the bait of luncheon at Fenway Court. On 27 August 1904, Prichard thanked Isabella for the success of a Trustee meeting: 'There is no doubt in my mind that the Museum acted wisely, though had it not been for you, heaven only knows what would have happened. The Director is quite surprised at the ease in which the matter went, and little knows how it all came about.'[61] The matter referred to was the trebling of the number of Greek coins in the museum collection. Matt had secured the extraordinarily choice collection of Canon Greenwell just at the time when the museum announced no new appropriation for the purchase of classical antiquities. Mrs Jack whispered its significance in just the right trustee ears. Undoubtedly, Matt and Isabella relished their little intrigues, and she benefited from Prichard's inside knowledge of just what Fenway Court's rival was manoeuvring to purchase, or let go by the wayside.

When Robinson returned from Europe, he wrote an extremely long letter about casts to the Building Committee which not only defended their place, but proposed an expansion of the collection. The battle lines were clearly drawn. On 3 November, Prichard wrote to Mrs Jack that the fight would be on Tuesday. He felt that he would lose, calculating that he had only two definite votes on his side (including Sam Warren). Two others were possibly for him; three were definitely against, and one probably against. The remaining five were uncertain. Prichard's calculations were wrong, and he picked up more support

with the voting going 50/50. The committee decided not to 'provide in the present plans for a material increase in the collection of casts'.[62]

In reality, that diffuse statement meant that the casts were doomed and not one can be seen in the museum today. Obviously Robinson was insulted by the development, but carried on until the summer of 1905 when he resigned. Almost immediately he accepted the post of Assistant Director of the Metropolitan Museum in New York.

A number of people expected Prichard to become the new Director at Boston. Writing from I Tatti, B.B. said to Mrs Jack that several Bostonians had visited him in the summer and 'all talked much of the Museum and of the candidates for a Director. Now that you have brought it to pass [a telling statement coming from B.B.!], the only sensible thing would be Prichard. I don't think they can get a man who would do as well.'[63]

Earlier, Mrs Gardner had written to B.B. that Robinson 'did absolutely nothing for two years, *but appear,* and the Museum work went on, as never before, under efficient go-ahead hands.'[64] Robinson had good reason to block any suggestion that his successor would be the Englishman. Despite the close relationship between John Marshall and Robinson, there was a certain long-standing antagonism between Prichard and Robinson . Part of that went back to their differing views on a gold necklace bought by Mrs J. Montgomery Sears. Robinson pronounced the supposed Greek antiquity genuine. She was not satisfied and sought a second opinion. Prichard not only said it was a fake – he proved it so to be.

Today, it seems ludicrous that Prichard actually thought he might succeed Robinson. Friends might suggest it but knowing the museum world, even they would have been surprised if Boston opted for Prichard at this stage of its development. Prichard certainly enjoyed fantasizing on the possibility in a letter to an English friend:

After seventeen months work here they have made me Assistant Director. This action is a mark of special confidence in view of the fact that there was a holder of the office already in the museum [Benjamin Ives Gilman]; but he has retired in my favour . . . I regard it as a compliment. Such has been my aim for the greater part of my life . . . You will see me in a frock coat on Sundays now, passing along Beacon Street and pounding regularly at the door-knockers. The mornings I shall pass in an automobile along the speedway, if I can find it. I shall buy a dog, and hire a mistress, drink cocktails and join the Tavern Club. I

shall sail in a catboat, get an introduction to Mrs. Stuyvesant Fish, speak with bated breath of the Director . . . go to church (or become a Roman Catholic), have an opinion of the negro problem, the importation of Jews, reciprocity and the tariff. I shall hunt, skate, go in for mixed bathing; marry (in the end), grow fat and rich, endow a school, rob the fatherless and widows, return to England and be knighted. What experiences there remain for me to undergo![65]

Intended as jest, there is no doubt that Prichard almost expected that scenario to ensue. Given any other circumstances, he just might have been designated the new Director. But aside from the vision he had presented to the Boston Museum and his remarkable self-confidence (most appreciated by Sam Warren), Prichard had also succeeded in splitting the Trustees right down the middle. They appointed T. Randolph Coolidge, a former trustee and architect as Temporary Director. Prichard was demoted from Assistant Director to the rather debased position of Bursar, and after six months he left the museum.

He next accepted an odd job – secretary of a committee on the Utilization of Museums of Art by Schools and Colleges, at Simmons College in Boston. Simmons was founded in 1899 as an institution offering women professional career training of which Matt Prichard was hardly the keenest advocate. Before taking up his new post he went to Europe for part of the summer, returning for a year of totally unsatisfying new work at Simmons. In 1907, Prichard went back to Europe for good, saying: 'America pulled up her skirts for me, but no scandal! It was only a skeleton she hid beneath them.'[66] That year John Marshall had married and joined Edward Robinson at the Metropolitan to be his European purchasing agent. Within three years Sam Warren was dead. Prichard's life changed irreversibly, and his days as collector and museum official were finished forever.

3

A Considerable Sojourn

Earlier in 1907, Matt had written to his brother, Charles, that he planned to stay abroad as long as possible: 'The last year [at Simmons College] was necessary to be here to show people that I existed and our cause was not wrecked, but I think I can now be spared to give the time to student life.'[67]

Prichard had no firm idea of what he was going to do. He talked about teaching but had no real employment in mind. The experience at Simmons College had been off-putting, and he really could not see himself following the out-of-work aesthetes he knew who took up public school teaching. Removed from treasure hunting for Lewes House and his position at the Boston Museum, Matt's ideas about art were hardening. They grew increasingly negative and reactionary to what he had been exposed to at Lewes. Like Fothergill, he experienced withdrawal; unlike Fothergill, Matt became bitter over the Lewes House period. He said that ancient art was 'all a mistake'. The Greek point of view was dead and so was the Renaissance. As for collecting, it was now 'impious' to Prichard and collecting ancient art was like 'ferreting in a charnel-house'.[68] He struck at the very foundation of Lewes House.

A great deal happened in the art world before the First World War and Prichard took a keen interest – but in a highly selective manner. Roger Fry met Prichard while he was still at the Boston Museum and was impressed by his 'severity': Prichard developed 'a very austere, esoteric system of aesthetics which enabled him at the end of his life to look on nothing with pleasure except a few Byzantine coins'.[69] However, Pritchard introduced Santayana's *The Sense of Beauty* to Fry which had a formative influence on him. After his confrontation with J.P. Morgan, Fry was advised by friends to resign his position as curator of paintings at the Metropolitan. Both Prichard and Mrs Gardner took Fry's side in the affair and saw Morgan as the culprit. Mrs Gardner told Berenson that Fry 'had been turned down by Pierpont Morgan'.[70]

During his years at the Met, Fry was regarded as an expert on Old

Masters who had little enthusiasm for modern paintings. In 1906, he saw the work of Cézanne for the first time and soon became interested in him and similar artists such as Gaughin, Van Gogh and Matisse. In time, Fry was a great exponent of the Post-Impressionists and lent his support in 1910 to an exhibition of their paintings in London. Quentin Bell said Fry was 'the man who brought Post-Impressionism to England',[71] and the latter was roundly condemned by critics of the art establishment. Wilfrid Blunt said in *The Times*: 'They are the works of idleness and of impotent stupidity, a pornographic show.'[72] Fry weathered the storm and, as Virginia Woolf put it, became 'the father of British painting and the leader of the rebels'.[73] He went on to be a painter of some distinction, a lecturer in constant demand and the author of several significant books.

Prichard was also to embrace radical changes in the direction of art, but his road to Matisse was a singularly peculiar one. Before his infatuation with the artist, Prichard nursed a new obsession with Byzantine art which at this time was generally despised by academicians, who viewed it as oriental, theocratic and fundamentally opposed to the spirit of ancient Greek art. In the last respect, Prichard's choice was an understandable continuation of his post-Lewes House reaction. He continued to assail the ramparts of Greek and Renaissance art and thought, and from Venice he extolled the virtues of St Mark's: 'you can defile its mosaics, but you cannot alter the unspeakable glory of its construction and atmosphere. Until I know that church I cannot think of deserting the town.'

Prichard also told Mrs Jack that his new artistic interest meant that he must 'devour the pala d'oro and other Marcian treasures'.[74] The pala d'oro is the fabulous Byzantine altarpiece crafted from gold, silver, enamel and jewels. Mrs Jack answered by saying that many in Boston wondered what he 'was up to'.[75] So did someone whom Matt regularly corresponded and argued, Claude Phillips. Phillips was the one-time art critic of the *Daily Telegraph* and from 1897 to 1911 was Keeper of the Wallace Collection. He admired Roger Fry and disliked B.B. Phillips had the reputation of being 'the cleanest man in London' since he gave advice on paintings absolutely free of charge, which, of course, was not the case with Berenson. Phillips once said that he never cared to meet Berenson as he was 'a man too much surrounded by an atmosphere of a storm'.[76]

Phillips was equally candid with Prichard: 'Do you see yourself as a new Messiah in the world of art?' To Phillips's way of thinking, Prichard was embracing an unreal exclusiveness.[77] Mrs Jack was

more gentle and referred to her friend's 'self-imposed task'. She asked when he would return to the New World and Prichard responded that his study was best fulfilled in Europe where he would try to 'penetrate the veil which separates us from the understanding of art'.[78] Several months later, he said that occasionally it depressed him to think of Boston: 'not for opportunities missed by me, but as a vale of suffering, and for the opportunities missed by it. I do not see the glimmer of dawn there, but hope that your prophetic eyes are richly blessed. It is clear to me, nevertheless, that it will be yet some time before I am free of the preoccupations that obsessed me in the land of the free.'[79]

Prichard left Italy for Paris in November which was very much a decision of the moment. At first he was overwhelmed by the city: 'I feel like a stranger in a great desert, a Columbus on an America where there are no footsteps to guide. The terror is increased, or begins perhaps, when I notice the treasure that is lying to be had at every turn.'[80] He enrolled at the Sorbonne, where he said it was months before he had the nerve to speak to any of his classmates. But he wasted no time getting to the philosophy of Henri Bergson, whose courses on Byzantine art at the College of France started a new obsession for Prichard. Two others were also to have a great influence on him: Royall Tyler, an American historian educated at New College, Oxford, who was at this time living on the Quai de Bourbon, and Camille Schuwer, a young student reading for his doctorate who frequented the salon of Sarah Stein. Sarah was the wife of Michael Stein, older brother of the famous Gertrude.

Schuwer was also a devotee of Bergson. Indeed Bergsonism became a cult among the young avant-garde of France and England, and the middle-aged Prichard was rather out of place at his lectures. However, Pierre Schneider, the biographer of Matisse, credits Prichard as being the 'indirect link between the painter and the philosopher'.[81] For Schneider there was a number of striking similarities between Matisse's aesthetics and the thought of Bergson.[82] Bergson's philosophy is complex, but he offered a new philosophical interpretation of evolution that stressed the importance of duration. He suggested that the evolutionary process should be seen as the continual creation of new forms by an enduring *élan vital* (vital impulse). Reality was a past which constantly became something new, and was also a present constantly emerging into the future. This kind of thinking fitted Prichard's post-Lewes and Boston mood perfectly.

Some observers interpreted the various radical changes in French

art as connected with Bergsonism. Matisse was but one example. However, except on the last page of his *Le rire* (1900) Bergson did not write systematically on art, although examples drawn from art abound in all his writings and attracted the attention of Prichard and others. Bergson insisted that by an effort of intuition the artist placed himself within the object of his work by a kind of sympathy. The painter could pierce the veil of conventional views and grasp the evanescent 'inner qualities of landscape or of human beings'. Early on, Prichard recognized this as occurring in Matisse's style.

In November 1909, Prichard gave Mrs Jack a full description of Bergson's lecturing:

Three quarters of an hour before the lecture begins, the hall is full and the doors are held by those inside to prevent the catastrophe which would be entailed were more of the public admitted; many take their seats two hours before he begins: I find I can find a seat near a distant window where breathing is difficult but possible if I arrive an hour early. He speaks clearly, fluently and impersonally without self-assurance but in a manner which convinces you at once that you are at last face to face with reality. He is in a way unaware of his audience . . . He is vivacious but aims at no oratorical display, remains strictly in the field of reason, though by nature he must, of course, have leanings towards mysticism. He is followed breathlessly by the most critical of audiences; you have the feeling that you are preparing in that room in company with a great teacher the future of the world.[83]

As to Bergson's approach, Prichard told Mrs Jack that

he is obliged to show very quietly the weakness of the intellectualist position, that is, the basis of action of our western world from the time of Aristotle until today. His position is that we can obtain a wider knowledge by our feeling than by our reason, that intellectual knowledge and science serve only for action, and that they only deal with that which is lifeless or is treated as if it were without life. To understand life itself we must refer to the data of our feelings and trust our intuitions. He puts reason, science, the concept on a lower plane, and feeling, art the intuition on the higher plane – they are the instruments of life.'[84]

It is very doubtful whether Mrs Gardner understood much of this, but she was willing in her inimitable way to recognize that her great friend was off on a new path. Prichard was convinced that there were two things pre-eminent in Europe at that time: 'the recognized leadership of Bergson and the importance of founding a new religion'. He added: 'One never knows how quickly things may proceed nowadays, but all points toward that recognition of life which seems to me the only matter of importance today. There only needs a spark to produce the most sumptuous explosion.'[85] Prichard wrote this to Mrs Jack in 1909. An explosion would occur in five years – the Great War – but it would not be sumptuous. Many of Prichard's friends felt that his world view was misdirected and impossibly idealistic. He became very defensive and told Mrs Jack to assure his American friends that he was busy and not 'wasting time'.[86]

Claude Phillips thought he was mad. Once, after hearing Prichard's postulations, Phillips 'burst forth' and said his thinking not only would destroy art, 'but life and everything which made life worth living'. Prichard admitted that the two had no common ground from which to start; Phillips said Prichard had 'destroyed his feeling utterly'. Despite this, they remained friends and Phillips acted as a good sounding board for Prichard: 'As long as we keep in Phillips's province – a word on my studies and he explodes like a powder magazine.'[87]

Phillips was not the only one with strong feelings about Prichard. One associate who remains anonymous said that he was 'a fanatic with a religion all of his own'. Another remarked: 'Oh, my dear! I have seen Prichard lately. He has arrived at complete incoherence.'[88] But Prichard appeared to relish his new role and wrote to one friend that he could now fantasize his own epitaph: 'Ci Git M.S.P. Qui Vit. Quelle Vit. Quelle Vie. One Bonnet but Innumerable Bees.'[89]

Roger Fry remained a friend and introduced Clive Bell, a writer on art and literature, to Prichard. Before Bell arrived in Paris, in January 1911, Fry gave him two letters: 'One to Miss Stein and one to Matt Prichard. I don't know if you know him. He will be able to show you a good many things. He's a great friend of the Steins. Anyhow, it might amuse you to look him up. He is a great Bergsonite, so you must either avoid that subject of be prepared to *listen*.'[90]

It is not known how Prichard first met the Steins. Probably, Camille Schuwer took him to one of Sarah Stein's gatherings. Prichard's letters are filled with references to the three Steins – Michael, Sarah and Gertrude. Gertrude Stein's *Autobiography of Alice B. Toklas* men-

tions Prichard and Fry together. Fry was a frequent visitor to her salon and also entertained her in London. We know less of how often Gertrude saw Prichard, but she did write: 'This was about the time too that Prichard of the Museum of Fine Arts, Boston . . . began coming. Prichard brought a great many young Oxford men. They were very nice in the room, and they thought Picasso wonderful.'[91]

Gertrude would not have admitted that Prichard was far more interested in Matisse whom she had dropped in favour of Picasso, nor would she have suggested that Prichard was more often at the less glamorous salon of her brother Michael and his wife Sarah in the Rue Madame. In 1903, Leo, Gertrude's other brother, decided to move to Paris and live as an artist, at first renting the apartment at 27 Rue de Fleurus which Gertrude later made famous. She soon followed, giving up an attempted vocation of becoming a doctor. The paintings which the two bought together in their first years in Paris were the foundation upon which Gertrude's later reputation as the prophetess of the avant-garde was built. In 1904, they bought Renoirs and a Toulouse-Lautrec. By 1905, they had discovered Matisse and the first Picassos.

It was Mrs Michael Stein whom both Prichard and Matisse liked best. Matisse described her as 'the really intelligently sensitive member of the family'.[92] She returned the favour and became his most loyal supporter. Berenson dismissed the Stein tribe generally as 'queer, conceited, un-worldly, bookish, rude, touchy, hyper-sensitive people';[93] he was kinder to Sarah: 'a quivering, fat creature, but magnetic, bold and genuine'.[94] It was she and Leo who made B.B. 'aware of Matisse's existence'. Leo began to weary of Matisse and Gertrude felt that he was totally eclipsed by Picasso. Sarah took charge, taking the first Matisse painting to San Francisco and starting a vogue for Matisse collecting in California.

Prichard was totally aligned on the side of Matisse, and he and Sarah would hold court for painters, students and others on Mondays. Often there were as many as thirty at these gatherings in the Stein studio. Tea was served, and after a while Sarah Stein, Matisse and Prichard would return into the private part of the house. Georges Duthuit (later to become Matisse's son-in-law) remembered Prichard's effect on the young. They were fascinated by 'his eloquence and presence . . . tall, distinguished and with hands whose fingers moved like snakes, with a life of their own'.[95] Duthuit first met Prichard at a vegetarian restaurant in the Rue Notre Dame des Champs, and was later taken by him to meet Matisse.

On 5 June 1912, Prichard wrote to Mrs Gardner:

I have seen Matisse occasionally lately. He goes from strength to strength, very rarely putting forth work which is not remarkable as colour and design. Since art nowadays has no aim, it can present no subject, for the subject of a picture is our action under the circumstances, and today we have no action, nor shall we have any until we have a religion. The weakness of Matisse's work is necessarily that it fails in suggesting important action to us, but that is not his fault; it has been the fault of all painting of all art since the 17th century. His gifts of colour and design are thus in a way lost; I do not indeed know where we could look for a parallel to their power.[96]

In Prichard's view, the questions raised by modern art appeared identical to those Matisse tried to resolve. Although Matisse did not fully succeed, he came nearer to doing so than any of his contemporaries. Of course, Gertrude Stein would say this distinction went to Picasso, and though he later changed his mind, Roger Fry's first impressions of Matisse were quite different from those of Prichard. Fry first met Matisse at the Steins in 1908. Writing to his wife, Fry said: 'Then we went to Matisse's studio. He's one of the neo, neo Impressionists, quite interesting and lots of talent but very queer. He does things very much like Pamela's.'[97] Pamela was Fry's 7-year-old daughter.

In June 1914, Matisse made an etching of Prichard when he happened to be in his studio and offered him twelve copies from the plate.[98] He sent one to Mrs Jack and it is still kept at Fenway Court. Earlier, he made another effort to involve her in his new life by asking if she would like to meet Mrs Stein: 'Would you like me to persuade her to go to Boston? A perfectly simple woman, frankly Jewish, absolutely straight with astonishing power in consequence, she is by persuasion a Christian Scientist and she goes home (San Francisco) to save her father's life. She has won much influence for herself in her circle here and has been most friendly and attached to me while I am most attracted to her.' The meeting never came about, and Prichard remained unsuccessful in uniting past and present relationships. Undoubtedly, Mrs Jack was already put off meeting any of the Steins after B.B.'s observations. Sarah and Leo had visited Berenson on several occasions and he said they were great adorers of Matisse: 'it was they who made me aware of his existence. They come to Florence

in the summer, and before we leave in June they come often to forage in the library, and to sit in our midst disapprovingly saying nothing. They all have power and brains, and I have always stood up for them, but I am getting so frivolous that I begin to be bored by them.'[99]

B.B.'s letter was in response to an earlier one from Mrs Gardner concerning gossip she had heard about B.B. and the Steins: 'Here comes your letter and I love it all . . . The Steins seem odd enough, and interesting, as you describe them. Someone said such nasty and horrible things about them, and their holding you in their hand!'[100] Prichard was far from such talk, and found almost as much pleasure in the company of Sarah Stein as he had with Isabella. Sarah once examined Matt's hand and 'expressed the greatest wonder that I had any aesthetic development at all . . . and she was amazed to find on my hand the sign that the capacity was gigantically developed. There was one of my old Boston colleagues present. He said it had taken him 2 1/2 years living with me to discover the quality in me, and then he learnt it was the governing force of my life – as, of course, it is.'[101]

Sarah also witnessed an odd power which John Pope-Hennessy noted concerning Prichard. (Pope-Hennessy's mother was quite close to Prichard, as we shall see.) As a boy in Sussex (1925-26), Pope-Hennessy watched a display which Prichard used to perform at the Michael Steins. He would put a glass of water on a table and seemingly, by sheer power, move it.

The only comments Prichard made concerning the best known of the Steins came after the war, on 6 June 1922, and as usual in a letter to Mrs Gardner: 'The others we saw were Miss Stein who writes prose in a cubist style. She is very pro-French, or, at least, anti-American, English or German; since, according to her, the French are realists, while the rest are all sentimentalists. She used to detest me, but was gracious seeing that we all called on her before seeing her sister-in-law, Mrs Stein.'[102] Prichard went on to relate that afterwards he went on to see Mrs Stein. He discovered that like her sister-in-law, she too had deserted Matisse in favour of Picasso: 'I said nothing but Picasso remains for me what he was to Okakura, who said, remember: "I stretched out my mind toward them [his paintings], and I touched nothing." '[103]

Like Mrs Jack, when it came to artists, Prichard was consistently loyal. Okakura-Kakuzo had been Curator of Oriental Art and adviser to the Boston Museum, and both Mrs Gardner and Prichard had come under his spell. Okakura's *Tea Book* showed the Western public for the first time what the function of a work of art was in the Orient. Matisse

met him when the Japanese was on a short visit to Paris, and Matisse's interest in the aesthetic philosophy of the Far East dates from this meeting.

Prichard did not have many friends in France, but one young man, recorded in Prichard's letters by his surname – Schaewez – was quite close. Prichard introduced him to Mrs Jack in a letter of 25 March 1911 as his French friend who just had a stroke of luck: 'They have released him from the ordinary soldier's life and put him on the auxiliary list as too delicate to serve as a soldier.'[104] Apparently, Schaewez wrote poetry and was delighted at this time to have a poem published in the *Mercure*. In August, Prichard told Mrs Jack that Schaewez 'is to be free of military service in six weeks time. He will go back to university and get his doctorate. He ought to become a leading philosopher though he has a literary tendency which tends to lead him to be discursive, but that is in the true French tradition and he is French to the marrow.'[105] It appears Schaewez lived for a time with Prichard, but he disappeared from his correspondence as abruptly as he entered it.

On 12 January 1910, Prichard first spoke of a family he came to know well, the Franchettis. Although he decried feeling 'obligated' to attend a number of social gatherings of rich Americans visiting Paris, there was enough of a snob in him clearly to enjoy being included. Many of these were friends of Isabella Gardner. Most notable was Emily Crane Chadbourne, a wealthy Chicago art lover, who had a large town house in Park Lane in London, where she entertained international society. She became devoted to Prichard and later he accompanied her on several trips. Prichard first met the Baroness Franchetti at one of Mrs Chadbourne's gatherings in Paris. She was the wife of Baron Giorgio Franchetti and described by the artist Walter Sickert as 'a distinguished ornament of Venetian society'. The baron's mother was Luisa Sarah de Rothschild of the Vienna branch of the family, and he married Marion Baroness Hornstein von Hohenstoffel. He inherited the Palazzo Cavalli on the Grand Canal from his parents, who, according to Sickert, 'had done it up in very elaborate and doubtful taste'.[106] After selling the palazzo he bought the famous Cà d'Oro (also on the Grand Canal) which he restored, filling it with a huge collection of paintings, sculptures and furniture. He sold that to the Italian State in 1922. Sickert thought Franchetti 'a typical dilettante, yearning for the craftmanship of the past and hostile to modern art'.[107]

Prichard took an interest in the two sons of the baron, Luigi (or Luigino as Matt knew him) and Carlo Giorgio Francesco (who were

cousins of Romaine Brooks's sometime intimate, Mimi Franchetti). Prichard first met Luigino in Paris with his mother and described him as 'a bundle of nerves, an intellectual Jack-in-the-Box'. At Eton at age 16, he was a musician, art critic and orator: 'I do not think I have ever seen such extraordinary development at that age.' Prichard spent much time with him but felt there was little heart there: 'They say Jews are defective in sentiment, though I confer that I have found exceptions. He asked me if I knew of his father's Mantegna [an agonised *St Sebastian* left unfinished at his death in 1506] and told me how pleased he was to put it where it could still act as the artist intended it to function as an altar piece.'[108] The piece remains today in the little oratory of the Cà d'Oro.

Luigino went back to Eton 'with many tears' and Prichard supposed he would never see him again. Luigino had amused Prichard by saying that 'he nearly' agreed with all his judgements. Prichard had heard Luigino was selfish and 'very tenacious of the principles he has acquired from the Rothschilds and which are nourished in a Rothschild heart. It was not my business to change him, but his extraordinary mental agility and catholic interest attracted me.'[109]

Following Prichard's hopes, Luigino entered New College after Eton, and was later followed by Carlo. Prichard was not pleased when Luigino told him he wanted to become a pianist. He responded, 'You can always get someone to play for you'. Apparently, Prichard was unaware that Baron Giorgio Franchetti had taught him to play and the baron was regarded as one of the finest pianists in Italy. To Prichard, Carlo was showing more promise: 'He is fifteen and writes better than Shelley did at that age.'[110] But Prichard refused to give up on Luigino. After he saw him again at Easter, Prichard wrote to Mrs Jack: 'Luigino talks an hour at a time . . . for the first time in my life, I am a listener.' Quite an admission for Prichard. He saw a great deal of himself in Luigino: 'He is very good . . . with the Jewish facility for grasping a point rapidly and seeing its bearings. I have seen no sign yet that he is great, nothing but extraordinary readiness, and a naturally superior disposition.'[111]

On 20 August 1911, Prichard recalled seeing Carlo as

much bigger than Luigino, and very serious with his head in the clouds. He looked very fine too . . . and a face marked with grief for he had just said goodbye to his mother whom he adores and exclaimed: 'Why were trains ever invented?' He was going to Salzburg travelling by Third Class at night, in order, he said that

he might not sleep for he wished to read one of Hawthorne's books through the night. It is splendid, isn't it, that there are real people yet. But how few, how few. I want to know no more rich people, and to lose the acquaintances of those whom I know. They don't count at all, and it is a waste of life to have to do with them.[112]

Oddly this was in a letter to Mrs Gardner who had just sent out a steady stream of Proper Bostonians to 'seek out Mr. Prichard in Paris . . . who is so very interesting'.[113] Prichard went on to admit that he had shocked one of them who was 'rich and superbly proper, of course, I was eating a bonbon in her presence and she recommended me a chocolate instead. I said, "Oh no. I prefer this sweet. It reminds me of the kisses of painted lips." '[114]

Prichard's last recorded encounter with Luigino Franchetti occurred in November 1911:

I went up to Oxford to visit Luigino who lives with a splendid Russian prince, very Russian and charming and rich – which is a defect, of course, and was there long ènough to see the process of thumbing all originality out of the most promising youth. Some of them came up to London to hear Bergson who gave four very great addresses. He spoke in French but was very closely followed, and one of the addresses was almost impossibly difficult. He said that he felt an immense response in his London audience.

For Prichard it was 'a tremendous moment . . . Bergson became for the moment a prophet.' Luigino was also excited, and after the lecture he grabbed Prichard by the arm and exclaimed, 'Talk to me of music; I have never been so moved in my life.'[115]

Luigino fulfilled his dream of becoming a pianist, and in the 1920s and 1930s gave numerous concerts across Europe, but subsequently he had to give up playing due to an infirmity he developed in his hands. Carlo had just started studying Greek and Latin at New College when the First World War broke out. He returned to Italy and became an officer of the Alpini troops. Later he married and had three sons, one of whom, Baron Giorgio Franchetti, remembers his father's speaking of Prichard and maintains a keen interest in contemporary Italian art. His sister is married to Cy Twombly, the American painter.

Among those regularly visiting Prichard in Paris were Sam War-

ren's son, Samuel III ('Bambo'), and his wife and children. After leaving Boston, Prichard never mentioned Warren or Marshall, but in a letter to John Fothergill there still appeared to be a chance of reconciliation. John Marshall wrote to Fothergill: 'Prichard is studying Byzantine art and is keen on it.' Then he added that Roger Fry who had just seen Prichard said he was 'coming to see Ned'. Marshall was delighted: 'I hope that he may come and an ugly cruel episode ends in an embrace. I have felt sorry, often, for the quarrel, and we suffered more than he did, much more.'[116]

There was no reconciliation, and after Sam Warren's death Prichard was never in touch with Warren or Marshall again. Sam's death hit Prichard hard. He said to Mrs Jack:

> It seems an infinite time since the tidings reached me . . . At the first blow I felt loneliness . . . The matter is not personal, cosmic rather . . . You know as I do not, for I was not there, what the Museum was, when Sam Warren became its president. It was despicable and despised. A few families had a special cult for it . . . There is no doubt in my mind that he was opposed almost from the start because of his liberalism and his indifference to aristocratic prejudice.[117]

It is not known how many (if any) outside the immediate family knew Sam's death was a suicide, but both Prichard and Mrs Gardner blamed Ned Warren for the tragedy. Prichard asked her: 'Will you tell me something? Tell me if Sam Warren's brother continues to beat the air in the halls of justice.'[118] In a letter to Berenson, Mrs Jack (who attended the funeral) was equally snappish: 'Sam Warren's death is unrealizable as yet. It is a terrible loss. His brother Ned's law proceedings killed him. Ned is crazy. This is his only excuse.'[119]

4

The Brotherhood of Ruhleben

Early in 1913, an uneasy feeling descended upon Matt Prichard: 'My friends who are doing their military service in France are about to have a third year added to their training. It seems an excessive demand to exact three years of life for submission to the foibles of youthful lieutenants, but this is the best answer France is able to make to Germany's warlike preparations.'[120] Matt's brother, Charles, became a colonel of his regiment and in the autumn of 1913 Matt visited him briefly in Malta.

Despite all the signs of the gathering war, Prichard naïvely embarked on a trip to Freiburg-im-Breisgau near the Black Forest in June 1914 – two months before the German invasion of Belgium. Prichard was following his latest passion – Mozart. A new edition of the composer's letters had just been published in Germany.[121] In a letter Prichard made an odd comment: 'There seems some fatality between me and Germany.' And indeed there was. On 28 June 1914, Archduke Francis Ferdinand was assassinated, and then on 4 August 1914, the day after Germany declared war on France, Prichard was arrested with a number of other Englishmen.

He recalled the arrest to a friend who left this account:

> One night he was standing alone on a bridge . . . In his pocket were letters from his brother, then a British colonel; others from an acquaintance in Egypt and from a French friend in military service . . . He had no passport. In those days they were not necessary. He was at once apprehended as a foreigner, and the papers he carried were sufficiently unusual to fasten on him the gravest suspicions . . . the cross-examination which followed reminded him of the ordeal of Christ in the Praetorium. They passed that night with a group of other foreigners rounded up by the military police with the expectation of being shot at dawn.[122]

None of them was. On 5 August they were taken to Baden-Baden

and kept under house arrest at a hotel. Then on 12 November they were removed to Berlin to a prison set up at the Ruhleben race course. A total of 4,000 Britons were kept there. Later on 30 November, Richard Fisher wrote to Sylvia Warren (Sam's daughter whom he had tutored in Boston) that Matt's brother 'was wounded on the 15 November, but not seriously, and he is still in the fighting line. The Germans fired 156 shells at the little house where he was sleeping (£3 a shell = £468, trying to kill him).' Fisher went on to talk about Matt: '[He] is now in prison . . . We heard from him through Switzerland . . . He was well, but he appears to suffer from cold and lack of exercise. We have got money through to him both from Holland and Switzerland. He says nothing about food, but a lot about the coming era of Peace and Love.' Then Fisher said that Royall Tyler was trying to get Prichard's release through Bode. Wilhelm von Bode, the founder of the Kaiser Friedrich Museum in Berlin, was well acquainted with Warren, Marshall and Prichard but was also quite anti-American, so their links with American museums never went down well with him. Fisher added that Tyler's idea was a bit tactless: 'unless Bode has a bad memory'. He continued: 'Our foreign office can give us no hope of a speedy release. This war is terrible. It is a veritable obsession of blood and destruction. One smells blood and tastes it every minute.'[123]

The Foreign Office was right – it was not going to be a speedy release for Prichard. The Ruhleben prison lay to the west of Berlin and consisted of a number of brick-built stables and wooden huts clustered at one end of the oval trotting racecourse. A high wire fence surrounded the L-shaped enclosure. Matt Prichard was there until January 1918. The stable in which he was placed (Barrack X) consisted of two rows of horse boxes divided by a passageway on the ground floor, with a loft above approached by external wooden ladders. Six men were lodged in each horse box. A single hot water pipe under the roof was the only heat and in severe weather the glass in the windows was often coated with half an inch of ice. Two cold water taps served the entire barrack. Each prisoner was given one blanket, one coarse towel, one earthenware basin but no spoon. Food was chiefly made of potato meal and coarse flour, turnip soup, potatoes and acorn coffee all of which had to be fetched from a kitchen under the grandstand, and then consumed at one's bedside. There was no dining room.

Despite the appalling conditions, the prisoners were well organized. One of them, Henry Andrews (later married to Rebecca West), wrote to his mother about life at Ruhleben, and his letters were

published during the war under a pseudonym. Prichard exerted an enormous influence on Andrews and other campmates, and Andrews lauded the 'informal camp university' Prichard organized.[124]

Ironically prison life brought out the best in him; Prichard had finally found an outlet for his fractured interests, and for the first time since Boston he had a real job to do. In Andrew's letters, there was no doubt as to who was in charge of the camp university:

> If you have noticed a more deeply optimistic tone in my letters from the camp than . . . before, it is in the main due to one man, of whom I have not spoken before, but to whom I owe more than I can tell. I can show it; I cannot lay it before anyone in words. His name is P-d [names were generally disguised in the letters] and W.U.S. and I am linked to him by ties of deepest friendship and respect. He is more than twice my age. It was he who was the centre of that little group into which I was introduced on my second day in camp, and which read Bergson's paper.'[125]

Later Andrews spoke of a lecture 'by P-d on St. Mark's, Venice', and added: 'The value of P-d's friendship is inestimable. His experience of the world seems the least part. It is rather that he is forever urging forward and has never given up the struggle. With him a true experience finds ever-ready sympathetic insight. Perhaps it requires an internment camp to teach the value of tact.'[126]

Another commented that the camp school soon resembled a fraternity and some of the men proposed that after the war they should arrange to live together in a similar community: 'resolving that no women should on any account be admitted to membership'.[127] Unexpectedly at a prison camp Prichard created the brotherhood Warren had longed for. Prichard taught the Italian language and culture to his comrades and later that touch of contradiction was not missed by one of his ex-students: 'It was perhaps typically paradoxical that despite this meticulous care in teaching the subject, he had for himself, rejected much of the essentially Italian in art.'[128]

At first, Prichard's students were starved of books and stationery, so Mrs Jack sent large shipments of both. Prichard held his classes out of doors and was dressed in the attire of a French workman with a sailor's fur cap and wooden clogs on his feet. He carried out his teaching 'with the attention of a scholar in a library. Breath froze on

face, papers fluttered down the wind' but Prichard ignored such interruptions with 'a scornful aristocratic grace of manner'.[129]

A circle of young prisoners – just out of college – were particularly drawn to him, and were nicknamed the 'disciples'. Prichard was in his element. They enjoyed gramophone records of his beloved Mozart and were subjected to endless discourses on Byzantine art and the ceremony of the Mass. At the end of the day Prichard's followers often found him sitting on his bed with his eyes closed, making ascending spirals in the air with his right hand as he tried to 'move matter' as he called it.[130]

On the first anniversary of his being at Ruhleben, Prichard wrote to Mrs Jack that he was quite busy:

> This morning I was at an important meeting; I have two more this afternoon as well as an invitation to tea to fulfill, and some microscope work to enjoy. Every day brings a sea of labour: I have never worked as unendingly. At present I have promised to prepare an Italian paper, to give a series of addresses on art . . . I have six hours a week to study philosophy . . . and nearly 30 hours a week to Italian instruction.

Mrs Jack continued to make inquiries concerning Prichard's possible release. They all failed, and Prichard said he knew why: 'They won't release me as I am physically fit to be a soldier!'[131]

Despite the cold, Prichard felt remarkably fit and the desire to survive was strong. He wrote to Mrs Jack that it was very cold, but not yet 'to an American degree':

> We are practically without heat in a low studded loft where at the sides my head touches the ceiling which is of half inch deal, you can picture the necessary effort to keep alive; the floor is cement. When not working I have to think and help others. Fortunately those who are sick and suffering are gradually leaving, and the Camp will not be the scene of anguish which it was a year ago. One day my turn to leave must come, for it is grotesque that the fortunes of war can be influenced by keeping a few civilians in discomfort.[132]

Prichard was kept in that discomfort until January of 1918 when he was one of a batch of prisoners who were exchanged for their German counterparts. He spent his forty-eighth birthday on the North Sea

and reached England days later. Ironically, Prichard landed at Boston – the one in Lincolnshire – and knelt in the snow. He began a 1918 journal with an assertion and a question: 'Never again will I be rude to an Englishman . . . I wonder what Life is to do with me next.'[133] Prichard was to spend the next eighteen years of his life in England, most of them being devoted to a new obsession: the plight of his fellow war prisoners.

For a while he stayed with his sister in London and his only activity was to walk around St James's Park to rest his mind. His sister noted her brother's 'reserve' and astonishment at being allowed to look into shop windows. Prichard told her that his internment had caused him to doubt his sanity – 'the bow does not know its tension until the arrow is released'. He felt restless and keenly missed his pupils and the experience of community. He was unable to find 'their equals in life at peace'.[134]

Despite this, Prichard gave himself to a rigorous reporting on what had occurred at Ruhleben and other internment centres. Early in 1919, with the cooperation of Lord Sandwich and Adeline Duchess of Bedford who were active with the Prisoners of War Committee, a Ruhleben Exhibition was held in London. It was largely organized by Dame Pope-Hennessy, who became Prichard's great supporter. In a year's time, work for 1,500 civilian prisoners had been found, and King George V opened the exhibition. Prichard was chosen to show Queen Mary around.

Prichard's work for the committee was far from being a permanent position and he complained that he often found himself 'very much alone' and said, 'For the life of me I cannot imagine that anyone would want to employ me.'[135] Despite this, friends on the committee knew he wished to continue his investigations and efforts for rehabilitation of prisoners, so a salary of £5 a week was paid to Prichard for the next four years. Unknown to him, the money came from committee members. Prichard himself was being rehabilitated. Without any wage he carried on the work for nine more years, and was sustained by gifts from American and British friends: Mrs Gardner was a major contributor.

Prichard first worked in an upper room in the Victoria Tower of the House of Lords. In 1922, his office was moved seven miles away to Isleworth in Middlesex which meant long periods of time on public transport. He told Mrs Jack how tedious things had become: he arranged thousands and thousands of papers which represented the information given by British prisoners of war while in captivity:

When that is done, I hope to write a report on the treatment by the Germans of our civilian prisoners, and that finished, I shall be clear of this longish interlude in my life. After that I hope in some way to be able to devote myself to a continuation of the work which has absorbed me, in spite of everything, since I left America in the year of grace, 1907, namely the reconstruction of life, which, as the world is rapidly dropping to pieces, becomes more and more a question to solve.[136]

Prichard never managed a full report on prisoners and as time went by there was, of course, less official interest in the project. His letters to Mrs Gardner became more and more pessimistic and Prichard's desire for a 'reconstruction of life' was increasingly diffuse:

The Empire has gone out like a cobweb, the Papacy will follow like a mist . . . In the war a Protestant country – Germany – , a Roman Catholic country – Austria – and an Orthodox country – Russia – went to the dogs. There is little to choose, therefore, among the Christian beliefs. The ecclesiastics are not prophets, merely hirelings, and can do nothing; the philosophers are pedants, and can do nothing; the laity is uneducated and can do nothing. I propose to educate everyone I come across and try to wean them to understanding. When once the thing starts, it will go like a flash. Patience. Life will show the way.[137]

Prichard's proposal to educate everyone he came across did not include any of his old contacts. He made no attempt to be in touch with them because he said they would not 'at all approve of my spirit of intransigence' and would be impatient with him and regard him as 'a bore and nuisance, especially as I am a vegetarian'.[138] Prichard did, however, give in to the persistent invitations of Mrs Chadbourne. Once, in 1922, he told her he could only spend thirty-six hours in Paris – his first vacation since 1914. Actually, Prichard managed more than thirty-six hours and he was able briefly to renew his friendship with Mrs Stein and a few other Parisians. Later he went to Egypt with Mrs Chadbourne but found it 'a vacuum': the pyramids and sphinx were 'useless engineering feats to satisfy the whims of childish princes . . . when you reach the Great Pyramid of Cheops – well, you surprise yourself by turning your back'.[139]

Mrs Jack continued to ask when he was going to return to America. Prichard responded: 'the carpet to carry me to America has never

presented itself. I have not uttered the wish preliminary to the transport. It is useless to harbour ideals, they only clog the course of life. Life directs me, what is expected of me, and tardily I obey. When life intends me to go to America, she will send me.'[140]

Despite that fatalism, Prichard managed to find a few in England to educate. The outlets varied considerably. Once, he visited an East End club 'run by a family with which I was on terms and presented to a boy who fought in the war'. The boy asked Prichard why he trembled when he listened to opera. Prichard thought that 'not a bad beginning for an Eastender!' Prichard's response led to other inquiries and the boy confessed that politics was his particular study. Prichard told him there was 'no solution of life there: It was like trying to steer a boat from the bow instead of from the stern.' Prichard said it was useless to attempt the effort without the assistance of religion. That led to a discussion of Christianity which the boy had studied and 'found that it was wrong'. Prichard agreed and the youth wanted to know what religion Prichard found helpful. His response was, 'We must make it.' The boy appeared impressed and Prichard saw him again. Prichard told him that 'life demands the attitude of giving'. The boy requested a specific example and Prichard said the boy could start by giving up smoking cigarettes: 'A great fight ensued with himself, but he took the cigarette which he wished to light out of his mouth and handed it with the whole packet to a companion.'[141]

Prichard commented that people like the East End boy were 'far more alive than many in one's own class'. However, Prichard did not overlook his own class and gave a number of lectures on Byzantine art at students' clubs in Oxford. And there was also the Gargoyle Club in Soho. There Prichard had a following of young listeners, and one was John Pope-Hennessy who remembers lectures 'held in the morning among the shattered glasses of the club . . . one was instructed on the few things it was permissible to like. I remember the Mauerische Trauermusik was one of them.'[142]

In 1921, Sir Eric MacLagan (later Director of the Victoria and Albert Museum) convinced Prichard to speak to a selected audience. The reaction was decidedly negative, and Lady MacLagan recorded some of it. Several in the group did not believe he was serious, and Laurence Binyon said:

> Prichard read his paper sitting in a corner of the room. He did not seem nervous, though there was perhaps a certain defiance perceptible, and an expectation of opposition. He would lay his

finger beside his nose when emphasizing a point, according to his habit. The audience – it was a small one – received the paper with some bewilderment. It approach the subject of art from so new an angle that it was hard to take it in all at once. I think the attack on the Greeks was resented by most. Sir Herbert Read spoke with no sympathy. Lord Crawford spoke on the Parthenon, and one or two others; the only one I remember was Henry Head, who told us that when he read the 'Ode to a Nightingale', the hair on his head stood up. By that time the discussion had got on to Beauty, and into side issues, as usually happens, I myself was rather annoyed with Prichard for saying that poetry was not an art, and I said something to him about it after the meeting. He smiled in a disarming way, and sent me a copy of his paper a few days afterwards.[143]

Prichard continued to advise his old friend Mrs Jack about art. Knowing of her long-time love for Gainsborough's *Blue Boy*, Matt reviewed it when it was exhibited for two weeks at the National Gallery, in January 1922, before it went to America. Joseph Duveen managed to tempt the Duke of Westminster to part with the painting for $728,000. It was the new possession of Henry E. Huntington of California. As far back as 1879, Mrs Gardner had craved the *Blue Boy*, and at least on one occasion Berenson thought he had it for her. Prichard told Mrs Jack: 'I have seen the *Blue Boy* . . . it will make the fortune of any collection or museum. Most carefully done and the most attractive, solemn face – the only criticism is that the colour is a little thundery, for Gainsborough has not sustained the blues in the dress. You lose your heart at once to the child who seems about eleven years old.'[144]

A week later, Prichard modified his judgement: '*Blue Boy* is not as good at the second visit, when, of course, you begin fatally to think of Rubens's vision. It is too artificial and inarticulate. I don't mind who has it – or anything else for that matter.'[145] Prichard – and no other friends – realized how seriously ill Mrs Jack had been since the stroke she suffered at the end of 1918. The effects of it were concealed and for the next six years she was, to some extent, an invalid. On 14 July 1924, she died. Prichard's 285th – and last – letter to 'Dearest – Dearest Isabella' was written two days earlier, and talked largely of the weather: 'We have had three weeks of summer weather and are in for a fourth.' He closed with the comment: 'What more foolish matters could I put on paper?'[146] These were his last words to Mrs Jack. She

had left strict directions for her funeral, and her coffin was placed in the chapel of Fenway Court. Nearby were her most prized paintings. A purple pall covered the casket and candles were placed at the head and feet. The funeral mass was at the Church of the Advent, and Mrs Jack had instructed: 'Carry my coffin high.' They did, and as her biographer, Louise Hall Tharp, added, 'as for the funeral of a queen'.[147]

Prichard did not go to the funeral but he poured out his feelings to a friend in America about the woman he had loved for so long:

> The person I knew was not the figure of romance, who lived and died as a Maecenas-Strawberry Hill-Sarah Bernhardt personage, but a simple enquiring woman, very much moved by the endeavours of workers and thinkers, but dreading the step that might put her at their side to share their efforts of discovery. I did not bask in the glamour of objects of art and the world of poets and musicians: I am proof on that flank. Her death puffed out our relation in a moment. I felt the jar but realized what had happened instanter. I knew how loyal she had been and I knew her loyalty was her contribution to reality.[148]

Amongst the papers collected by Dame Una Pope-Hennessy is a series of writings on women. Ned Warren would have liked the misogynist tone. But whereas Warren often appeared to belittle women in order to extol the virtues of Uranian love, Prichard's observations are didactic pronouncements of how he actually perceived women to be. Today, they seem ludicrous. Just how Mrs Gardner and the other women to whom Prichard was so closely attached were to fit into this thinking is more than questionable.

A few samplings will suffice:

> Woman is individualistic, woman is reproductive, woman is uncreative. She is practical, she is efficient, she is sick nurse, she is ministering angel; in business, in medicine, in politics – let her activities be legion and let the legion grow. So will the number of men be increased who are thereby freed for the higher activities which are their proper domain. For in the higher realms of thought, as in the disciplining of her individuality before the liberating demands of ceremony and art, women is unresponsive . . . I have never heard tell of a female philosopher. The understanding woman may sense the voice of prophecy before a hundred men, but of intuition itself – of that substance of which

philosopher and prophet are composed – woman is devoid . . .
As the Chinese proverb adds, 'A hen does not usually herald the
dawn.'[149]

Prichard felt that as in evolution the female sex was 'invented' to
leave man freer for his creative work, so in due course, with her
reproductive purposes achieved, Life will discover other methods of
achieving its advance, and the male family will reign, in a Ruhleben '
from which the Germans have been removed. Prichard never spoke
of homosexuality as having anything to do with such utterances, and
probably would have vigorously denied that it was a natural conclu-
sion to his dream of a male family. Ultimately, Prichard's feelings
were as befuddled and disjointed as Ned Warren's; both sought the
unattainable.

In the autumn of 1931, Prichard went to Lacey Green to stay with
his brother for what was to be another short visit. For several years
this had been his schedule. This time, however, he remained for a
year. The skin irritation from which he had suffered from childhood
returned. He was not a good invalid and spent much of his time
studying Latin. After returning to his work on war prisoners, he was
told at the end of 1933 that the War Office was moving his department
again. Prichard continued in a perfunctory manner for much of 1934
but felt he could not adjust to another move. In April 1935, Prichard
moved permanently to Lacey Green.

Apparently, he was unaware that he suffered from a heart condi-
tion. By his seventy-first year he had had no serious ailments, but he
had paid little attention to his teeth and his vegetarian diet was often
meagre. He also refused to enter hospital to have his skin treated by
specialists. By September 1935, Prichard was falling asleep in the
middle of conversations. In early 1936, he was at last about to leave
Lacey Green to pay a visit to a skin specialist in London when he
complained of a pain in his chest. Prichard's local doctor happened by
chance to look in at the time and found the pain was due to an
inflammation of the pericardium.

His brother got a nurse to look after him which he accepted with
some resignation. On 15 October, he appeared in good spirits, and
walked to the window of his room after breakfast. Turning around, he
made a small jest to his nurse and dropped dead. Two days later,
Prichard received several notices in *The Times*. Two were from old
comrades at Ruhleben. The obituary stated that Prichard 'had an
influence out of all proportion to his public fame . . . that fame,

indeed, can scarcely be said to have existed at all, for essential to his philosophy was the cult of anonymity and impersonality'. The correspondent added:

> his principle of anonymity triumphed and led him to regard such spectacles as the bull-fight and the military tattoo as the highest forms of art achieved by mankind. He had a flair for architecture, and used to argue that there were no monuments in the world more perfect than St Martin-in-the-Fields and Richmond Bridge. There is a wide if scattered circle of his friends who will regret his death and hope that his memory will be perpetuated by the publication of some of his writings.[150]

That never happened, and Prichard would probably have been pleased. His desire for anonymity continued to the very end. Following a cremation at Golders Green, Prichard's brother scattered his ashes in the back garden at Lacey Green.

PART VII

Harold Woodbury Parsons's Story – Thick as the Leaves that Strew the Brooks of the Vallombrosa

1

Escape to Europe

The last of Ned Warren's companions, Harold Woodbury Parsons, died in 1968. With that death all direct links with the long era of Lewes House collecting came to an end. Parsons was among the latter-day group of Ned's boys and was also the most audacious and elusive, and certainly the least likeable. Parsons's long-time associate and confidant, Giuseppe (Pico) Cellini, indicates that Parsons was both secretive about his background and inclined to pervert it to fit an image he had nurtured.

In obvious emulation of Ned Warren, he presented himself as a Bostonian and a graduate of Harvard – class of 1904. Actually, Parsons was born to the north of Boston at Lynn, a town largely known for its shoe trade, and where in 1875, Mary Baker Eddy wrote *Science and Health with Key to the Scriptures*. Parsons was not a member of Harvard's class of 1904. According to the Harvard archives, he was registered but did not graduate from the now-defunct Lawrence Scientific School which was attached to Harvard University until 1905. Even his name is an exaggeration of the truth. He claimed to be born in the year 1883. The birth certificate of Harold Parsons (no middle name) from Lynn says he was born on 13 July 1882, the son of Edward P. and Marcia E. Parsons of 11 Baker Street, Lynn. His father's birthplace was England; his mother's Lynn. The father's occupation was clerk. His brother, Woodbury Parsons (no middle name) was born on 26 January 1876, and at that time the father's occupation was given as insurance agent. In his letters, Parsons mentioned his brother but never by name. Evidently, at some stage, Parsons decided that Woodbury would make an effective middle name.

The only correspondence remaining where Parsons gave any information concerning his background was in a letter written a year before he died, to Henry Francis, the former Curator of Paintings and Drawings at the Cleveland Museum of Arts.[1] He said that he was raised by an 'indulgent Woodbury grandfather' whose house was on Commonwealth Avenue in Boston. Commonwealth Avenue is a verdant mall with elegant houses in the Back Bay, a long-time

favoured residential area. Parsons said his father died when he was still a small boy. He also mentioned his uncle, John Woodbury, Secretary of the Harvard class of 1880 which was Theodore Roosevelt's class. According to one biography of Roosevelt, John Woodbury was 'one of [Roosevelt's] most steadfast admirers' and one of his few friends at Harvard who predicted that 'Theodore might amount to something'.[2] John Woodbury was a direct descendant of the John Woodbury of Somerset in England who came to Gloucester, Massachusetts, in 1623. A number of his descendants have lived in Lynn, including Charles Jeptha Hill Woodbury, who was a turn of the century expert on fire prevention. Parsons's grandfather was one of the founders of Boston's Club of Odd Volumes, a group of self-styled eccentrics. In the 1967 letter, Parsons recommended the club and said he belonged to it before he moved to Rome.[3]

Parsons also related that John Woodbury was a friend of Sam and Fiske Warren and

when Ned came to Boston on one of his rare trips from Lewes . . . my uncle asked him to dinner to advise whether or not . . . my grandfather should let me go abroad for some years and study art. Ned advised it, and in 1906 I went to spend a year in a German Professor's house in Cassel . . . to learn German; then a year in Dresden . . . I travelled all over the country; then a year in England, my headquarters at Lewes House, where I spent eight months at a time but saw every corner of England and all the great collections.'[4]

Later Parsons liked comparing his introduction to the art world to that of Berenson, and, in a sense, it was similar: both had been inspired by Ned. All that Burdett and Goddard said about Parsons was that he was one of Ned's new friends, and had been eager to 'escape to Europe'. Parsons would have been 22 years old in 1904, and in a few years Marshall left Lewes to marry and begin collecting for the Metropolitan.

Once, Parsons boasted to a museum director that his art education had been obtained at Harvard, in Germany and in England, and that he was familiar with 'all the public and private art collections of Europe' and acquainted with 'experts in every field of art'.[5]

He told Henry Francis that Ned Warren had advised him to go to Oxford for some years and learn Greek. Parsons reacted: 'I knew only my school day's Latin; but I was bent on travel and the daily-and-all-

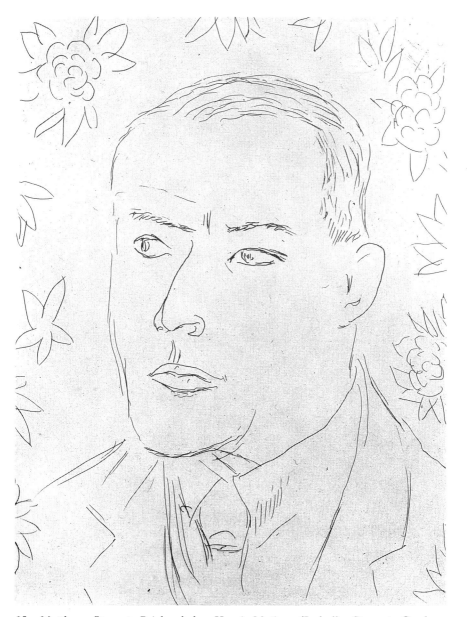

15. Matthew Stewart Prichard by Henri Matisse (Isabella Stewart Gardner Museum).

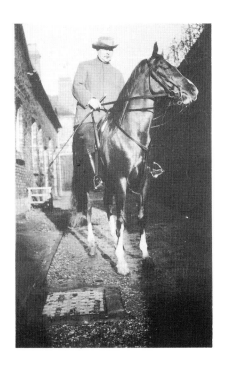

16. *Ned Warren on one of his Arab horses.*

17. *Ned Warren with Pamela Thomas Tremlett and Edward Thomas* (Harry Thomas's children).

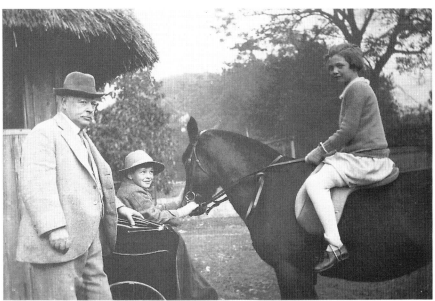

18. Isabella Stewart Gardner by John Singer Sargent (Isabella Stewart Gardner Museum).

19. The Filippino Lippi tondo (Cleveland Museum).

*20. Aphrodite: the 'Bartlett Head',
Attic Greek c. 325–300 BC (Boston
Museum of Fine Arts).*

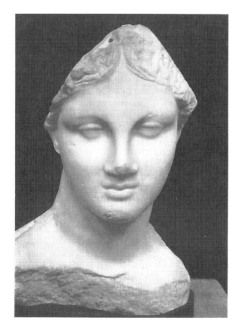

*21. Head of a goddess, fourth-
century BC, the 'Chios Head', greatly
coveted by Rodin.*

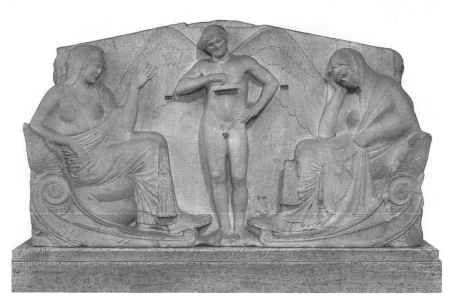

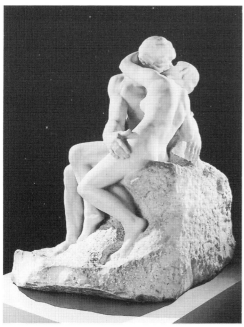

22. The Boston Throne thought by the Boston Museum to be a counterpart of the Ludovisi Throne in Rome (Boston Museum of Fine Arts).

23. The Kiss by Rodin commissioned by Ned Warren (Tate Gallery).

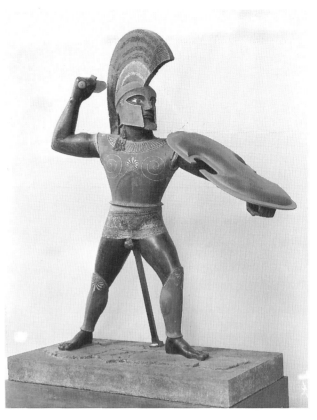

24. *'Etruscan' terracotta warrior purchased by John Marshall for the Metropolitan Museum of Art* (Metropolitan Museum of Art).

25. *Roman Corinthian column in the garden of Harry Thomas's cottage north of Lewes, now used as a birdbath.*

26. *John Fothergill when he was innkeeper at the Spreadeagle, Thame, Oxfordshire* (Angus McBean, London).

27. *The last known photograph of Ned Warren, aged 62 years.*

28. *Harold Woodbury Parsons as he appeared in* Time *magazine, 24 February 1961. Parsons is examining the 'inspiration' for the 'Etruscan' terracotta warriors, a genuine piece at Berlin's State Museum.* (Time *magazine*).

29. *The grave site at Bagni di Lucca as it appears today.*

daily examination of works of art of every period – dropping from fatigue after hours on my feet in the great museums and churches of Europe.'

Parsons described Ned as 'a belated Greek who seemed to live in the age of Pericles and not to belong to the modern world'. He maintained that on one of his later visits to Lewes House, Ned 'realised his artistic intention' and prophesied that Parsons would be 'consulted on art one of these days'.[6] He also remarked that Burdett and Goddard gave a totally inadequate picture of Ned and of the life at Lewes House. Parsons might have added that he was almost totally absent from their picture. He said that the Lewes House he knew was monastic in its quietness and regularity, and in some respects was like Berenson's I Tatti:

> Each one kept to his study in the morning, just as B.B. did; perhaps a bit of bowling on the green just before lunch, a habit which Marshall had acquired in the days of Athens, and Warren in Rome. Then a gallop over the downs or a couple of hours walking; then tea and conversation or music or return to one's studies. Shortly after dinner one retired to one's study and reading; but when there were guests it was conversation and music, for Warren played the clavichord beautifully, or Thomas the piano.[7]

Parsons fostered the impression that early on he was exposed to an I Tatti-style environment. He sprinkled his letters with references to Berenson, ingratiating himself with B.B.'s friends and implying that he often dined at I Tatti. However, the only known reference from Berenson about Parsons was hardly complimentary: 'Parsons is like the devil – here, there and everywhere.'[8]

After travelling around Europe (funded by his grandfather), Parsons came to settle in Rome. He lived in what he called 'the tall house' in the Trinità dei Monti with his mother from 1910 to 1920. Actually, it was a block of flats; the same building where the Marshalls lived. Parsons's mother died the same year as Mary Marshall – 1925. Parsons said that while living with his mother he acquired a few 'minor things' for Warren which he gave to Bowdoin College, and in 1906 purchased *Adam and Eve* by Lucas Cranach in Cassel.[9] There is no indication of other purchases made for Ned by Parsons at this time.

How directly involved Parsons became with Marshall's efforts will never be known. Warren never gave him a position at Lewes House as

he did Prichard, Fisher, Harding and Fothergill, but by the time John and Mary were living in Rome – and before Parsons and his mother moved to the same block of flats – his name appeared in various correspondences. In 1909, in a letter from Marshall to Fothergill, Marshall said that Friedrich Hauser (the German archaeologist and friend of Helbig) and Parsons 'got on better alone than when I intrude. What they have in common save a taste of Tavola Rotonda, I don't know'[10]

At first, Marshall was said to have liked Parsons, but later he and Fothergill complained that Warren was wasting his life with new friends like Parsons. They did not think Parsons was 'of their sort', and 'Ned was worthy of more'.[11] In July 1912, Parsons wrote to Marshall from the Grand Hotel Wust, Zandvoort in Holland that he had seen in Berlin a very large third or fourth-century torso in red porphyry which might belong to a head Marshall had just purchased. Not only that, Parsons was certain the two were related to a red porphyry base that the Roman 'dealer' Pacifico had recently sold to the Jandolos in the Via Margutta. (Interestingly, this is the same Pacifico Piroli who is thought to have carved the Boston Relief). Parsons was trying hard to be useful to Marshall with this little investigation. He added in his letter that he was off to Greece: 'If any points occur to you, I should be grateful – I mean as to what I ought to do. I want to make a start with modern Greek. Later I thought to go perhaps to Thessaly and Volo . . . I don't want to come back to Rome before Christmas.'[12]

It is obvious by this letter that Parsons was receiving some encouragement from Marshall and was beginning to cover much the same field. Parsons was also returning to Lewes at this time on a regular basis. Mrs Warner remembers him from those days. On several occasions he brought a young French boyfriend, Alfred Gerard, whom he insisted was his chef. Mrs Warner was amused by the youth especially when he asked the formidable Lewes House head cook, Mrs Shepherd, for a 'savage rabbit' to cook. Mrs Shepherd did not trust the French, maintaining they 'never washed their hands'. Mrs Warner, however, found Parsons pleasant but prissy: 'He was fastidious about the way he looked – far more than any English gentleman.'

Early in his collecting career, Parsons acquired a love of gossip and he learned to use it to his advantage. In 1916, he sent a communication to Marshall who filed it in one of his notebooks now at the Ashmolean. Parsons talked about a very wealthy and enigmatic private

collector with a chequered past. Often the collector was known as Breimoret and was either French or Belgian. Parsons said that others had known him as a Canadian who occasionally dealt with Agnew's in London. In his younger days he presented himself 'as Conte Bosdari, a *guardia nobile* or something like that at the Vatican'. According to the count's wife, from time to time Conte Bosdari disappeared. Once on a channel steamer, his raincoat, umbrella and valise were found, leaving the authorities to conclude that he had committed suicide. But he had not and the count reappeared in the United States becoming in time a friend of J.P. Morgan. Parsons maintained that Bosdari forged Morgan's signature and then disappeared again: 'When Morgan arrived unexpectedly at the Elkins Park estate of the art collector, Peter A.B. Widener, Bosdari [who also had been invited] was horrified to see Morgan there and feigning a nosebleed; covered his face with a handkerchief. He hurried from the room – and straight off to town.'[13]

Parsons loved these little stories and kept notebooks full of them. He well understood the deception and liked having something on the people with whom he did business. From a long memorandum dated 31 May 1921, but concerning events of two years earlier, we see that Parsons was as contaminated as many of those in his notebooks. There is nothing else quite like the following account in any of Marshall's papers, and obviously he was disturbed by what he had been told. The matter is complicated – not the least by the similarity of the names of those involved.

In April 1919, Parsons was short of capital and concocted a plan to sell some pictures in America. An Italian dealer, Marcucci, introduced Parsons to a young man with a similar surname, Marinucci, who apparently was the nephew of an influential cardinal. With Marcucci acting as tout, Marinucci advanced Parsons 250,000 lire to buy a group of works that Parsons had his eye on. They were soon stored in Parsons's salon. In November, Parsons needed money to pay his hotel bills and to get to America. Marcucci arranged for Parsons to have a loan from Paul Hartwig's cook, Riccioli Celestuio. (Hartwig was the German archaeologist associated with Helbig). As security for a loan, Parsons agreed in writing to share some of the profits he would receive from selling the painting in America. Parsons also took with him a Chinese hanging which belonged to Celestuio.

At first, things appeared to go well in America. Parsons wrote to Marinucci saying that he had sold 380,000 lire worth of goods, but as time went on Marinucci wanted his cut and Celestuio his loan paid. Parsons sent Marinucci 150,000 lire which, according to Marinucci's

wife, hardly covered what her husband had laid out. In all his correspondence, Parsons evaded the issue and said he would be returning to Italy in April 1921. That was extended to May and then to June. Marinucci and Marcucci realized that Parsons was stalling and pestered Parsons with letters and telegrams. Celestuio threatened Parsons with legal action; so Parsons sent him 6,000 lire on account of the Chinese hanging. Parsons tried hard to sell the best item in his collection – a tondo of the Madonna and Child by Antoniazzo Romano – and had taken photographs of it to Boston. While it remained unsold, Parsons argued he could not be asked to pay up yet.

In April 1921, Parsons wrote to Marcucci saying that he had repaid Marinucci's advance and had given him 60 per cent of the profit of his total sales. Marcucci was not satisfied with the 10 per cent he had received for arranging the loan from Celestuio and went to the Marinuccis for their version of what had transpired. As he suspected, far from receiving 60 per cent of the profit, Signora Marinucci declared they had not even been repaid all that they had originally advanced. Marcucci went to see John Marshall and told him that if Parsons did not soon come forth with the money 'something serious would happen'. To add to the drama, an American lady, Miss Du Cane, who had sublet Parsons's flat while he was away, asked Marshall when Parsons was returning. Like Marcucci, Miss Du Cane was receiving conflicting reports. In December, Miss Du Cane visited Marshall to tell him about the latest letter that she had received. Parsons had written that if Marinucci ever called for 'a small picture without a frame of a Madonna and Child which is in my studio' [the Antoniazzo Romano], she was not to let him in to see it, 'much less take it away'.

It was at this point that Marshall ended the saga in his notebook, but as a postscript he later added that Parsons had been forced to pay Celestuio because the cook's lawyer threatened him with proceedings on the strength of the written agreement he had made. Marshall also added that Parsons had never reimbursed Marinucci for other pieces he had purchased with his money. The matter went even further: 'As of 9 December 1921, Marinucci's pictures lay in the Boston customs house for four months – Parsons not being able to get money to pay the customs duty on them.' Marshall's last comment was: 'In that way, Parsons lost the chance to sell them.'[14]

This episode was damaging for Parsons, but he survived it largely because Marcucci and Marinucci were involved with more pressing concerns. Marshall was disturbed by the affair, but by 1921 he was

preoccupied with trying to uncover the provenance of the Metropolitan Museum's Etruscan warriors. Parsons weathered the storm remarkably intact, and for the next forty years became a major contact between American museums and European dealers.

The most substantial job he would have in the forty-year period was sixteen years as European representative for the Cleveland Museum of Art. Unofficially, Parsons continued to advise Cleveland for another seventeen years until Cleveland's Director, William Milliken, retired in 1958. How Parsons first got in touch with Cleveland is not known, but it was certainly a perfect choice for his operations. Though it was incorporated in 1913, making Cleveland far younger than its rivals in America, it had the advantage of being very rich. The Christmas issue of *Apollo* magazine, devoted to celebrating Cleveland's first fifty years, remarked: 'The Cleveland Museum enjoys the reputation of being a museum ... singularly well endowed financially.'[15]

Frederic Allen Whiting, the first Director, opened the museum doors to the public on 6 June 1916. Whiting was an odd choice since he was more interested in social work than museum management. He had once considered the ministry, but ended up helping textile workers in Massachusetts as well as club work with the mill boys. The official museum history written by Carl Wittke said that Whiting began at Cleveland with 'no more than a piece of land with a fence around it and a hole in the ground', and ended by making the museum 'a human institution rendering neighbourly service to all the people in the community'.[16] The art dealer, Renè Gimpel, described Whiting as 'a cold man with a warm heart'. He much preferred his assistant William Milliken who became quite close to Parsons. In 1923, Gimpel praised Cleveland's spirit: 'A day will come when [it] will give New York hard competition, Cleveland cultivates the civic spirit; it doesn't wait for the dead, but approaches the living.'[17]

The day did come – and soon Parsons was actively competing against John Marshall and others. Parsons's contacts began in 1914 when Whiting needed to develop a Classical department and wanted someone with strong Italian and Greek contacts. At first, Parsons worked on a commission basis; then he was paid an annual retainer plus a commission and a travel allowance.[18] It was not until 4 June 1925, however, that Parsons was officially recognized as 'European adviser' on the museum letterhead and as a member of the Cleveland staff.

Coincidentally, a few months before Whiting established contact

with Parsons, the director had written to Marshall. In his letter, Whiting inquired about a marble statue, photographs of which had recently been sent to him by a dealer in Rome. As the statue had the advantage of a free permit to leave Italy, Whiting wanted to know what Marshall made of it and went on to say: 'We are building here a new museum and I hope that in time we can secure for the central rotunda, four Greek marble statues of fairly good quality; although, of course, I realize that it may take us many years to find these and that we may not with available means ever secure what we want. If you happen to know of available material not needed for the Metropolitan, I shall be interested to know about them.'[19]

A decade later, Cleveland would get some 'material' not needed for the Met – and it would be two expensive fakes by Alceo Dossena. Nothing remains in his notes and letters to say whether or not Marshall had anything to do with Parsons's attachment to Cleveland. It is unlikely after the Marcucci-Marinucci episode that Marshall would have recommended him for a permanent position at Cleveland. Anyway, during the three years before his death, Marshall was preoccupied with his problems with the Etruscan warriors.

According to Dietrich von Bothmer, Parsons first registered his own doubts about the warriors 'in the early forties' but always maintained he knew about them earlier. In his letter to Henry Francis, Parsons declared: 'I think Marshall must have turned in his grave at Bagni di Lucca when I discovered when, where, by whom and just how the Mighty Warriors . . . which he had bought as masterpieces of Etruscan art were made.'[20] Parsons suggested that this was shortly after Marshall's death in 1928.

In the same letter, Parsons also claimed that it was he who had 'cornered Dossena, whose "archaic" kore Marshall had purchased shortly before his death.' What Parsons was reluctant to admit was that he had also fallen for two Dossenas and had recommended them to Cleveland. One of the two had earlier been rejected by Marshall when it was offered to the Met. Parsons was not warned by Marshall, and later in life, Parsons enjoyed drawing attention to Marshall's foibles with fakes. Their relationship deteriorated further and Bernard Ashmole said that Marshall came to regard Parsons as 'little more than a common dealer'.

Marshall's letters indicate a contempt for Parsons's lack of archaeological knowledge and his general superficiality. In the letter to Francis, Parsons recognized some of this: 'Marshall always considered me a dilettante, which, of course, is what I have always been

and aimed to be.'[21] He justified his dilettantism with monetary statistics and boasted that over the years he had been in control of more that $12,500,000 worth of art. That was, of course, an enormous sum in those days.[22]

Parsons developed a clever working position. As the European agent for Cleveland (later followed by Kansas City and Omaha), he was the necessary middle man between the dealers and the museums. To get to the rich American museums, European dealers had to go through Parsons. Aside from his retainer from the museums, Parsons expected – and got – 10 per cent of every sale from the particular dealer involved. Often all that Parsons did was arrange for an introduction between the seller and the museum director or curator. Parsons admitted as much to Thomas Hoving who interviewed him for his book, *King of the Confessors*: 'I am, my boy, a *marchand amateur* who dabbles from time to time in the amusing avocation of making the perfect marriage between a collector, a sublime work of art and a rich American museum, for their mutual benefit – and for the benefit of yours truly.'[23]

Parsons was aware that intellectually he could never measure up to the likes of Marshall, Prichard or Fothergill, but he had everything to gain by holding his tongue and biding his time. The low esteem in which he was held by Marshall and Fothergill hurt, but he endured and survived. With the deaths of Warren and Marshall, he would, in a sense, inherit their collecting mantle – at least in the eyes of Italian dealers who knew he had been connected with Lewes House. He was the last of the line and was soon free to gather a dazzling array of art objects.

Among the array, however, were the two Dossenas. Parsons was well set up for his first fall. At a dinner party at the Roman villa of the art dealer, Ugo Jandolo, he was told of a 'little known' 'Madonna and Child' by the Trecento master, Giovanni Pisano, which was kept in a tiny convent chapel in Montefiascone. The next week Parsons found the convent and was shown the beautiful statue which he said 'reeked of incense'. It looked like an outstanding piece for an American museum and convincingly reminiscent of Pisano's marble *Madonna and Child* at the Cappella degli Scrovegni in Padua.

Parsons was easily taken in but the details of the sale have never been revealed. It was a convincing set-up. In Cleveland's Bulletin (March 1925) Whiting stated: 'It is no school piece and at this moment there is no known artist to whom it could be logically ascribed if not to Giovanni. It is by the hand of a master and if not by Giovanni himself

by someone worthy to be called his equal.[24] Parsons recommended it to Whiting on 11 March 1924 and the museum gladly paid out $18,500. It was not long, however, before discordant voices were sounded. W.R. Valentiner of the Detroit Institute of Arts (duped himself by fakes on several occasions) challenged its authenticity. Others noted a sentimentalizing of 'the savage energy of Pisano' and 'faces too soft for Pisano'.

Three years later, Cleveland recognized that it was a clever forgery by Dossena. Ancient polychrome had been used after being painstakingly removed from old statues and paintings, and the effect was convincing.[25] However, after several experts expressed their doubts, the statue was X-rayed and discovered to be held together by nails and stuffed with old papers.

Whiting was shaken by the revelation and the 'Pisano' was shipped back to Italy. That very month a new Dossena was on its way to Cleveland; this time it was an archaic Greek statue of 'Athena'. It carried Parsons's recommendation and a price tag of $120,000. Wittke makes Parsons's role in the affair quite clear: 'The Museum acquired the Athena on the unqualified recommendation of Parsons, who continued to defend its genuineness even after doubts had been raised about its authenticity.'[26] Those doubts were quite strong so Parsons tried to calm Whiting: 'The matter of the Athena must not be hurried . . . there is no evidence of its fake origin.' Parsons said that 'leading German archaeologists' had pronounced the statue genuine.[27] It would not be until 1928 that Parsons admitted that he was wrong and advised the return of the 'Athena' to his old friend, Jacob Hirsch.

Hirsch was one of Parsons's best sources. He had offices in Paris and New York and Parsons developed a close relationship with him. He called him 'Papa' Hirsch. Parsons was fortunate to have his confidence as Hirsch reacted to his eccentricities and occasional deceit with considerable tolerance. When he first saw the 'Athena' Hirsch was ecstatic. According to one account, Hirsch was so delighted with her that he took the figure in his arms and kissed its stony mouth'.[28] Especially appealing was 'Athena''s golden patina. One antiquarian maintained that it was enough 'to dumbfound any connoisseur'. The faked patina was the finest ever seen, yellowish in colour, with here and there traces of a chalky deposit so hard as to be impervious to the sharpest steel.[29] After his disclosure, Dossena revealed that he had dipped the 'Athena' some forty times into an acid bath, the secret ingredients of which he never revealed.[30]

For much of 1927, Hirsch was hearing a barrage of rumours that

some of the sculptures he had purchased were fakes and that a Venetian dealer with whom he did business was involved with Dossena. The dealer was Balboni. In a rage Hirsch contacted Balboni who pretended to know nothing, and so both, according to one melodramatic account, 'stormed Rome in search of Dossena'. Uppermost in Hirsch's mind was the 'Athena' marked for Cleveland through the mediation of Parsons. Dossena was not difficult to locate. Innocently, he had produced work in the manner of ancient styles for a number of years, never knowing what some of the dealers were making of these creations. Hirsch became aggressive and produced a number of photographs of objects indicating the wide range of Dossena's creativity. Hirsch pointed to one after another with the same question: 'Did you make this?'

He saved the photograph of his beloved 'Athena' until last. 'All right, you may have done the others, but the Athena?' Dossena took Hirsch and Balboni to his studio and rummaged through some debris. He finally produced a hand – 'Athena''s missing hand which had been amputated to give the statue another touch of authenticity.[31] Hirsch was aghast – but convinced, and, to his credit, and to Parsons's salvation, Hirsch returned the $120,000 to Cleveland. The rapidity of that transaction cleared Parsons beautifully. However, he was furious when he pieced together the full story, realizing that John Marshall had known about the 'Athena', and had not told him that he had rejected it for the Metropolitan Museum. But by the time Cleveland returned the statue, Marshall was dead.

2

A Half-sinister Variation on Casper Milquetoast

Largely due to his swiftness of action, Parsons survived the Dossena scandal. He went on to learn as much as he could about the forger's world; he was never going to be duped again. One of the things he discovered was that once the dust settled, dealers' sons often resold exposed fakes. Parsons maintained that Dossena's 'Pisano' was, by 1947, in the Bencivenga Collection in Rome, sold by a relative of Ugo Jandolo.

Parsons had other concerns as well. After Ned Warren's death, he knew Harry Thomas would be selling some of the more important Lewes House pieces. Parsons was anxious to get his hands on four objects in particular: an exquisite first-century bronze bust of the Empress Livia (which eventually went to the Metropolitan); the *Adam and Eve* by Cranach; Rodin's *The Kiss*, and the *Holy Family* tondo by Filippino Lippi. As earlier noted, the latter came into Warren's possession in 1898 through Berenson. Parsons remembered how Ned had loved it: 'It is a great picture; it keeps you from work, from doing anything save look at it. The rich liquid colours, the sweetness of the Madonna, the adoring eye of St. John and the naturalness of Our Lord – all is charming. St. Joseph is somewhat out of the composition but his figure is the best painting of them all.'[32] Parsons knew the theatrical effects of the tondo were guaranteed to attract the attention of any major museum.

Once Mrs Gardner had appeared interested in the Filippino, and in 1903 Berenson had said he hoped that she 'would go for it'. He told her it was the artist's 'masterpiece' but she declined, explaining: 'I should not take the Warren Filippino. It ought to go the the Fine Arts Museum. Sam Warren is President of that, and is part owner, as heir, of the picture. And they all adore it, I believe.'[33] Warren had purchased the Filippino through his mother, and when she died in 1901 it was bequeathed by her to her four children. Ned and Cornelia bought out the other two and it became Ned's sole property on Cornelia's

death in 1921. He had been accused of spending too much money on it, but he was right about its potential value: he got it for one-tenth of the price Cleveland paid in 1929. Ned had also irritated his family and the Boston Museum by insisting upon 'fussy' conditions as to how it was hung, with correct and expensive temperature and atmospheric humidity. So for a long time the glowing colours of the tondo enhanced the dining room of Lewes House.

Parsons had control of the Filippino for four months in 1929, agreed with Harry Thomas, and got busy with his contacts in Cleveland. Three months into his control he cabled Thomas: 'Holden Family Cleveland consider presenting Filippino Cleveland Museum Stop Purchase seems certain but donor says cannot possibly exceed hundred seventy thousand delivered Cleveland including my commission and requests deferred payment Stop Could you accept hundred thousand on delivery balance January first if so send me cable.'[34]

The Boston Transcript once said of Cleveland: 'There is a wealth of iron and steel there only waiting . . . to be transmitted into the gold of art.'[35] The Holdens had acquired their wealth from silver (mines in Utah) located by ex-schoolteacher, Liberty Holden, who was chairman of Cleveland's first Building Committee. Parsons had courted their money on several occasions. On 6 June 1929, Cleveland's option for the Filippino was extended until 22 June, and William Milliken confirmed to Thomas a definite offer of $165,000. Milliken added: 'We are anxious as you are to avoid the appearance of bargaining over the matter.'[36]

All appeared to be going well until Thomas balked not at the sale price but the extra expenses involved, including Parsons's commission. Parsons wrote Thomas one of his typically obnoxious letters from his small yacht, the Saharet, which was then docked in Venice:

Dear Harry,
You are surely familiar with the rules of cricket but, apparently, not with those which govern art dealing throughout the world. An agent who arranges a sale of a work of art is invariably entitled to 10% of the sale price . . . the agent is never by any chance concerned with the matter of shipment, insurance, or packing. These expenses concern only the seller and the buyer. The Holden family via the Cleveland Museum are the actual buyers of the picture. I am concerned personally only with the matter of my commission which, in this case, happens to be

below the usual percentage paid in such cases. The Museum is the buyer; not I; and it is one of their rules that no work of art can be purchased by the Trustees except on the terms of payment on delivery and the price to cover the object consigned to the Museum free of all expenses. I do not think that 1000 dollars is a very large charge, considering the size and importance of the picture: and I am sure that you have had it packed by a very reliable person; and that it has been properly insured.[37]

Parsons was also keen that Harry should understand that his commission was to be divided into two accounts. One was for a bank in Rome; another for a New York bank: 'In this way I shall avoid a certain amount of income tax.'[38] He asked Harry what he planned to do about the Cranach. To Parsons that work was almost as exacting as the Filippino. Many years later he described it as 'Adam and Eve beneath a large apple tree with the brightest red apples you ever saw and a wonderful deer with great antlers taking up most of the foreground.'[39] Parsons's memory had apparently faded by the time he wrote that as the apples are a golden yellow and there are eleven other animals around Adam and Eve. As noted earlier, Parsons had bought it for Ned in 1906 – for $4,000. Parsons often related two episodes concerning the Cranach. He boasted that Roger Fry had praised the purchase, supposedly telling Warren: 'Your young American friend has a fine eye.' Secondly, when Parsons was taken by art expert, Langton Douglas, to see Viscount Lee of Fareham's collection in Windsor Great Park – there was his Cranach. Douglas had taken him there to see a picture or two Viscount Lee wanted to sell. Parsons asked if he cared to part with the Cranach. He said yes – for £10,000. Viscount Lee had bought it for £2,500.[40]

That was when *Adam and Eve* was Lot 546 in the October 1929 Lewes House sale. It was arranged by auctioneer Rowland Gorringe who had the premises down the High Street from Lewes House. In the eyes of many Lewesians, the sale was Gorringe's making. Parsons was unable to get any control over his beloved Cranach and it went to the Fareham collection, and then in 1967 to the Courtauld Institute Galleries. It is now on display at Somerset House. Ned's will gave Henry Thomas total control of what remained at Lewes House, but Parsons continued to pester Thomas with unsolicited advice: 'I hope you do not mean to put the Livia into the sale, for I think that would damage its chances in America. I am certain to get you a big price for it, if you will let me have it in America . . . Don't be stampeded into

selling . . . *The Kiss* for if you are patient you will get a big price for it, but one has to negotiate.[41] Parsons was not letting up one bit.

Thomas disliked what he came to call Parsons's 'high-handed American-style dealing', and though there was only one year's difference in their age, Parsons treated Thomas as if he were his junior, Parsons resented not being able to deal with any pieces other than the Filippino, but the matter went further. Unknown to Parsons, Thomas tried at the last minute to involve the Boston Museum. Days before he formally accepted Cleveland's generous offer (more than Berenson anticipated it would go for), Thomas cabled the Director of Boston to see if he might be interested. He counted on the intervention of an old contact, L.D. Caskey (then Curator of Classical Art at Boston) and the long-time associate of Lewes House. Before the sale, Caskey wrote to Thomas that he 'could do nothing about the Filippino'.[42] This was despite the Warren family connection with the painting, and again the museum displayed remarkable shortsightedness. Cleveland cabled Harry Thomas that the Filippino had arrived safely and in good condition. Milliken was overjoyed with the triumph, and when he retired he said that the tondo was one of the three greatest acquisition in Cleveland's history.

Parsons was reluctant to give up his interest in Rodin's *The Kiss*, but as Ned Warren had once offered it to Lewes, Thomas was not keen that it leave England. There was another reason as well. Not long after *The Kiss* was placed in the carriage house behind Lewes House, Warren had photographs made of it and sent them off to the Boston Museum. Parsons said that Warren 'offered the great group as a *gift*, the expense of shipment only to be paid by the Museum. But some of the then trustees felt that the subject was 'too fleshy' and the gift was refused!'[43] Shortly before Thomas finally offered *The Kiss* to the Tate Gallery for only £7,500, Parsons arranged for a representative of the Kansas City Gallery to look at it. Almost fifty years after Boston turned the sculpture down, Kansas City gave a similar judgement: 'It would never do for Kansas City.'[44]

Despite this failure, the Filippino acquisition was a great success for Parsons, and in many respects his 'making'. He wrote to one friend that he had 'really arrived' in the art of dealing, and expected American museums to take note. Parsons also continued his passion for tracking down forgeries, and on 16 September 1928 he wrote to Professor Edward Forbes at the Fogg Art Museum that a relief, *Noli me tangere* (in the style of the fifteenth-century sculptor, Amadeo), had been made for him by Dossena in Rome earlier that year, so that he

'might see the whole method of procedure'. More intrestingly, Parsons said that he had sent the relief to Charles Hawes of the Boston Museum 'to examine its relation to the "Mino" tomb at Boston [claimed to be by Dossena as well] so that Hawes may finally convince himself that the surface and broken edges and patina are identical with other works by Dossena.'[45] This was never done. Boston did not appreciate Parsons's intrusion into its affairs. The tomb remains in the museum basement, but Boston has never admitted it was created by Dossena. Parsons was only beginning to raise alarms over forgery in American museums.

He was not the only one raising alarms. In his diary of 1928-9, the art dealer René Gimpel noted that the American collector was 'prey to the hugest swindle the world has ever seen: the certified swindle'. Gimpel maintained that 'Thirty years ago the American bought so many fake pictures that eventually he wanted the authentications; expressly for him, experts were created and promoted; the dealer let the responsibility rest with all these irresponsible creatures, and the client no longer had anyone to whom he could appeal for justice.' Gimpel bristled with examples: Bache had faked Bellinis, and a Vermeer; Ernest Rosenfeld had a fake marble in the style of Rossellino. The Detroit Museum had a fake marble bust bought by 'the deplorable expert Valentiner'. He said all these were done in Italy: 'Americans have bought within a short period $10 million's worth of pictures whose certifications are indefensible.'[46]

Gimpel was amused by the Dossena disclosures but placed them into context: 'The Italians have sold Americans two million dollars' worth of marbles done by Dossena. A laughable sum, compared with the amounts obtained by means of certificates given daily by German experts to German dealers. Just as there were paper marks, so there are paper canvases, an easy way of bringing dollars into Germany.'[47] The situation regarding Greek and Italian objects of art was exacerbated by the regulations imposed in those countries which prohibited the export of objects except with a licence from the government. The result was 'bootlegging' of objects whose authorship must be nameless by the dealers. Parsons advised Cleveland that all references to price, country or origin, and prior ownership 'as regards provenance' be omitted from the Museum's Bulletin. He said that even such reliable dealers as Jacob Hirsch were bootlegging things out of Italy.[48]

The Cleveland Museum was stung in 1928 by the discovery that one of its purchases was an outright theft. How involved Parsons was with the event is not known. The object was a carved ivory book cover

which Cleveland purchased from a New York dealer for $30,000. Later it was discovered to have been stolen by a bogus 'count' from the Cathedral of Agram in Zagreb – the type of person Parsons often courted. Apparently, the 'count' had persuaded the bell-ringer at the cathedral to let him live there for a year; ample time to steal and replace jewels in precious art objects with worthless glass. Cleveland returned the ivory with great ceremony to the Yugoslav minister who went to Ohio for the occasion – and the dealer was forced to reimburse the museum.[49]

The year 1930 was important for Harold Parsons. In addition to his increasingly important position at Cleveland, he also became the adviser on European art for the Nelson Gallery at Kansas City, Missouri. The idea for the gallery began in 1896 when William Rockhill Nelson, publisher of the *Kansas City Star*, bought nineteen copies of European paintings in Italy 'for his pleasure and the elevation of his neighbours'.[50] Twenty years later, Nelson's project expanded into a bequest of 12 million untaxed gold dollars for the purchase of original works of art. After his death in 1916, Nelson's wife, daughter and lawyer gave funds for a museum building, and in 1933 the Nelson Gallery was inaugurated. Somehow Parsons got wind of what was going on in Kansas City, and with two other advisers amassed a museum collection within three years. Parsons was in charge of European art; Langdon Warner, formerly the Fogg Art Museum, handled Oriental Art; and the third adviser, American art. As *Apollo* magazine said: '[They] began their hunt in 1930. 36 months later, the gallery announced a collection in every way sound, and in some lavish.'[51] Parsons reported in 1940 that 'to date the Trustees have expended a sum in the excess of $5,000,000 on the recommendations made to them by Mr. Warner and myself'.[52]

Parsons's obituary in *The New York Times* asserted that as a buyer of art, 'Mr. Parsons in one period – the ten months before Feb. 1931 – made more than $1 million worth of purchases for the Nelson Trust . . . The purchases included a *Portrait of a Boy* by Rembrandt, *Christ and the Centurion* by Veronese, *The Penitent Magdalen* by El Greco, a portrait of the 17th-century Englishman Thomas Parr by Rubens, a Greek stele of the 4th-century B.C. and a bronze by Giovanni Bologna.'[53] At that time, Nelson's budget was said to have been second only to that of the Metropolitan.

Back at Cleveland, William Milliken succeeded Whiting as Director in 1930, and upon his appointment undertook 'one of the most daring acquisitions ever made by a Board of Trustees': obtaining a portion

of the great Guelph Treasure of Germany. Milliken was right to believe that by this act 'the seal of the future greatness of the Museum . . . was set.'[54] The House of Guelph was the most politically powerful in Germany in the twelfth-century, and its exquisite treasure in Brunswick Cathedral was comparable to its station.

But the extraordinary collection of medieval reliquaries, crosses, portable altars and other pieces was removed to Hanover in 1651. During the Napoleonic Wars, the treasure was sent to England then, to Austria in 1895, and during the First World War to Switzerland, In the 1920's, the Duke of Brunswick, desperately in need of funds, indicated his desire to sell the family's prized heirlooms which he valued at $10,000,000. In 1928, the treasure was quietly sold to a syndicate of German art dealers for an undisclosed sum. Two years later, it was put on public exhibition in Frankfurt, and during that showing Milliken and Parsons reserved six of the most important objects for purchase. One was the oldest item, an eighth-century Frankish cloisonné plaque and another was the gilt silver and rock crystal monstrance with the 'paten of Saint Bernward' which contained a relic of the True Cross.

In October, the trustees of the Cleveland Museum agreed to purchase the six pieces and the objects went on public view in the museum's rotunda before the month was over. The acquisition – for an undisclosed sum – was widely publicized with attention focusing on the relic of the cross and such headlines as: 'Fragment of True Cross in Cleveland' and 'Portion of Cross for Art Museum'. All eighty-two pieces of the Guelph Treasure were brought by the dealers to Cleveland from 10 January to 1 February 1931. A total of 74,000 visitors viewed the collection with the comment from the *Cleveland Press* that 'culture has been put in competition with World Series baseball'.[55] During the showing Milliken persuaded the Trustees to make a further commitment to purchasing three more pieces from the treasure: the exquisite portable altar of Countess Gertrude which had twenty-three figures in high relief and two ceremonial crosses.

Cleveland's conquest was attacked in the German press. Many German connoisseurs were horrified by the loss of such major medieval objects to Americans. Parsons told Milliken that while he was on his way from Europe to Boston he had read articles in the American periodicals *Art News* and *Art Digest* which carried the German reaction and spoke of 'looting by an American museum agent'.[56] Parsons was fearful that that meant him. He was not named, but he did not need to be. He said that dealers like Duveen and Wildenstein had told

him that the best way to treat the matter was 'to say nothing whatever about it, since nothing further will appear in print, and no names have been mentioned'.[57] Parsons further soothed Milliken by adding: 'It is, I suppose, impossible to build a great collection without having such experiences as these, but they are nonetheless trying.'[58] Parsons became a master of 'no comment', and that was one talent he had remembered from Marshall. Duveen and Wildenstein were right. The storm subsided and the Duke and Cleveland were generally viewed as having acted honourably. Any questions about how the deal was accomplished were soon forgotten. Milliken, with Parsons at his side, could bask in the glory of Cleveland's rank as one of the leading museums in terms of medieval collections. Parsons was sitting pretty.

Despite the success with the Guelph Treasure and some other pieces, letters between Parsons and Milliken show that his annual financial retainer was not always satisfactory. In 1934, Parsons received a letter from Milliken saying: 'Rather bad news about our budget for next year . . . it will be necessary to cut again a portion of the amount we pay you.' Parsons was to get $500, but Milliken added: 'What you have done for the Museum can never be paid through any terms of money.' Later Parsons wrote to Milliken: 'This is a personal note, not intended for the files, and merely to ask whether you can tell me when the cut will go into effect. It is not a matter of consequence to me, especially as my personal income has begun to pick up, but I shall have to readjust my expenditure somewhat.'[59] Milliken assured Parsons that the $500 'retaining fee' was forthcoming, and we 'will also hope that the clouds will lift some in the new year, so that we can go ahead and develop our collection as we formerly did.'[60]

Parsons had outlived much of his usefulness to Cleveland. Milliken was not going to increase his annual retainer and his activities became more limited. Parsons needed another museum to take up the slack and he found one in a highly unlikely place – Nebraska. In 1941, he added the Joslyn Museum in Omaha to his operation. Omaha had always been noted for meat processing and agricultural machinery – hardly the setting for a great gallery. George Joslyn was one of its citizens who had made a great deal of money. His fortune came from the operation of a newspaper cooperative service – the Western Newspaper Union. When he died, his wife Sarah created the Joslyn Museum as a memorial to her husband. It cost her $4,000,000.

The local newspapers introduced Parsons to Omaha as 'an artistic vagabond devoted to the ceaseless quest of rare objects of art'. Parsons was going to bring to Omaha 'prized possessions once

owned by Emperors, Kings, Popes, Sultans, Dukes, Lords and Cardinals'.[61] To a degree he did just that. During his time as art adviser (1941-53), Parsons secured for Joslyn a Raeburn, a Corot, an El Greco, a Titian, a Veronese, a Van Dyck, a Goya, and of the School of Rembrandt, the *Portrait of Dirck Van Os*.

When he accepted the post at Joslyn, Parsons formally resigned as European representative for Cleveland. However, he continued to have links of a sort, and until Milliken retired he would write about various 'finds' which might interest Cleveland. As the museum's historian put it, these finds greatly 'varied in merit'.[62] When Thomas Hoving interviewed Parsons he was asked what had happened at Cleveland. Parsons said his 'dear friend William Milliken' had become 'a little crusty: Perhaps he wanted to make all the discoveries on his own. Perhaps he thought I was getting too old.'[63]

As Hoving had been Director of the Metropolitan Museum (after Parsons's active period of purchasing), he wanted to know why Parsons had never been retained by New York. Before he answered the query, Parsons said that his arrangement with Cleveland had allowed him to 'place certain other works of art elsewhere' and this sometimes meant the Met.[64] He claimed to have found the Met's famous Hellenistic sleeping child in bronze. The reason why Parsons had done no more for the museum was because the director, Francis Henry Taylor, disliked him 'fervently'. According to Parsons, Taylor said he was 'a snob; superficial, devious; possibly not crooked, but weak intellectually and morally flabby'. Parsons added: 'All of which is exactly what *he* was.' Parsons felt marginally better about Taylor's successor, James Rorimer (Director in 1955) Rorimer was 'the best man in his profession' but also 'a pompous and stiff fool, and a liar'. Parsons admitted that Rorimer also appeared to suspect 'something untoward' concerning him and the only thing he could think of was that Rorimer was 'unhappy that I know that the famous Etruscan warriors at his museum are forgeries.'[65]

Many other museum directors disliked Parsons. Sherman Lee who succeeded Milliken made certain no connection remained between Cleveland and Parsons. Lee has described Parsons as 'knowledgeable, an excellent guide to Rome' but also 'unprincipled, venal, pretentious, physically unprepossessing (a kind of half-sinister variation of Casper Milquetoast) and a dreadful snob'. Lee first visited Europe in 1953 and was given 'royal treatment' by Parsons. But by that time it was too late to woo over Lee or any others of the new breed of museum hierarchs.

A dealer who wished to remain anonymous was even more damning. He described Parsons as 'a gray person: gray hair, gray face, and usually outfitted in dove-gray suits. Dealers learned never to cross him as they were fearful what he would do. He knew too much – and too many people. Dealers with any conscience wouldn't let Parsons in the door.'

One reason why Parsons was able to succeed for so long a time in Italy was because he established vital contacts with Italian aristocrats desperately in need of American cash. One was Alessandro Brass, son of Italico Brass who was born near the Yugoslav border – hence his rather Slavic surname. Italico married a Russian and settled in Venice. Duveen had dealings with him in the 1920s and was interested in his impressive collection in his ancient abbey home, Abbasia della Misericorda, which was costing a fortune to rehabilitate. Brass was both an astute dealer and a good artist. According to Edward Fowles's frank reminiscences of his many years with Duveen Brothers, Italico Brass

> dealt in old masters and sold those of his own hand, sometimes confusing the two. He was experienced at obtaining official permits from the Export Committee, and was fond of recounting his experiences in this connection. One yarn he told me concerned the difficulty he had had in obtaining a permit for a Titian which he had sold. He had apparently offered the Committee several pictures of good quality in exchange for the necessary permit to export the Titian – but without success. Finally, he offered an attractive Guardi, which was accepted. With the export paper in his hand, he then addressed the Committee members as follows: 'The picture by Guardi which you have accepted today is a good picture: I painted it myself!'[66]

By the time Parsons knew the Brasses, both father and son had become solicitors in addition to their art dealing pursuits. Their firm was located at Campo San Travaso and the arrangement made matters extraordinarily easy for the art business. Both Alessandro and Italico were ardent Fascists but by 1940 they had become disillusioned with Mussolini. Four years later, Italico died of a heart attack. After inheritance taxes had been deducted, little was left to his son. Alessandro carried on and offered more works of art for sale. Parsons notified Milliken to that effect: 'To create a foreign fund to protect his four fine boys, Alessandro must now part with certain things his father never wished him to sell. Parsons listed a number of treasures:

231

Titian's *Sultan*, two Tintorettos, a Veronese portrait and six Magnascos.[67] Several of these ended up in Cleveland.

Parsons's activities were greatly curtailed during the Second World War. He helped the war effort after a fashion as a delegate of the American Red Cross in Italy. From his office at 930 Fifth Avenue in New York, Parsons reported to an American friend in 1944 that 'the Swiss Legation in Genoa had said in March that the yacht and her gear are intact'. Later he said that a friend had seen his boat: 'A bomb fell into the yacht yard, destroying one of the buildings and most of the yachts drawn up in cradles there; mine escaped with only a shell fragment falling on the deck and breaking a small hole in one plank. I have been very fortunate.'[68] He wrote again that he was 'waiting out the end of the war' in Nantucket, 'where I have taken a shack . . . I shall spend my days reading art, history, and philosophy, cooking my own breakfast and luncheons, and lying on the sands and swimming. No doubt, I shall also dream of my boat.'[69]

Parsons also reported his general feelings about the war:

Perhaps I have looked too much at pictures and newsreels of the war, but I found myself impelled to grasp the details of what has taken place. Then, I have letters now from friends all over the place . . . giving me inside information about the destruction of works of art which I have loved for many years. I have always said that I care more about objects than about people – but you have been among the exceptions. Europe can never again be more than a shattered invalid in my eyes; but I shall return at the first opportunity.[70]

3

Obsessed with Fakes

Parsons returned to Rome in the spring of 1946 as soon as expatriates were allowed back, but found it a depressing place of grimy poverty. But, on the other hand, according to one observer, 'It retained, for the last time, the pastoral stillness of the preceding centuries.'[71] Parsons was able to take advantage of re-establishing old contacts, many of whom were then far more willing to pay attention to him. After all, he was one of the few left with long-established connections in the international art market. Basically, the Italian aristocracy was left intact; poorer, but still privileged and carrying on in a modified grand manner. Soon Parsons discovered who among them was willing to part with old treasures in return for ready cash.

At first, he wrote to his friends in America that the 'good old days' of collecting were over: 'No more early Italian sculpture will ever leave Italy . . . Really good works are rarer and rarer; and also the government is increasingly reluctant to grant export permissions.' Parsons would later modify that reaction somewhat, but there would never be any modification of an even greater concern:

I've been appalled at the enormous number of forgeries of every kind, some frighteningly skilful; but the latter state of affairs depends, of course, on the former. Rich manufacturers and producers in Northern Italy, mostly Milan and Turin, have made incredible fortunes out of Italy's misery. They have plunged into art collecting, partly as 'safe' investment; partly for the love of possessing what the aristocracy used to own . . . I have made only one or two purchases for Kansas City, the rest quite small objects which link together, especially in the classical field, certain things we have. The sinister side of the situation is that many of the old picture restorers have turned forgers. They find it more profitable to create Old Masters than to restore them. I regard with suspicion almost any object which has not been known for twenty years or so. Old University professors caught between the anvil and the hammer of high living costs and

stationary salaries have turned to writing 'expertises' which fall 'thick as the leaves which strew the brooks of the Vallombrosa'.[72]

Despite his protestations as to the scarcity of good works of art and rampant forgery, Parsons pressed on. His letters throughout the late 1940s and early 1950s were sprinkled with suggested 'finds' for Omaha, Kansas City, and even occasionally, Cleveland. In 1948, he discovered a new source of treasures and he wrote to Milliken:

> The beautiful bust of the youthful Saint John by Nanni di Banco is being packed and will be sent to the Museum at once. The bill for shipment and insurance will be paid by Cellini's friend, Mr. Sonnino. So far as the price is concerned, Cellini left this matter somewhat in my hands, asking me to obtain $7,000 for it if possible . . . I am rather torn between the desire to obtain for my friend as fair a price as possible, and to secure for the Museum as much of a bargain as I can. My professional fee in the matter is a small commission which in no way influences the valuation. Personally, I am convinced this is a very fine and rare work of art, probably worth $15,000.[73]

This is one of the earliest references to Cellini in Parsons's letters. He came to describe him as 'the find of my life'. Some in the art establishment view the Parsons-Cellini connection as an unholy alliance. Soon Cellini supplanted Brass as his chief source of art objects and he was also a ruthless exposer of fakes. At 84, Cellini described himself as 'one of the few surviving *conoscitori*', a vanishing breed of Italian experts who, without the benefit of laboratory equipment, can see overpainting, faulty surfaces and tell-tale forgers' marks. He is a *figlio d'arte*: his grandfather, Annibale, was Pope Pius IX's miniaturist; his father, Giuseppe, was a professor at Rome's Fine Arts Academy and a competent painter. Pico was the youngest of six children, and his father's favourite.

Cellini became the closest thing to a confidant Parsons ever had, and they first met when Parsons was helping the American Red Cross in the Second World War. He was assisted by a secretary who was a friend of Cellini and his father. Soon after the war, Parsons was extolling Cellini's merits to Milliken: 'I think we have in Pico a very valuable source of correct information and reliable advice as regards all that occurs or emanates from Italy.' Parsons hoped that with his expertise Cellini would help him increase his contacts in the Ameri-

can art market. He also told Milliken: 'Cellini is a man of very limited financial means, and supports his wife and children, and his very aged mother (an Orsini) by his life of restoring, writing, and trafficking in the world of art largely by telling dealers in Italy what is what.'[74]

That last touch did not always endear Cellini to some American and Italian connoisseurs. Paul Mallon, one of the few dealers who ever admitted liking Cellini, said 'he had an extraordinary third eye for art'. Others despised what they termed his 'I-told-you-so' attitude. Parsons admitted that Cellini 'knows all the forgers and their wiles and is *hated* by dealers like Jandolo and Barsanti for he says what he thinks and openly attacks their tripe or fakes'.[75] In the future, what Parsons came to know and report to American museums about fakery come from Cellini, and Parsons always acknowledged him as his 'mentor in fakery'.

In 1948, Cellini joined Parsons on a visit to America to see various museums and collections, and, according to Parsons, the tour left his 'few remaining hairs standing on end . . . The fakes he found! And most of them are still displayed; their curators and directors being too stupid to see the true light . . . The harvest of fake medieval pieces at Detroit was great; of the Renaissance at the Metropolitan, even greater.'[76]

At the tour's end, in January 1949, Parsons wrote: 'How Cellini ever finds time for his studies and writing has always been a mystery to me – at least until he stayed with me here at close quarters. He wrote incessantly and burns much midnight oil.'[77] When they returned to Italy, Parsons increasingly fell under the influence of Cellini and his family. Aside from the occasional boyfriend, the Cellinis were Parsons's only close companions since his days at Lewes House. In 1950, Parsons, like Berenson – doubtless in conscious emulation of him – became a Roman Catholic. He attributed the conversion to an extraordinary sixth-century ikon of the Madonna kept in the sacristy of Santa Maria Nova near the Roman Forum.

Cellini had discovered the painting under a far less interesting thirteenth-century work. Parsons said: 'On a particular October morning, Pico took me, Berenson, his secretary Mariano, Kenneth and Lady Clark to see the miracle he had brought to life.'[78] Most of those who knew Parsons in America were either amused or unconvinced by the conversion. He made a great display of his Catholicism. Sherman Lee recalls the exaggerated genuflections he made when they visited Roman churches. Parsons said of his conversion: 'What a

thing for a proper Bostonian to do!'[79] One associate retorted: 'You never before worried about being proper, and I hardly think Boston will take note.'

Parsons came to rely heavily on Cellini and his Roman contacts. Cellini had access to some wonderful pieces; some of them he owned himself. Parsons described to Milliken 'two of the finest Piazzeta drawings in existence and the most beautiful Dosso Dossi I have ever seen . . . if Dossi had only been *always* like that!'[80] Parsons tried further to whet Milliken's appetite by suggesting that the Dossi was not for Kansas City as they were concentrating on 'other things' at the time and that Milliken's curator of paintings, Henry Francis, was in love with it. Francis raved over the Dossi's 'jewel-like quality, reminiscent of Grunewald'. Parsons added that it was 'a dream picture, the sort of thing any visitor to a museum would notice and linger over; even the unregenerate H.W.P'.

Parsons added: 'Since Pico intends to develop his art contacts with a few American museums, he could offer the Dossi for $5,000 to $6,000.'[81] Milliken went for it: 'I have written Henry and told him to go ahead. You say if "Dosso Dossi had only been always like that". I can say thank heavens Harold hasn't always been like that.'[82] Milliken's increasingly conservative budget for Cleveland could not take any more of Parsons's 'finds'; he was in a delicate position. Parsons, of course, no longer had any official relationship with Cleveland, but often Milliken could not resist such tempting items.

Parsons continued the same tactic with Henry Francis and introduced him to Cellini. Francis was impressed by a 'memorable visit' he had with Cellini and his wife: 'I have met very few people who measure up to the description of their friends. I can only say Signor Cellini came away with honours. He is not only personally so charming, as is his wife, but unique in my experience in his keenness and honesty.'[83]

This admiration for Cellini lessened in time, however, Museum directors and curators became nervous as to how far Cellini's disclosure of fakes in American museums would go. Also his association with Parsons was to them a liability. Parsons's sexual proclivities had long been known, but never openly discussed. Milliken (himself asexual by all accounts) appeared amused by Parsons's exploits, and Cellini himself was extremely tolerant. He loved to relate how Harold would arrive from holiday with a new young man, and despite the fact that he often spoke not a word of English, would be introduced as 'a cousin from America'.

Cellini understood the scene, and knew how, as he said, young Italian men were often impressed by 'the image of the elegant Bostonian gentleman'. He was quick to add that the boys never recognized that often these 'rich American gentlemen were beneath the surface as hysterical and moody as Maria Callas'. Harold Acton recalls an American boyfriend of Parsons who was often with Parsons in Florence and 'knew little about art'. He was almost certainly the one known in Parsons's correspondence as Vanni, who lived with Parsons for a long period following the Second World War. In his letters, Parsons spoke of Vanni sometimes as his 'chauffeur', sometimes as his 'business assistant'.

In 1953, Parsons lost his connection with both the Nelson Gallery and the Joslyn Museum. It is not apparent what led to the severance but according to at least one source the Director of the Nelson Gallery had been trying to terminate the relationship for some time. The Joslyn soon followed. This meant that Parsons no longer needed an office or base in New York. Vanni counted dearly on that link, and would not accept living permanently in Rome.

Parsons unburdened his sorrow in losing Vanni to Milliken: ' . . . that last visit to his mother in California unnerved him'. Parsons said Vanni's departure was 'not a question of finance' for I always added generously to his very slender means of support'. He also said Vanni was 'heir to my estate which is not negligible'. It was apparent Parsons projected more potential to Vanni than was there and he told Milliken that 'he could have learned rapidly to judge a good work of art with such honest people as Alessandro Brass and Pico at his side.' Parsons even cited how 'Berenson, Acton, Osbert Sitwell and others sensed Vanni's intuitive feeling for beauty'. Unfortunately, this was solely Parsons's assessment. He predicted that Vanni's future in America would be bleak: 'Now Vanni will struggle on . . . and become a cog in a big wheel and probably lose half his soul in the process.'[84] Parsons never saw him again.

After losing his connections with Kansas City and Omaha, Parsons tried for a time to ingratiate himself with Perry Rathbone, the Director of the Saint Louis Museum. Rathbone was at Saint Louis until 1955 when he went to the Boston Museum as Director. He was a bachelor and found Parsons amusing for a time. It did not last long. In 1956, Parsons mentioned to Milliken that Rathbone had been in Rome but 'has reasons not to like me . . . perhaps it is because he bought a number of fakes, and fell into a trap'.[85] What happened was not

forthcoming to Milliken until after a most spectacular episode involving a work by the forger Alceo Dossena.

In December 1952, a 47 1/2-inch tall terracotta figure of 'Diana the Huntress' was purchased by the Saint Louis Museum from the Los Angeles dealer Adolph Loewi for $56,000. The provenance claimed 'Diana first saw the light in 1872 when she was excavated near Civita Castellana . . . north of Rome. Her discoverer was Count Francesco Mancinelli-Scotti, a landed aristocrat and amateur archaeologist of considerable renown.' 'Diana' was displayed in 1953 accompanied by a fanfare of publicity. In the *Illustrated London News*, Rathbone proclaimed: 'The statue is one of the most important revelations of the art of antiquity that has been made in the 20th century.' Ironically, Rathbone went on to compare 'Diana' to the Metropolitan Museum's terracotta warrior saying the two were 'the best-preserved Etruscan sculptures in existence'.[86]

It was not long until dissident voices were raised – including that of Pico Cellini. The first shots were made in Italian archaeological magazines which were largely ignored by Saint Louis. Far more serious was a slim little volume, *Alceo Dossena,Scultore*, purportedly by Dossena's illegitimate son, Walter Lusetti, which appeared in Rome in 1955. It seemed to be an appreciation of a son for his talented but misunderstood father. The text was barely three pages; the scoop was in the fifty-one illustrations. Pictured was the vast range of Dossena's creations with the already well-known works of the Cleveland Museum's 'Athena' and the 'Pisano' Madonna, the Frick's 'Simone Martini' set, and the Boston Museum's 'Mino' tomb.

Pictures 6, 7, 8 and 9 were of Saint Louis' 'Diana'. The little book hit the museum like a bombshell. It was the first direct linking of 'Diana' with Dossena. The four photographs were as the statue appeared in Dossena's studio in the winter of 1936-37; his last hurrah before he died on 11 October 1937. Publicly, Saint Louis put on a brave face; privately the museum began to have tests performed on the Etruscan goddess. Two thermoluminescence tests (one in Pennsylvania and another at Oxford) showed her to be of the time of Dossena. The tests did not occur, however, until after another public blast from Parsons. Only a very few people knew that Parsons and Cellini had written the Lusetti 'biography'. Naïvely, Walter Lusetti continued to think his book was intended as a tribute, and the publisher, De Luca, presented it as such. Perry Rathbone rightly interpreted *Alceo Dossena,Scultore* as a 'Parsons-Cellini trick'.[87] Parsons protested to those who suspected the truth that he was performing a service to American museums by

displaying the full repertoire of the forger's creativity – from Etruscan to ancient Greek to Renaissance works.

For several years Parsons had been on the rampage against forgeries in Italy. Visitors to his flat at the Palazzo Stroganoff were shown his file which indicated how many 'pompous American museum directors and art experts' had been duped. Many of them had also snubbed Parsons and belittled his usefulness as a commissionaire. He was exacting a certain revenge. Parsons had also given himself away; at least for those perceptive enough to take note. The adverb 'formerly' preceded the name of only one museum in the rogue's gallery of Dossenas – Cleveland. Harold Acton said Parsons became obsessed with fakes: 'He went for Dossenas as if they were masterpieces.'

Up to the time of Milliken's retirement, Parsons's letters were increasingly filled with gossip about forgeries. Noting the embarrassment several American museums were having concerning the revelation of forgery, Parsons boasted to Milliken:

> The smartest thing we ever did, Guglielmo mio [my William], was to move swiftly in the Athena and Pisano matters to protect the Museum. What a pity that Boston and Helen Frick and the Met would not follow suit – although I pleaded with them to do so. Have trustees, directors and curators the right – considering the fact that funds are contributions – to salve their incapacities by putting their mistakes in the cellar without a fight? I am glad that we did not. But as a result of my unmasking Dossena, my little yacht – on which you were afraid to venture forth at Venice – was . . . seized by the government and I was imputed with smuggling.[88]

Parsons and Cellini claimed that when Alessandro Morandotti, the Italian dealer who handled the sale of 'Diana' to America, heard how the two had let the cat out of the bag, he and his associates made life miserable for them. Claims were made that Cellini and Parsons had been dealing in fakes, and they even threatened to go to the police. However, Morandotti backed off and next Cellini discovered that the sale of 'Diana' had been carefully orchestrated with Loewi in Los Angeles, but Loewi was only told what the Italians thought absolutely necessary. 'Experts' were found attesting to 'Diana''s authenticity and the provenance, involving the long-dead Count Mancinelli-Scotti, created.

Not long after Saint Louis purchased the 'Diana', Parsons infuriated

Milliken by his action regarding a doubtful Greek kouros in which Cleveland was interested. Milliken was shocked to discover that Parsons had expressed doubts as to its authenticity to the New York dealer, Paul Mallon: 'Why should you write to Mr Mallon, a dealer, or anyone else on a matter which concerns us materially before you had laid the matter before us?'

Added to that, Milliken had just received a 'chatty' letter from Parsons which avoided mentioning the affair at all:

> I cannot understand this lapse in one whom we have been honored to have associated with us . . . If you had written your suspicions to us immediately and kept quiet until you received our answer, you would have been helpful . . . You know yourself that certain objects which have come through your hands have been questioned. We have protected you at all times and have kept our mouths shut . . . I am profoundly disturbed as you can see and I am sorry after so many years association this blight has come upon it.[89]

Not long after this, Milliken's words to Parsons were even stronger. Near the time he announced his retirement, Milliken said: 'I think it only fair to tell you that some of your letters have disturbed me greatly. I have made it a point over several years not to answer those portions of your letters which have dealt with forgeries, or mentioned individuals as having bought them. I frankly wish to keep out of this, and most of your friends, I am afraid to say, feel the same way.'[90]

Parsons's response to Milliken was weak. He said that his 'natural instinct' towards forgeries was to 'run up a red light of warning' to museums and friends.[91] Milliken's irritation, losing the connections with the Nelson and Joslyn museums, and the break with Vanni all added up and bore down upon Parsons. Naïvely, he had assumed that museums would welcome his forays into detecting fakes and unmasking unscrupulous dealers. However, like Milliken, most museum directors were irritated by what they considered Parsons's intrusions into private museum matters. His well-meant intentions backfired and Parsons was cutting himself off from old contacts and associates. Hanns Swarzenski of the Boston Museum summed it up well: 'Parsons's reputation was fairly rancid.'[92]

Everything seemed to come to a head in 1956. In his letters to American friends from the Salvator Mundi Clinic in Rome, Parsons said that he was 'recuperating from a slight thrombosis which I

suffered at the Excelsior in Florence – a few days after I had a pleasant lunch with B.B.'[93] To others he said he had had bronchitis 'which I neglected'. Cellini tells the truth: Parsons had attempted suicide in the winter of 1956. Apparently, this was a second attempt. A few years earlier, Parsons was going to use a long needle in front of the mirror. The 1956 attempt was far more serious and also like something from a bad film. Seating himself in his favourite chair and with two large ornate vases at either side, he slit his wrists. As he later confided to Cellini, he became worried as he looked down and saw that the blood flowing into the vases would spill over and make a mess on his fine carpet. He became hysterical. Parsons fainted and the blood clotted. When he regained consciousness, he called Clare Booth Luce who was the American ambassador and a friend. (She and Parsons had their conversion to Catholicism and a love of art in common). She sent an ambulance over to Palazzo Stroganoff, and also kept the matter totally hushed up. While he was recuperating at the Salvator Mundi, Cellini brought him a sliver of wood from his beloved Madonna at Santa Maria Nova which he kept as a talisman to the end of his life.

4

Red Moroccan Slippers

Activities in the last decade of his life brought Parsons public notoriety. He fully orchestrated one of them; the other occurred when he appeared as a major character in Thomas Hoving's saga of the acquisition of the Bury St Edmunds Cross. Hoving's book, *King of the Confessors*, created a stir in the American art establishment. It was the first time a museum director fully depicted the clandestine world of international art dealing. So detailed and revealing was Hoving's account of the politics surrounding the acquisition of the cross that to this day many who were involved insist the book is full of lies. Hoving told all, and other museum directors did not appreciate all the dirty linen that was washed in public.

Thomas Pearsall Field Hoving is the son of a past president of Tiffany and Company, and at the age of 35 he became the director of one of the four largest museums in the world, the Metropolitan Museum of Art in New York. His career as curatorial assistant in the medieval section of the museum, the Cloisters, started, as he put it, as 'the lowest you could have'.[94] Hoving yearned to get moving: 'My nimble feet were ready to race up that ladder to success.'[95] He did not have to wait long, for within six years he succeeded James Rorimer as Director. That was due in part to his success as Parks Commissioner under Mayor John Lindsay's quixotic tenure. Hoving was chosen for the Met's directorship over 120 candidates who included Perry Rathbone at Boston and Sherman Lee at Cleveland. The favourite of the more conservative trustees was John Pope-Hennessy.

A major reason for Hoving's meteoric rise was the acquisition of the Bury St Edmunds Cross: 2 feet of ivory with fifty-six carved figures only an inch high – 'the greatest English ivory in existence', as one put it.[96] Harold Parsons became involved in the matter during his bad year, 1956. He attributed the pursuit of the cross as part of his recovery. Parsons told Hoving that in the winter of 1956 he had begun to be fearful he was 'going to lose his health forever'. He also suspected that his and Cellini's resources for collecting had finally dried up.[97]

The next spring found Parsons in an entirely new mood: 'Rome had the most pellucid spring I had ever enjoyed.'[98] The change of heart was largely the result of a phone call from Cellini, who told Parsons that he had stumbled on a sizeable private collection of antiquities which included an extraordinary cross. The owner, who had the bizarre name of Ante Topic Mimara, was a wealthy eccentric Yugoslav collector who lived most of the time in Tangier and was also known to have amassed a large number of fakes. The cross, however, was another matter. All the experts who came to view it (including Kenneth Clark, Pope-Hennessy and Kurt Weitzmann) certified that it was a rare and genuine medieval piece worth major attention.

Rightly Parsons realized that the cross would be something American museums would go for. Despite Milliken's irritation with him, Parsons's first thoughts were of Cleveland. Something like this might restore his reputation with his old friend. It certainly was as significant as the Guelph Treasure. Three times during 1956-7, Milliken went to see the cross, but, as he was shortly to retire and Mimara was then asking for around $1 million, this was not something with which to saddle Sherman Lee, his successor. Furthermore, Mimara was not offering any clear provenance for the piece. He was not even willing to supply photographs of the cross to potential buyers.

Parsons did not limit his sights on Cleveland's purchasing the cross. He recognized that the Metropolitan Museum with the Cloisters was probably an even better choice. There was a big problem, however. Rorimer detested Parsons and strictly forbade Hoving to have any dealings with him: 'Whatever happens, do not, under any circumstances, ever contact Parsons . . . He's mixed up in some pretty peculiar transactions over the years. I don't wish the museum to have anything to do with him.'[99] That made matters rather difficult for Hoving since Parsons had wrested control of American contacts from Mimara.

Hoving found out from Hanns Swarzenski of the Boston Museum that Parsons had also contacted them. He had written directly to Swarzenski rather than to the director – Perry Rathbone, who he spoke of to Hoving as 'that erratic director'.[100] Swarzenski met Parsons in the summer of 1957 and gave a lively account of that encounter, saying that Parsons came for him and his wife 'in a black Mercedes sedan driven by a driver in dove-gray livery'. They were taken to one of the most expensive restaurants in Rome – Tre Scalini in the Piazza Navona. Swarzenski said of the evening:

I had expected to get detailed information about his fantastic ivory cross, its price, the provenance, some insights about its owner. But Parsons refused to reveal anything. He sat there looking very pleased with himself fluttered his hands over the candle like a pair of agitated moths. But he laughingly begged off all business talk. He kept saying everything was too superlative for serious discussion. The evening was too enchanting; the repast too exquisite . . . I didn't reveal it, but I was furious that this elderly art dealer was stringing me along about something that appeared to sound better than it actually was.[101]

He went on to say: 'I had an amusing time, nevertheless, with Parsons. I had never run into anything like *him* in my life. He seemed to be entirely composed of perfectly manicured baby fat. His skin was pink and delicate, and seemed to glow from within. Parsons wore a Savile Row double-breasted seersucker suit with a trim vest. *That* I'd never seen before! The man's *accent*! I'd never heard of anything like that either, an effervescent combination of Boston and Oxford, cadenced in a never-ending chain of skilful pleasantries.'[102]

Boston did not have the money at the time and so backed away. Rorimer increased his interest and even allowed Hoving to contact Parsons. Hoving said that encountering Parsons was like meeting in the flesh 'a gentleman of leisure who stepped right out of an elegant portrait of the turn of the century, perhaps by John Singer Sargent'. Parsons was 'courtly, soft-spoken, witty and charmingly dishonest'.[103] It was the Tre Scalini for Hoving as well, and Parsons made it clear that he alone could facilitate the sale of the cross, indicating how he liked to work.

Parsons described himself to Hoving as a retired adviser on works of art 'who from time to time gained pleasure from placing choice works of art in their proper sanctuaries'. He was a specialist in positioning, 'not an avid searcher or one of those restless, peripatetic hunters digging around private collections through auction houses long before the objects in a forthcoming sale were announced to the public'.[104] And this positioning took a great deal of time. Time was all important; time was money. Parsons told Hoving that over the years he had learned to be suspicious of quick decisions or hasty deals in the art world. The buyer should never feel he is being pushed. The pushing had to be delicate, gentle. Parsons's preferred technique was 'to prod easily and, in a soft way, remind his client that the object was available, was *very* worthy, but that it might not *always* be there'.[105]

Parsons had a clever strategy: he was telling Hoving how he operated and laying all his cards on the table. He revealed that he advised Mimara to first establish a high price: 'I wanted that price to drive away those who were not capable of reaching for a true masterpiece.' Parsons wanted to focus on the few most likely purchasers, and let them bargain the price down. Having started high, the advantage was already with him and Mimara. Next Parsons determined what institution would be the most likely eventual purchaser. That institution would be informed and given a clear option to buy – but the option would only last for three months. It was vital that the other competitors did not know exactly who was in the running – or how much they knew. As Hoving put it, 'Parsons counted on natural competitive drive or simple human greed to forestall any communication or cooperation among them.'[106]

To his credit, Hoving understood Parsons and his methods from the very beginning. He said he loved Parsons's rank candour as it was totally different from what he usually received. But he told Parsons that $1 million was preposterous. He reminded Parsons that Cleveland's Guelph Treasure – all of it – was purchased at a tenth of what Mimara was asking. Parsons decided to reveal more. He said that the Cloisters was the obvious place for the cross, but the 'one genuine threat to Rorimer' was Cleveland. He explained to Hoving that Rorimer's family came from Cleveland; he had always wanted to outshine their museum. Parsons said that Mimara was aware of his friendship with Milliken and his acquaintance with Sherman Lee: 'We agreed to use Cleveland as bait to attract Rorimer.'[107]

Unlike the competitors, Hoving took Parsons seriously, but he also recognized Parsons's limitations. He was particularly put out that Mimara and Parsons were also trying to press the Metropolitan into purchasing some of Mimara's less desirable objects as a condition for getting the cross. In the end, it was Hoving's own determination and obstinacy which secured the cross for the Met for $600,000. Hoving was able to stave off a last minute attempt by the British Museum to purchase the cross. Typically, the British Museum was plagued by the British Treasury's refusal to provide funds for the purchase. The great cross arrived at the Met at the same time as another coup occurred for the museum: a special exhibition of the *Mona Lisa*. The purchase assured the future of Thomas Hoving who declared upon his return to New York that he felt like 'a conquering hero'.[108]

Parsons had another moment of glory in 1961. James Rorimer called a press conference at the Metropolitan Museum and announced: 'As

a result of completed studies, [our] three Etruscan terracotta statues must be considered of doubtful authenticity.'[109] Others in the art world did not agree that it was the studies which had been the undoing of the warriors Marshall had purchased so long before. Alfred Frankfurter, the distinguished editor of *Art News* said: 'One wonders what would have happened if Harold Parsons hadn't tracked the forger down.'[110]

While Parsons was still negotiating with Mimara and Hoving over the cross, he had also been hot on the trail of Alfredo Fioravanti who had helped the Riccardi brothers create the terracottas. Parsons had heard Fioravanti's name mentioned by a variety of dealers in Rome. At 78, Fioravanti was working there as a repairer of antiques and jewellery, and Parsons got to know him. On 5 January 1961, Parsons persuaded Fioravanti to go to the American Consul and sign a confession of his involvement with the Riccardis in the forgery. Rorimer realised he had to act. He dispatched Dietrich von Bothmer, his curator of Greek and Roman Art to Rome to meet Fioravanti in Parsons's apartment. As *Time* magazine put it: 'Von Bothmer produced a plaster cast of one of the warrior's hands, from which the thumb was missing. Fioravanti in turn produced a thumb of baked pottery that he had been keeping for years. Placed together, thumb and hand fitted perfectly.'[111]

Parsons's long-time links with the Luce family came in useful. *Life* magazine's presentation of the event also played up Parsons's role: 'The warrior had long been under fire because of its size and surface details. But it took a 78-year-old American named Harold W. Parsons to prove it was a fake, once and for all.' *Life* did not stop with the warriors. In the article, Parsons was also allowed a snipe at Saint Louis' 'Diana'. He claimed that in 1953 when he saw a photograph of the statue, he thought it was 'amazingly like the Cleveland Museum's "Athena" and Parsons was sure he was looking at still another Dossena'.[112]

A far more serious blast came a year later, when in *Art News* Parsons produced his only publication in his long career. It was both his swan song and his last hurrah. He pulled out all the stops displaying the forgeries he had encountered. Aside from the Met's warriors ('the most audacious art forgeries ever perpetrated'), Parsons added Saint Louis' 'Diana' and two other suspicious pieces there: 'an archaic Greek helmet' and an 'Assyrian ivory relief'. Perry Rathbone's successor as director at Saint Louis, Charles Nagel, took it badly: 'Mr. Parsons is a man of considerable artistic discernment but he is – or

was – also a dealer. As such his opinion is somewhat suspect.' Nagel was especially irritated at Parsons's expanding upon the museum's seeming proclivity for fakes: 'This is not the first of Mr. Parsons's attacks on the Museum's "Diana": it is only the most carefully contrived to date. He is now branching out and one wonders whether, in including the Greek helmet [and Assyrian helmet] in his article, Mr. Parsons is well advised.'[113]

Parsons was allowed to reply to Nagel's letter to the editor in *Art News* and was especially peeved by the aspersions cast at his credentials: 'In my long career in the art world . . . as art adviser in building up the collections of . . . Cleveland, Kansas City and Omaha . . . I have recommended works of art owned by reputable dealers and private collectors all over Europe and America.' He also reminded Nagel that a copy of the book he and Cellini had produced in 1955 with the photographs of Dossena's 'Diana' had been sent to Saint Louis 'as a warning as to what had actually occurred; but [we] were ignored'.[114]

Parsons never mentioned John Marshall in the article; there was no indication that he felt any debt to Marshall's own sleuthing or discovery. The impression he wanted to leave was clear: 'Regarding the Metropolitan's warriors, it was reserved for the present writer to discover the factual evidence in the case – as he had been able to do with the colossal output of Alceo Dossena in 1928.'[115] Aside from Nagel, Parsons received no other reactions from American museum officials. Others in the art establishment followed William Milliken's standard advice given at the time of his retirement: 'I frankly wish to keep out of this.'

Parsons's last few years were little changed from how they had always been in Rome. He still lived at a good address – the Via Vallisneri in the Borghese Gardens; Cellini was nearby; a few Americans were still in touch with him when they came to Rome. He even managed to get some of Berenson's friends to invite him to I Tatti. Parsons's last surviving correspondence (Cellini destroyed most of Parsons's letters after his death) was with Henry Francis only a year before Parsons died. In it, he chatted away about Lee's directorship at Cleveland, saying he was 'running true to form in the quality of the new acquisitions'. As if nothing had changed, Parsons wanted to know if Francis had 'any inkling as to what direction [Lee] will take – I'd be most grateful to know in confidence, for there are still fine paintings to be had'. Parsons went on to mention a work from his old friend Brass, a Mazzoni. He could not resist a passing dig at Lee

concerning the Bury St Edmunds Cross: Parsons had heard that Lee confessed to an associate in Rome that he had made 'the mistake of his life not to capture the cross'. Parsons added: 'I did report it to him first.'[116]

The saddest part of the letter was Parsons's saying that he had just heard from John Walker, the Director of the National Gallery in Washington. Walker had stated what Parsons considered to be his 'artistic epitaph': 'Harold, those of us who work in museums will always be grateful to you for the many works of art you have caused to cross the Atlantic.'[117] And that was literally the best epitaph one could manage for Harold Woodbury Parsons. He was not a scholar; he had no real interest in archaeological studies. As Marshall noted, he was a dilettante and a dealer. Even his best efforts to expose art forgery failed to impress the people from whom he most longed for adulation. He felt shunned by Marshall's intellectualism and could never comprehend Warren's aestheticism. He was a dismal end to the Lewes House brotherhood.

Back in 1949, William Milliken put his finger on what was Parsons's most outstanding characteristic – his outrageousness. Parsons had described how he had decked himself out for a reception at the Asian Institute in Rome. He was certain he had chosen just the right Oriental touches. Milliken reacted: 'Harold, I can understand the full dress for a proper Bostonian. I can understand the Corona D'Italia medal that graced your lapel. But the rest! The decorations from the Bey of Tunis? The red Moroccan slippers?'[118]

Epilogue

Following Sam Warren's suicide, most of the Warrens wanted to forget about the days of Ned, Sam, Cornelia and Fiske. Sam's widow started early. She separated herself and her children from other Warrens and complained that Cornelia 'writes a letter just like Ned or Grandma'. She wanted as little to do with Cornelia as possible and even deplored the way her sister-in-law 'smelled'. In 1947, society writer, Cleveland Amory, wrote about Fiske's widow, Gretchen Osgood Warren, who thought the Osgoods were much better than the Warrens. After all, they were descended from John Quincy Adams, and she had been immortalized not only by the Sargent painting, but, at Matt Prichard's suggestion, in three drawings by Matisse. When Amory wrote about her she was in her seventies, and very much a leader of *The Proper Bostonians* as Amory entitled his best-selling book.

Amory said Gretchen Warren 'seldom leaves her antique-studded Beacon Hill home at all – never, if she can help it, for purely social engagements'.[1] It would have amused Ned Warren that she succeeded Amy Lowell as the President of the New England Poetry Society which was her sole passion, and her poetry-reading salons were, as Amory related, 'part of old Boston – unduplicated anywhere else – where Harvard professors, poets, and the better-bred Beacon Hill Bohemians distributed themselves gingerly around a large living room, among fragile sea shells and almost equally fragile chairs, sip tea and sherry, and engage in low-voiced discussion of poets, philosophy and kindred subjects'.[2]

Despite her mother's attempts to stamp out the past, Mabel Bayard Warren's daughter, Sylvia, became curious about Ned in particular, and took out the Burdett and Goddard biography from the Athenaeum Club library in Boston. So horrified was she at what she read about Ned's apparent homosexuality that she made certain no other Athenaeum Club member would read that. She kept the book. Except for the wife of 'Aunt Sylvia's' nephew, Mrs Margaret Thomas Warren, none of the current generation takes any interest in Ned. Margaret,

now a widow, lives in Ireland, and she is the only member of the family to be concerned about the deplorable condition of Ned's grave at Bagni di Lucca. The state of the English Cemetery has worsened. As of the summer in 1990, there was a rumour that the community was considering selling the property to a developer. The cemetery no longer has a lock at its gate and neighbours have taken to hanging their laundry over its monuments.

Today, a latter-day Aunt Sylvia might be more startled by Warren and Marshall's being duped so often by artistic forgery than by their homosexuality. Among the treasures left to Harry Thomas's daughter is a relief once attributed to Desiderio da Settignano. It is a fake by the talented nineteenth-century forger, Giovanni Bastianini. Nearby are fake ivories which Parsons mentioned, and a bronze bust (once thought to be from Herculaneum) which is a nineteenth-century copy of which there are many. In the doorway of Harry Thomas's cottage is what was once considered a third-century relief. It is a nineteenth-century pastiche.

Margherita Guarducci and Federico Zeri appear close to finding out the origins of the Boston Relief and the Ludovisi Throne. Despite attempts to keep a lid on the story, there is little doubt that the full account will soon surface. To date, the involvement of the actual purchasers of the relief, Warren and Marshall, has not entered the discussion of the authenticity of the related works – and the fact that they fought long and hard to win control of the Ludovisi Throne.[3] There is no doubt that the two works are related: they are approximately the same dimensions and of similar architectonic form. Both were carved from a single block of marble, and that marble has recently entered archaeological discussion because of its relationship to another work under scrutiny: the Getty kouros. The Getty Museum's star-crossed statue (purchased in 1974 for $7 million) is now very much under suspicion and has been removed from exhibition.

All three works: the Ludovisi Throne, the Boston Relief and the Getty kouros are from the same marble from the northern Aegean island of Thasos. This stone from the Thasian acropolis was only quarried at the turn of the last century and early into this century.[4]

Heretofore, no writer has suggested that another piece at the Boston Museum, Alceo Dossena's tomb in the style of Mino da Fiesole, was ever connected in any way with Warren. Far more than the Boston Relief, this pastiche of old and new marble, false inscriptions and missing carvings, purchased for $100,000 in 1924 has been

250

regarded as a fake by scholars. In his book *Artful Partners*, which maintains a secret collusion between Bernard Berenson and Joseph Duveen, Colin Simpson says that the Boston Museum learned about this 'Renaissance masterpiece' from 'Berenson's old Harvard and Oxford friend, Ned Warren, who in turn had been tipped off by Berenson'.[5] There is no other mention of this anywhere else but Simpson had access to the Duveen archives at the Metropolitan Museum in New York, and says the tomb was first considered by the Frick Museum: 'If the Frick turned it down [which they did] Boston was next in line.'[6]

Another unresolved case of forgery has partially surfaced and is connected with the numerous Greek statues and fragments John Marshall and others supplied Auguste Rodin. A visitor to the Hôtel Biron in Paris (which is now the Rodin Museum) can see some of these as they are displayed both in the house and spacious gardens. The Rodin archives mention a large number of battered Greek sculptures and antique Greek marble which was shipped to Rodin's atelier during the time when John and Mary Marshall were entertaining Rodin. Some of this material was used by Rodin's students to create new sculptures. Some of Rodin's assistants went further. In 1919, there was a sensational court case in Paris over the mass production of fake Rodins by his former assistants. Cellini believes that the origin of some false Greek kouroi may be traced back to Rodin's atelier. Apparently, some genuine Greek pieces in poor condition were worked over by assistants and sold as archaic sculpture.

One reason why there is little clarity to the story is that Joseph Brummer, once Rodin's studio aide, and later an important New York art dealer, gave conflicting accounts of such work in his meticulous notes. The reason is obvious: he desired to cover up his own involvement in the trafficking of some of these pieces. Harold Parsons bought a number of questionable pieces from Brummer and later Getty Museum's star-crossed kouros came from a ring of fakers associated with Rodin's studio. Jiří Frel, dismissed curator of antiquities at the Getty, was responsible for purchasing the kouros. Interestingly, he worked at the Rodin blew the whistle on Brummer's trade. Cellini has suggested that the Museum around 1966-7 cataloguing Rodin's collection of ancient sculpture. As Tom Hoving has asked: 'Is it smoke or fire? One may never know for sure.'[7] But now that the Getty has removed its kouros from exhibition, more of the story will probably be forthcoming, and as with the accounts concerning

Boston Museum's relief and 'Mino' tomb, it will be fascinating to see if any links with Warren and Marshall emerge.

One very substantial case has recently been announced. Michael Vickers, Senior Assistant Keeper at the Ashmolean Museum, published in the summer of 1990 what he termed 'a bombshell' to 'hit the field of Roman pottery studies'. Thermoluminescence testing at the Research Laboratory for Archaeology and the History of Art at Oxford (which was one of the three labs to carbon date samples from the Turin Shroud) indicated that Arrentine pottery moulds at the Ashmolean and also in museums in Germany, Italy and the United States were made in the early part of this century. As Vickers explains: 'These moulds until now have been regarded as central to the study of the pottery made at Arezzo in north central Italy in the first centuries BC and AD, a study which has become a minor academic industry since Arrentine ware is found throughout southern Europe especially in Italy, and is of great importance for dating purposes.'[8]

The moulds are all from Ned Warren's collection. J.D. Beazley's chapter on 'Warren as Collector' in the Burdett and Goddard biography mentioned them: 'These . . . represent classicising Graeco-Roman art at its truest and most tasteful.'[9] Once the Ashmolean set was tested other museums with Warren's pottery were warned, and the results were all the same. There was another twist to the tale. Vickers asked why anyone should have bothered to make forgeries of such things: 'Still less have been eager to acquire them.' The answer was clear when the subject matter of the scenes on the pottery was studied. Many had decidedly erotic scenes: 'loving couples in a state of undress engaged in activities rarely seen on TV'. Collectors of erotic *curiosa* would definitely be interested. In the meantime, Vickers maintained: 'Now that their authenticity has been called into question, one area of Roman archaeology, and of antiquities collecting, will not be the same again.'[10]

Ned Warren was one of those collectors of erotic *curiosa* Vickers described. Two summers ago, Colin Tompsett, current proprietor of George Justice's, the fine restoration firm near Lewes House, found two cigar boxes full of what first appeared to be ancient gems. They were in the wood shed out at the back which has remained basically intact since the days of Warren and Marshall. As George Justice had not only restored and cared for Warren's fine furniture, but also packed many of the treasures bound for Boston, Tompsett was quite excited. There were fifty-six intaglios, and they seemed to have been left from the collecting days.

Many items in the collection Tompsett discovered were of well-known Greek and Roman figures; but a third of the set was decidedly erotic: one with a Greek maiden carrying two large phalluses, another of the most explicit homosexual activity. A London dealer recommended by the British Museum recognized them as Victorian intaglios manufactured in Edinburgh. Other pieces left to Harry Thomas also attest to Warren's interest in erotica. A silver bowl remembered by Thomas's granddaughter was several times denied entry into the United States for possible sale as customs officials thought it to be 'immoral'. It is likely it went to the Boston Museum and has been termed a forgery of the early part of this century by a German expert. Extraordinarily, in the Ashmolean Museum's little cabinet of fakes is a copy of that fake.

The Boston Museum's catalogue of Classical sculpture refers to 'The Warren collection of Erotica': 'The gift of Greek, Etruscan, and Roman art of erotica was received quietly in 1908, but was not officially accessioned and catalogued until the 1950s. Thus, it figured not at all in Mr. Caskey's 1925 catalogue . . . '[11]

Earlier, Boston's puritanism was offended by some of the classical sculpture in its central museum. According to Whitehill:

In 1901 . . . a lively controversy broke out in Boston newspapers over the proposal to hold a YMCA reception in the Museum . . . which was, in the view of some, obviously no place for a mixed social gathering because of the presence of nude male statues. Two years later when Warren submitted photographs of five fragments of an archaic grave stele of a nude youth from Thebes, Edward Robinson wrote: 'The lower fragment of that could not be exhibited publicly, and I should be better pleased if it were not included.' When the sculpture arrived in Boston, Robinson observed: 'It is certainly a more interesting sort of archaic than I thought, and if the lower piece would be treated in any way so as to make it possible to exhibit in a public gallery, I should withdraw the opinion I expressed, though I do not see how this could be done without mutilation'.[12]

The museum did not buy the stele but did accept it as a gift from Fiske Warren in 1908. For fifty years it remained in fragments until William Young and an assistant put the pieces together, and the stele became one of the most impressive pieces in the Classical galleries.

Ned's stele was not the only piece to suffer banishment. Some of his

personal collection of bronzes and vase fragments of an erotic nature stayed in the basement for half a century. Worse occurred with many of the finest red-figured vases: added black paint censored 'the sexual exuberance of boisterous satyrs'.[13]

The Kiss also had a long rough ride to the Tate Gallery where, in its new setting, it has a decided place of honour and is the first work of art to be seen as one comes through the entrance. As we have seen, Ned tried to give it to Lewes and Boston. Later Parsons tried to sell it to Kansas City. Henry Thomas's daughter says that she refused an offer for it from the American art collector, Huntington Hartford. This was not long after the Second World War, and she would not even go to meet him at the Savoy as she did not want the sculpture to leave England – and as she puts it: 'Being just after the war, I did not have anything suitable to wear.'

In both Warren's obituaries and those of Thomas, it was *The Kiss* which was the most prominently mentioned art treasure with which they dealt. *The Daily Mirror* of 14 April 1953 announced Thomas's death as 'The man who owned Rodin's famous statue *The Kiss* which shocked a town has died.'[14] Lewes did not take to the statue favourably. In 1906, Ned allowed the International Society to exhibit *The Kiss* in its sixth annual exhibition and the reaction was decidedly more positive than in 1893 when Rodin's work appeared at Chicago's World Columbia Exposition. Then his statues were placed in a separate room where viewers were admitted only by personal application. In 1914, Warren arranged to have *The Kiss* exhibited in the Town Hall at Lewes and it was his intention that it would stay there. For several years it occupied a corner of the assembly room which was often used for concerts. The complaints soon came fast and furiously. Since young soldiers were at that time often present at concerts, the town fathers were worried that the statue might have 'a prurient effect' on them. For a time the piece was draped in black and the word went out that it 'occupied too much space'. The town council wanted it out – but it weighed 4 tons. Eventually, they got their way, and in February 1917, *The Kiss* was back in Warren's coach house. It stayed there until his death in 1928, and was sold to the Tate by Harry Thomas in 1953.

Despite the pups and fakes and proclivity towards erotica, the great collections of Warren and Marshall remain to this day one of the most significant collecting feats of all time. This is, of course, particularly apparent at the Boston and Metropolitan museums. Lesser known are Warren's gifts to Bowdoin College, The Rhode Island School of Design at Providence, the Ashmolean Museum at Oxford and Leipzig

University. And that was not all. Warren also gave works to Harvard, the University of Chicago, to Heidelberg, Bonn and to Bradford School. A vase at the British Museum is from him as is silver at the Louvre. To Vienna, he presented the head and hock of a bronze centaur which had been discovered in the Austrian excavations at Ephesus. As a token of appreciation, the Imperial government presented Warren with a little pillar of yellow onyx which he called 'The Emperor's column'.

In 1904 Warren met Mrs Gustav Radeke who started the Rhode Island School of Design. She was from the wealthy Metcalf family who acquired some notable works of art. Harold Parsons once bought for them. Through Warren Mrs Radeke bought some good vases and bronzes. But it would be the all-male liberal arts college a few miles north of Fewacres which would benefit greatly from Warren. He was attracted to this island of culture from his first days at Fewacres, and Bowdoin College has returned the favour. A third of Warren's 600 gifts are on view in the college museum, and nowhere in America is he more honoured. Beazley once commented on the benefactions in such an unlikely place: 'A coin, a gem, a vase, a statuette would speak of Greece in the heart of Maine; and sooner or later there would be the student whose spirit would require them. There was no hurry: an acorn in the forest.'

According to Beazley, Warren's connection with Bowdoin started in 1894 when Edward Robinson asked him to find a good vase for Mary and Harriet Walker's new museum at the college. Warren found an Attic pelike and then twelve years passed and he sent a letter from Fewacres saying: 'I beg to offer to the Walker Art Museum . . . three pieces of sculpture.'[15] One was among the best he would present over the next thirty years: a head of the Roman Emperor Antoninus Pius, one of the finest surviving Roman portraits of the second century AD. The gifts kept coming but by 1912 Warren admitted: 'This year, having an unusually good opportunity, to make up a small lot of antiquities, I am sending them to Bowdoin College. They are not the first pick since the first pick went to Boston by way of purchase, but Boston did not have all that was good.'[16] Warren went on to say that he would pay for the shipping and that his secretary, Frank Gearing, was attending to that. A month later, Gearing wrote to Bowdoin to say that he had made a mistake. One piece was 'indecent' and 'should never have been included in your consignment'.[17]

In 1927, Warren apologized to the museum for 'breaking a vase of yours'. It was on its way from Fewacres. However, he could 'console

[himself] by remembering that it is one of the worst in the collection'.[18] A catalogue of the Warren collection admits to a few forgeries as well: 'the false pieces include marble reliefs, terracotta figurines and pottery'. There was, however, a philosophical attitude towards the discovery: 'Ironically . . . all of these objects can now serve a function for which their makers never intended them. By the very falseness of their nature, they can help the student to sharpen his vision and thereby grow in the knowledge of the true and beautiful.'[19]

Warren would still recognize most of Bowdoin as he remembered it since many of its buildings have been designated National Historical Sites. Fewacres also remains – after a fashion. After Charles Murray West sold it, the estate became first a hospital, then a nursing home. At present it is a real estate office. As earlier described, Lewes House became the headquarters of the Lewes District Council in 1974. Following Ned's death, the house was sold in 1929, to Thomas Sutton who was employed by Sotheby's. From existing correspondence to Harry Thomas, it appears that Sutton tried to get Sotheby's control of all that remained. Three months before Gorringe's sale, Sutton wrote to Thomas: 'I am quite willing to purchase the whole contents of Lewes House, at prices considerably beyond those that have been offered. Or, I will do what you think is much fairer to you – make a really fine sale of everything, and so protect your interests that the total does not fall below the prices named. I am *quite* certain that I can make you a fine sale, a *very* fine sale, and I will take great pleasure in doing it – but we ought to get to work at once.'[20]

Earlier in April, Sutton asked Thomas: 'Did you do anything about the Filippino Lippi?' Sutton was only able to sell Warren's library in 1929. The catalogue announced: 'Works on literature, art and archaeology; ancient and modern classics; also many examples of early printing, and a few manuscripts.' Four paintings were sold by Christie's in 1944: *Circe Calling Ulysses* by Jan Brueghel; *Saint Veronica* by Joos van Cleve; *Three Cherubs* by Cranach and a painting by the Westphalian School of *Our Saviour and Saint John the Baptist*. Over the years other items – silver in particular – were sold as well. Harry Thomas's daughter was still able to exclaim: 'You should see the amount of silver that's in the attic.' Some of that went up for sale a year ago. Perusing Gorringe's Lewes House sale catalogue one is staggered by the sheer volume of fine china, furniture, antiquities and paintings left by Warren and his associates.

Only Charles Rose, the now retired Assistant District Secretary of the Lewes Town Council, has tried to commemorate Lewes House's

most illustrious occupant. It was he who finally got a small display case set up near the entrance indicating the days of Warren and his friends and their connections with art and archaeology. Rose hoped for more, and received some curious items from the past scattered around Lewes. He befriended Frank Gearing's widow who still lives at Hamsey Crescent in Lewes and produced for Rose a bronze bust of Warren which she said she found 'under my bed'. It was executed by a friend of Ernst Perabo.

It is, however, at the Ashmolean Museum and the library next door where the Lewes House brotherhood can best be evoked. Leafing through the letters and notebooks Warren and Marshall collected and deposited in haphazard fashion is bit like rummaging through the effects of a deceased friend. Bills from memorable meals at Ranieri's in Rome or the Grand Hotel in Venice are interspersed with lists of work not yet completed. There are endless translations of Horace's odes from Marshall to Warren; drawing of pediments and statues in Athens by Fothergill, and Prichard's meticulously kept receipts from the antiquarian Canessa in Naples or the Galleria Sangiorgio in Rome.

E.H. Goddard concluded the biography of Ned Warren by saying his had been 'the story of an unusual man and a more than ordinarily complex nature'.[21] Ned Warren was indeed complex, but basically spoiled and self-indulgent. He expected the impossible from the collection of aesthetes at Lewes House who each in his own way doted for his affection. Ned's vision of a brotherhood was doomed from the beginning. John Fothergill put his finger on the basic problem: it was 'too all-providing'. And more than the conversation was 'strained and unnatural'. None of Ned's boys could ever be themselves in that environment. Basically, Ned never knew what he wanted. By the time he really began to understand John Marshall, it was too late. He never knew what it meant to be 'a proper Puppy'. Ned's idea of friendship was not so dissimilar from Lionel Johnson's who loved his fellow creatures in theory but found it difficult in the flesh. Ned's warped sense of duty to the Boston he simultaneously hated and loved and his unresolved feelings concerning his family ultimately were his undoing and that of his circle of friends. He never really hated his brother – he never really faced him.

And there was more he never faced. Ned's vision of a male aesthetic élite modelled on an ancient Greek pattern was largely determined by his distaste for women. In the end, Ned was shattered by the realization that his 'brothers' did not share his basic misogyny. Prichard came the nearest in principle but hardly in practice with

'dearest Isabella'. Even Harold Parsons with all his homosexual pursuits could say that 'dear old Ned really didn't like the opposite sex'.[22] Unintentionally, the Ashmolean Museum has immortalized the tensions in Ned's life. At the entrance to the Petrie Room are two Roman copies of Greek statuary. To the right is a marble torso of a Greek boy; exquisite with all that was most admired in the young male form. It is a copy of a fifth-century BC original. The caption says it is 'In memory of Edward Warren and John Marshall', and was given 'by three friends'. They were Beazley, Ashmole, and Miss E.R. Price who was a student of Greek ceramics. To the left is the fragment of a maenad, probably from the collection of Count Stroganoff in Rome.

In Greek mythology, maenads were ecstatic women who accompanied Dionysus. At the peak of their ecstasy, they seized a living animal, rent it apart and ate it raw. Historically, maenads were housewives who abandoned their families to join secret female societies. On an Attic red figure vase Ned gave the Ashmolean, maenads tore apart a young man who had the misfortune to be caught watching their rites. It is a gruesome sight with one maenad holding aloft the youth's head, others wield arms and legs, and one a mass of entrails. There is much added red for all the blood and guts.

The maenad fragment looks awfully menacing across from the beautiful youth. Ned would have approved of the juxtapositioning.

Notes and References

Abbreviations

EPW – Edward Perry Warren
JM – John Marshall
JF – John Fothergill
HAT – Harold (Harry) Asa Thomas
HWP – Harold Woodbury Parsons
MSP – Matthew Stewart Prichard
BB – Bernard Berenson
ISG – Isabella Stewart Gardner
WMM – William M. Milliken
B-G – Burdett, Osbert and Goddard, E.H., *Edward Perry Warren: The Biography of a Connoisseur* (London: Christopher, 1941).
JF Ms – John Fothergill's memoirs
HRW Ms – Harry Rowans Walker's draft biography of Matthew Stewart Prichard

Wherever possible, original letters and texts have been used. Unfortunately, some of those referred to by Burdett and Goddard have disappeared from the major depository of Warren and Marshall's papers at the Ashmolean Libary at Oxford. The letters between MSP and ISG are at the Isabella Stewart Gardner Museum in Boston, and also on microfilm at the American Art Archives. The HWP-WMM correspondence is there as well. All other letters – except as otherwise noted – are in my possession.

The letters between ISG and BB were edited and annotated by Rollin Van N. Hadley in 1987. Fothergill's memoirs are handwritten, unpaginated and often with additional notes attached on the reverse side. It is, therefore not possible to refer to this material other than as the JF Ms. There is a similar difficulty with the Walker draft biography. I have devised numbered sectional indicators for the material quoted, and these are generally in chronological order. Quotations given to the author in conversation (such as those from Mrs Kathleen Warner) are not cited in the notes and references.

Introduction

1. B-G, p. 242.
2. Fothergill, John, *My Three Inns* (London: Chatto & Windus, 1949), p. 239.
3. Hale, Shelia, *Florence and Tuscany* (London: Mitchell Beazley, 1983), p. 129.
4. *The Sunday Telegraph*, 15 February 1981, p. 14.
5. B-G, p. 79.
6. Green, Martin, *The Warrens of Mount Vernon Street: A Boston Story. 1860-1910* (New York: Charles Scribner's Sons, 1989), p. xiii.

Part I: Edward Perry Warren – a Dream of Youth

1. Fletcher, Iain (ed.) *The Complete Poems of Lionel Johnson* (London: Unicorn Press, 1953), p. 53.
2. B-G, p. 1.
3. Ibid.
4. B-G, p. 64.
5. Ibid.
6. B-G, p. 65.
7. Ibid., p. 5.
8. Ibid., p. 15.
9. Ibid., p. 3.
10. *Samuel Dennis Warren: A Tribute from the People of Cumberland Mills* (Cambridge, Mass.: Riverside Press, 1888), p. 103.
11. B-G, p. 7.
12. Ibid., p. 14.
13. Ibid., p. 16.
14. Ibid., p. 10.
15. Ibid., p. 7.
16. Ibid., p. 14.
17. Ibid., p. 19.
18. Ibid.
19. Ibid., p. 12.
20. Ibid., pp. 67-8.
21. Ibid., p. 5.
22. JF Ms.
23. B-G, p. 189.
24. JF Ms.
25. Green, *The Warrens*, p. 153.
26. Fisher, H.A.L., *An Unfinished Autobiography* (London: Oxford University Press, 1940), p. 153.
27. Olson, Stanley, *John Singer Sargent: His Portrait* (London: Barrie & Jenkins, 1989) , p. 227.
28. Green, *The Warrens*, p. 3.

29. Ibid., p. 44.
30. B-G, p. 23.
31. JF Ms.
32. B-G, p. 64.
33. Ibid., p. 149.
34. JF, Ms.
35. B-G, p. 5.
36. Paper, Lewis J., *Brandeis* (Englewood Cliffs, New Jersey: Prentice Hall, 1983), p.22.
37. Green, *The Warrens*, pp. 13-14.
38. B-G, p. 26.
39. Ibid.
40. Ibid., pp. 26-7.
41. Ibid., p. 28.
42. Ibid.
43. Ibid., pp. 32 and 41.
44. Ibid., pp. 34-5.
45. Ibid., p. 37.
46. Ibid.
47. Tharp, Louise Hall, *Mrs Jack: A Biography of Isabella Stewart Gardner* (Boston: Little, Brown, 1965), p. 59.
48. Simpson, Collin, *Artful Partners: Bernard Berenson and Joseph Duveen* (New York: Macmillan, 1986), p. 50.
49. B-G, p. 48.
50. Ibid., p. 45.
51. Fisher, *An Unfinished Autobiography*, pp. 142-3.
52. B-G, p. 67.
53. Ibid., p. 52.
54. Ibid., p. 53.
55. Ibid., p. 57.
56. Ibid., p. 59.
57. JF Ms.
58. Morris, Jan, *Oxford* (London: Oxford University Press, 1965), p. 99.
59. Ibid.
60. Ibid.
61. Carpenter, Humphrey, *The Brideshead Generation: Evelyn Waugh and His Friends* (London: Weidenfeld & Nicolson, 1989), p. 80.
62. Morris, *Oxford*, p. 102.
63. Green, *The Warrens*, pp. 41-2.
64. Calhoun, Charles C., 'An Acorn in the Forest' in *Bowdoin* (Brunswick, Maine: Sept. 1987), p. 8.
65. Ibid.
66. JF Ms.

67. Raile, Arthur Lyon (Edward Perry Warren), *A Tale of Pausanian Love* (privately published, 1927), p. 19.
68. Ibid., p. 88.
69. Ibid., p. 7.
70. Ibid., p. 13.
71. Ibid., p. 27.
72. Ibid.
73. Ibid., p. 49.
74. Ibid., pp. 49-50.
75. Ibid., p. 82.
76. Ibid., pp. 121-3.
77. Ibid., pp. 118-19.
79. Ibid., p. 126.
80. Ibid., p. 136.
81. Ibid.
82. B-G, p. 85.
83. Raile, *A Tale of Pausanian Love*, p. 136.
84. Samuels, Ernest, *Bernard Berenson: The Making of a Connoisseur* (Cambridge, Mass.: Harvard University Press, 1979), p. 60.
85 Ibid.
86. Ibid., p. 63.
87. Secrest, Meryle, *Being Bernard Berenson: A Biography* (London: Weidenfeld & Nicolson, 1980), p. 126.
88. Holzberger, G. and Saatkamp, J. (eds), *Persons and Places: Fragments of an Autobiography* (Cambridge, Mass.: MIT Press, 1986), p. 300.
89. Simpson, *Artful Partners*, p. 53.
90. Holzberger and Saatkamp, *Persons and Places*, p. 300.
91. Fletcher, *Lionel Johnson*, p. xxxii.
92. Simpson, *Artful Partners*, p. 53.
93. Samuels, *Bernard Berenson*, p. 38.
94. Ibid.
95. Fletcher, *Lionel Johnson*, pp. 94, 353.
96. Samuels, *Bernard Berenson* p. 63.
97. B-G, p. 420.
98. Fletcher, *Lionel Johnson*, pp. xxi, xxii.
99. Holzberger and Saatkamp, *Persons and Places*, p. 301.
100. Fletcher, *Lionel Johnson*, p. 207.
101. Bowra, C.M. *Memories 1898-1939* (London: Weidenfeld & Nicolson, 1966), p. 31.
102. New College, Oxford Archives.
103. Fisher, *An Unfinished Autobiography*, p. 141.
104. Calhoun, 'An Acorn . . . ', p. 4.
105. Beazley, J.D., in *Oxford Magazine*, Oxford, 24 January 1929, p. 3.
106. B-G, p. 66.

107. Ibid., p. 62.
108. Ibid.
109. Ibid., p. 63.
110. Ibid., p. 64.
111. Ibid., p. 65.
112. Ibid.
113. Ibid., p. 66.
114. Ibid.
115. Ibid.
116. *Samuel Dennis Warren: A Tribute*, p. 16.
117. Ibid., p. 60.
118. Green, *The Warrens*, p. 84.
119. This information comes from notes in the papers of Harry Thomas.

Part II: Edward Perry Warren – the Collector

1. Clark, Kenneth in *Great Private Collections* (edited by Douglas Cooper) (New York: Macmillan, 1963), p. 13.
2. B-G, p. 79.
3. Samuels, *Bernard Berenson*, p. 60.
4. Warren, Cornelia, *A Memorial of My Mother* (Boston: 1908), p. 152.
5. Samuels, *Bernard Berenson*, p. 246.
6. EPW to BB, 22 October 1899.
7. BB to ISG 1 April 1900 in *The Letters of Bernard Berenson and Isabella Stewart Gardner, 1887-1924*, edited and annotated by Rollin Van N. Hadley (Boston: Northeastern University Press, 1987), p. 212. Henceforth referred to as Hadley.
8. BB to ISG, 15 Nov. 1897 (Hadley, p. 100).
9. B-G, pp. 132-3.
10. Calhoun, 'An Acorn . . . ' p. 6.
11. Samuels, *Bernard Berenson*, p. 338.
12. Clark in *Great Private Collections*, p. 13.
13. Weintraub, Stanley, *Reggie: A Portrait of Reginald Turner* (New York: George Braziller, 1965), before the Table of Contents.
14. B-G, pp. 110-11.
15. Samuels, *Bernard Berenson*, p. 168.
16. B-G, p. 101.
17. Ibid., p. 102.
18. Ibid., p. 103.
19. Ibid., p. 105.
20. Ibid., p. 108.
21. B-G, pp. 107-8.
22. Ibid., p. 105.
23. Ibid.

24. B-G, pp. 108-9.
25. EPW to JM, 27 Feb. 1887.
26. EPW to JM, 5 July 1887.
27. EPW to JM, 9 Aug. 1888.
28. EPW to JM, Sept. 1887 (day not given).
29. EPW to JM, March 1889 (day not given).
30. EPW to JM, June 1889 (day not given) and EPW to JM July 1889 (day not given).
31. B-G, p. 119.
32. JM to EPW, Sept. 1889 (day not given).
33. EPW to JM, 16 Nov. 1889.
34. EPW to JM, 22 Oct. 1889.
35. *The Times*, 29 April 1989, p. 51A.
36. HWP to Henry Sayles Francis, 14 March 1967 (in Bowdoin College Art Museum Archives).
37. Rothenstein, William, *Men and memories: Recollections 1872-1900* Vol. I (London: Faber, 1931), p. 343.
38. B-G, p. 130.
39. Ibid., p. 143.
40. JF Ms.
41. B-G, p. 252.
42. Ibid., p. 191.
43. JF Ms.
44. Ibid.
45. Clark in *Great Private Collections*, p. 19.
46. Andrén, Arvid, *Deeds and Misdeeds in Classical Art and Antiquities* (Partille, Sweden: Studies in Medieval Archaeology, No. 3, 1986), p. 51.
47. HAT to President of Corpus Christi College, Oxford, 28 Nov. 1912.
48. Moltesen, Mette, 'From the Princely Collections of the Borghese Family to the Glyptotek of Carl Jacobsen', in *Analecta Romana*, Instituti Danici (XVI), Rome, 1987, p. 11.
49. B-G, p. 192.
50. Ibid., pp. 151-2.
51. HAT to President of Corpus Christi College, 28 Nov. 1912.
52. JM to EPW, 22 Oct. 1892.
53. EPW to Henry Warren, 9 Jan. 1896.
54. B-G, pp. 153-4.
55. Andrén, *Deeds*, p. 92.
56. B-G, p. 117.
57. Andrén, *Deeds*, p. 94.
58. Ibid., p. 91.
59. Ibid., p. 75.
60. Moltesen, 'Princely Collections', p. 190.

61. Ibid., p. 191.
62. Curtius, Ludwig, 'In Memoriam: Edward Perry Warren and John Marshall', in *Mitteilungen des Deutschen Archaologischen Instituts*, Romische Abteilung, Rome, 1929.
63. *Michelin Guide to Rome* (London: Michelin, 1985), p. 119.
64. *The Guardian*, 27 April 1988, p. 14.
65. Headington, Ann, 'The Great Cellini', in *Connoisseur*, Sept. 1986, p. 100.
66. Guarducci, Margherita, in *Bolletino d'Arte*, No. 43, Series VI, 1987.
67. Andrén, *Deeds*, pp. 76-7.
68. Rothenstein, *Men and Memories*, p. 343.
69. Young, William J. and Ashmole, Bernard, 'The Boston Relief and the Ludovisi Throne', in *Museum of Fine Arts, Boston Bulletin*, Volume LXIII, No. 332, p. 59.
70. Jones, Mark (ed.), *Fake? The Art of Deception* (London: British Museum Publications, 1990), p. 32.
71. Andén, *Deeds*, p. 74.
72. JM notebook of 1923. Subsequent to this discovery, I was shown several papers at the Metropolitan Museum of Art which indicate this memorandum was part of a three-page report from Marshall discussing what he knew or had heard about the D.R. He says that Warren first heard about the Boston Relief in January 1895, and saw it for the first time on 20 March of that year. It was purchased on 27 January 1896, and was on its way to England on 1 February 1896. Marshall stated that the record concerning the involvement of the Jandolos, Hartwig, Martinetti, Valenzi etc. is complicated and there appeared to be no way he was able to have a clear picture of exactly what transpired.
73. B-G, p. 172.
74. JM to EPW, 28 Oct. 1892.
75. B-G, p. 209.
76. Ibid., p. 206.
77. Ibid.
78. Ibid., pp. 170-1.
79. *Raccolta Alfredo Barsanti Bronzi Italiani*, Rome, 1928, pp. 217, 223.
80. Jandolo, Augusto, *Le Memorie di un Antiquario* (Milan: Casa Editrice Ceschina, 1938), p. 338.
81. Ibid., pp. 338-40.
82. Ibid. and Mills, John Fitzmaurice and Mansfield, John M., *The Genuine Article* (London: BBC, 1979), p. 196. The marble 'Flora' may be the one exhibited in the *Fakes and Forgeries* exhibition at the Minneapolis Institute of Arts, 11 July 29 Sept. 1973. It was listed as number 101 in the catalogue and was from an 'anonymous loan'.
83. Private correspondence.
84. JM notebook (undated).
85. Undated ms from JM in several drafts.

86. JM to EPW, 20 March 1893.
87. B-G, p. 179.
88. B-G, pp. 198-9.
89. Ibid., pp. 351-2. There is a large correspondence on the Athena in the Ashmolean Library.
90. B-G, pp. 205-6.
91. Warren, Edward Perry (anonymously), 'The Scandal of the Museo di Villa Giulia', in *Monthly Review* (Jan-March 1902), pp. 78-9. In 1883, Moses Shapira bought fifteen leather strips containing part of the book of Deuteronomy from Arabs who had supposedly found them in Jordan. They were rejected as forgeries by scholars and he committed suicide. But, as Mark Jones says in the catalogue for *Fake? The Art of Deception*, the British Museum's exhibition in 1990: 'in 1959, following the discovery of the Dead Sea Scrolls, the question of Shapira's fragments was reopened. Meanwhile, the fragments themselves have disappeared' (p. 27).
92. HAT to President of Corpus Christi College, 28 Nov. 1912.
93. EPW in *Monthly Review*, p. 80.
94. EPW memorandum at Ashmolean Library. Apparently this was a draft.
95. Ibid.
96. Ibid.
97. EPW in *Monthly Review*, p. 95.
98. Ibid., pp. 99-100.
99. B-G, p. 72.
100. Green, *The Warrens*, p. 162
101. B-G, pp. 221-2.
102. Ibid., p. 221.
103. Ibid., pp. 222-3.

Part III: Edward Perry Warren – The Prince Who Did Not Exist

1. Warren, Edward Perry, *The Prince Who Did Not Exist* with pictures by Arthur J. Gaskin (Boston: Merrymount Press, 1900), p. 17.
2. Samuels, *Berenson*, p. 82.
3. *Warren, Prince*, pp. 1-3.
4. JF Ms.
5. B-G, p. 226.
6. Ibid., p. 230.
7. Ibid., p. 237.
8. Paper, *Brandeis*, p. 219.
9. B-G, p. 238.
10. Ibid., pp. 239-40.
11. Ibid., p. 240.
12. Green, *The Warrens*, p. 10.
13. Paper, *Brandeis*, p. 1.

14. Green, *The Warrens*, p. 10.
15. B-G, pp. 395-6.
16. Ibid., p. 251
17. Ibid., p. 363.
18. Ibid., p. 244.
19. Ibid., p. 235.
20. Robert Bridges to EPW, 22 Nov. 1903.
21. B-G, p. 287.
22. Ibid., pp. 289-90.
23. Raile, Arthur Lyon, *The Wild Rose* (London: David Nutt, 1909), pp. 32-3.
24. Ibid., pp. 116-17.
25. B-G, pp. 276-7.
26. Ibid., p. 277.
27. Ibid., p. 278.
28. Ibid., p. 300.
29. Thaite, Ann, *Edward Gosse: A Literary Landscape, 1849-1928* (London: Secker & Warburg, 1984), p. 182.
30. B-G, p. 301.
31. Ibid., p.302.
32. Ibid., p. 303.
33. Ibid., p. 304.
34. Ibid., p. 305.
35. Ibid.
36. EPW to JM, 25 February 1915.
37. B-G, p. 328.
38. HWP to Henry Francis, 14 March 1967.
39. Hassall, Christopher, *Rupert Brooke: A Biography* (London: Faber, 1964), p. 121. See also Ian Anstruther's *Oscar Browning: A Biography* (London: John Murray, 1985).
40. Holzberger and Saatkamp, *Persons and Places*, pp. 435-6.
41. Ellmann, Richard, *Oscar Wilde* (London: Hamish Hamilton, 1987), p. 60.
42. Spalding, Frances, *Roger Fry: Art and Life* (London: Granada, 1980), p. 17.
43. Anstruther, *Oscar Browning*, p. 134.
44. Ellmann, *Oscar Wilde*, p. 261.
45. Morley, Sheridan, *Oscar Wilde* (London: Weidenfeld & Nicolson, 1976), p. 68.
46. Borland, Maureen, *Wilde's Devoted Friend: A Life of Robert Ross 1869-1918* (Oxford: Lennard, 1990), p. 282.
47. Ibid., p. 248.
48. Grunfeld, Frederic, *Rodin: A Biography* (London: Oxford University Press, 1989), p. 369.
49. Ibid., p. 370.
50. Ibid., p. 403.
51. Ibid.

52. Rothenstein, *Men and Memories*, Vol. II, p. 45.
53. Grunfeld, *Rodin*, p. 404.
54. Ibid., p. 458.
55. B-G, p. 260.
57. Auguste Rodin to EPW, 13 Aug. 1903 (translation made by Jennifer Brooke of the American School in London).
58. Auguste Rodin to JM, 4 Oct. 1903.
59. Calhoun, 'An Acorn . . . ' p. 10.
60. Robertson, Martin, in *Dictionary of National Biography* (1961-1970), p. 85.
61. Bowra, *Memories*, p. 155.
62. B-G, p. 333.
63. Ibid., p. 336.
64. Ibid., p. 337.
65. Ibid., p. 345.
66. Bowra, *Memories*, pp. 250-1.
67. Calhoun, 'An Acorn . . . ', p. 10.
68. Bowra, *Memories*, pp. 249-50.
69. Private correspondence.
70. B-G, p. 76.
71. Ibid., p. 367.
72. Ibid.
73. Fisher, *Autobiography*, p. 141.
74. Private correspondence.
75. B-G, p. 382.
76. Ibid., p. 377.
77. JF Ms.
78. B-G, p. 380.
79. Ibid., p. 371.
80. Holzberger and Saatkamp, *Persons and Places*, p. 506.
81. Ibid., p. 507.
82. B-G, p. 374.
83. Ibid., p. 382.
84. Ibid., p. 376.

Part IV: John Marshall's Story – Life without Puppy

1. EPW to JM, 4 May 1914.
2. Jandolo, *Le Memorie*, p. 398.
3. Private correspondence.
4. Private memoirs of Bernard Ashmole made available to the author before his death.
5. Von Bothmer, Dietrich, 'The History of the Terracotta Warriors', Metropolitan Museum of Art, New York, 1961, p. 7.
6. BB to ISG, 1 Jan. 1908 (p. 417 of Hadley).
7. B-G, p. 157.

8. JM to JF, 23 July 1909.
9. B-G, p. 243.
10. BB to ISG, July 1903 (p. 318 of Hadley).
11. Sinclair, Andrew, *Corsair: The Life of J. Pierpont Morgan* (London: Weidenfeld & Nicolson, 1981), p. 205.
12. Ibid., p. 206.
13. Jackson, Stanley, *J.P. Morgan: The Rise and Fall of a Banker* (London: Heinemann, 1984), p. 246.
14. JM to J.P. Morgan, 11 May (1906? – no year given for this letter).
15. 1907 JM notebook at the Ashmolean Library.
16. Champigneulle, Bernard, *Rodin* (London: Thames & Hudson, 1967), pp. 242-3; and Harlan, William, *The World of Rodin: 1840-1917* (New York: Time-Life Books, 1969), pp. 155, 166-7.
17. JM to EPW, 28 Jan. 1912.
18. JM to EPW, 24 Jan. 1912.
19. JM to EPW, 31 Jan. 1912.
20. JM to EPW, 6 Feb. 1912.
21. Grunfeld, Frederic, *Rodin: A Biography* (Oxford: Oxford University Press, 1989), p. 626.
22. Ibid., p. 629.
23. JM to Edward Robinson, 6 Jan. 1908.
24. Ibid.
25. JM to Edward Robinson (undated).
26. B-G, pp. 338-9.
27. Ibid., p. 337.
28. Von Bothmer, 'Warriors', p. 14.
29. JM to Gisela Richter, 14 Nov. 1915.
30. JM to Edward Robinson, 13 August 1919.
31. Von Bothmer, 'Warriors', p. 7.
32. Ibid.
33. Ibid.
34. Ibid., p. 8.
35. Ibid.
36. Frankfurter, Alfred, 'Unhappy Warriors', *Art News*, March 1961, p. 65.
37. B-G, p. 253.
38. Ibid., pp. 253-4.
39. Ibid., pp. 255-6.
40. Von Bothmer, 'Warriors', p. 10.
41. Ibid., p. 11.
42. Ibid.
43. Ibid.
44. HWP to WMM, 31 Dec. 1948.
45. Parsons, Harold Woodbury, 'The Art of Fake Etruscan Art', *Art News*, Feb. 1962, p. 36.

46. Richter, Gisela M.A., 'Etruscan Terracotta Warriors in the Metropolitan Museum of Art', Metropolitan Museum of Art, New York, Papers No. 6, 1937, p. 5.
47. *Apollo*, April 1939, pp. 151-2.
48. Sox, David, *Unmasking the Forger: The Dossena Deception* (London: Unwin Hyman, 1987), pp. 172-3.
49. Private memoirs of Bernard Ashmole.
50. Ashmole, Bernard, 'The First J.L. Myres Memorial Lecture', New College, Oxford, 9 May 1961: 'Forgeries of Ancient Sculpture: Creation and Detection' (Oxford: Blackwell, 1961), pp. 10-11.
51. *Art News*, 28 Nov. 1928, p. 32.
52. *Art News*, 8 Dec. 1928, p. 4.
53. Private memoirs of Bernard Ashmole.
54. EPW to JF, 27 Feb. 1928.
55. B-G, p. 398. Notes at the Ashmolean Library indicate that these words used by E.H. Goddard were observations supplied by Beazley.
56. B-G, p. 399.
57. EPW to JF, 26 Feb. 1928.
58. Ibid.
59. Ibid.
60. B-G, pp. 399-400.
61. Ibid.
62. Ibid., p. 234.
63. Ibid., p. 401.
64. Clark, Kenneth, in *Great Private Collections*, p. 13.
65. Beazley, J.D. in *Oxford Magazine*, p. 7.
66. Portland, Maine, *Sunday Telegraph*, 29 Dec. 1928, p. 28.
67. B-G, p. 399.

Part V: John Fothergill's Story – the Architect of the Moon

Quotations in this section which are not noted all come from John Fothergill's memoirs.

1. Meryle Secrest refers to Fothergill's memoirs as *Lest an Old Man Forget*. Actually that title refers to a collection of anecdotes Fothergill compiled in 1954.
2. Secrest, Meryle, *Between Me and Life: A Biography of Romaine Brooks* (London: Macdonald & Jane, 1976).
3. Ellmann, *Oscar Wilde*, p. 526n.
4. Holroyd, Michael, *Augustus John: A Biography* (London: Penguin Books, 1976), p. 452.
5. Fothergill's sons say that their father planned to add to his memoirs before his death. They end abruptly soon after Ned Warren's death.
6. Ellmann, *Oscar Wilde*, p. 505.

7. Hart-Davis, Rupert (ed.), *Selected Letters of Oscar Wilde* (London: Oxford University Press, 1962), pp. 285-6.
8. Ibid., pp. 291-2.
9. Ibid., pp. 300-1.
10. Ibid., p. 308.
11. Ibid.
12. Also see Hart-Davis, *Selected Letters*, pp. 290-1.
13. Ellmann, *Oscar Wilde*, p. 507.
14. Rothenstein, *Men and Memories*, pp. 343-4.
15. JF to Robert Ross, 17 Jan. 1901.
16. JF to William Rothenstein, 19 Jan. 1901.
17. Holroyd, *Augustus John*, p. 114.
18. Secrest, *Romaine Brooks*, p. 116.
19. Ibid., p. 117.
20. Ibid.
21. Ibid., pp. 116-17.
22. Ibid., p. 118.
23. Ibid.
24. Ibid., p. 114.
25. Sir Harold Acton to JF, 12 Oct. 1948.
26. Secrest, *Romaine Brooks*, p. 119.
27. Ibid., p. 115.
28. It is interesting that Fothergill used E.M. Forster's 'yaller dog' anecdote and did not mention that it was from *A Room with a View* (p. 81 of the Penguin Books edition).
29. Borland, *Ross* pp. 69-70.
30. Fothergill did not mention another major achievement in his memoirs. His essay on 'Drawing' for the eleventh edition of the *Encylopaedia Britannica* was brilliant, and Bernard Ashmole wrote to me: 'This excellent piece was replaced by a superficial and comparatively worthless essay.'
31. B-G, p. 226.
32. These words from Fothergill's memoirs are echoed in B-G, pp. 241-2.
33. B-G, pp. 234-5.
34. Secrest, *Romaine Brooks*, p. 119.
35. Carpenter, *Brideshead Generation*, p. 115.
36. Holroyd, *Augustus John*, p. 347.
37. Rothenstein, *Men and Memories*, p. 333.
38. *James Dickson Innes*, collected and edited by Lillian Browse; with an introduction by John Fothergill (London: Faber, 1946), p. 12.
39. Holroyd, *Augustus John*, p. 450.
40. Ibid., p. 452.
41. Ibid., p. 456.
42. Ibid., p. 391.

43. Epstein, Jacob, *An Autobiography* (London: Vista Books, 1963), pp. 18-19.
44. Ibid., p. 19.
45. Speaight, Robert, *William Rothenstein: The Portrait of an Artist in His Time* (London: Eyre & Spottiswoode, 1962), p. 186.
46. JF to William Rothenstein, 15 Sept. 1941.
47. Roberts, Frank C. (ed.) *Obituaries from The Times 1951-1960* (London: Newspaper Archive Developments, 1979), p. 89. The original obituary was in *The Times*, 29 August 1957.
48. Carpenter, *Brideshead Generation*, p. 116.
49. Fothergill, John, *An Innkeeper's Diary* (London: Penguin Books, 1931), p. 15.
50. Ibid., p. 16.
51. Hilary Rubinstein's foreword to Faber & Faber's reprint of *An Innkeeper's Diary* (1989), p. xii.
52. Fothergill, *My Three Inns*, p. 49.
53. Wells, G.P. (ed.) *H.G. Wells in Love* (London: Faber, 1984), p. 170.
54. As repeated in Carpenter, *Brideshead Generation*, p. 114.
55. Sir Harold Acton to JF, 12 Oct. 1948.
56. Rubenstein, p. x.
57. Fothergill, *Innkeeper's Diary*, p. 168.

Part VI: Matt Prichard's Story – One Bonnet, but Innumerable Bees

1. HRW Ms. Walker's draft biography is a mish-mash and often unpaginated. Most of it, however, is divided into sections fairly chronologically. When no section titles have been provided, I have used numbered sectional indicators. I have found some of Walker's references inaccurate so have tried wherever possible to use the exact words of quotations available. I cannot, however, vouch for some of the letters he quotes. He relies heavily upon the ISG-MSP correspondence which can be quoted with accuracy.
2. B-G, pp. 140-1.
3. HRW, section II, 4.
4. Ibid.
5. Ibid.
6. Ibid.
7. Ibid., II, 6. (Henceforth Roman numerals refer to sections of the HRW Ms.)
8. Ibid.
9. Ibid., II, 7-8.
10. Ibid.
11. II, 8.
12. Ibid.
13. II, 11.

14. Ibid.
15. II, 10.
16. II, 9.
17. Ibid.
18. Ibid.
19. Ibid.
20. II, 12.
21. Ibid.
22. Ibid.
23. III, 1.
24. Ibid.
25. III, 3.
26. Ibid.
27. Ibid.
28. III, 4.
29. JM to EPW, 28 Oct. 1892.
30. B-G, p. 191.
31. B-G, p. 146.
32. JM notebook at the Ashmolean Library probably dated 1898.
33. HAT to President of Corpus Christi College, 28 Nov. 1912.
34. B-G, p. 212 and B-G, p. 6.
35. III, p. 6.
36. III, p. 6 (see also Comstock, Mary B. and Vermeule, Cornelius C., *Sculpture in Stone: The Greek, Roman and Etruscan Collections of the Museum of Fine Arts, Boston* (Boston: MFA, 1976), p. 39.
37. III, 7.
38. Ibid.
39. B-G, p. 219.
40. JF Ms.
41. Ibid.
42. MSP to May Prichard, 20 April 1902.
43. Tharp, *Mrs. Jack*, p. 256. There is another major biography of ISG: *Isabella Stewart Gardner and Fenway Court* by Morris Carter (Boston: Isabella Stewart Gardner Museum, 1925). By far, the Tharp volume is more interesting and informative.
44. Hadley, *BB and ISG*, p. xviii. Hadley's volume is filled with up-to-date and useful annotation.
45. MSP to May Prichard, 20 April 1902.
46. Edel, Leon, *The Life of Henry James*, Volume 2 (London: Penguin Books, 1977), p. 578.
47. Ibid., pp. 578-9.
48. Hadley, *BB and ISG*, pp. 354-5.
49. Whitehill, Walter Muir, *Museum of Fine Arts Boston: A Centennial History* Vol. 1 (Cambridge, Mass.: Harvard University Pres, 1970), p. 178.

50. Tharp, *Mrs. Jack*, p. 257.
51. Ibid., pp. 257-8.
52. I, 3.
53. Whitehill, *MFA Boston*, Vol. 1, p. 188.
54. Ibid., pp. 181-2.
55. Ibid., pp. 183.
56. Ibid., pp 184.
57. MSP memorandum given to me by Charles Stewart.
58. Whitehill, *MFA Boston*, Vol. 1, p. 185.
59. Ibid., p. 188.
60. Ibid.
61. MSP to ISG, 27 Aug. 1904.
62. Ibid.
63. BB to ISG, 14 Dec. 1905 (pp. 375-6, Hadley).
64. ISG to BB, 26 Oct. 1905 (p. 369, Hadley).
65. I, 6.
66. I, 10.
67. MSP to Charles Prichard, 10 April 1907.
68. I, 15.
69. Spalding, *Fry*, pp. 85-6.
70. ISG to BB, 22 Jan. 1905 (p. 360, Hadley).
71. *Fine Art File*, Issue V, July 1990, p. 12.
72. Spalding, *Fry*, pp. 82-3.
73. Ibid., p. 83 (see also Bell, Clive, *Old Friends* London: Cassell, 1956) pp. 81-37.
74. MSP to ISG, 4 Aug. 1907.
75. 'Venice' section, HRW, p. 2.
76. Secrest, Meryle, *Being Bernard Berenson* (London: Weidenfeld & Nicolson, 1979), p. 156.
77. Claud Phillips to MSP, 13 Dec. 1907.
78. 'Venice' section, HRW, p. 4.
79. Ibid., p. 5.
80. '11 Nov. 1908' section, HRW, p. 6.
81. Schneider, Pierre, *Matisse* (Zurich: Kunsthaus, 1982), p. 360.
82. Ibid., pp. 732-4.
83. MSP to ISG, 12 Nov. 1909.
84. Ibid.
85. 'Jeanne d'Arc and Henri Bergson' section, HRW, p. 20.
86. Ibid.
87. Ibid.
88. Ibid.
89. Ibid.
90. Roger Fry to Clive Bell 26 Jan. 1911, in *Letters of Roger Fry*, Vol. 1, edited

and with an introduction by Denys Sutton (London: Chatto & Windus, 1972).

91. Stein, Gertrude, *The Autobiography of Alice B. Toklas* (London: Penguin Books, 1966), pp. 134-5.
92. Russell, John, *The World of Matisse* (New York: Time-Life Books, 1969), p. 72.
93. BB to ISG, 27 Aug. 1909, pp. 453-4, Hadley.
94. Ibid.
95. Schneider, *Matisse*, p. 733.
96. MSP to ISG, 5 June 1912.
97. Spalding, *Fry*, pp. 118-19.
98. MSP to ISG, 26 June 1914.
99. BB to ISG, 27 Aug. 1909, pp. 453-4, Hadley.
100. ISG to BB, 4 Sept. 1909, pp. 454-5, Hadley.
101. '1909-1910' Section, HRW, p. 3.
102. MSP to ISG, 6 June 1922.
103. Ibid.
104. MSP to ISG, 25 March 1911.
105. MSP to ISG, 13 Aug. 1911.
106. Sutton, Denys, *Walter Sickert: A Biography* (London: Michael Joseph 1976), p. 119.
107. Ibid.
108. MSP to ISG, 17 Feb. 1910.
109. Ibid.
110. MSP to ISG, 19 July 1910.
111. Ibid.
112. MSP to ISG, 20 Aug. 1911.
113. Ibid.
114. Ibid.
115. MSP to ISG, 13 Nov. 1911.
116. JM to JF, 10 Oct. 1907.
117. MSP to ISG, 3 March 1910.
118. MSP to ISG, March 1910 (no day given).
119. ISG to BB, 4 March 1910 (pp. 467-8, Hadley).
120. MSP to ISG, 18 Sept. 1913.
121. MSP to ISG, 26 June 1914.
122. 'August 4, 1914' section HRW, p. 1.
123. Richard Fisher to Sylvia Warren, 30 Nov. 1914.
124. *In Ruhleben: Letters from a Prisoner to His Mother*, edited by Douglas Sladen (London: Hurst & Blackett, 1917). Also see Glendinning, Victoria, *Rebecca West: A Life* (London: Weidenfeld & Nicolson, 1987), pp. 131-2.
125. Ibid., pp. 93-4.
126. Ibid., p. 170.

127. *Times Literary Supplement*, review, Feb. 1917.
128. *The Times*, 17 Oct. 1936, p. 19.
129. Ibid.
130. 'August 4, 1914' section HRW, p. 2.
131. MSP to ISG, 28 Nov. 1915.
132. Ibid.
133. '1918' section, HRW, p. 1.
134. Ibid.
135. Ibid.
136. MSP to ISG, 7 Nov. 1922.
137. '1918' section, HRW, p. 4.
138. Ibid., p. 5.
139. MSP to ISG, 4 June 1922 and '1924-1929' section, HRW, p. 4.
140. MSP to ISG, 4 Oct. 1922.
141. '1920' section, HRW, pp. 1-2.
142. Private Correspondence.
143. '1921' section, HRW, pp. 1-2.
144. MSP to ISG, 10 Jan. 1922.
145. MSP to ISG, 17 Jan. 1922.
146. MSP to ISG, 12 July 1924.
147. Tharp, *Mrs. Jack*, p. 324.
148. 'Mrs. Gardner' section, HRW, last page – unpaginated section.
149. 'Das Ewig Weibliche' section, HRW, pp. 1-2.
150. *The Times*, 17 Oct. 1936. p. 19.

Part VII: Harold Woodbury Parsons's Story – Thick as the Leaves that Strew the Brooks of the Vallombrosa

1. HWP to Henry Francis, 14 March 1967.
2. McCullough, David, *Mornings on Horseback* (New York: Simon & Schuster, 1981) p. 208.
3. HWP to Henry Francis, 14 March 1967.
4. Ibid.
5. HWP to Paul Grummann, 12 Oct. 1940.
6. HWP to Henry Francis, 14 March 1967.
7. Ibid.
8. HWP to WMM, 10 Oct. 1948.
9. HWP to Henry Francis, 14 March 1967.
10. JM to JF, 23 July 1909.
11. B-G, pp. 241, 243.
12. HWP to JM, 19 July 1912.
13. HWP to JM, 4 Aug. 1916.
14. JM memorandum in a notebook dated 31 May 1921 at the Ashmolean Library.

15. Sutton, Denys, 'Treasures from Cleveland', *Apollo*, Christmas 1963, p. 432.
16. Wittke, Carl, *The First Fifty Years: The Cleveland Museum of Art 1916-1966* (Cleveland, Ohio: CMA, 1966), pp. 46-47.
17. Gimpel, Renè, *Diary of an Art Dealer* (London: Hodder & Stoughton, 1966), p. 226.
18. Wittke, *Cleveland*, pp. 48-9.
19. Frederic Allen Whiting to JM, 23 April 1914.
20. HWP to Henry Francis, 14 March 1967.
21. HWP to Henry Francis, 14 March 1967.
22. Ibid.
23. Hoving, Thomas, *King of the Confessors* (New York: Simon & Schuster, 1981), p. 165.
24. *Bulletin* of the Cleveland Museum of Art, March 1925.
25. Sox, David, *Dossena*, p. 49.
26. Wittke, *Cleveland*, pp. 115-6.
27. HWP to Whiting, 31 Dec. 1927.
28. Jeppson, Lawrence, *Fabulous Frauds* (London: Arlington Books, 1971), p. 53.
29. Sox, *Dossena*, p. 47.
30. Ibid.
31. Ibid.
32. B-G, p. 209.
33. BB to ISG, 3 May 1903 (p. 315, Hadley) and ISG to BB, 19 May, 1903 (p. 315, Hadley).
34. HWP to HAT, 19 May 1929.
35. Wittke, *Cleveland*, p. 10.
36. WMM to HAT, 11 June 1929.
37. HWP to HAT, 5 July 1929.
38. Ibid.
39. HWP to Henry Francis, 14 March 1967.
40. Ibid.
41. HWP to HAT, 21 Sept. 1929.
42. L.D. Caskey to HAT, 9 Aug. 1929.
43. HWP to Henry Francis, 14 March 1967.
44. *Sussex Express Herald*, 19 Sept. 1952.
45. HWP to Edward Forbes, 16 Sept. 1928.
46. Gimpel, *Diary*, p. 352.
47. Ibid. p. 358.
48. Wittke, *Cleveland*, pp. 113-14 (NB footnotes on p. 153).
49. Ibid., pp. 118-19.
50. *The Collections of the Nelson-Atkins Museum of Art* (New York: Harry Abrams, 1988), p. 9.

51. Sox, *Dossena*, p. 80.
52. HWP to Paul Grummann, 5 July 1941.
53. *New York Times*, 29 May 1967, p. 25.
54. Wittke, *Cleveland*, p. 87.
55. Ibid., p. 85.
56. HWP to WMM, 21 Nov. 1932.
57. Ibid.
58. Ibid.
59. WMM to HWP, 25 Oct. 1934 and HWP to WMM, 7 Nov. 1934.
60. WMM to HWP, 8 Nov. 1934.
61. Parsons actually wrote this to Grummann, 5 July 1941.
62. Wittke, *Cleveland*, p. 49.
63. Hoving, *Confessors*, p. 171.
64. Ibid.
65. Ibid.
66. Fowles, Edward, *Memories of Duveen Brothers* (London: Times Books, 1976), pp. 118, 122.
67. HWP to WMM, 10 Oct. 1948.
68. HWP to WMM, 11 June 1950.
69. Ibid.
70. HWP to Paul Grummann, 30 Aug. 1944 and 15 July 1945.
71. Amfitheatrof, Erik. *The Enchanted Ground: Americans in Italy 1760-1980* (Boston: Little, Brown, 1980), p. 155.
72. HWP to WMM, 3 Sept. 1947.
73. HWP to WMM, 31 Dec. 1948.
74. HWP to WMM, 12 Jan. 1949.
75. HWP to WMM, 12 Jan. 1949.
76. Hoving, *Confessors*, p. 173.
77. HWP to WMM, 12 Jan. 1949.
78. Hoving, *Confessors*, p. 193.
79. Ibid., p. 176.
80. HWP to WMM, 12 Jan. 1949.
81. HWP to WMM, 12 Jan. 1949.
82. HWP to WMM, 17 Jan. 1949.
83. HWP to WMM, 12 Jan. 1949 (included in this letter as a postscript).
84. HWP to WMM, 11 June. 1953.
85. HWP to WMM, 10 June 1956.
86. Rathbone, Perry T., 'An Etruscan Diana of the First Rank', in *The Illustrated London News*, 19 Sept. 1953, p. 435.
87. On the BBC TV *Timewatch* programme for which I was presenter in 1986.
88. HWP to WMM, 18 Oct. 1956.
90. WMM to HWP, 13 Aug. 1957.
89. WMM to HWP, 3 May 1954.
91. HWP to WMM, 17 May 1954.

92. Hoving, *Confessors*, p. 91.
93. HWP to Henry Francis, 12 June 1956.
94. Hoving, *Confessors*, p. 21.
95. Ibid., p. 22.
96. Ibid., p. 52.
97. Ibid., p. 176.
98. Ibid.
99. Ibid., p. 67.
100. Ibid., p. 175.
101. Ibid., p. 92.
102. Ibid.
103. Ibid., p. 165.
104. Ibid., p. 184.
105. Ibid., pp. 184-5.
106. Ibid., pp. 185-6.
107. Ibid., p. 189.
108. Ibid., p. 299.
109. Sox, *Dossena*, p. 112.
110. Frankfurter, Alfred, 'Unhappy Warriors', p. 65.
111. Sox, *Dossena*, p. 111.
112. *Life*, 10 March 1961, p. 40B.
113. Parsons, 'The Art of Fake Etruscan Art', pp. 10, 65.
114. Ibid., p. 65.
115. Ibid., p. 35.
116. HWP to Henry Francis, 14 March 1967.
117. Ibid.
118. WMM to HWP, 28 Nov. 1949.

Epilogue

1. Amory, Cleveland, *The Proper Bostonians* (New York: E.P. Dutton, 1947), p. 124.
2. Ibid., p. 125.
3. An interesting profile designating Zeri as 'the biggest discoverer of all time' appeared in *Art News*, Nov. 1990.
4. *Minerva*, Vol. I, No. 10, Dec. 1990, p. 4.
5. Simpson, *Partners*, pp. 149-50.
6. Ibid.
7. *Connoisseur*, Sept. 1986, p. 103 and Aug. 1987, pp. 75-6.
8. Vickers, Michael, 'Arrentine Forgeries Revealed', *The Ashmolean*, summer and autumn, 1990, p. 5.
9. B-G, p. 361.
10. Vickers, 'Arrentine Forgeries', p. 5.
11. Comstock and Vermeule, *Sculpture*, p. xi.

12. Whitehill, *MFA Boston*, p. 674.
13. Ibid.
14. *The Daily Mirror*, 14 April 1953, p. 15.
15. EPW to 'Professor of Fine Arts', Walker Art Museum, Bowdoin College, 22 Sept. 1906.
16. EPW to Professor Henry Johnson, 13 Nov. 1912.
17. Frank Gearing to Professor Johnson, 16 Dec. 1912.
18. EPW to Miss Smith, Bowdoin College, 19 Oct. 1927.
19. Herbert, Kevin, *Ancient Art in Bowdoin College* (Cambridge, Mass.: Harvard University Press, 1964), p. 210.
20. Thomas Sutton to HAT, 20 July 1929.
21. B-G, p. 404.
22. HWP to WMM, 10 Oct. 1948.

Index

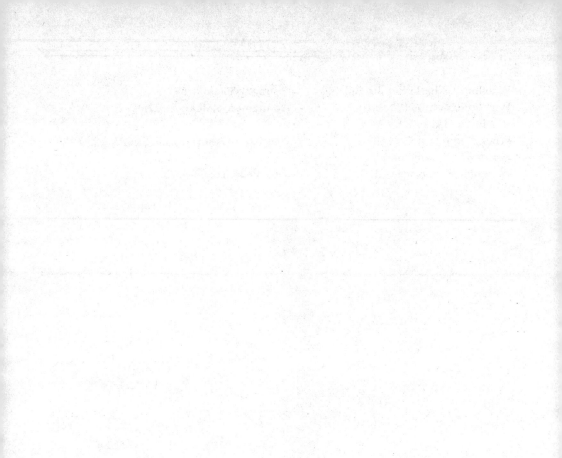